BECOMING MARY SULLY

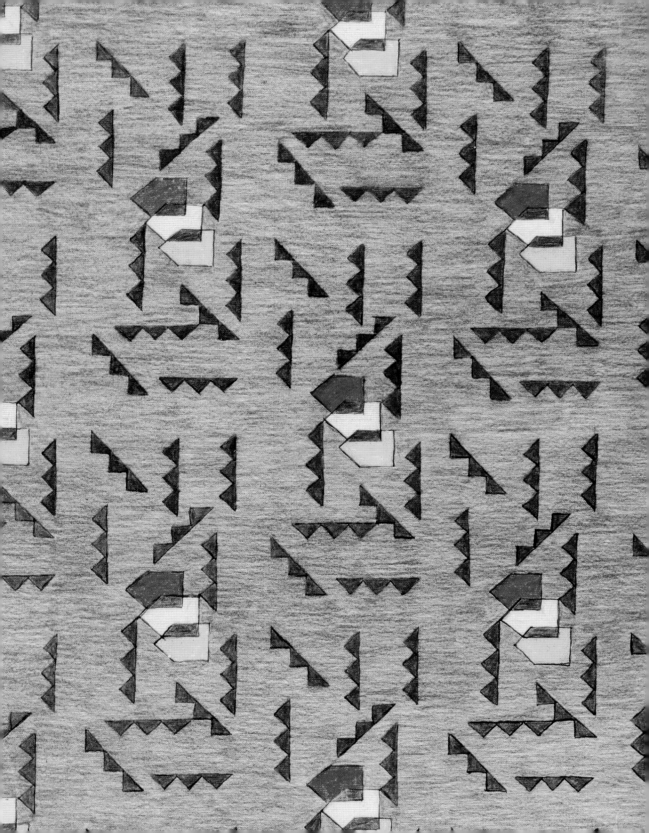

BECOMING MARY SULLY

TOWARD AN AMERICAN INDIAN ABSTRACT

PHILIP J. DELORIA

UNIVERSITY OF WASHINGTON PRESS | *Seattle*

Becoming Mary Sully was made possible in part by a grant from the Tulalip Tribes Charitable Fund, which provides the opportunity for a sustainable and healthy community for all.

Publication of this book has also been aided by a grant from the Millard Meiss Publication Fund of CAA.

Additional support was provided by Harvard University, the Harvard University Department of History Publication Fund, and the University of Michigan, Ann Arbor.

Design by Katrina Noble
Composed in NCT Granite, typeface designed by Nathan Zimet

23 22 21 20 19 5 4 3 2 1

UNIVERSITY OF WASHINGTON PRESS
www.washington.edu/uwpress

LIBRARY OF CONGRESS CATALOGING-IN-PUBLICATION DATA
LC record available at https://lccn.loc.gov/2018046902

The paper used in this publication is acid free and meets the minimum requirements of American National Standard for Information Sciences—Permanence of Paper for Printed Library Materials, ANSI Z39.48–1984.∞

FRONT COVER *Hervey Allen*, middle panel (detail); INSIDE FRONT COVER *Leo Carillo*, middle panel (detail); INSIDE BACK COVER *Lowell Thomas*, middle panel (detail) FRONTISPIECE *Eugene O'Neill*, middle panel (detail); PAGE VI *Father Flanagan*, middle panel (detail); PAGE VIII *Ernest Schelling*, middle panel (detail); PAGE 24 *Nila Cram Cook*, middle panel (detail); PAGE 57 *The Indian Church*, middle panel (detail); PAGE 90 *Patsy Kelly*, top panel (detail); PAGE 188 *Patsy Kelly*, middle panel (detail); PAGE 225 *The Architect*, middle panel (detail)

"The Great Figure" by William Carlos Williams, quoted on page 157, is from *The Collected Poems*, volume 1: *1909–1939*, copyright ©1938 by New Directions Publishing Corp. Reprinted by permission of New Directions Publishing Corp.

The soul selects her own society,
Then shuts the door;
On her divine majority
Obtrude no more.

Unmoved, she notes the chariot's pausing—
At her low gate;
Unmoved, an emperor is kneeling
Upon the mat.

I've known her from an ample nation
Choose one;
Then close the valves of attention
Like stone.

EMILY DICKINSON, POEMS, VOLUME 1, BOOK I (LIFE), XIII (1890)

CONTENTS

ACKNOWLEDGMENTS

This project has had a life as complicated as the work that it seeks to introduce and explain. It might be said to begin in the mid-1970s when, as a teenager, I first encountered the art of Mary Sully in the basement of our home. An initial round of gratitude and acknowledgment begins with my great-aunt Ella Deloria and my grandfather Vine Deloria Sr. for preserving the works and sending them our way. In 2006, my mother and I looked at the pieces with fresh eyes and the internet and I first realized just how special they were. A second round thus requires the strong acknowledgment of my mom, who preserved, protected, and appreciated the art for three decades. I first presented these images in 2008, at the conference *Images of the American Indian, 1600–2000*, organized by the National Museum of the American Indian and the National Gallery of Art. I thought my presentation was going to be a quirky one-off and then I'd be on to other business. Paul Chaat Smith, Jolene Rickard, Nancy Anderson, Kate Flint, and Ned Blackhawk, among others, thought differently, and I want to thank them for spurring me to pursue a deeper investigation of the images.

The project unfolded while I was engaged in the work of academic administration, and it proceeded in iterative fashion as an extended series of lectures, with time to rethink and write between each one. I am deeply indebted to the insights and observations of countless audience members over the years at institutions in the United States, Taiwan, Finland, and Australia, as well as commentaries given at the College Art Association and the Native American and Indigenous Studies Association from luminaries like David Penney, Ruth Phillips, Jackson Rushing, Kathleen Ash-Milby, and Sascha Scott. I'm particularly indebted to a young man in Lincoln, Nebraska, who described his own experience of synesthesia; to colleagues in Taiwan

who pushed me to read the images in more spatially complex terms; to specifically useful comments from Elizabeth Hutchinson, Aaron Glass, Bill Anthes, Robert Warrior, Jeani O'Brien, Mauricio Tenorio, Hsinya Huang, and Alexander Olson; and correspondence with Lilah Pengra, Stephen Bloom, Ray DeMallie, Abby Stewart, Gus Buchtel, Susan Gardner, and Susan Gunderson, among others. The ideas in this book have been kicked around by a huge roster of colleagues. Gratitude, in particular, to Rita Chin, Peggy McCracken, Mary Kelley, Jim Adams, Susan Douglas, Beth Piatote, Susan K. Kent, Carlo Rotella, Tina Klein, June Howard, Kristin Hass, Michael Witgen, Greg Dowd, John-Carlos Perea, Ellen Taubman, and Cindy Ott. As a friend, mentor, and boss, Terry McDonald made many things possible. This list is partial. Thank you to all those who engaged me in thoughtful conversation over the last decade.

The project has benefited from a gifted group of research assistants. Thanks to Courtney Cottrell and Katherine Carlton, who consulted with conservator Cathleen Baker as part of a University of Michigan Museum Studies capstone project, and to Nikki Roulo, Ekoo Beck, Julia Triezenberg, Roberto Nakay Flotte, and Noah Greco, each of whom made signal contributions. In the early stages, I had the great good fortune to engage Jordan Weinberg, the single best undergraduate research assistant I have ever had, and much of the blocking and tackling work bears his imprint. With near-perfect symmetry, I was privileged also to have the help of Sarah Sadlier, whose creativity and tireless enthusiasm eased the burden of permissions and reproduction work at the last stages. That this book is able to reunite on the same page three Alfred Sully images from 1857 is a testimony to Sarah's skills. I consider myself fortunate to have shared the labor with such a talented group.

A significant portion of this project rests on oral histories, and I am grateful in particular to my mother, Barbara Deloria; my aunt, Barbara Deloria Sanchez; and my father, Vine Deloria Jr. I conducted over sixty combined hours of interviews with my father in the mid-1990s, and these provide much of the grounding for this work. Likewise, this project depends on a collection of archives: the Ella Deloria Archive, a collection of Ella Deloria's correspondence gathered from a range of archives by Dr. Agnes Picotte, which is currently located with the Dakota Indian Foundation in Chamberlain, South Dakota. A major part of that archive has been digitized by the Amer-

ican Indian Studies Research Institute at Indiana University and is available online, for which I am eternally grateful. Much of the Ella Deloria Archive is dependent on the Franz Boas papers at the American Philosophical Society, and I want to acknowledge and express my gratitude for the friendly relationship I have had with APS over the years. I have also relied heavily on the records of the South Dakota Episcopal Diocese, located in the Center for Western Studies at Augustana University, in Sioux Falls, where Dr. Harry Thompson helped facilitate my research in what now seems the far-distant past. I would also like to acknowledge my longtime archival coconspirator and friend George Miles, of Yale University's Beinecke Rare Book Library, as well as Kathy Lafferty of the University of Kansas Archives and Roland Baumann (now emeritus) of the Oberlin College Archives.

Much of my argument rests on comparative readings of other works of art. I am grateful to Christina Burke and Darcy Marlow at the Philbrook Museum of Art; Ruby Hagerbaumer of the Joslyn Art Museum; Nathan Sowry at the National Museum of the American Indian; Carolyn Cruthirds at the Boston Museum of Fine Arts; Lauren Leeman at the State Historical Society of Missouri; Erin Bouchard at the Weisman Art Museum at the University of Minnesota; Angela Bell-Morris at the North Carolina Art Museum; Stephen Lockwood at the University of New Mexico; Daisy Njoku at the Smithsonian National Anthropology Archives; Jo Anderson, of Jo Anderson Galleries; John Tarrant, Bishop of the Episcopal Diocese of South Dakota; Mai Pham at Bridgeman Art Library; and Meghan Brown at Art Resource.

I am particularly thankful to those who have given me permission to publish and engage with the works of their forebears: Gary Roybal (Awa Tsireh); Joe Herrera Jr. (Joe Herrera); Vanessa Jennings (Stephen Mopope); Inge Maresh (Oscar Howe); and Coralie Hughes, for the John Neihardt Trust.

The publication of this book has been supported financially by Harvard University, the University of Michigan, CAA, and the Tulalip Tribes, and I am grateful to all four. At the University of Michigan, Scott Soderberg did most of the photography for this project; at Harvard, Robert Zinck picked up the photographic baton and completed a small but critical portion of the project.

I have been fortunate to have a fantastic group of friends and colleagues for the exchange not only of ideas but of the actual stuff of drafts and manuscripts. My deepest appreciation to Jay Cook and Gregg Crane, both of whom

did deep, fine, useful readings of an early draft, and who remain among my closest friends, professionally, musically, and personally. Thanks to you both! Sascha Scott brought her deep knowledge of American Indian art history to bear on the manuscript, while Jill Ahlberg Yohe offered an incredibly useful curatorial perspective. A later draft benefited immensely from readings and advice from Rani-Henrik Andersson and from my Michigan colleagues, Nick Delbanco—a master of the writing craft—and Carroll Smith-Rosenberg, my trusted friend, mentor, and chair-honoree. Two anonymous readers for the University of Washington Press offered useful encouragement and advice, and their thoughts are much appreciated. With all this help, one would think that the book would be perfect. It's not, of course, and any and all errors are mine alone.

At the University of Washington Press, Larin McLaughlin was the model editor, always supportive, willing to dig into the manuscript and respond with great ideas that pushed the project forward. My appreciation to her is paralleled by my gratitude to Mike Baccam, who held my hand through the nuts and bolts of the production of an art history book. I'd also like to thank Beth Fuget, Michael O. Campbell, Katherine Tacke, and Margaret Sullivan. Copy editor Jennifer Comeau and indexer Eileen Allen did excellent work, for which I am grateful.

There are really no words to express my gratitude to my curious and patient family. Jackson and Lacey have come into their own during the course of this project, and I have to imagine that my conversations with them made my own thinking clearer and more coherent. My mother, the quiet guardian of Mary Sully's legacy, made this project possible, and I hope that she takes as much joy in it as I have. Peggy Burns has been my partner and intellectual companion for four decades, always guiding the way. Her vision, good sense, creativity, and passion for changing the world are second to none, and I've been privileged to walk alongside her. Of course, at the end of the day, this book is a reclamation—of an interesting, sometimes troubled, deeply creative and intelligent woman, Mary Sully. I can only pray that I've done her some justice.

BECOMING MARY SULLY

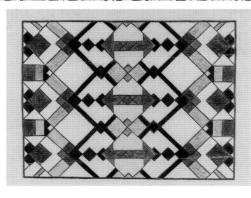

INTRODUCTION

Native to Modernism

BEGIN WITH THE IMAGE, DENSE WITH COLOR, FORM, PICTURE, AND geometry.[1] Three panels, of distinct character and size, stack atop one another. In one panel (fig. I.1, top), hard-edged graphite outlines of fences and dull despair jostle with cartoon Indians sitting on green grass. In another (fig. I.1, middle), a pattern of garish color—purple, pink, red, yellow, and green—leaps out of a swirl of undulating bands of small repeated designs. Somber brown silhouettes with demonstrative hands seem visually familiar, invoking the pains and anxieties of modern uncertainty. Diamonds and triangles dominate the bottom panel (fig. I.1, bottom), horizontal bands the top one—though all are linked together through a symmetry that bisects the three panels down the middle. A tear at the bottom of the top panel testifies to hard use. A small, folded piece of cloth tape at the top of the middle panel suggests a formal articulation of the three pieces of paper—though it reveals that the joining was done on the cheap. The image has a title, one that gestures to historical chronology—a time of goodness, followed by unhappiness and then uncertainty. That chronology structures the mural-inflected logic of the top panel. Additional study reveals iconic forms that link the three panels together: shoes, fences, arrows, and silhouettes. One's eye wanders

I.1. Mary Sully (Dakota, 1896–1963), *Three Stages of Indian History: Pre-Columbian Freedom, Reservation Fetters, the Bewildering Present* (after 1938). Colored pencil on paper, 34.5 × 19 inches. Author's collection. Photo by Scott Soderberg

through a seeming incoherence that hints at unifying principles, structures of feeling that link American Indian pasts to . . . to what? Perhaps to an Indian future yet to be made, given uncertain shape through an image—*this image*—yet to be understood.

This book is an effort to make sense of both the triadic picture *Three Stages of Indian History* and a moment of American/Indian history itself. I aim to understand the modes and motives of the image's creator, the archive of drawings of which *Indian History* is a part, and the cultural meanings and forms to which it speaks. At the same time, I want to explore the social and political moment of its creation, the possibilities and constraints imposed on actual American Indian people, refracted in the artist's framing of history. What might it mean to understand *Three Stages of Indian History* in the fullness of its context, to make new sense of the contemporary arts and politics that have emerged out of Indian history? Above all, I plan to make a case for the aesthetic power and importance of the art and the peculiar genius of its creator, Mary Sully.

These aims mark the questions that structure this book—and they suggest a different beginning. Start with a gray box, about two feet on a side, constructed of thick paperboard with steel reinforced corners. Mary Sully carried the box with her, along with her paper and colored pencils, and kept it in her room as she moved from place to place: New York City. South Dakota. Oberlin. Tampa. South Dakota. Omaha. South Dakota. The box contained her life's work, a project that produced an identity—artist—that helped explain her eccentricities, both to herself and to anyone who may have been watching. Almost no one was.

The box that held *Indian History* and her other drawings passed from hand to hand after Mary Sully's death in 1963. It went first to her sister Ella, the long-time companion who had labored (and lived) with Sully during the course of the project. Together, the sisters nurtured dreams for Sully's drawings and designs: exhibitions, patronage, sales. Those hopes long gone, the box now sat lost in the stack of Ella's own papers and manuscripts. Nearly a decade later, Ella too died. Their younger brother sifted through the pair's belongings. Some papers went to a university library; other things were thrown away.

The gray box passed a precarious moment, quivering beside a trash can. No one would have cared much if the drawings disappeared, for Mary Sully

had been an odd bird with few friends. But the brother remembered his daughter-in-law, a librarian. He gave it to her with vague instructions, a directive to "catalog it or something." To him, the drawings were the debris of an earlier generation, worthless notebooks from a long-forgotten schoolroom. The librarian was the daughter of a librarian, however, born with a commitment to saving and storing things. She looked through the drawings—over one hundred of the three-part images—and tried to make sense of them. She failed but decided that she liked them anyway. When it looked like the drawings might be thrown out in a basement purge, she transferred them to a large suitcase and hid them under a stairwell. They survived more spring cleanings and even a house fire. In 2006 she unearthed them, and they saw the light of day for the first time in decades. I was there, for the librarian was my mother.

That fact reveals both the genealogy (the artist Mary Sully was my great-aunt) and my own not-disinterested position as an interpreter of her work. To me, the images embodied a magical nostalgia; they literally smelled of the past. To breathe their atmosphere was to reach for that critical moment—sometime in the 1920s, perhaps—when many American Indian people crafted new and different lives for themselves. Those new Indian lives were not legible through the old histories of the nineteenth century, or the ethnographies that sought to reach further back in time, or the childhood recollections of my father, or the more recent historical memories of World War II and the postwar decades. That curious moment, now past, had once been fresh, exciting, and difficult. Mary Sully's art suggested the possibility of a return.

This book is an exercise in multiple returns. Think of it as a kind of onion-peeling, the systematic excavation of intertwined worlds of meaning and context. I tell histories that try to close the gap between the analytic and the affective, between meaning and feeling. I will oscillate between narrative and formal analysis, between historiography and biography, between critical interpretation and context. I engage questions of periodization, schools of thought, moments in time, categories, and comparisons—all in an effort to connect the aesthetic experience of Mary Sully's images with the richness of their historical situation.

Let us return, then, to the moment when many Indian people, like Mary Sully, staked a native claim to modernism—and did so through the medium of visual art. We might begin here:

In 1928 or 1929, the Kiowa artist Stephen Mopope created an image, *Kiowa Warrior on Horseback* (fig. I.2). Against a bare tan background, a horse and warrior gaze together to the left of the picture plane. Both are cast in shades of brown: solid and dark for the horse, muddy for the warrior's upper body, a lighter buckskin tan—almost orange—for his legs. Bow, shield, feathers—the latter similarly aligned, pointed forward on both horse and man—add sparse, clean detail to the image. The horse's hooves, tail, and mane are set apart through the use of a blue-gray accent. These active colors cause the otherwise flat image to leap off the page. The picture evinces at once an American Indian past, an engagement with modern primitivist aesthetic desire, and a connection to the American Indian ledger-book arts traditions of the nineteenth century, in which Kiowa artists were prominent.[2]

Sometime between 1925 and 1930, the Pueblo artist Awa Tsireh gathered his watercolors and paper and created a similar image, *Mounted Warriors* (fig. I.3). Two warriors on horseback charge at one other, splitting the picture plane into a bilateral symmetry. Their horses mirror one another in form (though not color), and the human figures, marked with more visible distinctions in color and design, play closely with symmetrical reflection. With sun above and stair-step mountains below, the landscape itself is represented through quasi-abstract icons, rich with color. Absent background, the figures hang ethereal and mythic, suspended in the empty space of the white paper. Though these figures, too, are flat on the page, the image is full of motion. Like Mopope's *Warrior*, Awa Tsireh's painting is spare and lovely. Rich with feeling, it offers an equally powerful blending of "traditional" imagery with modernist aesthetic desires.[3]

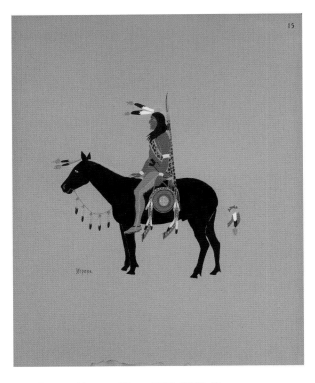

15

I.2. Stephen Mopope (Kiowa, 1898–1974), *Kiowa Warrior on Horseback* (1929). Pochoir print, 79 × 37.8 cm. Manuscript 7536, National Anthropological Archives, Smithsonian Institution. Courtesy of Vanessa Jennings

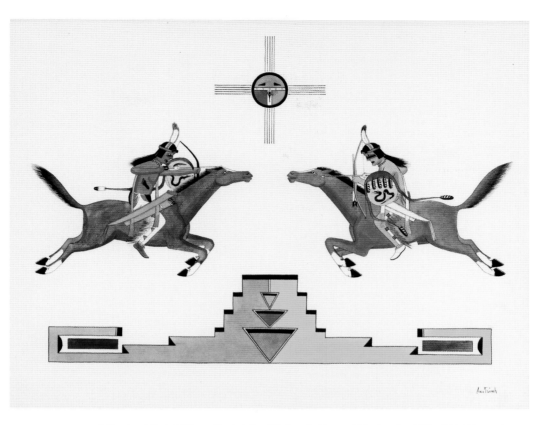

I.3. Awa Tsireh (Alfonso Roybal, San Ildefonso), *Mounted Warriors* (ca. 1925–30). Watercolor and ink on paperboard, 11¼ × 14¼ inches. Smithsonian American Art Museum, Corbin-Henderson Collection, gift of Alice H. Rossin. 1979.144.27. Courtesy of Gary Roybal

Sometime between 1927 and 1929—perhaps in July of 1929—Dakota Sioux artist Mary Sully set out to record, on paper with colored pencil, her meditations on the young American tennis star Helen Wills (fig. I.4). Wills was, like Sully herself, a shy, sometimes awkward woman with an interest in art. She was also, between 1927 and 1933, the world's best female tennis player. In both 1928 and 1929, she won the US Open, Wimbledon, and the French Open, in effect garnering what we would today call a Grand Slam (American and European players did not yet travel to Australia for its tournament). In 1928 Wills published—and illustrated—her own coaching manual, *Tennis*. In 1930 the Mexican muralist Diego Rivera painted her in San Francisco as a

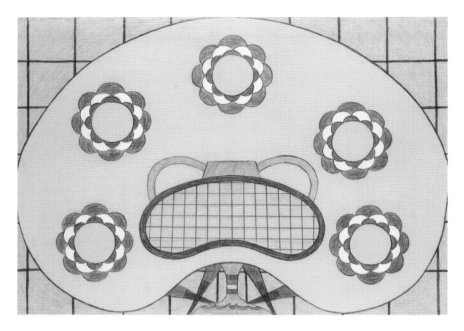

I.4. Mary Sully, *Helen Wills*, top panel (ca. 1929)

model for an image in his piece *The Riches of California*. And on July 1, 1929, she graced the cover of *Time Magazine*, her second appearance (she was first on the cover in 1926). Wills was an intriguing and compelling subject, one Sully obviously considered worth her time.[4]

It is as if we have entered a different world. Sully's image is both *abstract*, in its obvious abandonment of realism, and *representational*, in its willingness to invoke coherent signifiers of tennis (the net background, the echoed cross-hatching that suggests a racquet). Like the works of Mopope and Awa Tsireh, *Helen Wills* relies on empty space, though less as a timeless background and more as a color and design element of the composition. The image poses representational puzzles: Should one try to make sense of the five colored circular patterns? Do they, for instance, gesture to the white visor and pleated skirts Wills made famous as women's tennis wear? Or to the five US Open championships she had already won by July 1929?[5] What of the kidney-shaped structure that seems to rest on a kind of stand (is it a warped abstraction of a tennis racquet, an artist's palette, or something

else?) or the red and brown cones that crisscross at what begins to look like a base, or focal point? Do these carry meaning? If so, what might it be? Are they symbols from the unconscious? Surrealist distortions? Icons that we might associate with Helen Wills? In subject and execution, Sully's art has almost nothing in common with the works of Mopope or Awa Tsireh—or with that of other contemporaneous American Indian artists. Yet all were part of the flowering of Indian art that began in the 1920s—that curious, critical moment—and has continued to the present day.

Stephen Mopope was one of the five men and one woman that made up the Kiowa Six, a group of young Native artists who have offered scholars a reliable anchor for sounding out the development of new traditions of American Indian arts in the twentieth century.[6] Most had benefited from artistic training at the St. Patrick's Mission School and, later, painting classes offered at the Kiowa Agency in Anadarko, Oklahoma. Susan Peters, the agency field matron, arranged with Oscar Jacobson, director of the School of Art at the University of Oklahoma, to create a special program for these Kiowa students, who were thus able to consolidate a style and a bona fide artistic school. Jacobson became deeply committed to the training of Indian artists, providing studio space, supplies, encouragement, and his home as a refuge and meeting place. He also devoted significant effort to the dissemination of their work. In 1928 the Kiowa artists participated in the First International Art Exposition in Prague; in 1929 Jacobson engineered the Paris publication of their work, *Kiowa Art*, a portfolio of paintings and pochoir prints, of which *Kiowa Warrior on Horseback* is one.[7]

Awa Tsireh's career offers an equally compelling point of entry for tracing a foundational American Indian arts history, for it unfolded in close dialogue with the collectors and patrons who sought to create, define, and often control Southwest modernism. The story is often situated around Awa Tsireh's community, San Ildefonso Pueblo in northern New Mexico, which was also home to the famous black-on-black pottery traditions of Maria Martinez. Awa Tsireh began as a decorator of pottery, but, encouraged by white patrons, he shifted his work to the medium of watercolor and paper. He became a favorite among the primitivist artists, writers, and anthropologists who blended the modern and the antimodern together in Santa Fe— among them Alice Corbin Henderson, who collected *Mounted Warriors*.

Commentators on the San Ildefonso school commonly select 1917 as a key date in the development of what art historian W. Jackson Rushing describes as "nonceremonial paintings on paper that were derived from traditional culture and intended for consumption by a non-Native audience."[8] Along with Crescencio Martinez, Awa Tsireh is considered a foundational figure in this painting tradition, which underpinned a great deal of American Indian art between the 1920s and 1950s.

Taken together, the Oklahoma and New Mexico schools reveal critical factors defining the emergent Indian arts: market patronage, sustained mentoring, community-based collectives, and the structure provided by educational institutions and museums.[9] And the Kiowa Six and the San Ildefonso painters represent only a few of the many Indian artists who worked in the United States during a first long wave of Native American aesthetic production that located itself in the cultural triangulation between older Native styles, new artistic practice, and the modernist primitivisms that influenced patrons, collectors, teachers—and, of course, artists. At Bacone College, another Oklahoma school of painting emerged around figures such as Acee Blue Eagle, Woody Crumbo, and Richard West. Kiowa photographer Horace Poolaw began building a powerful visual archive in the mid-1920s. At the Santa Fe Indian School, Dorothy Dunn and her successor, Gerónima Cruz Montoya, developed the Studio School, which trained an entire generation of Indian artists.[10] Across the country, quillwork, beadwork, and basketry crossed with pottery, painting, photography, metalwork, and sculpture.[11] Old ideas mixed with new; reservations with boarding schools; small Indian communities with global art scenes.

At the 1931 Exposition of Tribal Arts in New York City's Grand Central Station Gallery, one found hundreds of works from both contemporary artists and anthropological collections, from tribes in every region of the continent (Awa Tsireh's *Koshare on Rainbow* graced the cover of the catalog).[12] In 1939 at the San Francisco Golden Gate International Exposition, and in 1941 in a massive show at the Museum of Modern Art (MoMA), this practice of mingling old and new helped solidify American Indian arts, redefining older ethnographic objects *as* art through recontextualization and then surrounding them with contemporary artistic productions, neatly linking the new art back to authentic points of origin in ancestral pasts. By the 1960s these

kinds of institutional supports—schools, patronage, curation, publication, artists' groups—would take new shape with the founding of the Institute of American Indian Arts, one of the most critical contemporary institutions for American Indian artists.[13] Distilled into a few paragraphs, this brief history of Native modernism reflects our common understanding of the moment.

Mary Sully lived outside its story. She was largely self-taught and had no institutional support. Living at the uneasy bottom edge of economic stability, she made no money from her work, exhibiting it only a few times in informal venues far removed from the arts world. Her life was peripatetic and marked by economic dependency on her sister. She struggled with emotional distress. She had no artists' circle where she might exchange paintings, ideas, or techniques. In many ways, she sits more comfortably in the category of vernacular, or perhaps even "outsider," art than she does with the Indian artists of Oklahoma, New Mexico, and elsewhere.

Stephen Mopope, by comparison, learned from his grandmother and other relatives; from his mission school teacher, Sister Olivia Taylor; from a local artist, Mrs. Willie Baze Lane, who taught Indian students in Anadarko; and from Oscar Jacobson and others at the University of Oklahoma. He was aware of the legacy of the well-known Kiowa artist Silver Horn (whom he named as his first teacher) and others who had developed ledger-book styles while in captivity at Fort Marion, Florida (1875–78) and who continued a tradition of image making afterward.[14] His background offered a rich environment for skills and technique training, as well as the growth and consolidation of a coherent aesthetic. Likewise, Awa Tsireh benefited from the equally strong artistic traditions of San Ildefonso, the early emergence of a paying art market in the Southwest, and the expertise and counsel of collectors and patrons.

Mary Sully may have audited a few classes in art at the University of Kansas or possibly in Chicago. Her slight record of sketching is unimpressive and suggests that she learned, at best, from "how to" books and correspondence courses. She had no collectors, patrons, or peers, and her work is not to be found in museum or gallery. You might consider her a kind of motivated doodler, a small-time artist with no possibility of finding an audience aside from supportive family and friends.

On the other hand, the catalogs of the Kiowa Six or the Santa Fe School make it clear that the same institutional supports that enabled new levels of artistic production also constrained artists in both their choice of subject matter and their approaches to it. They would paint *Indians*, almost always visions of the past that appealed to white audiences.[15] Sully's lack of institutional support enabled her to evade those constraints, leading her to produce works that are complexly Native but also expansive in subject matter and unorthodox in conception. It is quite literally *impossible* to imagine a member of the Kiowa Six or of the San Ildefonso or the Santa Fe School of painters offering, in the late 1920s, an abstract portrait of a white, female tennis champion. Mary Sully, then, offers an opportunity for—and perhaps requires—contemporary viewers to consider alternative histories of American Indian artistic thought and production. Primitivism did not offer the only route into a Native modernism.

The majority of Mary Sully's artistic output is represented by what she described as "personality prints," a collection of three-part images, each of

I.5. Mary Sully, *Helen Wills*, middle panel (ca. 1929)

I.6. Mary Sully, *Helen Wills*, bottom panel (ca. 1929)

which contemplates, abstracts, and represents the personality of a particular individual. To grasp the form and structure of Sully's work more completely, then, we ought to consider the rest of the personality print for *Helen Wills*, for we have examined only the first panel. Stacked vertically underneath the first image, the viewer will find two additional images, repeating the tripartite structure found in *Three Stages of Indian History*.

In the middle panel (fig. I.5), Sully reworks the forms, icons, and colors of the top panel into a repeating pattern—in this case the tennis net background is thickened, as if one has drawn closer to it, even as the curiously anthropomorphic figure (in the top panel, there is a suggestion of legs, head, and mouth) is reduced in size, simplified, and angled in the corner of each repeating square. The bottom panel (fig. I.6) takes the dialogue between the top two panels in a completely different direction, establishing a strong bilateral symmetry and emphasizing the colors green and brown, with white opened up through the empty space in the center of the image. Having been called to our attention in this bottom panel, the bilateral symmetry becomes

immediately visible in the top panel. The "net" pattern remains central in this bottom panel, though it has been fragmented slightly and shifted 45 degrees in its orientation. The small red scalloped shapes visible in the top and middle panels now become small diamonds, arrayed both vertically and horizontally.

If the top panel offered a few meaningful signifiers of tennis—mostly in the form of cross-hatched net and racquet patterns—and the middle panel blurred those signifiers to the point where they ceased to carry import, the bottom panel's revisioning establishes a new code for the assertion of meaning: a loose but visible gesture to the "Indian" patterns found in beadwork, quillwork, or weaving design. From tennis Sully has taken the viewer—subtly and carefully—on a surprising journey into something like an Indian visual world.

We might locate Sully's work in the context of Indigenous modernism—but it bears little resemblance to the more famous works of the Native artists of Oklahoma, New Mexico, or elsewhere. So how should we think of her as a modern artist? Where might one locate Mary Sully amid the riot of worlds that a well-traveled Dakota cosmopolitan might inhabit in the 1920s, 1930s, and 1940s, when she conceived and produced the personality prints?

THE PERSONALITY PRINTS

To answer that question, we might begin by looking systematically at the collection itself. The personality prints comprise 134 sets of three-panel works, with a few incomplete panels scattered among the sets, and six that do not have names or captions. Some of these are possibly from unfinished projects; others have lost explicit identifiers and cannot (yet) be attached to a name or idea. The personality prints are not "prints" at all but unique, individual drawings. In almost every case, the medium is colored pencil or graphite; on a few rare occasions Sully has overwritten her pencil work with inexpensive tempura paint or sharpened up an edge with black ink. She seems never to have expanded to logical extensions of the pencil—pen, crayon, or pastel, to say nothing of watercolor or oil. Each image is executed on the same kind of paper, which might be considered "middle-grade" art paper.[16] Curiously, each category of panel (top, middle, bottom) is drawn on the same sized

paper as other panels *within* the category—though the paper size of each category is different.

Top panel: 18 inches by 12⅞ inches
Middle panel: 19 inches by 12 inches
Bottom panel: 12 inches by 9½ inches

Each triptych, then, has the same spatial structure, with the middle panel slightly more horizontal in form than the top panel, and the bottom panel noticeably smaller than the others. The greatest variation in these measurements is to be found among the top panels; in many cases the left (and sometimes the right) edge of the paper has been cut slightly unevenly.

Sully prepared her work for display. We know the intended arrangement of the three images because almost all the panels are attached together with tape, in a top–middle–bottom order. The general pattern among these three—abstraction, geometry, "Indian"—is also consistent. In most cases, the backside of each panel has been reinforced at the edges with brown paper tape. In some instances, the top panels include inexpensive hangers made of paper or light cloth, allowing one to hang the image from a small hook or pin. In many pieces, a title card—hand lettered in black ink on white paperboard—can be found attached to the bottom panel, naming the personality that is the subject of the triptych. In cases where no label exists (a not-insignificant number), the name of the personality is often written in pencil on the back of one of the panels or at the lower edge of the bottom panel.

In a number of instances (for example, fig. I.7), the back side of the paper shows evidence of false starts, which in turn demonstrate the underlying structures Sully used to organize her images. These generally consist of grids—triangles and squares—that offer opportunities to explore center-of-the-paper rotational symmetry and to offer boundaries and guides for organizing circles. In some cases, it seems possible that Sully developed and used stencils in order to regularize her symmetry. In many others, however, she has drawn circles and other geometric forms freehand. Such forms were outlined with some precision in graphite pencil and then color was added, eventually covering much of the original structural drawing. The tape reinforcement, taped articulation of panels, title cards, and mounting hangers

I.7. Mary Sully, *Titled Husbands in the USA* (reverse). This false start on the reverse side of paper illustrates Sully's use of tape to reinforce the edges of her paper, the taped articulation of the three panels, the triangular grid structure she often used in middle panels, and her interest in rotational symmetry.

evidence public display of the works, and indeed, in the correspondence of Mary Sully's sister Ella, one finds acknowledgment letters from Indian School principals in Pipestone, Minnesota, and Flandreau, South Dakota, thanking Sully for short-term (one- or two-day) displays of the images. Both of these date to 1938, and there are indications that Sully may have mounted a small number of other informal exhibitions at about the same time.

Accompanying these acknowledgment letters is a typed list of 106 individuals for whom Sully had completed personality prints (fig. I.8). If one makes the speculative leap to date the list around the time of the 1938 showings, it is possible to construct an extremely rough periodization. There are 30 images in the archive—including some unidentified—that do not appear on the list, which suggests that they were produced near the end of her effort, in the late 1930s and the early 1940s. This speculation is supported in part through stylistic analysis—these later images often fill the entire paper, use color more lavishly, and evidence more sophisticated drawing and color technique. In some cases, speculation concerning dates is supported by the

```
              PERSONALITY PRINTS

           INSPIRED  BY

   Albert Einstein              Mayor LaGuardia
   Billie Burke                 George Ade
   Eddie Cantor                 Colleen Moore
   Florenz Ziegfeld             Bishop Hare
   Lowell Thomas                Bishop Rowe
   Phillips Brooks              Kay Francis
   Edward Everett Horton        Mae West
   Greta Garbo                  Glen Cunningham
   Margaret Speaks              Cornelia Otis Skinner
   Rickard Crooks               Katherine Cornell
   Marian Anderson              Alice Brady
   Maud Adams                   Albert Pyson Terhune
   John Charles Thomas          Babe Ruth
   Dan Beard                    Pearl Buck
   Bob Ripley                   Bobby Jones
   Fred Astaire                 Walter Winchell
   Lupe Valez                   Kagawa
   Helen Keller                 Mildred Dilling
   William Lyon Phelps          Noel Coward
   Ernest Schelling             Anna Peck Smith
   Sir Wilfred Grenfell         Pavlowa
   Tom Noonon                   Shirley Temple
   Florence Nightingale         Father Flannagan
   J. Edgar Hoover              Beryl Markham
   Dr. Carl Seashore            Channing Pollock
   Anton Lang                   Delores Del Rio
   Eugene O'Niell               Patsy Kelly
   Schumanheinok                Lawrence Tibbet
   Eugene Field                 Sonya Henie
   Father Damien                Alice Fazende
   Sterling Holloway            Helen Wills Moody
   Alison Skipworth             Dr. DaFoe
   Sousa                        Judge Hartmann
   Victor Heiser        (Ideas)The Red Cross
   Joe Penner                   Greed
   Gutson Borglum               Easter
   Henry Ford                   Good Friday
   Dizzy Dean                   Children of Divorce
   Hervey Allen                 Clash
   Zazu Pitts                   The Church Organ
   Howard Hughes                "Good King Wenceslas"
   Sir Thomas Lipton            "Philip"
   Gertrude Stein               "Alice"
   Steinmetz                    "A Gloomy Dean"
   Loretta Young                The Princes Mdivani
   Thomas Edison                Gossip
   D. Fairbanks Sr.             Timothy Cole
   Amelia Earhart               Igor Sykorsky
   Luther Burbank               Franklin Delano Roosevelt
   Joseph Conrad                Edna St. V. Millay
   Major Bowes                  Will Rogers
   Admiral Byrd                 Edith Cavell
   De Lawd (who played in       Lunt-and-Fontanne
         Green Pastures; Mr.

              Harison)
```

I.8. Mary Sully, "List of Personality Prints" (ca. 1938). Ella Deloria Papers, Dakota Indian Foundation and American Indian Studies Research Institute, University of Indiana

matching of subjects with significant moments in their public lives. It is also the case that a few of the names on the typescript list do not appear among the extant 134 images, suggesting the possibility that some have been lost. And the linkage of personalities with significant dates can—in general—offer only crude chronological connections, evocative on occasion but untestable as a rule. There is no reason to think that Sully might not have been intrigued by a person's story in 1934 yet waited any number of years to make a corresponding image.

Sixty-nine of the names on the list are of men; forty-five are of women. Near the end of the list, Sully introduces the possibility of personality prints for "Ideas" and lists twelve of these. Several are related to church life (Easter, Good Friday, The Church Organ); others suggest more mysterious conceptual origins (Children of Divorce, Titled Husbands in the USA). Some of these "idea" prints (A Gloomy Dean, for example, or The Red Cross) are less ideas than unnamed personality prints focused on specific individuals. The Gloomy Dean was almost certainly William Ralph Inge, widely known by that nickname; the Red Cross likely refers to Clara Barton, its founder. Some of the "idea" images appear to have been drawn after the creation of the typewritten list, suggesting that the concept of "idea" prints may have been part of the mature project.[17]

One can usefully rearrange the list into a number of subcategories: sports figures, opera singers and classical musicians, theater and Hollywood figures, writers, and radio celebrities. And a close study of some of the images on the list does, on occasion, suggest possibilities for putting dates and periods on images. The typewritten list, for example, names "Helen Wills Moody," though the image itself is labeled "Helen Wills." Wills married Frederick Moody in December 1929, allowing at least a tentative dating of the image's making prior to that date. The personality prints project, we might reasonably speculate, began in the late 1920s, had a robust life throughout the 1930s, and slowed in the years after. Stylistically, one can see a clear difference between, for example, the *Helen Wills* image, with its pervasive use of empty space—a clear feature of a number of images with less sophisticated execution—and later images such as *Three Stages of Indian History*, which fill every inch of the page, using cross-hatching and shading techniques to give texture to solid blocks of color.

In 1946 Virginia Dorsey Lightfoot, a correspondent and patron cultivated by Mary Sully's sister Ella, sent Sully a questionnaire: "Please tell me about yourself and your art—I am deeply interested to learn all that I can about you and your work and *please don't be modest!*"[18] Sully left the response to her sister, who admitted that Sully herself did not feel competent to answer the questions: "Mary does not want anything said about her or her work other than that she is an artist, and is successful in designing books and other illustrations, ornamentations and the like. She paints in oils, too, but not seriously. She has always preferred to stay out of publicity . . . she is quite shy about her work. She feels bad to be unable to help you."[19] It is a curious withdrawal on the part of an artist who clearly hoped for an audience. Indeed, Mary Sully might be viewed as an Indian soulmate to Emily Dickinson, for—though often reported as personable and gay—she avoided social interaction by taking refuge in her bedroom, a practice that increased with the passage of time. Mary Sully left behind no artist's statement or interviews. She did not like to write, and on the rare occasions when it was necessary, her sister corresponded on her behalf. The writing that has survived dates to Sully's early years, before she commenced the project, and there is little of it. To the extent that we can know them, her intents must be laboriously carved out of the work itself, and out of the contexts we can weave around her through deductive reasoning and careful speculation.

My analysis, then, proceeds through a series of interpretations and contextualizations that link, circle back, and build upon one another to create an extended reading of her work, her life, and her world. This book unfolds across three parts, each with two chapters. In the first section, "Becoming Mary Sully," I aim to situate the artist in the intimate time and space of her own genealogies and histories. The first chapter explores her family background—American art, the frontier military, the missionary church, and a long history of cross-cultural traffic—in order to trace and contextualize American/Indian inflections in the works. The second chapter follows her upbringing in South Dakota and a troubled period in Kansas, which engaged her not only with the possibility of making art but also with the emergent psychological ideas surrounding "personality" and mental hygiene.

In the second section, "Reading Mary Sully," I turn from the biographical to the work itself, offering interpretations and analyses that seek to make it meaningful. Chapter 3 delves deeply into the visual vocabularies and influences visible in her project—Native women's traditions are central, but Sully also drew on cosmopolitan engagements with modernist art, popular culture, and industrial design. Chapter 4 places her work in the contexts of modernism itself, arguing that her influences rest in the 1910s and 1920s, while also contemplating her relation to European, American, and alternative modernisms.

The third section, "Realizing Mary Sully," considers the psychological, cultural, and social politics implicit—and on occasion explicit—in her work. In chapter 5, I situate her in the realm of Boasian psychological anthropology, arguing that her work sits in dialogue with the leading theories of the day, focused on culture and personality. Chapter 6 places the project in the context of the politics of the Indian New Deal of the 1930s, rereading the images against social evolutionary policy arguments and returning full circle to an extended exploration of *Three Stages of Indian History*. A brief conclusion aims to extend each of these examinations as a series of larger claims about Sully's significance as an artist, as a woman, and as a Dakota person.

The non-Indian patrons who supported the American Indian art movements of the 1930s relied heavily on the power of recontextualization. They reframed archeological and ethnographic material culture in aesthetic terms, producing fresh identities for old objects and recent paintings, both to be newly visible as "art." As artist John Sloan and writer Oliver La Farge suggested in a short introductory essay to the 1931 Exposition of American Indian Arts catalog, "Our museums have collected Indian manufactures with scientific intent, placing as it were, the choice vase and the homely cooking pot side by side." Sloan and La Farge rejected this approach and insisted on an aesthetic context: "The Indian artist deserves to be classed as a Modernist; his art is old, yet alive and dynamic."[20] In the 1920s and 1930s, new Indian artists—many of whom used "she" and "her" rather than "he" and "his"—became legible in relation to a re-visioning of old objects, which were no longer bounded by strictly ethnographic interpretation. A new aesthetic dispensation had arrived.

This book enacts a similar species of recontextualization, aiming to rethink both modernism and American Indian arts, and to do so in the tradition of recent scholarship on multiple, populist, colonial, and postcolonial modernisms. For Mary Sully's story strongly resists the contexts that might enclose her in a clearly defined aesthetic field. She finds little common ground with the primitivist-inflected Indian artists of Oklahoma or New Mexico, or the rise of the Institute of American Indian Arts as a venue for an Indian modernism defined in terms of an art market.[21] She largely precedes the generation art historian Bill Anthes has identified as "Native Moderns," which is roughly bounded between the 1940s and 1960s and which is the subject of an analysis meant to challenge the narrative primacy of the IAIA as the incubator of modern Indian arts.[22]

Neither does she fit any of the classic master narratives of modernism. She was not a bohemian. She did not position herself against academic painting. She had nothing to do with a performative avant-garde, nor was she part of any identifiable "movement." Even as an example of modernism's "multiplicity," Sully stands apart. So many of the variations on modernism have been framed in terms of colonial, postcolonial, decolonial, or immigrant experiences.[23] As *Indian History* suggests, Mary Sully was working within and against what we might today name as a *settler* colonial history, an awareness of a past characterized by ongoing displacement and loss. In relation to modernisms and American Indian arts, then, she was, quite literally, an impossible subject.[24] Our inability to situate her suggests that we take a deeper look at our operative categories. Indeed, the deepest question that drives this book emerges from her particular form of impossibility: How do we make sense of a body of work by a Native artist that seems so radically out of the received traditions of American Indian art of the mid-twentieth century—and so much not a part of the received traditions of modernism, even at their most capacious? In what ways might this art change our understanding of both Native arts and American modernism itself?

I have figured the relationship this way: Mary Sully was *native to modernism*. She was a Native person exploring modernism, that temporal and aesthetic other. But she also was native—indigenous—to the terrain of modernism itself. The evidence for this doubling trope, as I suggest later, is to be found in her uncanny, distanced gaze on the modern world and her

effortlessness in making it her own. Consider *Helen Wills*, with its tennis-net grid structure. Is there any platform more modernist in nature than the grid, that template around which so many artists experimented with time, space, form, and function? Watch the turn that Sully puts on the grid in the bottom panel: the 45-degree rotation Indigenizes the structure—but how?

On a threaded row, at the center of a line of symmetry, place a red bead and surround it with white, green, or brown. In the next row, arrange three red beads beneath the first. In the next row, five. Then seven, nine, eleven. Then nine, seven, five, three, and one. The diamond is as central to Native women's arts as the grid is to the modernist—and yet Sully made them one and the same, dialogic and simultaneous. It was not the only trick in her bag, for Sully was indeed native to modernism.

Mary Sully belongs in the canon not simply of American Indian art but of American art as a whole. To make that claim is to question the boundaries that create and empower such categories as "American" and "Indian." I don't mean to destroy those lines. Surely there is such a thing as American Indian art, though any determination of its edges and parameters ought to occasion a certain wariness. But American Indian art is, necessarily, American art. The categories operate at different registers, yet they are interlocking and dialogic, and to carve out distinctive space for the former is not to foreclose inclusion and openness on the part of the latter.

But it is not just art movements such as modernism that matter. So too do temporal markers—in this case *modernity*. The danger in making "American Indian art" into an object lies in the exclusions of Indian artists, not simply from broader canons but from modernity—and, by extension, *futurity*. This temporal exclusion happens constantly to Native people, who are almost always framed in terms of their pastness. Indian people, we need remind ourselves, were and are more than inhabitants of someone else's modern, forced by someone else's history out of one time and into another. But as Mark Rifkin has argued, a simple reclaiming of modernity for Indians risks a too-tight embrace of Western temporality.[25] It threatens to universalize "settler time."

We can say, however, that Indian people were cocreators of the heuristic category the West calls modernity. Some swam in it; others understood their critical distance from it; others rejected it entirely; most paid it no atten-

tion whatsoever. Because they *just lived* rather than self-reflectively obsessing about the category, Indian people such as Mary Sully often engaged the modern—and the aesthetics of modernism—in surprising ways. They became Native cocreators of the aesthetic forms we bundle under the name *modernism.*

Mary Sully's work suggests ways to think about other Indian people as being native to modernism. Her eye was simultaneously celebratory and critical, her balance between immersion and distance near-perfect. To follow her is to undertake a deconstructive journey, exploring the meanings, limits, transcendences, and confoundings of racial and aesthetic categories like American (Indian) art, modern and traditional, art and design. It is also to place Indian arts in an assertive position, through a claim to a quality of vision, execution, power, and evocation that insists we cannot talk about twentieth-century American art without talking, in a serious way, about American Indian images such as these.

The works of Stephen Mopope and the Kiowa Six, Awa Tsireh and the New Mexico painters, Woody Crumbo and the Bacone Group, and many other Native artists have quite beautifully established the parameters for American Indian arts in the early and middle twentieth century. In the postwar period, Oscar Howe, T. C. Cannon, Fritz Scholder, Jaune Quick-to-See Smith, and many others took these new traditions into the realms of modernist abstract expression and engaged the various postmodern turns, creating powerful new forms of Native arts. The last five decades have seen explosive creativity, visible not only in classical visual arts forms such as easel painting and sculpture but in renewals and transformations of "traditional" Native forms: quill- and beadwork, pottery, carving, weaving, quilting, hide painting, ledger art, and many more.

The practices of twentieth-century American Indian arts offer genealogies that produced these new aesthetics, coded through the genotypes of modernism, primitivism, transformation, revitalization, and politics. Mary Sully's personality prints weave in and out of all these genealogies while remaining distinct in their own right, impossible to pin into a category or a developing school. They assert their own powerful presence, insisting on the importance of—and exploring the possibilities for—an American Indian aesthetic that was native to modernism, modernity, and America itself.

BECOMING MARY SULLY

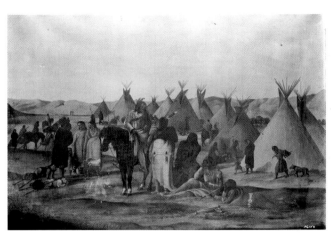

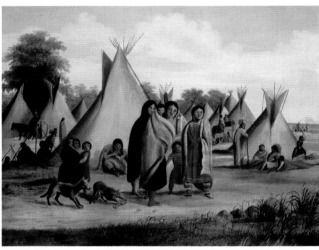

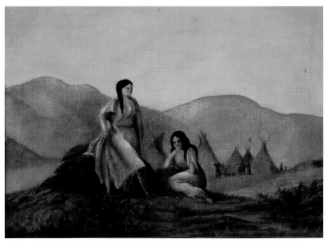

GENEALOGIES

Sound from Everywhere

I N APRIL 1857 COLONEL ALFRED SULLY SENT A BOX TO HIS FAMILY IN Philadelphia, posted from the ragged military station at Fort Pierre, South Dakota. Inside were a letter, three paintings, and a pair of moccasins. "The big picture [see fig. 1.1] is taken from part of an Indian village when they are dressing buffalo skins," Sully wrote, noting that the view out his window had provided the background for what was a composite image. Three of the figures were drawn from memory—likely three of the five figures that occupy the center of the image. Others, however, he proclaimed that he had painted from life: "The two girls are meant for likenesses. One near the horse is called Peh-han-lota or Red Crane, the other Ke-ma-me-lar or Butterfly. They are both right good looking girls & very well behaved."[1]

The two young women jump out from the image, their light-colored fringed dresses framed by the black of the nearby horse and of the maternal figure standing to the left side of the picture. Indeed, the dresses—and thus the figures—stand in high contrast to the muted colors that characterize

1.1. (Opposite, top) Alfred Sully (1821–79), *Sioux Village Fort Pierre* (1857). Oil on canvas, 21 × 29 inches. Photograph by Ira W. Martin. Frick Art Reference Library Negative 36150

1.2. (Opposite, middle) Alfred Sully (1821–79), *Dacota Sioux Indian Encampment* (1857). Oil on canvas. Joslyn Art Museum, Omaha, Nebraska. Given in memory of Jasper L. Hall by Mr. and Mrs. Edward W. Aycrigg. 1966.358

1.3. (Opposite, bottom) Alfred Sully (1821–79), *Sioux Indian Maidens* (1857). Oil on canvas; overall: 22 × 36¾ × 2¼ in. (55.9 × 93.3 × 5.7 cm). Gilcrease Museum, Tulsa, Oklahoma. GM 0126.1100

the remainder of the painting, and they seem qualitatively distinct. Unlike anyone else in the Sioux camp, these women are named in the letter, both in the Dakota language and in English translation. Sully knew them. He posed and painted them, judged their looks, and, in what we should probably read as an arch implication, commented on their "good" behavior.[2]

Indeed, Sully painted them more than once, for the other two paintings in the box featured the same two women. *Dacota Sioux Indian Encampment* (fig. 1.2) lives at a more intimate scale, suggesting that it too was drawn from life, focused in particular on one of the women who is identifiable through her clothing and facial features. And in *Sioux Indian Maidens* (fig. 1.3), he pursues them even more directly. Here the background has turned generic, with a featureless camp backed by towering, romantic mountains. The two women are explicitly posed; *they* are the subjects of the image. On the left, the woman who seems to be Peh-han-lota (Pehánlútawiŋ) stands strongly upright, wearing a dress that suggests buckskin (in the fringe near the arms and the hem) or cloth (in the looseness of the folds and flows); she wears the same horizontally striped socks or leggings visible in *Sioux Village Fort Pierre* and what seem to be shoes or slippers. Ke-ma-me-lar (Kimímela), whose dress matches that illustrated in the larger painting, sits demurely on the ground, barefoot, with legs tucked beneath her.

Sully offers viewers two contrasting representations of these Indian women. Neither reflect the laboring drudges often found in such images (though such women are visible in the backgrounds of both pictures, reflecting Sully's internalization of this colonial gender ideology). Rather, Kimímela offers the demure sensuality attached to Indian princess figures, frequently portrayed as simply waiting for the right white man—with whom they will then cross (and affirm, and produce) sexual, social, and cultural boundaries. Pehánlútawiŋ, on the other hand, is strong, sturdy, confident. Connected to and emergent from a pile of stones, her head positioned amid the mountains and her feet solidly grounded, she is literally as solid as a rock, a noble Indian maiden.

It may seem curious that the question of footwear—stockings, leggings, shoes, moccasins, bare feet—should emerge from such images. But it does. One of the central visual linkages across the three paintings is found in the distinctive leggings and ambiguous footwear. The paintings literally shared their traveling box with a pair of moccasins. And in *Sioux Indian Maidens*,

Kimímela seems to have removed her leggings and footwear altogether, the better to melt evocatively into the ground.

It is less curious that Alfred Sully should send his family such paintings, as he had made image making a regular part of his military career. An 1841 graduate of West Point, Sully served as an infantry commander during the Mexican War, during which he sketched military positions, landscapes, battles, and scenes of camp life. In his later career, he ventured into the more challenging work of oil painting, demonstrating that his limitations as a serious artist can simultaneously be read as a significant skill set for an amateur, working under often challenging conditions.

Sully arrived in the Dakotas following four years of military service in California in the immediate aftermath of the Mexican War. During that time, he "eloped with"—*abducted* might be another word—Manuela de la Guerra, the fifteen-year-old daughter of a Californio family that had befriended him while he served as an occupying officer in Monterey. Sully's aggressive courting ran against the grain of Californio social convention, particularly since he had been a friend of Manuela's mother, only five years his senior (and, in a strained marriage and soon to be a widow, perhaps a better match for the officer). In 1851, not long after the marriage, Sully experienced a three-part tragedy rich with colonial psychodrama: Manuela died shortly after childbirth, an event closely followed by the suicide of Sully's African American servant (distraught, it was said, over the death of Manuela) and then by the death of Sully and Manuela's newborn son, smothered while sleeping with Manuela's mother. Sully left Monterey for a posting in Benicia, California, and eventually found his way to the Northern Plains in the fall of 1854, still bearing the imprint of this highly suspect tangle of death, in which colonial and social domination mixed with the tropes of romantic tragedy. It is hard not to see in the events a kind of final revenge of the repressed, in this case, of the slave, the conquered, and the vengeful parent—who might also have been a jilted lover. And as historian Stephen Hyslop has observed, Sully's behavior also suggested a larger pattern: the three women who bore him children were all members of societies confronting military domination (Californio, American Indian, and Confederate), of which he was a prime instrument.[3]

Like many officers on the Great Plains, Sully was not averse to establishing temporary relationships with "right good looking girls" who were "well

behaved." At Fort Pierre and later Fort Randall, both frontier posts along the Missouri River, he would find opportunities among the Yankton people. For hundreds of years, Indian people and European commercial and military adventurers had understood the practical utility of cross-social marriage and alliance, which opened up networks of kinship and power. Sully's relationship with Pehánlútawiŋ and Kimímela likely involved a broad range of exchange, cultural, social, and economic in nature. Indeed, even as Sully painted the women's footwear—shoes, stockings, and moccasins—he portrayed it as a mode of exchange in his letter and offered material evidence of a trade: "To fill up the box I also send some mocassins made by the young Dakotah ladies and presented to me by them in the Indian fashion that is with the idea of getting me to give them something in return. Give them to whoever they will fit."[4]

MARY SULLY AND FOOTWEAR

Mary Sully was heir to the traditions of quilled and beaded moccasin making, and she sometimes crafted bottom panels that turned from patterned design to representations of footwear itself. She figured Indiana writer George Ade in terms of his rural estate, with an overhead topographic view of rustic drives, footpaths, bridges, and trees. The bottom panel, however, is a gesture of honor and respect—red quilled moccasins, gifted visually from the artist to the generous subject, much as Pehánlútawiŋ had gifted Alfred Sully with a pair of moccasins of her own.

In *Bobby Jones* Sully makes a similar move, developing a highly abstracted pattern into a colorful design but then turning to pictorial representation: another pair of quilled moccasins. While most of Sully's bottom panels are abstract designs, in a number of cases she did offer pictorial figures—many of which might be described as ethnographic in nature—drawn from Indigenous material culture.

But Sully was also a habitué of the city. In *Good Friday* she captures New York as a place of conspicuous consumption. Indeed, the juxtaposition in *Good Friday*'s top panel between the grim crosses of Calvary and the haughty expressions of women unsatisfied by a proliferation of shoe

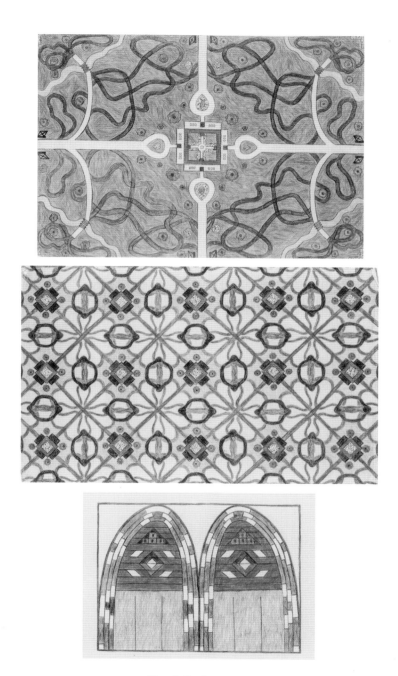

Mary Sully, *George Ade*

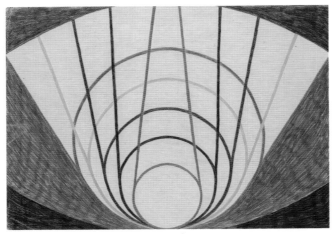

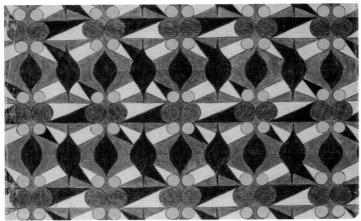

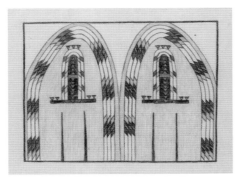

Mary Sully, *Bobby Jones*

Mary Sully, *Good Friday*

choices offers both celebration and critique of the buying habits of the urban elite. The three crosses (echoed by three trees) in the top center are transformed in the bottom center into a parallel triad. Christ has taken the form of a wealthy shopper, while the two thieves appear as bellhops weighed down by packages, their strong horizontal lines refiguring the horizontal bar of the cross.

Pehánlútawiŋ and Alfred Sully engaged in an exchange and transformation of footwear, in which the respect represented by gifted moccasins was refigured by him first as a commodity ("getting something in return") and then as a casual throwaway ("give them to whoever"). In *George Ade* and *Bobby Jones*, Sully invoked the more generous Dakota meanings that may have been encoded in Pehánlútawiŋ's gift. In *Good Friday*, even as she celebrates the joy and color of a busy city, she also speaks cynically to the excesses of a world of goods and purchases. The day on which one remembers the death of Christ becomes the day on which one shops for shoes to wear on Easter, the day of the Resurrection. Even as *Good Friday* proclaims the life of the city, it also suggests an underlying hypocrisy, a contradiction between belief and action, between appearance and reality. Indeed, if one was to look back at *Indian History* through the lens of shoes, the top band of the top panel—a frightening collection of feet and legs— might leap out as yet another representation of domination. These meanings echo from the past, strikingly visible in the vexed relation between Alfred Sully and Pehánlútawiŋ and in the ways the military artist chose to represent it in both image and text.

Perhaps Sully offered the shoes and stockings shown in the paintings as a gift to Pehánlútawiŋ or Kimímela; one of these women likely offered the moccasins to him. Sully's expressed view of the exchange was utilitarian, even crass: she gifted him out of self-interest, he thought, expecting something in return. Willing to have them distributed at random in Philadelphia, he attached little sentimental value to them. The view from the Dakota camps was likely quite different. Beaded moccasins were meant for family or ceremonial uses, not for sale or trade. Some—for babies or brides or *hunka* "friend" ceremonies—featured beaded soles; they were not meant to touch

the ground.[5] In that sense, Sully's understanding of the "Indian fashion"—an initiation of trade—missed the mark. As a prominent Dakota ethnographer observed, "Outside the family of birth, the tiyospaye, it was improper to give a present to a man. Yet now and then a young woman who fancied herself much in love secretly made elaborate moccasins or some male costume accessory and slipped it to the man of her choice."[6]

In this Dakota context, the shoes and stockings and bare feet in Alfred Sully's images appear as iconographic signifiers not merely of exchange but of some form of commitment—and, like the women, their footwear too seems suddenly to leap out of the images. The stockings, in particular, are both prominent and disorienting. They serve as evidence *not* of the oddity of Western goods mixed with Indian clothing (not actually odd at all) but of the possibility of a relationship conceived, at least on the Native side, through kinship politics and access to the power represented by the US military. And perhaps as something more, something that also carried emotional freight.

Alfred Sully, of course, could not have written of sexual alliance or emotional entanglement with an Indian woman in a letter to his parents. They had previously expressed their unhappiness about his marriage to Manuela de la Guerra and were likely anxious about the kinds of familiar frontier relationships Sully was representing in these paintings—close and affectionate exchanges with Indian women, known by name in two languages. Perhaps a mutual, unspoken awareness of this anxiety speaks to Sully's effort to contain the situation through the distancing words of his letter. There, the women are more object than subject—artist's models and nothing more.

Sully was transferred from Fort Pierre to Fort Randall in May 1857 and then left the Dakotas in early July. Pehánlútawiŋ was pregnant with his child.[7] While it is possible that he knew of the pregnancy, he was not on hand for the birth of his daughter in 1858. The baby bore his imprint nonetheless, carrying the name Akíčitawiŋ, or Soldier Woman. She was also known—in a much more precise use of her father's surname—as Mary Sully.

After a short stint of eastern Civil War duty in 1862, Sully returned to the Northern Plains, where he was relentless in quelling the 1862 Dakota War in Minnesota—or, more properly, its aftermath. He is particularly well known today in North Dakota for leading bloody pursuits and reprisals—massacres, essentially—at Whitestone Hill and Killdeer Mountain, locations

where the mutuality of the Civil War and Indian Wars become provocatively visible. In 1866, following the Civil War, Alfred Sully married Sophia Webster, a southerner and resident of Richmond, Virginia. She was no fool and refused to allow Sully to hang any paintings of Indian women on the walls of their house. Pehánlútawiŋ—commonly known later in life as Susan Pehandutawin—married Peter LaGrande, an important Yankton Dakota headman, and lived a full life on that reservation.[8] Sully and Pehánlútawiŋ's daughter Akíčitawiŋ/Mary Sully grew up at Yankton and married John Bordeaux, a mixed-blood rancher with whom she had two children. When he died in a tragic accident, Mary Sully Bordeaux married a second time and bore three additional children.

The second daughter of this second marriage was the artist, born in 1896, who took her mother's name, Mary Sully, as her *nom de plume*. Her decision made a certain sense, particularly for an aspiring artist engaged in a project exploring questions of personality and celebrity through the form of portraiture. The Sully name had traction in the world of American art that far surpassed that of the talented amateur soldier-artist Alfred Sully. Alfred Sully's father—that is to say, the artist Mary Sully's great-grandfather— was the American portraitist Thomas Sully, a master painter celebrated in both the United States and Europe for painting political leaders, elites, and celebrities of the early republic, as well as "fancy paintings" from literature, the theater, and life (fig. 1.4). In a richly ironic twist, his image of Indian-killer Andrew Jackson still features on the twenty-dollar bill.

The artist Mary Sully never met her grandfather (Alfred Sully) or her great-grandfather (Thomas Sully), but she was well aware of his place in the world of American art. Born in 1783 in Lincolnshire, England, Thomas Sully immigrated to the United States with his parents at the age of nine. He studied with his brother-in-law Jean Belzons, a miniaturist, and then with his brother Lawrence

1.4. Thomas Sully (1783–1872), *Alfred Sully* (1839). Watercolor on ivory. Metropolitan Museum of Art 2006.235.201

Sully. He took a short course with Gilbert Stuart and passed through New York before eventually setting up his studio in Philadelphia in 1806. Sully studied with Benjamin West for nine months in London in 1809, thus acquiring training from two of America's most respected artists, and fine-tuned a style that was realist and romantic. His 1824 portraits of John Quincy Adams and the Marquis de Lafayette made him one of the most sought-after commission painters of the period, and his extensive catalog includes images of Thomas Jefferson, Queen Victoria, James Polk, and hundreds of others.[9]

Mary Sully's selection of personalities—chosen freely by her, without the incentive of commissions—bears echoes and traces of her great-grandfather's canon, particularly in her frequent choice of figures from the world of music and theater. Thomas Sully's parents were both actors, an uncle was a theater manager, and he himself acted and was a founding member of Philadelphia's Musical Fund Society. Even Alfred Sully had a modest reputation as a community actor. Mary Sully and her sister knew of the works of Thomas Sully and actively discussed the possibility that artistic talent had genetic elements and might, thus, flow across generations.[10] Her choice of name marked an engagement with her mother and her parents' cross-cultural Indian world, but it more directly expressed aesthetic dreams and ambitions, given shape both by Thomas Sully's famous name and by one of his defining practices: the representation, through portraiture, of individuals and the attempt to capture, through paint, line, light, and texture, something of their unique personalities.

Thomas Sully painted more than "subjects" or even "personalities." Like Mary Sully, he painted celebrities, and he did so in the moment when celebrity—as both word and concept—first entered American and European cultural vocabularies.[11] Lafayette, for example, was one of the earliest celebrities in American history, feted as an object of fascination in person and print. Thomas Sully, then, painted at the first of two watershed moments in the modern culture of celebrity—that of its invention. Mary Sully made her art in the second critical moment, that of the emergence of celebrity as a central trope in a mass culture industry powered by film studios, news and fan magazines, and radio. Her work would rest on these media, in the same way that Thomas Sully's had rested on his own protocelebrity—as a painter of protocelebrities.

THE CULTURE OF CELEBRITY

Most of the subjects of Mary Sully's personality prints project were visible to her through the industrial apparatus that generated celebrity—that layer of fast-paced superficial fame that accrues through mass and popular culture to both the accomplished and the interestingly novel. Her image for *Pavlova* was likely one of the first in the project (there is a series of eight images—all stylistically early—that uses only the subjects' surnames; in most other images, Sully used both first and last names). Anna Pavlova, a Russian ballerina famous in the early twentieth century, was one of the first to tour internationally, performing across the world. Sully's image references her most famous role, *The Dying Swan*, a short dance that she performed some four thousand times. In 1931 Pavlova was told that she had pleurisy and needed a career-ending operation. She refused, and she died three weeks later, thus fusing together exceptional skill (she is still regarded as one of the best ballerinas in the history of dance), wide media exposure, and the kind of novel death that ensures celebrity status (she is said, on her deathbed, to have called for her swan costume). Her death, which took place early in the chronology of the personality prints project, likely spurred Sully to make Pavlova's portrait, which uses a quavering figure-ground illusion of white bars, located at top center, to reflect the motion of the dance. Similarly, the entire top panel is itself a figure-ground illusion, either a bursting forward of the motion of the swan, the grass, and the depthless reflection . . . or a pair of jagged-edged doors closing, from each side, on the last moments of a life.

In *Amelia Earhart* and *Babe Ruth*, Sully offers images for two of the most visible celebrity personalities of her era. In 1932 Earhart flew alone across the Atlantic, retracing Charles Lindbergh's 1927 flight and creating a popular-culture platform from which she promoted both the viability of commercial aviation and the importance of gender equality and women's rights. Working with promoter/husband George Putnam, Earhart parlayed her fame into true celebrity status. Her disappearance during a 1937 attempt to circumnavigate the globe continues to fascinate; Earhart remains a touchstone in American popular culture to this day. Sully's image focuses on Earhart's single-engine prop plane, doubling up the spin

Mary Sully, *Pavlova*

Mary Sully, *Amelia Earhart*

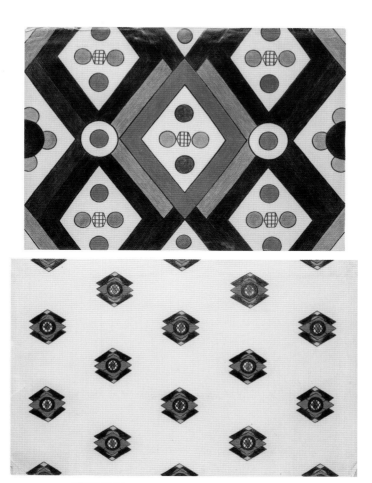

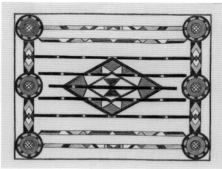

Mary Sully, *Babe Ruth*

of a propeller with large conical swaths of color that also suggest aviation searchlights and the spotlight glare of media attention. Within the circle of the engine, one finds the silhouetted outline of a crowd. Closer inspection reveals a pattern of three figures, repeated in each quarter of the circle, with each figure offering a lens through which to see Earhart's transatlantic journey. One figure is simply an onlooker. Another puts hand to head in a gesture of worry and concern, while a third raises arms up in triumph. The spotlight-as-propeller theme is reinforced in the boxed patterns of the middle panel.

Babe Ruth was the most famous athlete in the United States during the 1920s, hitting more home runs per season than anyone else, including a record-setting sixty homers in 1927. Ruth, too, was a larger-than-life personality, a man with both a high salary and an appetite for food, drink, and companionship that kept him in the papers and on the newsreels. Sully's image explodes with signifiers of baseball and of Ruth himself. Diamonds suggest a baseball field, to be sure, with four bases and a pitcher's mound. And yet the diamonds are elongated and multiple, manipulated abstractions of the field itself, exploding in multiple colors. They might be seen to double, perhaps, as a baseball scorebook, in which home runs are marked by overwriting a complete diamond. At the same time, the diamonds carry connotations of flashy dress, buttons, and perhaps dice—all part of the color that was Ruth. The middle panel transforms into a viable commercial design, while the third panel establishes another optical illusion, one that complicates the image: a second design lurks behind the first, visible through what seem to be slits in the paper, suggesting a depth behind Ruth's celebrity surface.

A DOUBLED GENEALOGY

That the artist used her mother's name, Mary Sully, as a *nom de plume* means that she had another name, and it is in the tracing of that name that we can take additional steps toward situating her more precisely in time, space, and culture. To get there, we need to return to the Dakota War of 1862, a conflict generated by a particularly vicious if familiar combination of events: treaty violations; annuity payments of food and supplies that were late, insuffi-

cient, or nonexistent; the arrogance, graft, and greed of Indian agents and traders; and the boiled-over frustration of Dakota young men and leaders alike. The conflict ran from August through December, when the United States hanged thirty-eight Dakota men on an enormous gallows complex in Mankato, Minnesota—the largest mass execution in American history. The United States held convicted Indian prisoners for almost four years; over sixteen hundred Dakota noncombatant men, women, and children were interned on Pike Island, in the Mississippi River, and more than three hundred died there during the winter of 1863. In May soldiers placed the people on steamboats and moved them to the Crow Creek reservation in Dakota Territory, as the federal government abrogated Minnesota Dakota treaties, abolished reservations, and sought to expel every Dakota person from the state.[12]

At the same time, Alfred Sully's Civil War experience was leaving much to be desired. He attached himself to General George McClellan, Abraham Lincoln's first failing commanding general, and as McClellan fell out of favor, Sully's star dimmed as well. In the politics of mobilizations and militias, civil leaders with no military experience were often placed in charge of military units, with regular army veterans like Sully interlaced unhappily among the amateurs. As the Dakota War exploded across Minnesota in the late summer of 1862, Sully—already experienced in the region from his 1857 tour—was a natural choice to return to the Northern Plains, and perhaps he was glad to go. His campaigns unfolded in the summer of 1863, well after the trials, hangings, internments, imprisonments, expulsions, and treaty abrogations that followed so quickly after the Dakota War. They were reprisals that often had little to do with Minnesota Dakotas and everything to do with opening up new territory and subduing Sioux tribes. At Whitestone Hill in September 1863—a full year after the Dakota War had concluded—Sully attacked a village of five hundred lodges, killing warriors, women, and children while sustaining minimal casualties among his own men. And he continued to campaign along the Missouri River, engaging in other punishing fights in 1864 at Killdeer Mountain and the Badlands. He was, in short, one of the many architects of a military policy that treated Indians as insurgents in their own territories and that was willing to lump together tribes and bands: "punishment" did not, for Sully, necessarily attach to "responsibility." Southern insurgents and

Indian insurgents alike were to be subject to total war directed against their resources, subsistence, and noncombatant population.[13]

There is a story that Alfred Sully entered a camp of Yankton Sioux, likely sometime in spring or summer of 1863, and offered the headmen an ultimatum. He accused them of harboring Minnesota Santee Dakotas and notified the camp that if those men were not given up, he would treat the Yanktons as enemies. As the headmen discussed the issue, one of them suggested that, since he had once had a vision in which he killed four of his own people, he might kill one of the refugees as evidence of the Yanktons' friendship—while then advancing the claim that they had harbored only the one person. The plan was agreed upon and carried out, and this man, Saswe, presented Sully with the body of a dead "enemy" and asked him to leave the Yanktons alone. The two men were, in this sense, antagonist and protagonist, partners in the brutality of the on-the-ground diplomacy of the Plains. It was a partnership of violence that offered a very different sense of the cross-cultural possibilities embodied by Sully and Pehánlútawiŋ and the child they produced, Akíčitawiŋ/Mary Sully.[14]

This headman, Saswe, was a cross-cultural person in his own right; his name was a Dakota pronunciation of the name François Des Lauriers, which he inherited through multiple generations of French and then mixed-blood traders who had over time become part of the fabric of the Yankton people. He was the leader of the so-called Half Breed Band, a medicine man, a woodcutter, a cultural broker and go-between, and, on four occasions, a killer of other human beings. It was said that Saswe could see the faces of those men taunting him when he raised a cup to drink—and that one of the great joys of his baptism into the Episcopal Church in 1871 was the disappearance of those ghosts.[15]

Saswe entered the church through the offices of his son, Tipi Sapa (Black Lodge, named after an image taken from Saswe's own vision), later one of the first Sioux men to be ordained as a minister in the church. And Tipi Sapa had a second name as well. He was also known as Philip J. Deloria. The threads of the story join together. For Philip Deloria/Tipi Sapa was the second husband of Mary Sully Bordeaux and the father of the artist Mary Sully. Her actual birth name was Susan Mabel Deloria—the "Susan" a gesture back to her grandmother, Susan Pehandutawin.

Mary Sully/Susan Deloria, then, was not simply a descendent of the artists Thomas and Alfred Sully but also a member of a prominent and accomplished Yankton family. Her grandfather Saswe/François Des Lauriers was a band headman and spiritual leader. Her father, Tipi Sapa/Philip Deloria, was a political leader and important figure in the Sioux Episcopal Church. Her brother was Vine Deloria, an athlete, Episcopal minister, and beloved leader in South Dakota church circles. Her sister was Ella Deloria, an ethnographer and linguist who worked with Franz Boas, Ruth Benedict, Margaret Mead, and other critical figures in twentieth-century American anthropology. One nephew was my father, Vine Deloria Jr., a keystone figure in American Indian intellectual history; another was my uncle Philip (Sam) Deloria, who has made significant contributions in law and legal training, policy, and education. Her niece was my aunt, Barbara Deloria, a dedicated educator in her own right. This is the genealogy (fig. 1.5) that brought the gray box to the basement of my parents' house, where my mother could look after its contents.

In 1863 Saswe and Alfred Sully faced off over the question of refugee Dakotas in the Yankton camps. When they did, Saswe's son Philip Deloria was ten years old; Sully's and Pehánlútawiŋ's daughter, Mary Sully, was five. The two children moved in the same circles in the Yankton camps along the Missouri. In 1875 Philip Deloria married Annie Brunot, who died in childbirth four years later. In 1881 he married Jennie Lamont, only to lose her in 1887, shortly after the birth of their second child, leaving him twice-widowed, with small children. Meanwhile, Mary Sully had married the mixed-blood rancher John Bordeaux, who ran cattle on what is now the Rosebud reservation. While celebrating the sale of some stock in the town of Valentine, Nebraska, John Bordeaux was killed by a stray bullet fired by a group of drunken cowboys, leaving Mary Sully a widow with two young daughters. In 1888, mixing together affection, pragmatism, and lifelong familiarity, Philip Deloria and Mary Sully married, creating a blended, mixed-blood family. Their oldest daughter, Ella, was born the following year, with a son, Philip Ulysses, arriving in 1893 (d. 1902), Susan following in 1896, and Vine in 1901.[16]

The union of Philip Deloria and Mary Sully was thus the meeting of two distinct currents of cross-cultural possibility. On the one hand, it reflected a colonial situation of uneven power, undergirded by the military dominations

represented by Alfred Sully: a daughter abandoned by her father and raised among Yankton people, even while the family maintained both a memory and a genealogical affiliation with "Sully" that stretched across four generations. On the other hand, it also represented a long history of French and mixed-blood engagement, exemplified by Saswe, which took place largely on Dakota terms, undergirded by spiritual and social networks, marked by the near-constant losses and tragedies that accompanied the stark colonial realities of nineteenth-century Native peoples. Brutal victories, pragmatic strategies, and suffering losses all came together in these two families over those two generations. The historical legacies that undergirded Mary Sully's cultural vision and aesthetic practice joined at a pinpoint in her parents' marriage, which brought the two trajectories together in the social form of a family. Those legacies, and the realities of the dominations and hurts of the past, are reflected in her choice of a name. She would use "Sully" as she worked to untangle and represent her own location, dense with aesthetic and cultural possibility.

THE INDIAN CHURCH

Central to her subjectivity was the Sioux Episcopal Church, which Mary Sully chose to represent in one of her later personality prints (fig. 1.6). The richly drawn top panel offers viewers a number of focal points: the white cross at top center; the strong vertical line that moves from the cross down through cords and then the hairlines and single bodies of the row of Indian women that define a bilateral mirror symmetry; the two tan triangles that jump off the field of purple and that mediate between the large blocks of color at the image's edge and the busyness of its interior. The triangles appear first to the eye as the flaps of a tipi, defining an open door into a Plains Indian lodge. Scores of women and children—mostly Plains but also, perhaps, Navajo, Hopi, and other Pueblos—move through the lodge, as the image creates motion by carrying the viewer from fine-grained detail in the foreground to silhouettes in the rear.

It is only when one steps back from the captivating detail of hair and costume (dominant visually, but occupying perhaps a third of the picture space) to consider the image's large blocky shapes that one realizes that

1.5. Deloria family genealogy

1.6. Mary Sully, *The Indian Church*

the central light blue forms represent the body and outstretched arms of a priest, and that the tipi flaps function simultaneously as the royal robe of the church itself. The purple color is significant here, for it reflects not simply vestments but church authority, which is cast in terms of welcome and nurture. The Episcopal liturgy designates purple (violet) as the color appropriate to Advent—the season of anticipation—and Lent—the season of denial, self-discipline, and sacrifice. Both are appropriate to the kind of historical and political consciousness Mary Sully was developing at this point in her project, a theme I develop at greater length in a subsequent chapter.

At the far edge of the tipi lies not the dark back edge of a lodge but rather the *light*, a yellow glow that transforms the image's pilgrims from precise detail to generalized outline. And the light is not simply God or heaven, the "way and the truth" in a Christian context; it is framed by a rainbow, an Indigenous theme found in many traditions, including those of Dakota people. The rainbow is repeated on the shoulder and arm accents of two women in dark blue, each about to pass by the priest and follow the crowd to the rear. Together, they create a parallel sense of the rainbow's arch.

The structure of the image evokes familiar themes in Plains Indian visions. For example, in Lakota holy man Black Elk's great vision (one of the most famous and best-known accounts), he enters a lodge that seems then to open up into a vast area. The entire space is marked by a rainbow that extends across the door of the tipi, which Black Elk then reproduced in all subsequent articulations of his vision. Black Elk went so far as to gift to John Neihardt, his literary partner in the writing of *Black Elk Speaks*, the name "Flaming Rainbow."[17]

1.7. Mary Sully, *The Indian Church* (detail): Note the rainbow iconography on the woman's dress and the overarching rainbow that frames the lodge itself. The rainbow figure reappears in the middle panel.

Though Sully was dedicated to the church, the image actually points more powerfully to the Dakota world and more specifically to Mary Sully's grandfather Saswe, whose vision had conveyed powers of death and healing. In Saswe's vision he, too, entered a lodge—a black lodge (thus Tipi Sapa)—and found that he must follow one of two paths that led not through the center, but, like the women in Sully's

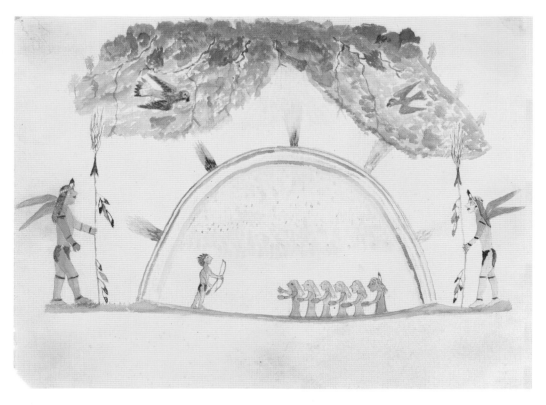

1.8. Standing Bear, *Black Elk in the Flaming Rainbow Tipi* (1932), from *Black Elk Speaks* by John G. Neihardt. The State Historical Society of Missouri, with permission of Coralie Hughes and the Neihardt Estate

image, around the edges of the tipi. On one side, he saw four sweat lodges; on the other, four fearsome skeletons. Saswe's choice of the sweat lodges determined his future: he would kill four of his own—and thus require purification—rather than killing four enemies. This was the spiritual mandate that brought him into relation with Alfred Sully. In his vision, too, Saswe found that the tipi had no rear edge but expanded into space; after he made his way around and through the lodge, Saswe's vision continued into this expanded world.[18] On its face, Mary Sully's image seems to suggest an assimilated pleasantry, the affectionate statement of a church daughter concerning the possibility for Indian people to find shelter and fealty through the welcoming arms of the church. And yet within the image are to be found

a number of important gestures that place the church squarely in relation to Dakota traditions. The top panel features a pleasing visual pun (robe=tipi) that expands into a cross-cultural theological exchange (robe=church=tipi =Dakota spiritual tradition) that drew directly on a Dakota narrative well curated in Sully's own family history.

The spiritual shapeshifting surrounding the possibility of a sheltering Christian/Indian church takes material shape in the form of the cross that centers the image. This cross, with its curious three-part rounding at each tip,

1.9. *The Niobrara Cross.* Courtesy of the Episcopal Diocese of South Dakota

is not simply Mary Sully's decorative elaboration but a meaningful form: the Niobrara cross, designed specifically for the Indian converts of the Niobrara missionary district in 1874 by the Episcopalian bishop William Hobart Hare. The Niobrara cross (fig. 1.9) is awash in semiotic meanings, featuring Hare's seal, four small lodges topped with crosses, and the Latin motto "That they may have life."[19] It takes us to a further consideration of both the place of the Indian church in Sully's life—and to the second panel of Sully's personality print.

There are two interlocking accounts of the conversion of Tipi Sapa/Philip Deloria to the church. The church version focuses on the pleasure that he took upon hearing the hymn "Guide Me, O Thou Great Jehovah" coming from the Reverend Joseph Cook's missionary chapel at the Yankton Agency.[20] As he recounted it, Tipi Sapa returned several Sundays in a row, hoping to hear the hymn again. He came to the attention of Cook, who convinced him to cut his hair, dress like a white man, receive confirmation, and attend school. In 1874, after three years of patchy education in Nebraska and Minnesota, he returned to his people, serving both as a church lay reader and as a political leader, heir to his father's role. Over time, however, the balance between these vocations shifted, and in 1883 he was ordained a deacon and assigned to various reservations, putting Dakota political leadership aside for a life in the church. By 1888 he was placed in charge of the Standing Rock reservation, and by 1892 he had an effective mission school, St. Elizabeth's, which his children Ella, Susan, and Vine would all attend. During this time, he was one of the cofounders of a group called

the Planting Society, which aimed to help Yankton people by encouraging successful farming and by bridging denominational competition.[21]

The other account shifts the emphasis and motive from the power of the missionary church to the pragmatics of Indian politics in a world of white domination. It is my father's story, and it emphasizes Saswe's vision, which committed generations of his family to cross-cultural mediation. The key to this account is Saswe's mutual theorization, with his son Philip Deloria, of a moment in which older tribal leadership structures were losing efficacy, while new potential for social, spiritual, and political leadership was to be found in the emerging structures of the church. In that sense, Saswe was not simply passing forward his leadership but also redirecting his son into anticipated structures of leadership that might be productive in the future. In this, he was not wrong.[22]

Relatively quickly, the Planting Society became the Brotherhood of Christian Unity (BCU), and it modeled both the sheltering, cross-cultural vision found in Mary Sully's *The Indian Church* and the new Native leadership possibilities envisioned by Saswe and Philip Deloria. The BCU did most things right. While missionaries fought one another for converts and preached the evils of Presbyterianism or Catholicism, the Indian leadership of the BCU bridged Episcopal, Congregationalist, and Presbyterian denominations. It focused on charity and support, building on traditional structures. It established mechanisms for cross-reservation travel and communication, renewing the social world that defined older spiritual practices. Among very poor people, it established itself as a primary conduit for trickling flows of money and resources. Its hymn-singing groups and charismatic preachers— simultaneously denominational and BCU—offered powerful outlets for social and cultural expression and excellence. By establishing common practices in the common language—Lakota and Dakota—it created what was, in effect, a particularly Sioux Christianity, one that allowed and engaged older social and spiritual traditions within new forms that were generally acceptable to colonial authorities.[23]

At places like Standing Rock, the Episcopal Church itself was able to create similar structures.[24] There, parishioners used the Dakota hymnal and Bible, spoke to their minister in English or Dakota as they wished, and were able to keep their children close to home for an education that was less aggres-

1.10. Mary Sully, *The Indian Church* (detail): A "blanket" design icon structures the middle panel's pattern

sively dedicated to destroying Native cultures. Women's and men's societies within the church echoed and reproduced older counterparts, and the annual Convocation incorporated many elements from the Sun Dance and familiar practices of travel and visitation. This version of the Indian church was bent and blurred, and it mixed Indian initiative and control with mainline Christianity's undeniable dogma, hierarchy, and colonial wish for Indian cultural assimilation and transformation. It is not difficult to see, however, the ways in which this interlocked cross-cultural, multidenominational, sacred-secular structure offered a home of sorts to Mary Sully, her siblings, and many of her generation. Nor is it difficult to see the ways in which transformation of "churched" *appearance* in relation to underlying Dakota *form* might focus not only social but also aesthetic questions.[25]

The middle panel of *The Indian Church* (fig. 1.10) distills a number of these cultural densities—visible in the top panel—into a single design icon, repeated several times. The crowd of Indian women in detailed dress is captured and reduced into a set of seven hanging "blanket" designs. Compare, for example, the Woodlands floral pattern found in "blankets" 2 and 6 with the dark blue dress hiding beneath the tipi flap (fig. 1.11) in the lower corners

of the top panel; or the red circles in "blanket" 4, which translates the red headband and shoulder yoke (fig. 1.12) found on the woman located in the exact center of the top panel.

In this middle panel, the tan of the tipi flaps, pale blue of the vestment, and purple of the robe become key background colors. The three bulbs of the Niobrara cross (note that the cross figure itself disappears) sit squarely at the center of an inverted black triangle—a tipi sapa, or black lodge. In other words, the middle panel is centered on an inside gesture (consistent with the larger theme) that draws almost entirely on Mary Sully's father and grandfather. Arcing about the entire iconic structure is a three-color rainbow. Inside the black lodge, a micro-version—the design icon distilled to its simplest form and located within the three bulbs of the Niobrara cross—repeats the entire structure.

The top panel of *The Indian Church* advances a seemingly transparent claim to the welcoming quality of a church that blurs its sheltering robes with the shelter of a traditional Sioux home. The middle panel makes a different, more specific claim, one that recodes the first panel in significant ways. It locates the Indian church in the figure of the black lodge and the rainbow, in the blanket and dress designs that clothe Indian women. Indeed, the image offers a clear statement about the primacy of Indian women: the priest is literally headless, while the body of the church itself is made solely of the forms and labors of women. If one were to try to explain the cultural mysteries of the Indian church (and *The Indian Church*), one could do worse than to look at the two-generational shift from Saswe—a converted medicine man—to his son Tipi Sapa, a stalwart in a church that was both a colonial institution *and* a strategy for evading the broad contours of colonial power. The bottom panel in the set (fig. 1.6) offers a third and utterly critical way of seeing, for it focuses fully on the figure of the rainbow, which is flipped 45 degrees, turning the entire image (now expanded with the addition of purple and brown to the red, green, and orange) into a Sioux quillwork pattern similar to those found on the moccasins of *George Ade* and *Bobby Jones*— the image culminates, in other words, with highest of the arts practiced by Plains Indian women.

This tracing of Mary Sully's genealogical past offers evocative clues to understanding an artistic project situated across a tangled, multigenerational

1.11. Mary Sully, *The Indian Church* (detail): Woodlands floral textile pattern from the top panel is visibly carried forward in the design of the middle panel.

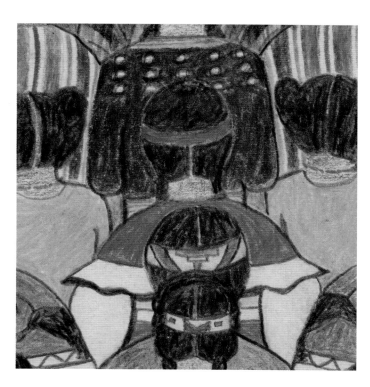

1.12. Mary Sully, *The Indian Church* (detail): The red headband and shoulder yoke are translated to the central "blanket" in the middle panel.

cultural thickness. She claimed a link to Thomas Sully's world of elite antebellum portraiture, which placed both artists at critical moments in the historical development of modern celebrity culture. Her gesture to Sully, however, necessarily also connected her to the worst ravages of American military conquest on the central Northern Great Plains, conducted by her grandfather, Alfred Sully. What kind of politics might emerge from that affiliation?

At the same time, her claim was also—and perhaps as pointedly—to her mother, the product of cross-racial exchange, of relationships established and then cast aside, unacknowledged by whites but remembered by Indian people. Sully's art carried every bit of that cross-cultural cargo in both its aesthetic concept—portraiture—and its subjects—white American celebrities, the elites of the 1930s. But images such as *The Indian Church* also offer a kind of master key into her consistent engagement with Indian arts and epistemologies, not least those found in her family's own commitment to, and transformation of, the colonial form of the Christian church, often figured through the activities of women. Her critique of the commodification of *Good Friday*, viewed in the light of those commitments, carries a more deeply personal and invested meaning.

Mary Sully was a highly complicated subject who created intriguing and sometimes mysterious work. She heard many distinct cultural elements over the course of her life; some were loud and commanding and likely to structure her sense of self and her practice of self-expression; others were soft, or episodic, or even solitary—but that did not mean that they did not carry the potential to shape her world and her art. Indeed, some of her subjects likely crossed her path only once or twice. Some of these culture-sounds extended multiple generations back into the past; others bore the shiny newness of modernism, art deco, the urban, the technological, the traveling highway. Some were repeated in a steady drumbeat; others were unearthed carefully from Dakota collective memory; still others were experimental, the subject of reports from the front lines of the artistic avant-garde. They emanated from museums and reservations, magazines and radios, family and strangers. She was a shaped observer, positioned to see, rethink, and represent. Her familial genealogies give us some sense of that shape; to understand it more completely, however, we need to track her life biographically, paying attention to the ways she moved out of her family past and into her own history.

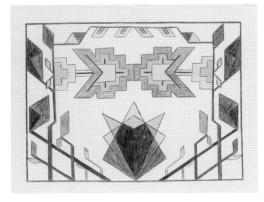

CHAPTER TWO

HISTORIES

To Wake Up and Live

MARY SULLY'S PERSONALITY PRINT FOR WRITER DOROTHEA BRANDE (fig. 2.1) features a top panel done entirely in brown and white, a rare instance in which Sully chose not to use color. The image limns the rich shapes of a garden, and its silhouetted forms call one to *imagine* the missing colors: a white pedestaled fountain spews a stream of crystal blue water, while purple grapes and red berries nestle among a proliferation of green leaves, tendrils, and grasses. The middle panel suggests transformation, with a design pattern that separates fountain from vegetation and injects green into both. Yet the fountain in this second panel looks something less than aqueous—more like the charting of an atomic or wave structure. And the vegetative icon has shifted as well, from a Claudian frame in the top panel to a single anthropomorphic pile of silhouette, with head, shoulders, and hands—and perhaps a rabbit or two nearby. The bottom panel is more mysterious yet. The fountain/waveform has shapeshifted again, into a multifaceted diamond geometry in orange, yellow, greens, and brown, while a new, horizontal figure rests overhead. From each side of the paper, a yellow and orange three-pronged box pushes an arrow toward the center. The arrow, in turn, pushes a more complex iteration of the box figure to the point at which the two edges meet as symmetry. Around the edges of the paper,

2.1. Mary Sully, *Dorothea Brande*

59

abstracted tendrils culminate in the diamond-shaped leaf figures of a transformed garden—even as they also suggest musical notes (a technique Sully used in a number of the images).

Why the grim, frightening garden? And how to make sense of the other imagery? We might begin with Dorothea Brande, noted for her 1934 manual *Becoming a Writer*. It is a pithy guide that offers some clues: the blooming of an imaginative literary garden out of repressed fear, for example, or Brande's strong sense of dualism—defined by the conscious and the unconscious mind but also complicated by "genius" or "magic." *Becoming a Writer* is a get-up-and-go kind of book that might inspire a visual artist as much as a literary one. Perhaps it made an impression on Sully, who had had her own dark garden waiting to blossom into color.

But the ominous garden might reflect a different aspect of Brande's life and personality: her partnership with husband Seward Collins in advocating American fascism. Collins was a modest American literary figure in the 1920s and '30s, publishing the *American Review* (1933–37) and running a New York bookstore of the same name. The *Review*—which featured Brande's writing and editing work—published works by the Southern Agrarians and other conservative antimoderns, but it also served as a forum for Collins's (and Brande's) explorations of fascism as a political antidote to both communism and capitalism. Collins's declarative article "The Monarch as Alternative" praised both Hitler and Mussolini, and he would go on to espouse anti-Semitism and to proudly claim, "I am a fascist." Brande was working at the *American Review* when she married Collins in 1936.[1] The pair later explored the occult, and Brande even offered herself as a medium—so perhaps Sully's bottom panel frames her as a diamond-like mediating power between the dualistic worlds of the living and the dead.

Another way of crystallizing Brande's personality, however, is through her 1936 book, *Wake Up and Live*, which was made into a Hollywood musical the following year (though the film's plot has no coherent link to the book). Cribbing from Nietzsche, Brande posited that most people were burdened by a "Will to Fail" that could be exorcised through a simple mental leap: "Act as if it were impossible to fail." As Johanna Scutts has argued, 1930s self-help manuals (of which *Wake Up and Live* is exemplary) often skirted the edges of fascistic thought. They told readers with relatively little control over their

lives that willpower, discipline, and other qualities of the personality could in fact give them that control and thus lead to success.[2] Brande's descriptions of the unwakeful life are usefully read against Sully's image of a dark garden, waiting to bloom with lively, wakeful color:

> So we slip through the world without making our contribution, without discovering all that there was in us to do, without using the most minute fraction of our abilities, either native or acquired. . . . We might suddenly wonder why we are running about like this, how we happen to be playing away at hide-and-seek as if our lives depended on it, what became of the real life we meant to lead while we have been off doing nothing. . . . If we go on with the game, it turns into a nightmare, and how to wake out of it and get back into reality becomes our whole preoccupation. Then sometimes the nightmare seems to deepen; we try one turn after another which looks as if it led to freedom, only to find ourselves in the middle of Alice's Looking Glass Garden, beginning the hunt all over again.[3]

Sully's dark garden suggests the stifled potential Brande sought to awake. One might read in this personality print an awakening that takes representational shape in the middle panel's "greening." And yet the odd shift from fountain to waveform ovals may also gesture to something else: the film version of *Wake Up and Live*, which is plotted around a radio studio, a supposed feud between newspaper columnist Walter Winchell and bandleader Ben Bernie, and the "waking up" of a singing studio guide stymied by his fear of the microphone. Seen in this light, the fountain figure carries a feeling of "radio" as much as "water," a feeling echoed in the bottom panel. There, the horizontal structure suggests radiating radio signals, as well as both the Winchell-Bernie feud *and* the tension between an unconscious will to fail and the effort necessary to "wake up." The tendrils and diamonds that double the garden as musical notes may then reflect the film, which is a classic 1930s musical, with fifteen song-and-dance numbers, almost all set in the radio studio.[4] In the large diamond icon, the brooding structure of the unconscious—which permeates Brande's book—is both included and transcended through a series of overlapping tetragons that burst into the world

with color. The image juxtaposes tension and transformation, coming down in favor of the latter.[5]

Brande argued that one should nurture "secondary talents" as a way to develop confidence and willpower so as to pursue the "important matters." She offered three forms of art that helped transform practitioners: clay modeling, painting, and music.[6] She also suggested a series of "disciplines," each aiming to structure life so one could achieve "mastery," manage time, focus creativity, sublimate the ego, and train the will to the impossibility of failure. The book reverberates with the language of psychology and personality, as well as the overemphasis on the power of individual agency that characterized self-help writing of the era.[7]

Dorothea Brande's descriptions of the unwakeful life ("the solitaire players, the pathological book-worms, the endless crossword puzzlers, the jigsaw puzzle contingent") describe Mary Sully's own world—and reflect the language she and others used to explain her early years.[8] Sully's effort to make something of herself through her art—to "wake up"—follows Brande's prescription closely, though Sully had made the effort a decade earlier. She must have read *Wake Up and Live* with a shock of recognition. At the same time, the related film appealed to her love of music, movies, and popular culture. The dark garden and the bright notes both resonated: the leafy gloom reflected a psychological location Sully could not escape, even as she sought the willful discipline that let her anticipate transformation. The Brande image captures something of Sully's own psychology and the struggles that defined her personal history.

Sully appreciated subjects who had undergone transformation. Eddie Cantor had not always been Eddie Cantor. Bing Crosby had not always been Bing Crosby. Cartoon celebrity Betty Boop was a surreal projection of actress Helen Kane. And like them and so many other figures in the personality prints, Mary Sully had not always been Mary Sully. For almost three decades, she was Susan Mabel Deloria. Then, she made a decision to claim a new identity—artist—signified by a new name. As we have seen, a submerged iceberg of cultural genealogy lies beneath the name "Mary Sully," revelatory of her art. Following the historical and biographical path that led Susan Deloria to become Mary Sully offers an opportunity to deepen our reading.

Mary Sully's genealogical chart suggests that her work captured the meeting of three distinct strands: first, her "sullied" sense of an ancestral *American* birthright of artistic ambition, portraiture, celebrity, and reputational capital; second, an equally ancestral American birthright to be found in her *Dakota* heritage, strengthened (as we will see) through the ethnographic work of her sister; and finally, a complex legacy of *cultural crossing* visible in the relation between her subjects and the "Indian turn" to which she insistently subjected them. Having some sense of where she came from, we can begin to ask the harder question of who she was. Locating the artist historically, it turns out, is no easy task, for she left behind a scant trail, marked by only a few stray letters. None contemplated the aims and strategies of her art. "Mary Sully" was a dreamed identity, the come-to-life personality portrait of Susan Deloria, a sleeper who hoped to wake up and live.

WAKE

Born on May 2, 1896, Susan Mabel Deloria followed her sister Ella (b. 1889) into the world—and into most other things. Indeed, tracing Susan Deloria's history is in many respects an exercise in tracing the movements of her sister, for the two shared a common upbringing and lived as companions as adults.[9] Their father had been the resident missionary at the Standing Rock reservation's St. Elizabeth Mission for not quite four years when Susan—commonly called "Susie"—arrived. Like her siblings Ella and Vine, she had to navigate the distinct worlds of the reservation and the mission, and to do so as a "PK"—a preacher's kid, expected to model the church's Victorian values while not running afoul of the Lakota customs that structured daily life away from the mission.

An early schoolmate, Anna Gabe, remembered Susie as "a pretty, fun-loving person." The two of them joined together in such antics as chewing buttons off their blouses to throw into the collection plate so as to keep the nickel they'd been given for church.[10] But as she grew older, Susie struggled. Ella described a shyness that bordered on the pathological. Susie was too bashful to take communion in church—a problem for the daughter of a clergyman. Sometimes, when forced to interact with a group of people, she

would simply faint. Other times, she seemed to have fits—and it did not take many of these occasions before she was allowed simply to withdraw from the public eye.

Both girls attended the St. Elizabeth's Mission School, and both did so under the tutelage of Mary Sharpe Francis, a small, fearless missionary teacher who ran the school with a sympathetic and challenging approach that gave Indian children an education superior to the vocational training found in most Indian schools. Ella adored Miss Francis and schooling in general. She recalled the school as a kind of beacon. Lit at night by oil lamps and candles, it looked "like an immense ship plowing across the West."[11] Miss Francis, Ella recalled, challenged students with advanced subjects such as astronomy, physics, and chemistry. She gave students individual music lessons, had plants flowering in every room of the school, and demonstrated respect for Indian people who continued to observe traditional lifeways.

Mary Francis was also tough: "She would never squint at work half-done and she would never tolerate half-truths from anybody. And if a child tried to slide out of an obligation, he or she could never get away with it. Miss Francis was uncompromising; you couldn't buy her off. If you deserved punishment, you got it, every time."[12] For Ella, the challenge was stimulating, and it laid the groundwork for her formidable intellect and productive career. Susie found the school's rigor less compelling. Where Ella prospered, Susie got by.

Mary Francis, St. Elizabeth's, and the Episcopal missionary church all aimed to transform Lakota culture, and all succeeded. But the transformation was not straightforward, and the success was qualified. One might read Miss Francis's apparent cultural sensitivity not simply as an aspect of her personality but also as a politic response to Indian power on the ground. At Standing Rock, Philip Deloria led the St. Elizabeth's Mission. He did so out of sincere Christian belief—and he could be toughly dogmatic—but his Dakota upbringing underpinned the practices of his church: bilingualism, continuities between old forms and new, and use

2.2. Susan Deloria, ca. 1903, at work sewing, while wearing moccasins

of the rhetorical and social conventions of Sioux leadership. He practiced a Christian life shot through with unspoken sympathies for "the old ways," which grew over the years.

Following the practices of Bishop William Hobart Hare, who took charge of the newly founded Niobrara Missionary District in 1873, the Episcopal Church aimed—at least partially—to train and utilize Native clergy among their own people, creating cohorts of ministers like Philip Deloria and, in the next generation, his son Vine.[13] As Virginia Driving Hawk Sneve points out, Niobrara was the church's first and only "racial episcopate," one organized around a social group rather than a particular geography.[14] Indeed, along with certain Catholic missions, the Episcopalian effort—due in large part to this strategy—was among the most effective missionary organizations in the region in the late nineteenth and early twentieth centuries.

At the same time, Native clergy also banded together across denominations through the Brotherhood of Christian Unity, creating a thriving Sioux Christianity on South Dakota reservations. Indian people within the church raised up a Native-centered home—a tipi, in Sully's terms—around the colonial efforts to convert and educate them. All clergy contended with the power of local people to shape the practices and aims of congregations. Such congregations—local social collectives managed by Sioux laypeople—sat distant from the seats of power and so forged their own particular meanings for the church. Mary Francis carried a significant amount of power from the colonial center to the Dakota periphery, but that power was qualified by locality. Indeed, the measure of her effectiveness is found not in her imposition of a metropolitan civilizing will but in the compromises between coercion and willing consent that she offered to pupils such as Ella and Susie Deloria.

2.3. Susan Deloria, ca. 1908 (standing, center)

In the personality print *Bishop Hare* (fig. 2.4), Mary Sully reflected yet again on the nature of the church. As in *The Indian Church*, Hare's legacy takes an Indian shape, as a camp circle of tipis surrounding a black cross figure. The cross could not be more different in form from the Niobrara Cross that Hare devised for his Indian charges. Here, its base has been split to form leglike structures, while the arms have been clipped diagonally to suggest wings. The image includes shapes that suggest cross, man, and bird—which turns out to be an appropriate semiotic gesture. Known among the Sioux for his frequent traveling, Hare was given the name Zitkána Dúzaháŋ / Swift Bird.[15] Beneath the figure, angles and lines cross in a curious pattern, evoking a broad-shouldered, square-headed man—or an oddly insectlike pair of legs. The tipis carry an anthropomorphic tinge, suggesting an abstraction of robed people viewed from behind, even as they function like a repetitive design stamp. In the background, three buttes evoke the Trinity, transplanted to the Plains.

The image captures Hare's essential nature—man, Christian, bird—even as it encloses him within the traditional Indian camp circle. Indian life has an order and symmetry to it, resplendent in gentle green—the color reflecting the earth, the plains, and regeneration—and the clean geometry of what Black Elk and many others have called the "sacred hoop" of the Dakota people.[16] The bishop himself, however, appears slightly ominous, a looming black shade that occupies the center of the society, like the shadow of a predator bird flying overhead.

In 1944—perhaps roughly contemporaneous with the late style of *Bishop Hare*—Ella used one of her sister's designs on the cover of her book *Speaking of Indians* (fig. 2.5). The caption, written for a church audience, situates Hare, Sully, and the church in a Dakota context. Likewise, in the second and third panels of the personality print, the figure of Hare has morphed to look like the "altar" figure on the book cover—a cross of equal-length arms, emphasizing the four directions. Sully seems to query the bishop: "who really converted whom?"

The St. Elizabeth's school offered the possibility of an education not far removed from that being offered non-Native students. For both Ella and Susie, success meant moving to the All Saints High School for Girls in Sioux Falls, South Dakota. Ella graduated from All Saints in 1910; Susie finished in

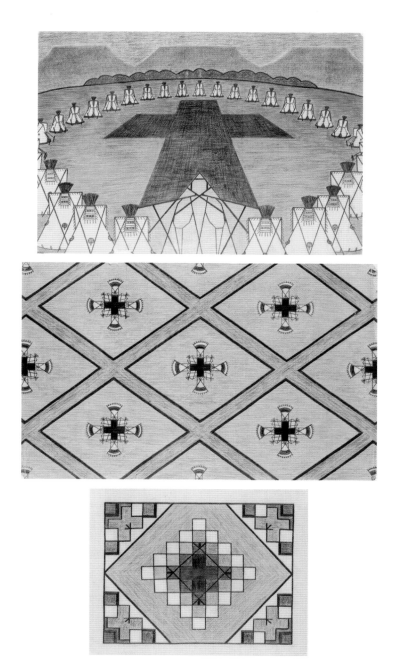

2.4. Mary Sully, *Bishop Hare*

2.5. Mary Sully, cover for *Speaking of Indians* by Ella Deloria (1944). From the flyleaf: "The cover design . . . is composed of the traditional camp-circle of the Dakotas and within it a figure representing the 'altar' or enclosed space used by a man fasting in solitude and seeking a vision. Its elongated points, originally indicating the four winds, form a cross. The artist here had in mind some allusion to the fact that many Indians today hold almost unconsciously to what is good in the old ways, at the same time giving a new significance to it."

1916. As was typical of Indian students, their trajectories had been uneven through the preparatory grades, where it was easy to lose track of age and to promote students by capability through classrooms that included a range of ages and capacities. Ella was twenty-one when she graduated from high school; Susie was twenty.

A boarding school situated in the eastern edge of South Dakota, All Saints served government officials, missionaries, and economic elites seeking a high-quality education for their children. Ella did well at All Saints—taking a special interest in Latin, among other subjects—and she went directly on scholarship to Oberlin College in Ohio. After two years, she transferred to the Teachers College at Columbia University in New York City. Following her graduation, she returned to teach at St. Elizabeth's and then, from 1916 to 1919, at All Saints. Susie, on the other hand, continued to struggle during her high school years. She was reluctant to participate, and her shyness became

a serious liability. Ella, in a later letter to Episcopal bishop Hugh Latimer Burleson, diagnosed Susie in terms of the cultural confusion that came with the alternation of two sets of surroundings:

> She and Vine and I were brought up in more abnormal circumstances than most other missionary children. From a thorough Indian life, where it was not decent even to play very openly, and where we had always to "set an example," we were plunged into the cultured atmosphere of school, and then thrust back again each vacation. There were so many conflicting influences which I cannot go into now, but it was a hard thing to come through. Vine and I managed pretty well, because we were not bashful. But Susie is still slowly recovering from the effects, because she was always shy . . . [shyness] was supposed to be a maidenly virtue among Indians, and look where it put her. Honestly, I think she has suffered agonies that I cannot realize.[17]

Susie herself recognized the same issue, but in her own letter to the bishop added new dimensions, including a suggestion of parental indulgence, a pattern of difficult behavior, and a pointed diagnosis: "I think bashfulness and sensitiveness have almost ruined my life and Ella's. Everyone petted me at home and I became one that was hard to manage. I would have overcome all that if I hadn't been so bashful. It is, I believe, a disease."[18]

The first Mary Sully—mother to Ella, Susie, and Vine—died in August 1916, only a few months after Susie's graduation from high school. Ella, who had spent the year at St. Elizabeth's, took the opportunity to move to Sioux Falls to teach at All Saints, while Vine was put on a train to Kearney Military Academy, a church-sponsored boarding school for boys in Nebraska. Susie returned home, providing domestic support for her father and retreating back into a home-centered security.

Mary Sully had owned three allotments of land, and her will disbursed these among her heirs. The will suggests that Susie's mother may have recognized her as a person of limited capacity, for it assigns a forty-acre tract to Ella and Susie jointly, whereas Vine and Ella were each assigned individual tracts. In 1918 Susie sold her share to Ella for one dollar, and Ella began working with the Indian Office to sell the allotment, a transaction completed

in 1919.[19] Their father was an outspoken opponent of land sales, constantly exhorting his congregations to hang on to their allotments. Ella's sale of the land ran directly contrary to his advice. On the other hand, neither woman had any plans to farm—or to marry a farmer or rancher. In 1919 Ella moved to New York City to begin training for a position with the Young Women's Christian Association, and she was soon serving as the YWCA's Secretary of Health Education for Indian Schools and Reservations, a job that had her traveling to reservations across the country, periodically returning to the city. In this context, perhaps it made sense to sell the land to help finance the move to New York. Susie played little part in the decision.[20]

In the spring of 1921, the Haskell Indian School in Lawrence, Kansas, asked the YWCA for help in developing a physical education program for Indian girls, and over the next years Ella spent significant time there, teaching on a detached assignment. Philip Deloria had remarried in 1917, and neither Ella nor Susie got along well with their new stepmother. It is not entirely clear when Susie left South Dakota, but at some point in the early 1920s, she joined Ella in Lawrence, also home to the University of Kansas.

Under the name Mary Susie Deloria, she registered at KU as a special student, allowed to take courses without being regularly admitted.[21] Her registration came late, in November 1922, and it is difficult to know whether Susie had taken classes that fall (and was late with the paperwork), planned to be in class during the winter semester, or took a more limited course available under the "special student" designation. She registered through the School of Fine Arts, marking her first visible and formal engagement with the world of art. That engagement did not last, at least not in the academic context, as she did not take classes at the University of Kansas for the next two years. Indeed, it is not clear how many courses—or even how many class *sessions*— she attended while registered.

WAKE UP . . .

Between August 1924 and June 1926, Ella (mostly), Susie, and their brother, Vine (occasionally), engaged in a startling round of correspondence with the Office of Indian Affairs, the local Indian agent at Standing Rock, Haskell Indian School superintendent Henry Peairs, and South Dakota's Episcopal

bishop, Hugh Latimer Burleson. The exchanges began with issues of money and debt; they ended with diagnostic and treatment issues surrounding the mental health of Susan Deloria.

Perhaps the most useful way into the story is to begin near its end, in January 1926, when Ella wrote a series of increasingly frantic letters seeking to transfer the patent to her brother's land allotment to her, so that it could be sold. She told the Indian Office of Vine's impending graduation from St. Stephens College, his responsible nature, the sociology degree that suggested he would eschew reservation farming, and his need for funds to complete his education. In subsequent letters, she would begin to speak of a debt that she claimed he owed her for his own education.[22] She enjoined Vine to write a similar letter, asking that the land patent be delivered to her. The letters are misaligned in their stories, however, suggesting that Ella told Vine what to write and that he garbled the assignment. In his letter to the Indian Office, Vine emphasized not his own educational debts to Ella but the load of debt that *she* had been carrying—and he attributed this debt to Susie: "I have a sister who has never been well and who at times, in the past, has been really quite ill. . . . During all these years, Ella has used everything she had to take care of this sister, and is even now carrying some debts that she is very slowly paying back."[23]

Ella's letters muddy the waters still further. Vine was a scholarship athlete at St. Stephens, and his debt to her was not substantial—nor did he need to sell his allotment to complete his education. As Ella kept writing letters, the nature of the supposed debt started to shift, relocated from Vine's college years back to his military school days, and the amount suddenly ballooned from a couple hundred dollars to seven hundred dollars. In an April 1926 letter asking Haskell superintendent Henry Peairs to help speed the process along, Ella claimed—incorrectly—that she had sold her allotment to complete her own education. Her tone becomes increasingly desperate:

> Can you use your influence to bear in this matter? You must, Mr. Peairs, for you are my friend and I am just standing the trouble through sheer "fight." I want you to tell Mr. Mossman [the agent at Standing Rock] that you know the particulars for indeed you know it all with this letter, and to recommend that he hurry. Please, Mr. Peairs. They gave me

my patent outright, without a question, before they knew whether I would squander it or not. It was before I finished high school, and I got the best education in the best university I could with it. Why, when we need it so now, and when my brother is finishing college and practically owes me the seven hundred anyway, why must it take so long? . . . I consider you and Miss Dabb and Bishop Burleson as my three great friends. The other two—they cannot help me in this, because it is out of their sphere. But you can and you must, or I shall be dead by June.[24]

What exactly was the trouble that led Ella to suggest that the debt she was carrying was life threatening, as if she had somehow fallen under the thumb of the Kansas City mob? And what kinds of issues could be attributed not to Vine's supposed obligations—transparently false—but to Susie and her health?

Given her lifelong trouble with school it should come as no surprise that Susie failed to thrive at the University of Kansas in 1922–23. A few years later, Ella would note that Susie was working as a housekeeper—and not particularly well suited for it—and one might speculate that she spent the last months of 1923 in a low-end job or perhaps simply hunkered down with Ella, who was teaching at Haskell during the 1923–24 academic year.[25]

In the spring of 1924, though, Susie Deloria tried, in one ill-fated gesture, to change her life, to wake up and live. She had followed Ella's educational path but as a pale imitation, scraping by in the anonymous middle or sinking to the bottom as she found it impossible to match the reputation of her talented sister. Where Ella used schools to network with privileged elites, Susie grew increasingly self-conscious, living a life focused on her social inferiorities—and what she believed to be her very real talents and potentials. Ella was hardworking, pragmatic, and opportunistic; Susie was a dreamer, insecure yet aggrieved, drifting unmoored while also imagining that big things lay in store. In 1924 she was twenty-eight years old, with all the achievement of a high schooler—and with a cosmopolitan, educated sister close at hand to remind her of what was possible.

Susie Deloria aimed to go into business, opening a candy and ice cream store in Lawrence, through which she hoped to chart her own course and

to fund a college education. The challenge was capital: how was she to pay rent, buy inventory and equipment, create signage and advertising, and decorate the shop? She had no money. There seems to have been a loan, perhaps a partner, and there was certainly Ella's small bank account. As Ella wryly put it later, Susie failed to see that "my money was rather mine more than hers." On at least one occasion, Susie wrote bad checks out of Ella's account, requiring Ella to scramble to avoid legal entanglement.[26] Among Ella's papers is to be found a memo, marked "highly confidential," that lays out the challenges faced by Indian people as they engaged wage work, consumerism, and money economies. Written late in her career, it reflects years of experience—and yet many of her analyses seem to have originated close at hand, in her own struggles and those of people like Susie.[27]

The candy store enterprise ended quickly, creating a debt that the sisters would carry for the next two years, to be shed only through the desperate sale of their brother's allotment in June 1926. The situation led them to play fast and loose with the truth, to shift strategies, claims, and timelines, and to work the church and the Indian Office from both sides as they sought money to cover their obligations. It also helped produce Mary Sully, the artist.

In August 1924 Susie Deloria first pled her case—without Ella's knowledge—to Bishop Burleson, in a sad, desperate letter:

> All I tried failed and I am at a loss and sometimes I think life is not worth living. I study myself and really think sometimes that I am the most impossible creature alive. This spring I thought I could go into a small business and from what I made I could attend school half days. But I find the business world very different from what I had been used to. Now I need money so much I don't know what to do. I owe some, too, because I started to go into business and I had to pay out. If I could just have some money now—I need it because I have to make some payments and I do not know what to do. If I had $500 I think I can get into a decent way of living again.[28]

Susie seems to have written more during this period than at any other during her life, and her correspondence centers on this debt, as both sisters sought help from the Episcopal Church.

But their correspondence, focused on keeping money coming in to retire their obligations, slowly shifted from the debt itself—never a compelling request and growing less so with every passing day—to the newly pressing issue of Susie's personality and her psychological health. In early 1925 Susie wrote the bishop again, and Ella followed up. This time, Ella confessed that Susie was not simply a shy person who had made financial mistakes but a deeply troubled character: "When she is beyond controlling herself, she is most unreasonable, and makes such scenes as I would die to have anyone see. . . . It is with those scenes that she made me, against my better judgment, get the money for her that is such a nightmare now."[29] Over the period from August 1924 to June 1926, when he sent a final check, an accounting of his generosity, and the news that the spigot was now closed, Burleson would send $450 to the sisters, sometimes in relation to the debt but more often in efforts to get Susie on her feet and back in school at the University of Kansas.[30]

By the time of the 1926 effort to sell Vine's allotment, the story of Susie's mental health had taken on new dimensions. In Vine's letter to Commissioner Burke, he noted that "a comparatively simple operation, performed last spring on the back of her head, restored my sister so much that she is now entering the University of Kansas, and doing as well as the average student."[31] The debt now had as much to do with this medical procedure, and perhaps with Susie's college costs, as it did with the failed business, which quickly disappeared from the discussion. Indeed, the story of the successful operation proved critical for Ella's requests to the bishop, for only a refocused Susie could justify continued investment.

The picture of a bright future also proved critical to the requests to the Indian Office for the allotment. It sounded so much better to say one was selling land to support the college dreams of Indian students rather than to help retire their debts—for debt was the classic mechanism through which white grifters seized Indian allotments. As the candy store debits were converted to a successful medical operation, the story grew even more compelling. And so Ella explained to Henry Peairs: "My sister, through the queer type of illness and early psychological difficulties that I told you of, never till the operation I spoke of, really found herself enough to know what she wanted to do. Now she is so bright and cheerful and so certain as to what she

wants, that I am more anxious than I can ever tell you, that nothing shall happen now, that will divert her from her plan."[32]

The story of the operation appeared many times, in many different guises. Ella suggested that "the poor child has had a bump on the nape of her neck for years" and that it surely had something to do with her troubles.[33] My father grew up hearing about the removal of "benign brain tumors."[34] At one point, Ella suggested that the surgery had been performed in Chicago by Carlos Montezuma, the famous American Indian doctor and political activist. In later correspondence with Franz Boas, the surgery had seemingly not taken place at all but was still urgently needed. It seems unlikely that any surgery took place, but it offered an excellent story that supported requests for funding, even as it explained (and perhaps explained away) Susie's peculiarities.

If the surgery story materialized as an odd cross between speculation, wishful thinking, and fraud, there was in fact a medical intervention for Susie, one less easily fundable but perhaps as interesting. During the 1924–25 academic year, Ella spent most of her time in New York or in visiting various reservations; Susie remained in Kansas, working as a maid. Damage control and planning for the future seemed to be the order of the day. Bishop Burleson, spurred by the sisters' letters to think of mental health rather than business debt, advised Ella to contact a local mental health association and to get Susie into treatment.[35] During the early winter of 1925, Ella started reading in the field of psychology. Clifford Beers's 1908 book, *A Mind That Found Itself,* was at the top of her list.[36]

Like Susie, Beers had been pathologically nervous, worried that he had inherited his brother's epilepsy and was overdue for a seizure in a public place. After a failed suicide attempt and increasingly delusional behavior, he was institutionalized. Ella saw the commonalities: Beers's brother had had a bump on his neck; there were the alternating states of grand overconfidence and episodic depression; and there was nervousness that hindered social interaction and led to a retreat to solitude. Beers's book also offered an example, however, of a person who turned mental health issues into opportunity. With its publication, Beers became a leading figure in mental health reform, founding in 1909 the National Committee for Mental Hygiene, which aimed to improve institutional practice, educate the public

about mental health issues, and thus produce greater acceptance of those with mental health challenges.[37]

Beers's book presented a template for a diagnosis. It let Susie give a name to her condition and suggested the possibility of improvement. But Beers also detailed the harsh treatment found in standard institutional settings. Ella needed to find Susie a progressive place that emphasized medical approaches toward a cure rather than a human storage locker focused on protecting society from the insane. Soon, she believed that she had found the place: the G. Wilse Robinson Sanitarium for Nervous and Mental Diseases, a private hospital in Kansas City.[38]

The Robinson hospital was a continuation of the Punton Sanitarium, an institution founded in 1890 by Dr. John Punton, a pioneer in humane mental health treatment.[39] After his medical training, G. Wilse Robinson served as superintendent of the Missouri State Hospital No. 3 in Nevada, Missouri. There, in 1908, he instituted a farm work program, insisting on the importance of environment and activity as important factors in treatment. In 1910 he took over Punton's practice. Both doctors had long been committed to the mental hygiene work called for by Clifford Beers. Indeed, during World War I, Robinson was chief of neuropsychiatry for the US Army. In short, Susie was to see the best possible doctor in the area.

Psychological theories surrounding mental health and personality broke like a wave over the early twentieth century. G. Stanley Hall pushed Americans to see the importance of childhood development. William James exemplified the meeting of medical science, philosophy, and psychology that made sense to practitioners such as Robinson. The theories of Sigmund Freud had been exported and assimilated thanks to his American disciple A. A. Brill, who translated Freud and advanced the field of psychoanalysis in the United States. Alfred Adler, the first to break from Freud's circle, established the concept of individual psychology and introduced key concepts such as the "inferiority complex," the holistic approach to individuals, and the importance of "exterior" factors like social and cultural context. Carl Jung visited Taos, New Mexico, in the winter of 1924–25, locating powerful psychological experiences among Indian people, even as he proposed concepts such as the collective unconscious, the archetype, and individuation. Progressive reformers such as Clifford Beers took clear aim not simply at

the institutions that managed mental health but at the philosophy and psychology that guided them. One did not need to be studying Freud's latest article to absorb these concepts; they floated through the news, magazines, and even everyday conversations. G. Wilse Robinson had twenty-five years of institutional experience and was versed not simply in this world of theoretical psychology but also in medical psychiatry and clinical practice. He would be Susie's guide to the new ideas, if only for a short time.

PERSONALITY ON THE SOCIAL EDGES

Sully made personality prints for an eclectic range of individuals. These included substantial numbers of women, among whom can be found two aviators (Amelia Earhart and Beryl Markham), a mountain climber (Annie Peck Smith), health professionals (Clara Barton and Florence Nightingale), athletes (Sonja Henie and Helen Wills), and many actors, writers, and musicians. Indeed, images of high-achieving and often nonconforming women make up a significant part of the project, suggesting the presence of a feminist consciousness, likely developed in tandem with her sister. Sully paid her respects to Indians (Will Rogers), Latinas (Dolores del Río and Lupe Vélez), African Americans (Marian Anderson), Jews (Eddie Cantor, Annie Stein, and Albert Einstein), and anti-Semites (George Bernard Shaw and Charles Lindbergh). She admired physical courage and unique talent (explorers, race car drivers, inventors, and heroic doctors and priests). She also left room for the anonymous (Alice Fazende) and for those who, like her, confronted challenges at the social edges: sexual outsiders, spiritual seekers, those less abled, and those struggling with family legacies.

Comic actress Patsy Kelly, who appeared in the film *Wake Up and Live*, lived a life as an out lesbian in 1930s Hollywood, following a career as a vaudeville dancer and comedian. She had a long-term relationship with actress Wilma Cox, which she never endeavored to hide, and later worked for Tallulah Bankhead, who was also a lover. In a 1936 *Collier's* profile, "Haphazard Patsy," she is presented as scattered and slightly out of control—owing back taxes, spendthrift, "the sloppiest dressed girl in

Hollywood," and, according to her official profile, "unmarried, but doesn't give the reason." She nearly died in an accident (driving off the Venice Pier) that killed female impersonator Gene (Jean) Malin, and she developed a reputation for loud ejections from cocktail lounges. There's little doubt that her open sexuality limited her ability to garner roles, and Kelly disappeared from the big screen for decades. Mary Sully's own exceptionality did not mirror that of Kelly, who was public, brash, wisecracking, and anything but shy. But one can't help but note an affinity in shared marginality and speculate about Sully's respect for Kelly's confident nonconformity. For *Patsy Kelly,* the result is a complex image with an M. C. Escher–like play around four-sided scrolls, a patterned universe that strongly suggests nonpatterned randomness, and a brightly colored band of expressive geometry.[40]

Many of Mary Sully's subjects invite one to trace six (or fewer) degrees of separation. Nilla (sometimes spelled *Nila*) Cram Cook sits within one particularly interesting web of people. Her father, George Cram "Jig" Cook, was the founding spirit of the Provincetown Players, often considered the United States' first experimental theater company, and the center of a rich network of modernists that included two people represented in the personality prints—Eugene O'Neill and Edna St. Vincent Millay—and a number of writers and artists who plied the modernist circuits stretching from Provincetown to Greenwich Village to Europe and to Santa Fe: Charles Demuth and Marsden Hartley, Mabel Dodge Luhan and John Reed. *New York Times* critic Alexander Woolcott (for whom Sully made an image) served as an early booster of the theater company. When Cook dissolved it in 1922, he took his daughter to Greece, where she became his primary student. Cook and his third wife, the writer Susan Glaspell, lived near Delphi. They camped in the mountains, and he wore the traditional clothing of the local Greek shepherds, while Nilla learned Sanskrit (among other languages), studied theology and metaphysics, and led choral festivals in classical robes.[41] Married as a teen in 1927, by 1933 she was a divorced mother searching for meaning.

Nilla Cram Cook became a devoted student of Mohandas K. Gandhi, traveling to India, where Brahman priests identified her as an ancient spirit reincarnated and made her into a street cleaner as part of a campaign

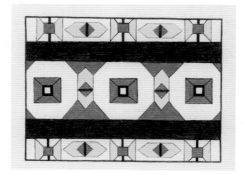

Mary Sully, *Patsy Kelly*

against the caste system. After eight difficult months, she broke out—perhaps in something of a Provincetown mode—crashing a car into a ditch and registering at a New Delhi hotel under a false name. The Indian government locked her in a mental hospital before deporting her in February 1934. Arriving in New York, she declared herself in love with both America (and Iowa, where the Cook family was from) and a ship's steward named Albert Hutchins. Their whirlwind marriage did not last, and Nilla's first brush with fame—likely the one that grabbed the attention of Mary Sully—came to an end. (Cook would reappear in 1939 as a war correspondent, serve as a cultural attaché in Iran in the 1940s, convert to Islam and translate the Koran, and serve in the Iranian Ministry of Education, advocating for the arts and for the roles of women.) On December 11, 1933, *Time Magazine* wrote a gossipy note about Gandhi's "Runaway Disciple," which may have served as inspiration for Mary Sully:

Of all his strange disciples the one who has caused Mahatma Gandhi the sharpest pangs of dismay is plump & pleasing Nilla Cram Cook, 23-year-old daughter of the late George Cram Cook, Iowa poet. At 19 Nilla Cram Cook married a Greek nobleman. Three years later she was converted to Hinduism under the name of Nilla Nagini and Devi, "The Blue Serpent Lady."

Her difficulty in adjusting her good intentions to her Iowa temperament caused sorrowing St. Gandhi to embark on a hunger strike seven months ago. Nilla repented and for five months slept on a bed of bricks in penance. Two months ago she erupted once more, turned up wild-eyed and dusty at the home of an astonished Hindu in Muttra only to disappear again.

Last week toothless little St. Gandhi writhed in embarrassment at news from New Delhi. A brand new automobile, ordered on approval, had gone roaring down the road 70 m.p.h., hit a bump, overturned. Out rolled Serpent Goddess Nilla, bruised, battered, but bitterly determined to lead her own life.

"I don't care what others say," cried she. "My heart is leaping for thrills. I want speed. I want to fly. I want to attend orchestra dances. . . . One day Gandhi stated that he had not put a fence around the

Mary Sully, *Nila Cram Cook*

cantonment and any girl could leave, so I took the hint. . . . I have written to Gandhi fully concerning my change of heart including the flutter caused in meeting a man with beautiful eyes and brows."

To a New Delhi hotel keeper she announced that she thought of going into cinema, insisted that her name was Janet Gaynor.

Mary Sully's image, *Nila Cram Cook*, is an abstract study of planes and forms, with a yellow pole rising as if the prow of a ship—and indeed, white sail-like structures fill the top panel. Or perhaps the yellow figure is a bridge, a path to enlightenment across a complicated well of perspectival play? The middle panel converts the iconography into something like a ship's signal pennants. Is the theme oceanic? Or is it metaphysical, suggested again in the middle panel, in which the pennant structure cuts through a series of labyrinths? The bottom panel plays with the theme of windows—perhaps to the soul—and an optical illusion that shifts the eye between a squared-off tunnel into depths or an overhead view of a step pyramid.

Mary Sully was not a child of divorce. But she knew half sisters and brothers from three families broken by the death of a parent: her father had lost two wives; her mother had lost a husband. The children of those families were part of her own. And of course, equally challenging family separations of another sort characterized the boarding school era in which she grew up. Her brother—still grieving the loss of his mother—was packed on a train shortly after her death and sent to military school, and Ella and Susie were both sent to Sioux Falls for their educations. Vine and Ella brought Sully into their own discussions of sociological questions, and it is not difficult to see how Sully may have made an affective and intellectual connection to the plaintive account published in the March 1934 issue of *Ladies' Home Journal*, "Children of Divorce," likely the origin of this image.

You would not put your seven-year-old child in a boarding school except for some extreme necessity. Yet, like so many others, I was in a boarding school when I was seven—a neglected tot, lonely, miserable and ill. Many such unfortunates were and are sent to school for the

Mary Sully, *Children of Divorce*

same reason that I was—their homes are broken up. . . . "If I can't have her, you won't!" was the bitter theme song of my childhood. This song would remain forever unsung if divorcing people got divorced with their children's welfare foremost in their minds. The problem ought to be considered this way: Which is more important—the parents' possessive love, or the child's security and future? The latter, of course, divorcing people say; so they proceed to arrange for the child to know and share the lives of both parents. To my mind this is the next lesser evil to boarding school. I think that both courses deprive a child of a normal home, and I believe that a secure, unified home permanently with one parent is the fairer thing for the children of most divorced people.

Despite all the familiar compromises in the custody of divorced people's children—the half year with each parent, with winter with the mother and summer with the father, the bimonthly visits from the deprived parent—I believe the average child is better off, and its future more secure, if it is given into the sole custody of its mother or of its father, the other parent not to be seen until the child is grown.[42]

. . . AND LIVE

In March 1925 Susie Deloria entered G. Wilse Robinson's clinic in Kansas City. He gave her a physical and concluded that (in Ella's words) "nervously, she was bad off." He did not suggest an operation for the bump on her neck, and he rejected another theory, of heart trouble. She was so nervous that her heart started racing whenever she was examined, but he determined that it was a symptom rather than a condition. According to Ella, Robinson's diagnosis was that Susie "needs to develop a good deal of egoism and push, and he was going to see that she did." In addition to this recentering of the ego, there was a vocational dimension to the therapy—or Ella felt it important to frame her correspondence that way. She reported that the doctor felt he would "get at the type of thing she would succeed in, by the time she is well, by getting at her psychology in talking to her."[43] Robinson—as equipped as any doctor in the United States to adopt a more active medical intervention—seems to have offered a light form of what we would today call "the talking cure," one of many variations on the theme that was psychoanalysis.

After only a week, however, Susie begged Ella to get her out of the sanitarium, saying that it was too depressing to be surrounded by people so much worse off than she. She stayed at the local Kansas City YWCA for another few weeks, visiting Dr. Robinson as an outpatient until there was mutual agreement to end the sessions after little more than a month.[44] It seems likely that her week in the sanitarium and her sessions with Robinson brought her to an understanding that her own mental health issues—undoubtedly real and significant—were in fact manageable, and that the alternative—escalating treatment and residence in a sanitarium or public mental health hospital—was a bad option. The diagnoses she might receive today—episodic depression, anxiety disorder, bipolar disorder—are usually treated pharmaceutically; in 1925 that was not an option. The better course was to develop a life strategy for protection, management, and coping. Clifford Beers's case seemed to offer evidence that this was possible.

There is no direct evidence linking Sully's therapeutic experience to the personality prints project. Formal art therapy as a diagnostic or therapeutic practice was over a decade away, but as Judith Rubin has suggested, the climate of psychoanalysis led a number of mental health professionals to offer pencil and paper as part of their treatment.[45] Nor was Robinson likely to have placed Rorschach Test cards in front of her; Hermann Rorschach had published his study only in 1921, after which it lingered in obscurity for several years.[46] But it is surely the case that the entire context of sanitarium and talk therapy offered Susie an opportunity to personalize the psychological chatter that floated through American society and to think hard about personality and character—about whether there was an essential quality to a person, about the extent that such qualities could be altered or controlled, and about the nature of childhood development and surrounding environment. These themes proved central to her aesthetic project, which required not only artistic vision and technical skills but also discernment, the ability to look at a person and *see* them in the new and penetrating ways modeled by the psychoanalyst. Whatever her liabilities, Sully clearly had such a discerning eye.

The question for the sisters, then, was how to devise a path forward. They decided to try once more for a college education, though in a carefully protected environment. First, Susie—again registering as Mary Susie Deloria—

returned to the University of Kansas in 1925 as a nondegree student in fine arts during the less-stressful summer session. And throughout that summer and fall, Ella and Bishop Burleson exchanged letters concerning her possibilities. Susie's poor All Saints record and her long period of inactivity weighed against her, but Burleson pulled strings to gain her admission, in January 1926, to Tabor College, a small Christian institution in Tabor, Iowa. Maddeningly—but probably wisely—Susie decided at the last minute to stay at KU instead, allowing her to remain with Ella in Lawrence.[47] Still not formally enrolled, Susie signed up for four classes during the winter semester: French, Contemporary America, Art History, and Design.[48] Ella also registered herself as a special student, perhaps so that she could accompany Susie to classes and support her psychologically and academically. Indeed, one might imagine a beginning point for Susie's personality prints project in an intellectual discussion between the two sisters, structured by shared courses on art and design history and on contemporary America, underpinned by Susie's therapeutic experience in the Robinson sanitarium.

The flurry of debt-related correspondence in the winter of 1926 was not only about selling Vine's allotment; it was also now (semilegitimately) structured around Susie's effort to continue her education. With Susie in classes, the requests to Bishop Burleson came fast and furious. Susie needed eyeglasses (and now that she has them, she is much happier and more successful). Susie was in a room for ten dollars per week, but the family moved and she has found new quarters at fourteen dollars per week, and may we please have the difference? The costs of Susie's supplies are more than we anticipated, and we need help. Susie has gotten Bs in her courses. And finally, the news that Susie had figured out her future: she wanted to be an elementary school art teacher and could become certified by taking summer school courses in 1926, for which an additional one hundred dollars was needed for tuition. Burleson sent the money, but it was his last contribution.[49]

When the fall semester came, Susie was no longer enrolled. She seems to have relocated—or to have been relocated by Ella—to Chicago. In a January 1927 letter to Burleson, Ella observed that it was better for Susie to be in Chicago, for there was little in the way of artistic work or training to be found in Lawrence, and it was also good for her to be on her own.[50] In a December 1926 letter, however, she more realistically confessed to worrying about

Susie being able to make it in the city. According to my father, Susie was set up in an art and design program but could not attend classes and quickly dropped out.

At some point, she took one or more correspondence courses, a claim knowable only through a couple of casual asides in letters from Ella.[51] By January 1927 Susie had come to the end of whatever formal education she would have. It seems unlikely that she had any studio training; at best, she had access to a few introductory college courses in art and design history and perhaps in drawing. She consulted popular do-it-yourself books and developed her style and project more or less on her own. Susie had access— through media—to the full range of production of the growing American culture industry. If she did not attend the theater or opera, she was able to read about it. If she was not perusing European museums and New York galleries, she was able to see their notices in magazines such as *Time, Cosmopolitan,* and the *Saturday Evening Post.*

By January 1927 both sisters understood that Susie was unable to make a life on her own and that Ella would take responsibility for her. Ella crafted useful roles for Susie—most importantly as her driver on the many road trips the sisters would take over the course of Ella's career. And as the personality prints project took shape, Ella served as a kind of press agent for Susie, pushing her work with enthusiasm, if little success.

During the 1926–27 academic year, Ella reestablished contact with Franz Boas, the Columbia University anthropologist she had met her during her final semester in New York, in 1915. At that time, she had served as a kind of "practice informant" for his students in training. Now, Boas needed translation help with a thousand handwritten manuscript pages composed in the Lakota language by George Bushotter and assembled in 1887 by the Episcopal missionary and Bureau of American Ethnology collector James Owen Dorsey. During the summer of 1927, Ella jumped into the work, beginning what would be a sometimes vexed but always fruitful collaboration with the man who was arguably the key foundational figure in the development of American anthropology in the twentieth century. In January 1928 she left Lawrence and the Haskell Indian School for New York and Columbia and a new career as a linguist and ethnographer. Susie stayed behind in Kansas with friends that winter, but in the years that followed, she would accompany her

sister as Ella alternated between ethnographic fieldwork in the South Dakota summers and linguistic and interpretive work in New York City during the rest of the year. The sisters would spend much of the 1930s on the road, not exactly Depression-era farm refugees but living a similar story of cash-starved mobility, hustling, and making do.

I have dwelled on these years when Susan Deloria's garden was dark and unawakened, and have done so partially in response to the written archive—produced largely by Ella, but also the result of the institutional structures of the Indian Office and the Episcopal Church. It offers the only sustained record of Susie's written voice, and of a conversation in which she was a central figure. But more important, the years between 1922 and 1928 contain the personal, psychological, intellectual, and aesthetic beginnings of the personality prints project. During that time, she made an effort, in Dorothea Brande's terms, to "wake up and live," becoming something more than the troubled Susan Deloria. She transformed herself into the artist Mary Sully—odd and reclusive, but with a project that grew in coherence and matured in style over the coming years. By 1929 there was every possibility that a *Time Magazine* cover featuring tennis champion Helen Wills might be turned into a personality print, with a three-part form that was well established and that would carry Mary Sully creatively for over a decade.

Within these years are to be found a series of markers of transformation: In 1922 she broke from South Dakota and signaled her desire to engage the arts; she proclaimed that break, in part, through the adoption of her mother's first name, Mary. In 1923, unable to continue her education, she was reminded of her own psychological and emotional limitations, and she experienced a possible future of menial labor in domestic work. Yet she believed herself to have special gifts, and this belief led in the following year to an ill-fated effort to create a different future, as a business owner. The financial burden that resulted occupied the life of her siblings for the next two years and made clear the limitations already signaled in her mother's will.

In 1925 she learned that she was not crazy, but that there were consequences to craziness—and that she could hold her life together enough to avoid them. At the same time, she was led to think more deeply about individuals, psychology, and culture. In 1926 she returned to school, trying again to acquire skills and knowledge concerning art and design. Though she may

indeed have received basic training, she also came to understand that a college degree and more advanced work in artistic technique were not likely in her future. That future would be defined by three things: first, by Sully's ability to manage her life to compensate for her limitations; second, a safekeeping partnership with her sister, in which the two developed strategies for coproducing both intellectual knowledge and their own economic survival; and finally, by the opportunity to develop her own art as a way of making meaningful contributions and perhaps even creating an income for herself. It was the often-vexed triangulation of these three factors that allowed Susan Deloria to become Mary Sully, to create new possibilities out of the ruins, to become *an artist*.

She had imagined that a candy and ice cream store would quickly split her life story in two, but in fact that split was slow and additive. It included repeated failure and the recognition of limits, mixed with an increasingly robust intellectual engagement with her own background and with the big questions that dogged Ella and Bishop Burleson and G. Wilse Robinson and Franz Boas and so many others: Where did individuals come from? What was their relation to their culture? How did women negotiate such relations? How could one capture and document the uniqueness of any one person? How did one establish a distance from the world and look on it with a penetrating eye, or dive deep into the world and see it from the inside?

Susie Deloria's failed life laid the groundwork for Mary Sully to take a crack at these questions. The effort took concrete form sometime between Mary/Susie's spring–summer coursework in 1926—perhaps during a short period of time in Chicago in the fall of that year—and the beginning of 1928, when Ella was able to offer what may have been the first assessment of the personality prints: Susie "is making some designs that are beautiful; but when she will turn them into cash is not so clear."[52]

READING MARY SULLY

INTERPRETATION

Toward an American Indian Abstract

MARY SULLY'S TOP-PANEL IMAGE OF HENRY FORD (FIG. 3.1)—ONE of the most famous men of her generation—leaves little to interpretive chance. Despairing of the ability of pencil to capture the bright white of Ford's cursive logo, Sully turned to paint, applied in the cloudy white curves of Ford's violinic script letter "f." And in a cartoonish image, Ford has literally put the world on wheels, a gesture not only to the ubiquity of his Model T and Model A cars but also to the internationalist aspirations that accompanied his World War I pacifist activities and his multiyear rubber plantation venture in Brazil.[1]

The anonymity of Alice Fazende, on the other hand, challenges the viewer to make sense of a familiar trope: a lit candle resting in a window (fig. 3.2). To tell Fazende's story is to understand the image. As a young woman, Fazende had promised her love to a Confederate soldier and, over the course of a long life, had refused all others. By the 1930s she was in essence the "last Confederate widow," visible in brief newspaper and magazine reports as a Civil War relic who had kept her lamp trimmed and burning.[2] For both images, symbolic or representational content comes into clear view when one is aware of the individuals and their stories. Other images—such as that for

3.1. (Opposite, top) Mary Sully, *Henry Ford*
3.2. (Opposite, middle) Mary Sully, *Alice Fazende*
3.3. (Opposite, bottom) Mary Sully, *Katharine Cornell*

actress Katharine Cornell (fig. 3.3)—are much more challenging, tantalizing the viewer with obscure, coded hermetic knowledge. If this image suggests something about Cornell, it is hard to discover what it might be.

The next two chapters turn from the question of Sully's creative biography—who she was and where she came from—to take up the challenge of textual interpretation: how might one read these images, which often take the shape of visual or conceptual puzzles? This chapter focuses on the images themselves and offers a series of interlocked reading practices and interpretations. In the chapter that follows, I address more broadly the ways the images sit in relation to the contexts and meanings of modernism, the modern, and the arts movements of the 1920s, which offered intellectual and aesthetic guidance as Sully called the project into being. There are chickens and eggs around this question of modernism and its constituent texts, however, suggesting that we'd best clear the ground by revisiting a familiar story.

It goes something like this: Around 1860, European visual artists inaugurated a long movement that turned explicitly away from the past and sought out "the new." They looked for fresh ways of seeing, different formats, distinct materials and techniques, new visual influences, and models that drew on experience and impression, the "primitive" arts of colonized peoples, and a developing notion of the psychological unconscious. They rejected academicism and older styles of narrative art in favor of a growing vocabulary of abstraction, symbolism, and formal experimentation. They insisted on a self-reflexive engagement not simply with their subjects but with the very notion of "art" itself, and of its function as a social object. They gravitated to particular locations, forming circles in Paris and Berlin. They clustered themselves—or were clustered by critics, galleries, collectors, curators, and other institutions—into movements and schools that crossed national boundaries: romanticism, realism, impressionism, symbolism, fauvism, expressionism, futurism, cubism, and surrealism, among others. Many of these movements were defined by small coteries of artists, sometimes possessed of manifestos and claims; they saw themselves as the exploratory advance parties of the future and were part of a wider world of modernists visible in literature, music, design, architecture, and other intellectual and aesthetic fields.

Many American artists had taken similar approaches and often made European pilgrimages for study and inspiration, creating a transatlantic flow of ideas and practices. In 1913 that transatlantic link was codified and marked in the form of the Armory Show in New York City, in which European modernism came visibly and publicly to American shores, creating the context for new audiences and explorations of American modernism. As Wanda Corn and others have demonstrated, many American artists worked out of paradigms and sensibilities that were nationalist at heart.[3] They concerned themselves not simply with the questions dear to European modernism but with the ways those questions surfaced in relation to a longstanding effort to develop a distinctively American art and culture. In doing so, they engaged *modernity*—a new world of machinery, advertising, urban street life, popular culture celebrity, landscape, and distinctively American forms of primitivism. Unlike European interests in Africa (Picasso, famously) or the Pacific (Gaugin, for example), Americans framed their primitivisms close to home, around Native American and African American cultural expression.

Aesthetic modernism linked itself to mass and popular culture, and so a wide swath of Americans engaged the same issues and questions in mediated forms, as both producers and consumers of culture. In the years following the Second World War, both American art and criticism tangled with what were by then seemingly "old" modernist questions, sketching out boundaries for a "post" modernism and crafting an array of critical perspectives and methods—abstract expressionism, formalist readings, grids, flatnesses, postperspectivism, and psychoanalytic and poststructuralist theories—many of which relied on re-viewing and redefining the art of the early twentieth century.[4]

To take a slightly side-eyed look at the contextual chicken that is modernism (more fully trussed in the chapter that follows), I want to begin with the interpretive egg—that is to say, with readings of the Mary Sully images themselves. Indeed, much of the art criticism to which I've gestured is largely built around the question *How shall we read*, and with what stakes and structures? My particular reading—in the onion-peeling mode so suited to understanding Mary Sully—winds through familiar interpretive territory: structural, formal, semiotic, and contextual. I hope to demonstrate how the personality prints work and stake at least a few claims on *how they mean*. Central to that claim is the concept of an American Indian abstract, Sully's

invention of a new aesthetic at once deeply Indigenous and uncompromisingly modernist.

THE MIDDLE: PATTERN, GEOMETRY, AND DESIGN

It may be useful, in beginning, to think about the qualities that inhere in the different locations of the panels. We might, in other words, read "horizontally" across the full collection, viewing as a unified group each of the categories "top, middle, and bottom." There are of course limits on our ability to recategorize these images—the tape that binds them in bundles of three serves as a powerful statement of the artist's intent. But Sully set the project up around a generic form, establishing the three-part structure from the very beginning and wavering from it only once. Each category of panel was of a distinct size, and each panel shared a species-similarity with all the others occupying its formal position.

The middle panels establish a wide range of patterns, from simple to experimental, many suggesting a desire to engage the world of commercial design. Middle panels such as those for Confederate widow Alice Fazende (fig. 3.4) or Boy's Town founder Father Flanagan (fig. 3.5) offer traditional looks, easily imaginable as wallpaper, cloth, or linoleum. There are many similar examples across the personality prints project: *Babe Ruth*'s simple pattern (fig. 1.7b) seems an inviting wallpaper, for instance, as does *Bishop Hare*'s (fig. 2.4b).

Other middle panels—in the vein of *Leo Carrillo* (fig. 3.6) and *Boake Carter* (fig. 3.7)—offer more experimental visions of modernist design, a move carried even further in the color explorations of *Ernest Schelling* (fig. 3.8), *Patsy Kelly* (see chap. 2 sidebar), and *Highway Rudeness* (fig. 3.9), built around the optical illusion of floating in space. While still "decorative," in these images Sully stretches the idea of "pattern" toward its limits. Absent focused attention, the designs skirt the edge of randomness. Most of the "false starts" found on the backs of the paper are from these middle panels, which required significant structure and ambition.

Some part of Mary Sully's aesthetic identity—given visible form in the middle panels of the personality prints—was as a designer. We know from her sister's correspondence that Mary Sully tried to market her design work.

3.4. Mary Sully, *Alice Fazende*

3.5. Mary Sully, *Father Flanagan*

3.6. Mary Sully, *Leo Carrillo*

3.7. Mary Sully, *Boake Carter*

3.8. Mary Sully, *Ernest Schelling*

3.9. Mary Sully, *Highway Rudeness*

And during her short time at the University of Kansas, she had undertaken formal study in design. If that class was in the mainstream of American art and design education, it may well have relied on Arthur Wesley Dow's *Composition: A Series of Exercises in Art Structure for the Use of Students and Teachers*, which served as the dominant text for decades following its publication in 1899. Dow, who taught at Columbia University Teachers College at the same time that Ella Deloria attended (1913–15), drew from a range of cross-cultural aesthetics to propose a system based on the importance of line, color, and notan (a Japanese word signifying light, dark). Each rested on the other, Dow suggested, and excellent compositions created harmony—analogized as music—across all three. *Composition* closes with a section on color, textile, and woodblock printing, illustrated by repeated patterns that seem close siblings to some of Sully's middle panels.[5]

Older design innovations lingered in popular consciousness, and their traces are palpably visible in Sully's panels. These include art nouveau, which began in Europe as a revolt against the major currents that defined late nineteenth-century design (primarily, ideas about ornament that emanated from past epochs or from elsewhere). Emphasizing symmetry, bold lines, and complex patterns, nouveau literally embodied the modernist call to "make it new."

Or perhaps one might make it old. Emerging in mid-to-late-nineteenth-century Great Britain in response to standardized mass production, poor-quality manufacture, and excessive ornamentation, the arts and crafts movement emphasized high-quality handcraft on small production scales, simple forms, and folkloric or archaic design idioms. It took shape in the United States roughly between 1910 and 1925 and served as the aesthetic partner of the social and political reforms we bundle together under the label "progressivism." Led by vocal proponents such as Gustav Stickley and Elbert Hubbard, arts and crafts colonies and small industries emerged across the country. "American craftsman" design could be found across a wide spectrum, including architecture, furniture, glasswork, pottery and tile production, printmaking, and decorative and applied arts. Interior design features such as facades, carpets, and wallpaper offered prime opportunities for the craftsman aesthetic, and Sully's patterned panels sometimes seem to speak their own dialect of the language of arts and crafts (see figs. 3.10–3.12).[6]

3.10. Mary Sully, *Jesse Crawford.*
Images such as *Jesse Crawford, Carl Seashore, Mildred Dilling, Nila Cram Cook,* and *Lupe Velez* offer reference points for art nouveau, American craftsman, and art deco styles, visible in Sully's use of color, form, curve, angle, and pattern.

3.11. Mary Sully, *Dr. Carl Seashore*

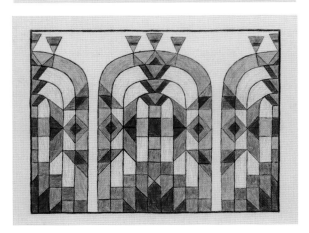

3.12. Mary Sully, *Mildred Dilling*

Perhaps the most significant marker of innovation and transatlantic flow came in 1925 with the Paris *Exposition Internationale des Arts Décoratifs et Industriels Modernes*, which consolidated trends in European design and gave us the term *art deco* (though it was only named and periodized during the 1960s). Globally popular from the 1920s through the early 1940s and readily visible in consumer product design and public architecture, art deco offered an observer like Sully a number of visual possibilities. One stream of deco must have looked familiar: it favored symmetry and the reduction of complex figures to basic geometries. A parallel stream—particularly in the 1930s—developed around ornamentation, visible for example in the great movie palaces of the decade. Yet another sought to capture and fuse the premodern with the technological and industrial, favoring rectilinear forms and modern materials such as stainless steel and Bakelite plastic. There was the familiar aerodynamic streamlining and the curving of square lines that characterized another 1930s form, often designated "streamline moderne." And another, in the repetitive angles and patterns and exotic geometry of "zig zag moderne," drew on Egyptian and Meso-American archeological discoveries, exhibiting yet another form of primitivist orientalism.[7] (See figs. 3.13 and 3.14.)

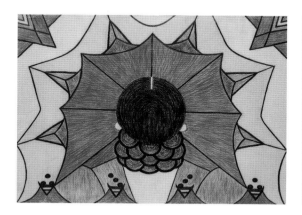

3.13. Mary Sully, *Lupe Velez*

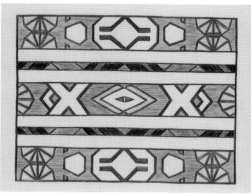

3.14. Mary Sully, *Joe Penner.* In this image, one can visualize art deco's frequent citation of Egyptian hieroglyphics.

Though the United States did not send a formal delegation to Paris in 1925, American visitors returned with samples, imports, and inspirations. One of those delegates was Kneeland "Ruzzie" Green of the Stehli Silks Corporation. Between 1925 and 1927 Green oversaw the creation of the Americana Prints Collection, which fused avant-garde design and American themes in a series of patterns created by celebrity artists, designers, and even cartoonists.[8] Helen Wills, for example, created two design patterns on the theme of tennis.

The Americana Prints Collection—which broke in the years immediately preceding the very first personality prints—had a gleeful edge to it (see, for example, figs. 3.15–3.16). More restrained pattern designs of the 1930s tended to follow a similar grammar, however, which included simplicity, repetition, geometric shapes (variations on circles, squares, and triangles), unbroken lines, grid systems or other organizing structures, pure colors—often primary—and the use of graphic symbols or icons.[9] A comparative look at patterns of the day suggests that many of Sully's middle-panel designs (see, for example, figs. 3.17–3.18) were in accord with the look and feel of the mid- to late 1920s and early 1930s. By 1934 modernist design had become entrenched to the extent that one could find "machine age" exhibitions at the Metropolitan Museum of Art, the Museum of Modern Art, and the Philadelphia Museum.[10] And while there is no way to know whether Sully would have seen the New York shows, we can know for certain that she and her sister attended the 1939 world's fair—itself a modernist design fete.[11]

As early as 1915, Americans began considering the promotion of specifically American schools of pattern design, often around American primitivisms and frequently in the form of open calls and contests that allowed consumers to see themselves as designers. As Lesley Jackson points out, Morris de Camp Crawford, design editor of *Women's Wear*, encouraged designers "to use museum artefacts as a source of inspiration for textile patterns. Native American, South American, and African objects, including pottery, textiles, and baskets, were particularly recommended."[12] And between 1916 and 1922, *Women's Wear* organized five competitions that helped advance both design and production among American companies.

For self-taught or minimally trained would-be designers like Mary Sully, Dow's *Composition* could be enhanced through correspondence courses or

3.15. Charles B. Falls, *Pegs* (Americana Prints, Stehli Silks Corporation, 1927). Metropolitan Museum of Art 27.243.2

3.16. Charles B. Falls, *Ticker Tape* (Americana Prints, Stehli Silks Corporation, 1927). Metropolitan Museum of Art, Gift of the Stehli Silks Corporation. 27.243.2

3.17. Mary Sully, *Hervey Allen*

3.18. Mary Sully, *Lowell Thomas*

other reading. Denman Ross's 1907 *A Theory of Pure Design* laid out for a general audience systematic advice on creating harmony, balance, and rhythm. In 1919 Jay Hambidge offered a complex but influential series of lessons on "dynamic symmetry," full of the possibilities for "the golden section" and "the whirling square." In 1932 Clarence Hornung published the *Handbook of Designs and Devices*, which offered over eighteen hundred sample symbolic

3.19. Mary Sully, *FDR*

designs, many with the same generic feel—one that might easily be captured in the personality prints.[13] Mary Sully could observe a rich world of design, and its influences are readily visible in her work. Moorish tile traditions, for example, were part of the vocabulary of international deco (which influenced artists like M. C. Escher, who would later develop mathematical arts based on grid structures and tessellations) and feature in middle panels such as those in *FDR* (fig. 3.19) and *Fred Astaire* (fig. 3.20).

If she imagined this work in terms of commercial design, Sully's execution took many of her middle panels out of the realm of the marketable and into that of artistic expression. The middle panel for *Good Friday*, for example, is lovely and executed with precision (see chap. 1 sidebar). But its abundance of signifiers, colors, and complexities did not position it well for a design competition—to say nothing of the challenges of placing Jesus's

3.20. Mary Sully, *Fred Astaire*

death and resurrection in a wallpaper pattern book. Such panels suggest that Sully was willing to create patterns occupying a space at the far edges of (or beyond) commercially viable design. *Amelia Earhart* (fig. 1.6), *The Indian Church* (fig. 1.9), and many other prints function in similar ways, gesturing to commercial design but with strong colors and overwhelming patterns likely to test the patience of the interior decorator.[14]

If we were to distill these middle panels down to their essential commonalities, we might give the category a descriptive, analytic name: *the geometric abstract*. Each panel rests on geometric grids and patterns, and each uses that geometry to reach for a form of abstraction based on pattern and repetition. Its imagery focuses on symmetry, aims at modern design aesthetics, and evidences a commitment to taking the icons and signifiers found in the top panel deeply—though often not completely—into the realm of abstraction.

THE TOP: PICTURE AND SYMBOL

The top-panel images range from the inscrutable (*Katharine Cornell*, fig. 3.3) to the obvious (*Henry Ford*, fig. 3.1)—though their obviousness becomes apparent only with knowledge of the personality in question (*Alice Fazende*, fig. 3.4). What they have in common, however, is a desire to communicate some central aspect of a person or idea through a constellation of signifiers. In a heuristic spirit, then, let us also create a category name for these images: call them the *signifying abstract*. Sometimes, those signifiers are explicitly representational—coherent or altered forms of pictorial presentation. Other times, they are symbolic—easily recognized icons that take viewers to widely shared cultural meanings. Most often, however, they are semiotic—constellations of signifiers that evoke and stand in for ideas that take on coherence only through an engaged exercise in decoding. All three of these strategies function in metaphoric, metonymic, and connective ways, trading certain sets of meanings for others. And of course representations, icons, indexes, and symbols—all powerfully familiar strategies for conveying meaning—are subsets of the wider world of signification.

In 1921 Father Edward Flanagan established Boys Town, an orphanage near Omaha, Nebraska, that became the most celebrated such institution of the era. Under his direction, Boys Town grew into a large community, with its own boy-mayor, schools, chapel, post office, gymnasium, and other facilities where boys between the ages of ten and sixteen could receive an education and learn a trade. Flanagan became a nationally known celebrity figure in 1938, when MGM made the first of two popular films about Boys Town. The following year, Spencer Tracy won a Best Actor Oscar for his portrayal of Flanagan, and the priest embarked on a successful fundraising campaign that allowed him to expand the home's capacity to five hundred boys.[15]

The top panel of Mary Sully's *Father Flanagan* (fig. 3.21) divides the paper with two strong horizontal lines, defined by the top pole and bottom boundary of a fence that separates the black-and-gray world of orphaned boys from the verdant green town that figures the orphanage itself. Those strong horizontal lines are crossed by the center axis of Sully's familiar bilateral symmetry, which is figured in the gaps between muddy footprints that form a linear series of pointers, leading through the gate to the vertical line

3.21. Mary Sully, *Father Flanagan*

of the church.[16] The verticals are echoed in the poles of the fence. These strong axes—the (vertical) church and the (horizontal) world—are qualified and softened by curvilinear forms: the arch of the gateway, the swell of the hills, and the gentle bend of the fence itself. The result is an image that lays out boundaries and institutional authority but also a sense of warm welcome. The strategy is pictorial, but it is loaded with symbolic and semiotic content—the church, the boundary of the fence, the color that holds out the promise of Boys Town's healing, the gray of the world, and the black, muddy footprints of abandoned urchins, which magically disappear into the grass upon passing through the gate.

Less obvious, though still clearly representational, is the top panel for *Cornelia Otis Skinner* (fig. 3.22). The daughter of actors, Skinner grew up in the theater and made her Broadway debut in January 1923. She later developed a series of short character sketches that she toured as a one-woman performance between 1926 and 1929. Her sharp wit and insightful humor appealed

3.22. Mary Sully, *Cornelia Otis Skinner*

to a wide audience, and she wrote numerous short pieces for publication in the *New Yorker, Harper's Bazaar, Reader's Digest*, and *Ladies Home Journal.* By the early 1930s, Skinner was focusing on historical women, crafting and performing a series of three monodramas that included *The Wives of Henry VIII* (1931), *The Empress Eugenie* (1932), and *The Loves of Charles II* (1933), as well as a one-woman play, *The Mansion on the Hudson* (1935).[17] She would continue writing and performing for the next four decades.

In the image, Sully compresses thirteen female figures like nested wooden dolls, each representing one of Skinner's characters. We can see two young girls, one in white and another in red; a hard-to-scan figure in tan with an elaborate circular headpiece; two young women, one with black hair and a tiara and the other blonde with a blue ribbon; and five additional figures—the bare shoulders of a woman in a spaghetti-strap dress, a figure in black,

a white-yoked figure (perhaps with a red hair embellishment), a figure with ragged sleeves and broad shoulders, and a matron easily visible in purple dress with symmetrical black handbags. Larger still are three outlined figures in gray, then red, then brown. Behind the entire complex array, tan drapery and cordage suggests stage curtains—or perhaps yet another figure. Delicate arms lock and intertwine, heads and hair blur together, bodies acquire increasing mass, and a tangle of feet and dresses map age and dramatic character into a perspectival distance. It is difficult to match bodies, clothes, and hats together: the image proffers a challenging visual puzzle. The women grow into one another and accumulate, becoming the single mass of personality that makes up Skinner. Both *Cornelia Otis Skinner* and *Father Flanagan* illustrate a strategy of *pictorial* representation and copious detail in order to communicate the personalities of Sully's subjects.

In *Glen Cunningham* (fig. 3.23), one can see Sully's use of symbolic iconography. While a sophomore at the University of Kansas, Cunningham ran a mile in 4 minutes, 11.1 seconds, setting an American record. He ran for the US Olympic team in 1932 and 1936 and held the world record for the

3.23. Mary Sully, *Glenn Cunningham*

mile from 1934 until 1937. Cunningham's personality is made visible through two familiar symbols: winged feet for speed, and a red-and-blue Jayhawk for the University of Kansas. The silver wings function as a classicist gesture to Hermes or Mercury, whose winged sandals (note the sandal-like lacing on Cunningham's feet) let him fly as swiftly as a bird. But Sully doubles the meanings of bird speed: the Jayhawks bear the runner aloft through shoelace strings held firmly in their beaks—and Cunningham has a flock of twelve pulling him along.

Actress Billie Burke—married to Florenz Ziegfeld and destined in 1939 to play the role of Glinda the Good Witch in *The Wizard of* Oz—appears as a series of dangling multicolored balls on stage (fig. 3.24), referencing the film's opening scene in which Glinda floats into Munchkinland in a shimmering, color-shifting ball. Framing her arrival are a rainbow-colored proscenium arch, a brown stage, and the colorful heads of an audience. Sully dances between the abstract and symbolic images established in the film

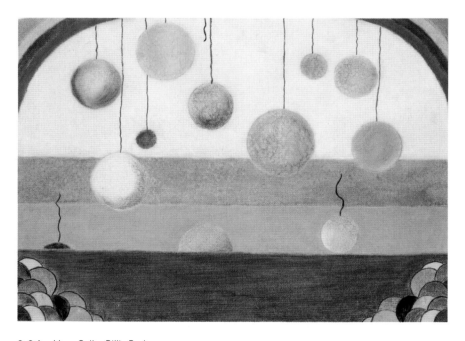

3.24. Mary Sully, *Billie Burke*

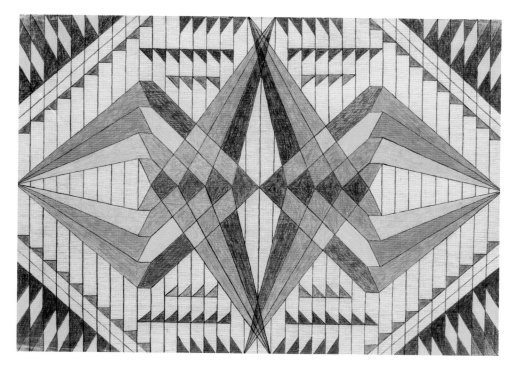

3.25. Mary Sully, *Mildred Dilling*

(the rainbow, the floating balls, the good and bad witches) and the more representational signifiers that seek to capture Burke's theatrical career (stage and audience).

Bobby Jones (see chap. 1 sidebar) and *Mildred Dilling* (fig. 3.25) take viewers more deeply into semiotic abstraction. In the image for Jones, the face of a golf club is made symmetrical, tilted 45 degrees, and marked by vertical lines (perhaps evoking the grooves found on club faces) and a series of concentric circles. One might see the red circle and connecting lines in the center as a ball coming toward the viewer, or as a ball to be struck and to expand away from the club, or as something other than a ball entirely. Perhaps the circles mark the effective ranges of the various clubs, the jigger or wedge occupying the near circle and other clubs—mashies, niblicks, spoons, and drivers—fanning outward across the course. The relative clarity of representation found in *Cornelia Otis Skinner* and *Father Flanagan*, complicated

in *Billie Burke* (that is, as *representations* of the filmic symbolism of floating witches), has here taken a turn to mystifying abstraction. Or consider the image for harpist Mildred Dilling. Harp strings make up the image's background, while Dilling herself is figured as a highly abstracted synecdoche—the color of talent, the motion of the performance, and the triangle-point precision of her plucking fingers stand for the whole person. Reduced to her fingers, Dilling is figured not pictorially but as a crablike waveform image of plucked sound.

Helen Kane, the actress whose "boop-a-doop" baby voice (in the 1928 song "I Wanna Be Loved by You") inspired the 1930 cartoon creation Betty Boop, is represented by a sequence of circles and half circles (fig. 3.26), a tone-sensitive gesture to Boop's strange bubbly voiced mix of baby talk and sensuality. Is the point of view in the image someplace below the rim of a champagne glass, with bubbles emerging and then floating over the rim into empty space? Or—more likely—a bathtub, with a curious point of view positioned just above the spigot, looking out on the bubbly tub found in cartoons such as *A Little Soap and Water* (1935) or the "Baby Betty" sequence in *Is My Palm Read* (1933), both of which have bubble bath sequences. The Boop/Kane image captures the airy sense of the uncanny attached to both Betty Boop and Helen Kane, and it does so with a surrealist sensibility that is at the far edge of Mary Sully's engagement with *signifying abstraction*. (Betty Boop herself was a surrealist vision compressing innocence and sexuality, baby-sized head and voice with womanly setting and content, 1920s flapper with 1930s Depression, and jazzy scat singing with emergent cartoon forms.)

These kinds of top-panel images reflect Sully's engagement with modernist aesthetics—surrealism, abstraction, and quasi-cubist experimentalism around time, space, perspective, and symbol. At the same time, they also reflect Sully's engagement with, as Wanda Corn has phrased it, a distinctive modernist call for a "new American art" well suited for a "modern American identity." For Corn,

> machine age modernists focused on industrialized America. . . . They eagerly rendered Americanness in an abstract, formal language drawn from [such] modern inventions to give their art a distinctive but not necessarily literal American identity. Calling upon symbolist theories

3.26. Mary Sully, *Helen (Kane) and Betty (Boop)*

of correspondences and equivalences, they researched new materials and new forms of line and color and devised new metaphors to embody their understanding of Americanness.[18]

Golf club, bathtub, track shoes, movie special effect, musical instrument, women's theater performance: Sully's top panels—her *signifying abstract*—drew on an archive of technique, strategy, and subject that resonated strongly with the questions being pondered and painted by other American modernists. If the middle panels—the *geometric abstract*—are in dialogue with the world of modern design, the top panels, taken as a discrete category, suggest an equally compelling dialogue with modernist art.

THE BOTTOM: TOWARD AN AMERICAN INDIAN ABSTRACT

Let us turn, then, to the bottom panels, which form their own category, abundant with overdetermined images that want to leap out of any categorical box that might try to contain them. Many of the panels bear clear affinities to American Indian forms found in beadwork, painting, pottery, and weaving. Even these panels, however, are *not* simple templates for such work but elaborations that bear traces of many other visual inputs. Indeed, across the spectrum of the bottom panels are images that demonstrate little explicit interest in Indian imagery, or that gesture to other sources rich with synthetic complexity. Such panels (and there are many) draw from a broader visual and cultural imaginary. Still, even these carry a unique and powerful sense of Indianness.

Figures 3.27, 3.28, and 3.29 strike one as radically different: one panel offers a wavy series of horizontal rows with folded joints articulating angles and turns; a second represents a pair of connected boxes; another explodes with bright color and bold form. And yet in all three of them one can see foundational elements in Mary Sully's visual vocabulary: a Plains Indian women's artistic tradition of geometrical abstraction.[19]

In traditional Great Plains arts, men and women assumed distinct roles. Men created representational drawings: the tipi covers, hide paintings, maps, winter counts, war books, and ledger-book art that recounted historical or spiritual events. Women created geometrical and abstract images, using triangles, diamonds, rows, circles, and patterns to symbolize stories and knowledge and to create recognizable personal styles within relatively fixed forms and media.[20] For many Plains women, skill in porcupine quillwork was, and remains, essential to their place and reputation, and women's quillwork societies paralleled the warrior societies of men. Among the earliest media used by Plains women, porcupine quills were dyed, flattened, moistened, and then stitched onto tanned skins or rawhide with sinew thread, the quill folded over the stitch to hide and protect it. Quills could also be embroidered, appliqued, wrapped, and woven, and they could be applied to birch bark as well as to leathers.[21]

Mary Sully grew up knowing the importance of quillwork; she also observed her sister collecting stories and descriptions of it. Ella Deloria

3.27. Mary Sully, *Schumann-Heink*

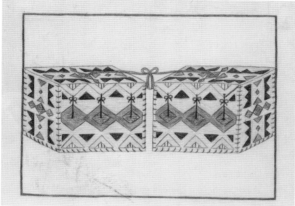

3.28. Mary Sully, *Lunt and Fontanne*

3.29. Mary Sully, *Cornelia Otis Skinner*

described quillwork as "the original art," "*the art*" for Indian women, who systematically cleaned, sorted by size, and then dyed the animal's quills before beginning. "The most common type was *flatwork*," she recorded, "with the quills lying straight. Harder was the *twisted quill*. Still harder was the technique of 'braiding' the quills, as seen on pipe stems. A very gifted worker used to start with eight or ten or more quills and plait them, in such a manner that the finished effect was like fine basketry."[22] The technical challenges of matching and aligning quills produced design patterns based on horizontal rows, concentric circles, or small triangles or diamonds. They decorated shirts (fig. 3.30), dresses, headdresses, and frequently moccasins. Quillwork pendants woven around narrow strips of rawhide, called *óskapi*, could be found on lodges, shirts, pipes, and pouches. Given quillwork's high status within Dakota aesthetics, it is hardly surprising that Mary Sully should invoke its forms in many of her third panels: *Schumann-Heink* (fig. 3.27) provides one example, but there are several others, almost all of which feature bent horizontal line-and-fold patterns.

3.30. Sicangu Lakota, *Spotted Tail Shirt* (1845–55). Hide, porcupine quills, glass bead/beads, human hair, horsehair, dye/dyes, and sinew, 156 × 91 cm. National Museum of the American Indian. 17/6694

A second visual tradition was that of hide painting, commonly used as decorations for parfleches (fig. 3.31). For nineteenth-century Plains Indian people, the parfleche served as storage box, suitcase, and food container. Indeed, the word *parfleche* is simply a French generic for a range of carrying cases that included large and small boxes, envelopes, pouches, wallets, and cylindrical cases, named in the Dakota language *wiziȟaŋ*.[23] Made from rawhide, usually bison, and scraped smooth of hair, the parfleche bore painted geometrical decorations, applied while the stretched untanned hide dried in the sun.[24] These Plains adaptations of the birch-bark containers of the Great Lakes spread across the region between the late seventeenth and early

3.31. Sicangu Lakota, *Pair of Parfleches* (1880–85). Rawhide, pigment, and Native-tanned skin ties, (1) 22½ × 13⅜ (2) 22¼ × 12⅜. Ralph T. Coe Collection, Gift of Ralph T. Coe Foundation for the Arts, 2011. The Metropolitan Museum of Art, 2011.154.152.1.2

twentieth centuries. By the late nineteenth century, parfleche makers used a bold color palette focused on red, yellow, blue, and green, with empty-space whites and tans making up a significant color element. Designs reflected coherent cultural conventions—triangle and diamond shapes, hourglass structures, and bilateral symmetry—but the variations also coded distinct identifying marks, for a single dugout food cache could contain parfleche from a number of families, each filled with sheets of dried meat.

Ella Deloria observed that these painted designs were distinct from quillwork, serving as "the ancient decoration for ordinary items."[25] Among Dakota women, the diamond patterns found so often in parfleche painting carried a range of gendered meanings associated with the turtle, reflecting

that animal's connections to women and childbirth. "Sioux parfleches," according to Gaylord Torrence, "are distinguished by their bold designs, strong saturate color, and heavy black outlining. The painted surfaces are rich and opaque. Brilliant reds, blues, and yellows in their primary forms are the predominant colors, usually combined in relatively equal amounts throughout the painting. Smaller areas of green are almost always included and rarely do other colors appear."[26] Describing a Cheyenne parfleche, Torrence observes two other aesthetic elements, both worth remembering when viewing Sully's work: the motifs and patterns "established shifting focal points and rhythmic directional movements throughout the design. . . . the composition is precisely balanced, with nearly equal amounts of painted and unpainted surfaces, creating a subtle figure-ground reversal and quiet sense of visual tension."[27] The patterns, in other words, were geometrical abstractions that carried symbolic content, an American Indian tradition of abstract art available and familiar to Mary Sully.

We can take the particular relation between abstraction and symbol found in both parfleche and quillwork traditions as a key to understanding Sully's work. In her hands, the relation between symbol, representation, and abstraction became cross-culturally dialogic, resulting in a series of artistic puzzles that lured—and sometimes demanded—a complex engagement with Indian visuality on the part of the viewer at both conscious and unconscious levels.[28] And thus Alfred Lunt and Lynn Fontanne—the husband and wife acting team prominent in the theater of the late 1920s and the early 1930s—appear as two parfleche boxes, mirroring and semi-facing one another, tied together by a marital bow (fig. 3.28).[29] Cornelia Otis Skinner is represented through the colors and geometries of the parfleche tradition—reds, yellows, and blues in diamond and triangle patterns, with green accents (fig. 3.29).

With the advent of glass trade beads, which arrived in North America with Columbus, design patterns emerging from painting and quilling took on new possibilities, marked by increasing intricacies and variations (figs. 3.32–3.33). Ella Deloria commented on this third form as well: "The remarkable thing about [beads] is the rapidity with which they were taken and used to develop a new art form. The Teton (Western Sioux) style of beadwork on skin is geometric in design. The Santee (Eastern Sioux) style is floral, and the Yankton is both. . . . Originally, the designs with beads were close to

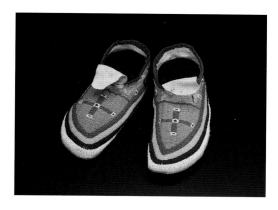

3.32. Lakota, *Man's Moccasins* (ca. 1880). Hide, glass beads, rawhide, paint, cotton cloth, sinew, and thread, 27.00 × 11.00 × 11.00 cm. National Museum of the American Indian. Catalog 8888

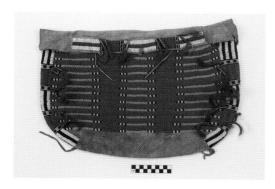

3.33. Lakota, *Possible Bag* (ca. 1885). Hide, glass beads, horsehair, metal cones, and sinew, 34 × 54 × 2 cm. National Museum of the American Indian. Catalog 2/9762

the bold and big designs of porcupine quill work. Gradually, smaller and more intricate designs began to appear. Today, we find all sorts of designs worked out in beads."[30] "Like quills," suggest Janet Berlo and Ruth Phillips, "beads could be used to form both small, discrete color areas and large monochromatic ones. Easily sewn to both hide and cloth, they could be used to outline a form or to ornament a fringe."[31] Many of the key elements from quill and parfleche, however, remained central to beadwork design: triangles, hourglasses, boxes and borders, circular medallions, and repeated rows. Among these were also, as Christian Feest suggests, a continent-wide "tradition of cut-outs and the resulting interplay between positive and negative shapes."[32] The three media confirmed a shared ethos, a dance of aesthetic meaning that crosses geometry, symbolism, representation, and abstraction.

Such influences are everywhere in Sully's bottom panels. *Loretta Young* (fig. 3.34) suggests the circular form of the quilled or beaded medallion, and *George Bernard Shaw* (fig. 3.35) the triangles and hourglasses of much beadwork. *Bobby Jones* and *George Ade* (chap. 1 sidebar) convert shoes into row-quilled moccasins. *Henry Joy* (fig. 3.36) exemplifies the cutout tradition of optical illusion and multiple perspective. Among the most telling evidence for Sully's sense of her own connection to a Dakota aesthetic tradition is the label for the *Alice* image (fig. 3.37; the personality "Alice" is almost certainly Lewis Carroll's Alice, of Wonderland fame). Beneath the name, and explaining the representational strategy of the bottom panel, is a surprisingly long caption:

3.34. Mary Sully, *Loretta Young*

3.35. Mary Sully, *George Bernard Shaw*

3.36. Mary Sully, *Henry Joy*

3.37. Mary Sully, *Alice*

"When little girls dressed up, they wore their own 'life charm' hidden within the beaded turtles hung from the belt in back." Here, Sully speaks to the persona of Alice through Dakota cultural practice and decorative artistry. And here too, her sister's ethnographic work deepened Sully's knowledge:

> The turtle as one symbol of longevity was used to contain within its filling the dried bit of navel cord as it fell from the baby. *Wotawe* means charm, in a very broad sense, to cover whatever was held sacred

and revered for its "inherent power." The beadwork over the back was of fancy designs in keeping (though not always a faithful replica) with the design on the reptile's back. This object was fastened as an ornamental touch, to the center back of a little girl's gala costume. Boys did not carry their own turtles around, but their sister wore it for them so that on some girls' belts two or more might be fastened.[33]

In the years of reservation confinement and cultural reimagining, Native women and men transformed artistic work, shifting media, engaging tourist and collector markets, and changing forms and styles. Beadwork exploded into new forms, with objects that featured solid fields of beads—dresses, for example, with beautiful yokes of color. Likewise, women expanded into male domains, crafting representational and even pictorial bead designs. At Standing Rock, where Sully was raised and where she continued to visit, Edith Claymore and Nellie Two Bear Gates made suitcases, purses, vests, and other clothing with pictorial imagery (fig. 3.38). These moves toward the pictorial found their way into some of Sully's bottom panels, exemplified by her image for *Eugene Field* of a child in a cradleboard (fig. 3.39).[34]

3.38. Nellie Two Bear Gates (Yanktonai Lakȟóta, Standing Rock Reservation, born 1854), *Suitcase* (1880–1910). Beads, hide, metal, oilcloth, and thread, 12½ × 17¹¹⁄₁₆ × 10¼ inches (31.75 × 44.93 × 26.04 cm) (closed). Minneapolis Institute of Art, The Robert J. Ulrich Works of Art Purchase Fund 2010.19. Photo: Minneapolis Institute of Art

Sully found other forms of geometrical abstraction close at hand. In the late nineteenth century, with the near extinction of the bison, the decline in other game, and restrictions on off-reservation hunting, traditions that required hide, sinew, quills, and fur gave way to new possibilities. Women's quilling societies on the northern Great Plains sometimes reinvented themselves as quilting groups, and quilts and blankets replaced robes. Taking full advantage of scrap cloth, quilting proved an easily adopted practice for people at the bottom of the economic scale, and agents and missionaries were happy to teach women the basics of a "civilized" domestic art. Sioux women quilted in many

3.39. Mary Sully, *Eugene Field*

different kinds of patterns, though over time a central decorative tradition emerged—the "star quilt," itself amenable to a range of forms and strategies (fig. 3.40). Critical to these quilting traditions was the diamond-shaped piece, a technical mainstay of American quilting in general but also a familiar part of the abstract geometries of painting, quill, and bead practices. Growing up at Standing Rock in the early twentieth century, Mary Sully would have participated in quilting circles and family quilting. She received training in sewing as part of the domestic instruction of the mission school, and she would, at various times, engage in costume design and other fabric arts work.[35]

The quilled horizontal row, the horizontal and vertical matrices of parfleche painting, and the diamonds and triangles of beadwork all gave Mary Sully a sense of the possibilities for bilateral symmetry and geometrical abstractions that relied on a grid. As we have seen, many of the "abandoned" efforts found on the back sides of her paper demonstrate grid templates laid out with meticulous precision. Likewise, the forms of the quilled

3.40. Yankton Nakota, *Star Quilt* (1930–35). Cotton cloth and thread, 206.5 × 255 cm. National Museum of the American Indian. Catalog 26/7173

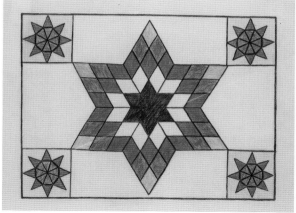

3.41. Mary Sully, *William Lyon Phelps* **3.42.** Mary Sully, *Lupe Velez*

medallion and the star quilt helped her conceive of rotational symmetrical geometries, which took the center of the paper as their starting point (figs. 3.41 and 3.42). Rooted in the tradition and culture of Plains Indian women's artistic practice and social perception, these two forms of symmetry—rotational and bilateral—structure many personality print panels. At the same time, these critical stylistic moves place Sully in the midst of a long tradition, drawn from and through a particularly female consciousness, of Indigenous aesthetic innovation.

COSMOPOLITAN VISUAL VOCABULARIES

A powerful array of Native visual vocabularies structured much of Sully's aesthetic, both in conceptual terms and in the visual techniques she carried in her toolkit. She pulled out pencils in order to quill, bead, paint, and sew. But these are by no means the only ways one might think about the cosmopolitan visual vocabularies seen across the top, middle, and bottom panels that make up the form. Consider, for example, her most explicitly representational "Indian" drawings—roughly ten of the bottom panels. Here, Sully turned not only to emergent Plains women's practices of beadwork pictorialism but also to the *ethnographic illustration*, a distinct aspect of the academic work her sister was undertaking. In three crystalline examples, we can

3.43. Mary Sully, *Jane Withers*

see how this ethnographic impulse helped push Sully away from traditional forms of geometric abstraction and into pictorial representation. One of these images, *Alice* (fig. 3.37), we have already considered. In a second, *Jane Withers* (fig. 3.43), the caption offers a charming and romantic explanation of hair ties: "Little girls wore heavy hair-ties, to encourage long braids. The perfumed balls were filled with sweet grass and . . . so some think! . . . buried in the center are irresistible love charms!" And in *Billie Burke* (fig. 3.44) she appropriates the "culture areas" language of anthropology: "Flowery designs are typical of Eastern Dakota art, which the Santee Sioux borrowed from the 'Woodland Culture Area' of the Algonkins."

In all three of these cases, the labels aim for an explanatory mode akin to a museum wall label rather than the simple names she used in almost all other instances. Of course, these "Indian" images also speak directly and powerfully to the personalities in question. Jane Withers, who starred oppo-

site Shirley Temple in her first film, *Bright Eyes*, and then as a child star in her own right for much of the 1930s, was often cast with braids or large hair bows. In *The Wizard of Oz*, Billie Burke arrives as Glinda in a Munchkinland that is overloaded with flowers.

Given her sister's ethnographic work, it is easy to imagine Mary Sully in a museum. But now think of her in a church, at service in the chapel at the All Saints School. Looking up, she sees the only Tiffany windows in South Dakota, which offer her another set of lessons concerning rotational and bilateral symmetries; the triangulated relationship between symbolism, representation, and abstraction; and the philosophy of color.[36] Vestments, organs, pulpits, altars, vaults and arches: all offered opportunities to internalize new geometries and visual and sonic textures.

Her image *The Architect* (fig. 3.45), for example, celebrates the dizzying geometries and elevations of churches and cathedrals. The circular form that structures the image forces the viewer to "look up" in both the interior of

3.44. Mary Sully, *Billie Burke*

the ring *and* its exterior, daring the eye to move from vanishing-point perspective (in the interior) to distinctly different perspectives visible in the repeated symmetries that occupy the four quarters of the paper outside the circle. As the eye oscillates between the two dimensions, one cannot help but feel a bit of the dizziness that comes with looking up in a high-rise city or in the interior of a lofty cathedral. It is an image that tries to force perception into the experiential physical realm of balance.

Dakota aesthetic culture, ethnography, and the Episcopal Church provide coherent touchpoints for Sully's work, tracing important visual experiences that shaped her as a maker of art. At times in her life, Sully was also an example of that curious but not atypical figure, the urban "recluse," and it is worth tracing influences from the possibilities available in a place like New York City, where she lived with her sister on and off throughout the 1930s.

Popular culture offered Mary Sully a wellspring of possibility. Comic pages and comic books offered lessons in color, framing, and the representation of the human figure. Her image for *Good Friday* (chap. 1 sidebar), for example, adopts the box form and high-color characters of a strip. The prevalence of figures from stage and screen suggests that she tracked and attended theatrical productions and movies. She was, for example, likely to have seen

the complex choreographies that characterized the Busby Berkeley musicals of the early 1930s (Berkeley choreographed fourteen films between 1930 and 1934, in addition to stage choreography in the late 1920s, including work with Florenz Ziegfeld). One feature of those films was the overhead camera shot revealing groups of dancers shaping kaleidoscopic geometries through the arrangement of their bodies (see figs. 3.45 and 3.47). Neither Berkeley nor Sully would have been the first to take inspiration from the colorful symmetrical views offered by the kaleidoscope, a popular toy that offers a simple but beautiful view of light, color, and rotational symmetry.

3.45. Busby Berkeley dancers, 1931. Author's collection. Berkeley's interest in rotational symmetry—human bodies arranged in circular geometries, aligned here by facial type and hair color—finds an uncanny correspondence in Sully's *Ziegfeld* (fig. 3.47).

3.46. Mary Sully, *The Architect*

3.47. Mary Sully, *Ziegfeld*

Time Magazine began publishing in 1923, and it featured on its weekly cover a portrait of a significant person; the magazine offered Mary Sully a weekly prompt for a project of portraiture focused on celebrity personalities. Indeed, twenty-nine of her personalities appeared on *Time*'s cover between 1923 and 1942, some of them multiple times. Even if they did not make the magazine's cover, a large majority of her subjects appeared within the pages of the magazine. And if they did not appear in *Time*, then they appeared in one of the many other magazines and newspapers that modeled design and celebrity for the popular reader. Some images almost certainly have their origin in specific news stories. Alice Fazende, for example, remained anonymous but for a 1936 human-interest story on the occasion of her one-hundredth birthday and a quick revisitation on the occasion of her death in 1939.[37] *Leap Year* (fig. 6.16) was likely inspired by media coverage in 1932, 1936, or 1940, the three leap years that took place during the mature project.

Popular media allowed observers like Sully access to the world of fine art as well. Cubist manipulations of time and space, and its reorientation of classical perspective toward optical play—these things (visible in Sully's work) appeared with some frequency to the attentive general reader. Georges Seurat's famous pointillist work *A Sunday on La Grande Jatte 1884*, after being almost unseen for three decades, reemerged in 1924 at the Art Institute of Chicago—just in time for Mary Sully to be able to view it during her short stay in the city in the fall of 1926. Whether she did is unknowable, but the pointillist technique and style was visible to her through popular reportage. Perhaps she filed a mental note, to be recaptured as a way of representing the huge populations of the city in the bottom panel of *Easter* (fig. 4.15), which mixes an arts and crafts woodwork design with a pointillist crowd.

CELEBRITY STORIES

TITLED HUSBANDS IN THE USA

In the early twentieth century, Europe overflowed with aristocrats with ostensibly royal backgrounds—a host of dukes, counts, barons, and princes with internationally recognized social status. Combined with a handsome face and a suave manner, they proved attractive potential

husbands for American women of celebrity-caliber beauty or wealth (or both). The papers and magazines reported on their transatlantic comings and goings and the money flow from generation to generation, from heiresses to princes and princes to actresses and heiresses. Weddings were over the top or secretive, divorces spectacular, hearts frequently broken.

Mary Sully's interest in such unions took direct shape in her image *Princess Mdivani*, found on the late 1930s list of personality prints and a perfect subject of tabloid gossip. The image refers to the Woolworth heiress Barbara Hutton, who married the Georgian prince Alexis Mdivani in 1933. Following two years of marriage and a whirlwind Nevada divorce in 1935, she turned to an immediate union with the Danish count Kurt von Haugwitz-Hardenberg-Reventlow. Hutton would eventually have five "titled husbands," also marrying Prince Igor Troubetzkoy (1947), Baron Gottfried von Cramm (1955), and Prince Pierre Raymond Doan (1964).

On the other side of the equation, Sully may have followed the news buzz surrounding French aristocrat Henri de la Falaise, Marquis de la Coudraye. In 1925, after serving as her interpreter during a film shoot in France, he married American actress Gloria Swanson, then at the height of her silent film career. Falaise was Swanson's third (of six) husbands. With this marriage, however, she returned to the United States as a *marquise*. In November 1931, only days after his divorce from Swanson was finalized, Falaise married another actress, Constance Bennett, making her the new marquise and confirming his own role as a titled husband.

The interchangeability of such unions—and the money, flowing like the milk being sucked from a bottle by the men in *Titled Husbands in the USA*—proved an object of fascination for American audiences. Swanson, for example, starred in a number of Cecil B. DeMille's "marriage films": *Don't Change Your Husband* (1919), *Why Change Your Wife* (1920), and *The Affairs of Anatole* (1921) all featured Swanson moving through interchangeable affairs, divorces, and reunitings. As early as 1908, the *New York Times* reported on several instances in which American women had married minor European royals and made lives with them. By the 1920s and 1930s, however, even this story had changed. With no real ties to the lands that accompanied their titles, these husbands and their often wealthy American wives were jet-setters, free to travel around Europe

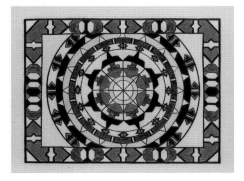

Mary Sully, *Titled Husbands in the USA*

Mary Sully, *Dr. Dafoe*

and America. Transatlantic travel and news reporting allowed audiences to focus on the finances and lifestyle purchases of such couples, and Sully's image offers a didactic lesson in romantic expectation, brokenheartedness, and the flow of money from the land of milk and honey to slick European men.[38]

DR. DAFOE

In May 1934 small-town doctor Allan Roy Dafoe presided over the successful birth and the immediate care of the Dionne quintuplets, the first in which babies and mother all survived. Catapulted overnight from obscurity to international fame, Dafoe reoriented his career to center on the quints. Dafoe established a nursery/hospital where visitors could watch from behind meshed screens as the children grew up under the care of nurses and tutors. Though the Dafoe Nursery itself did not charge admission, the surrounding tourist infrastructure generated millions of dollars and brought visitors from all over Canada and world, creating a sideshow atmosphere. Across the street, the quints' parents had set up their own massive souvenir stand. Almost immediately after the birth, they had entered negotiations to bring the children to the Chicago Century of Progress exposition; the Ontario government removed their parental authority and handed it to Dafoe.

Dafoe wrote advice books for mothers and managed movie productions. In 1936 the quints starred (if one can call two-year-olds being filmed "starring") in *The Country Doctor*, a lightly fictionalized account of the birth that centered on a Dafoe-like character, Dr. John Luke, and in *Reunion*, which placed the quints and the Luke character into a broader plotline. Two years later, a third Hollywood film, *Five of a Kind*, offered a sequel, again starring the quintuplets and the doctor character. The Dafoe Hospital and Nursery was a distinctive building with a nearby "playhouse," where tourists lined up to watch.

Mary Sully's image for the doctor illustrates the silhouetted form of the buildings, with their peculiar rooflines, while offering a repeated series of fives—moon, cloud, halo, house, tree, umbrella, plant, flower, cat. These "quints" alternate between evocations of growth (trees and flowers, for example) and of nurture, protection, and shelter (umbrellas and buildings).

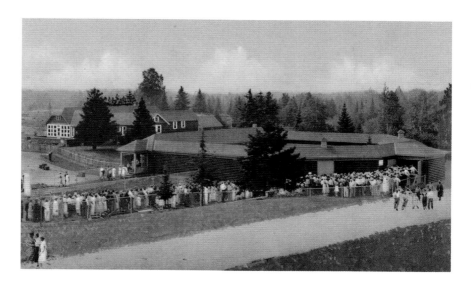

Dafoe Hospital and Play House of Dionne Quintuplets, Callander, Ontario, Canada. Postcard, ca. 1934. Author's collection

In the second panel, Sully does not simplify or distill any of these icons but rather incorporates them all, largely unchanged, in a series of circular patterns, beautifully woven around five-way rotational symmetry. The bottom panel mixes icons: cats and sunflowers are joined, as are umbrellas and plants. The moon-cloud-sky images are transformed into a quasi-southwestern Indian motif, with the white clouds taking on the stair-step quality sometimes associated with mountains or clouds, while the Dafoe Nursery and play area is reshaped into a band of vaguely architectural badges. The entire bottom panel has the feel and flair of a rug or weaving design—generically Indian in its execution, a bit deco in its feel—but solidly linked to the persona of Dafoe, "the world's most famous doctor."

STRUCTURE OF THE FORM

The categories "top," "middle," and "bottom" help clarify and complicate a useful (if crude) affinity grouping: top panels, the *signifying abstract*, live in dialogue with modernist art and popular culture; middle panels, the *geometric abstract*, reflect elements of modern design; and bottom panels,

an *American Indian abstract*, offer a complex, culturally overdetermined engagement among a wide world of visual possibilities. Each category exceeds these descriptions, and they flow into and between one another.

"Into" and "between," in this case, are metaphors with distinct meanings for the relations among the three panels. "Between": envision an Escher-esque image in which three buckets simultaneously pour water into one another. Though an optical illusion, the picture suggests unity and simultaneity. "Into": now imagine a Rube Goldberg machine's sequence in which one bucket empties into another, which then tips and pours into a third. The story here is quite different, focused on sequence and development. Both are valid structures for thinking about parts and wholes.

Viewing from a slight distance and seeing the three panels holistically, one is struck by the continuities of the colors, icons, and geometries that bridge across each individual drawing. These continuities function simultaneously and synergistically to create each triptych as a single coherent object. Blur your eyes and the three images come into a kind of unified focus. They signal to one another across the panels through structural similarities that make the experience of difference between them a subtle one at best. In *Thomas Edison* (fig. 3.48), for example, Mary Sully creates a complex central figure: a flower/rotor/star figure that shifts its nature only slightly from panel to panel. The figure evinces stasis in the top panel, motion in the middle, and centrality at the bottom, all the while maintaining unifying color continuities and balances, particularly among red, yellow, and green.

The middle panel's tighter structure militates against using the full four-color palette offered by the top panel; red emerges as the dominant color in the middle panel, green remains strong (and connected, since it appears in the lower portion of the top panel), and yellow is paired with the black background, causing it to leap out of the image, thus maintaining a kind of balance. In the bottom panel, the feel of the color has shifted slightly, but its overall sensibility and balance remain consistent across all three panels. Forms help hold the images together, with the grid and the diagonals serving as important elements of continuity even as their colors shift. The semiotic possibilities also work toward coherence. The central figures—a flower, a rotor, a star—maps meaningfully to components—filament, cog, light—that reflect Edison's most famous inventions, the lightbulb and the

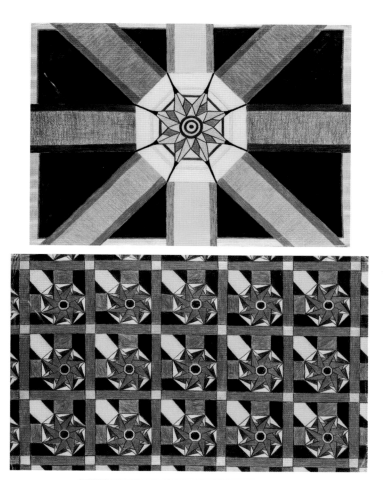

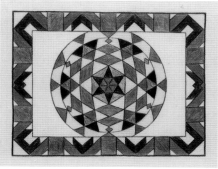

3.48. Mary Sully, *Thomas Edison*

motion-picture projector. It is easy to see in the three panels a harmonious whole, like a jazz improvisation over a series of structuring chord changes. And when displayed on a wall, many of the personality prints demonstrate these same sorts of visible unities. The three panels appear as a collection, energized in singular and static relation to one another. Their shared *space* is privileged over a reading that would unfold sequentially over *time*.[39]

But is it not just as compelling to see the relationships not through holistic simultaneity but through the *transformations* that appear across the three panels? Why shift the viewer between a flower, a rotor, and a star? Why eight points or six? Why change the background from black to negative-space white? These transformations point us, briefly, back to a consideration of Mary Sully's engagement with Dakota epistemology, for such transformational shape-shifting is a critical standpoint in many Native cultures. In the story of White Buffalo Calf Woman, for example, which details the coming of the sacred pipe to the Sioux people, the sacred woman who brings the pipe transforms numerous times, from a bison to a woman to a cloud. In visions, humans and animals shape-shift back and forth. The Deer Woman—a dangerous figure of seduction—appears first as a beautiful woman but then transforms into a deer. The idea that the essential quality of a thing can take on multiple forms is key to understanding Dakota worldviews.[40]

It is important, then, to see these images both in terms of *simultaneity*—an epistemology of space that some would call "Native" or "Indigenous"—and *transformation*—an epistemology of time, equally "Native." Still, transformation, with its sequential sensibility, raises a new interpretive question: can we translate "top," "middle," and "bottom" (spatial terms I've been careful to use thus far, which indicate only relative position) to the temporal language of "first," "second," and "third?"[41] To ask the question is to introduce a notion of *developmentalism*—the idea that the panel we name as "first" introduces content that will be developed in subsequent panels, that there is an unfolding relation among the three images.

I have frequently implied that "top" equals "first," but it is worth problematizing that assumption. What if the three panels are an unfolding not of chronological development, for example, but of developments of *scale*? That might lead us to think that perhaps "bottom" equals "first." Imagine the bottom panel of *Thomas Edison* as a scientific specimen, visible to the

naked eye. Place it under a microscope and suddenly (in the middle panel) structures emerge—lattices, crystals, and cells. Magnify it further and those biological or crystalline structures now become visible (in the top panel) as chemical or perhaps atomic structures. Substitute a telescope for a microscope and the image unfolds differently. The bottom panel looks something like the expanding universe of the Big Bang, the middle panel like a collection of galaxies, and the top like the zeroing in on a single star.[42]

I offer these "scale" readings as a caution, for the images can be read in many ways, and even as I assert a particular kind of reading, I don't intend to rule out others. It's art, after all. But I believe that the question of transformation is worth further contemplation. What kind of developmental story might we read out of a sequence? A narrative with beginning, middle, and end? An individual biography traced from childhood to maturity? Human histories of social development from primitive to modern? Developments of artistic philosophy, arguments or sums, or simply the form itself? What does "first" look like and what does it imply?

Consider the personality print for Harry Emerson Fosdick (fig. 3.49), the most prominent ministerial spokesman for modernism in the religious debates of the 1920s, a prolific writer and the host of the *National Vespers* radio show. The bottom panel's relatively simple Indian-esque design might be thought of as the "first" image. Its themes, one might argue, are taken up in a kind of evolutionary middle panel, in which one can see illustrated the reworkings of cultural themes and icons. Hexagons expand to octagons, red diamond patterns become more complicated, background colors are gathered up and reworked into complex forms. Simplicity is multiplied and elaborated; a sense of busyness and urbanity suggests that lower-energy forms (bottom panel) are moving to higher and more complex social and aesthetic orders. The top panel then places the viewer in the thick of modernist aesthetics, with bold color, abstract forms, the altered realities of radio speaker and bookshelf, and colored geometrical forms that are open signifiers—representing perhaps radio sound, perhaps a listening audience.

Locating the "Indian" bottom panels "first" generates a powerful constellation of meaning: the familiar developmental narrative of social evolution that moves from Indian primitive to modern white America. This narrative,

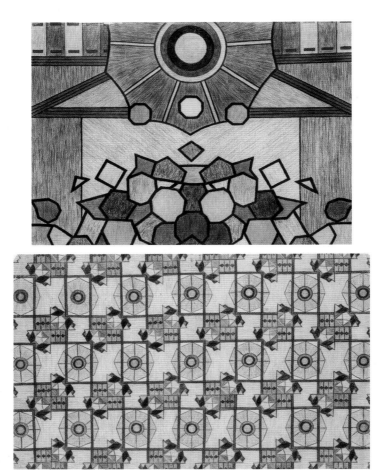
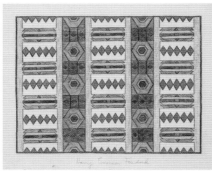

3.49. Mary Sully, *Harry Emerson Fosdick*

which I explore more deeply in what follows, underpinned every racial assumption about Indian inferiority—or, for some, the exotic *superiority* of authentic Indian communal, spiritual, and cultural life. It descended from nineteenth-century origins, took shape in the evolutionary debates of the 1920s, was reformulated by eugenicists, and was reflected in the primitivist fascinations of both modernist artists and the patrons supporting the emergent schools of American Indian painting in the Southwest.

Mary Sully—at least in my reading of these images—was an *antiprimitivist modernist*. She resisted this narrative in the very form of the personality prints, a resistance that is visible in a developmental reading that begins with the top panel.

From a perceptual perspective, it seems to me that the most plausible sequence runs from top to bottom—or rather, from the text label attached at the bottom, which asks the reader to see the image through their knowledge of the personality, to the top panel, and then down. Top panels, as we have seen, almost always have large shapes and strong lines, more easily grasped by the eye than the smaller designs of the other two panels. Often, those lines are reinforced by substantial blocks of color. Mounted on a wall, they would have been at eye level for an adult, or perhaps slightly above. In *Harry Emerson Fosdick*, for example, the entirety of the image directs the eye to two paired focal points: the yellow octagon and the white circle at the center and center-top of the first panel. Looking from the bottom plane of the first panel, the complex structures of the bottom and middle panels culminate in a rabble of colored geometry that points—both in its accumulated weight and through the purple diamond that rises above—to the yellow octagon. From above, the centrifugal white lines and scalloped edges of the speaker cone lead the eye to the white circle at its center. If you let your eye wander to the striking brown triangles on the sides of the speaker, the image takes on a vaguely anthropomorphic character, with the white circle a face, the brown triangles shaping shoulders and arms, and the green octagons standing in for hands. This image—and it is representative in this way—demands perceptually and experientially that your eye begin with the top panel, with its clear forms, bright colors, and visual funnels.

There are equally compelling visual arguments that suggest that the middle panel should in fact be read second, and as a development of the

first. The triangle of multicolored geometrical blocks is distilled and refashioned as a design element—still a triangle, but with only one uneven edge. The books—sublimated in the corners of the top panel—are extracted and extended, now with the addition of a diamond pattern. The speaker cone has been reduced from ten subdivisions to eight. Within the geometry of the middle, or second, panel, Sully has emphasized a few key signifiers from the top panel while taking them into their own forms of abstraction: the books that testify to Fosdick's expertise, the radio that channeled his wisdom, and the jumble of blocky color that functions simultaneously as the words spilling from the radio and as the audience that sits rapt in front of its speaker cone. Here, that color has been refigured as interconnected hourglass triangles, proximate to Fosdick's books and binding together a grid pattern. From the pictorial we are being led through abstraction and distillation to a new nexus of meaning; one might think of the transition as a move from picture-writing to a kind of hieroglyph.

In the bottom, or third, panel, the distillation continues: the radio speaker changes from octagon to hexagon, forming an alternating pattern with three of the brown/diamond "books." Crossing two vertical bands of radio/book design are rows of red diamonds, alternating with rows of color, now simplified even more. The look is Indian but not completely so, as it is structured not only by an adaptable Indigenous aesthetic but more pointedly by the icons, signifiers, and essential imagery attached to Harry Emerson Fosdick, radio preacher and modernist theologian. One might read the bottom panel as revealing the connection between Fosdick (the "radio/book" bands, which suggest his nature as a popular intellectual) and his audience (the band of colored rows and red diamonds). In that sense, the image takes as its subject the act of communication: the red diamonds in the bottom panel mix together both the top panel's color (reflecting, as I've suggested, both the words of Fosdick's sermons and his listening audience) and the middle panel's hourglass triangles and books. If one analogizes the second panel as something like a glyph, this third panel is akin to an alphabetic letter, a development that traces the efficient and evocative communication of meaning across time and representational shorthand.

Or consider another developmental reading. In the top/first panel of *Sir Malcolm Campbell* (fig. 3.50), a blue bird with green eyes, yellow beak, and

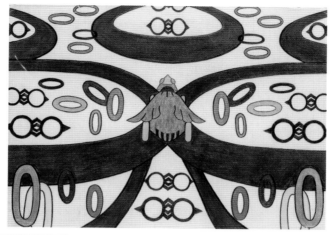

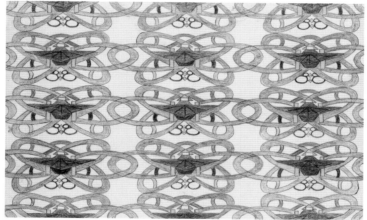

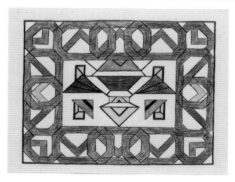

3.50. Mary Sully, *Sir Malcolm Campbell*

what looks to be four wheels sits at the intersection of two brown ovals, the largest of five ovals, all only partially represented. Ten pairs of oddly connected circles, each with a spikelike protrusion on its outer edge, sit within the brown ovals, as do twenty-six colored ovals that float, dreamlike, across the image. Indeed, the picture has all the qualities of a surrealist dreamscape.

Sully's audience, however, would have known Malcolm Campbell as the driver of cars and boats—all named "The Bluebird"—designed to set land and water speed records. With this knowledge, the top panel becomes less a dream and more a signifying work of abstraction. The brown ovals become speed tracks, the connected circles become head-on views of Campbell's driving goggles, and the bird's tail, one now realizes, has the character of an automobile. Indeed, the two vertical tracks at the bottom of the panel suggest that the bluebird has just entered the picture, screeching to a stop at its center. As with *Harry Emerson Fosdick* and so many other personality prints, color is used to capture intangibles such as speed, emotion, sound, talent. Here, the twenty-six colored ovals give us the key to Campbell's personality, defined by his dreams of speed.

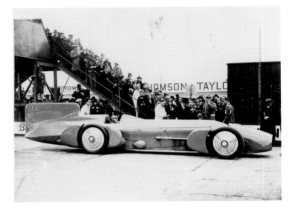

3.51. *Sir Malcolm Campbell at the Wheel of the Bluebird* (ca. 1931). Museum of Applied Arts and Sciences, Sydney, Australia

Those dreams are elaborated in the second panel, in which the speed tracks are transformed—looped, interlocked, and accelerated into a kind of "Celtic electron" pattern emphasizing rapid movement around an oval. The bluebird centers the loops, its wings spread and yellow tires firmly grounded. The colored ovals are segmented and, like the driving goggles, connect the speeding brown oval forms. In the final panel, the now heavily stylized bluebird aims directly at the viewer, wheels at the ready, beak thrust forward, aiming to reverse direction and zoom directly out of the picture. The brown speed tracks have been transformed into a kind of arts and crafts border, with the colored ovals—now squared off—forming a backdrop. The border summarizes the meanings conveyed by the image, with both the location

(brown ovals) and the emotion (colored ovals) of speed surrounding the automotive bluebird itself.

These kinds of developmental readings can be applied to all of the images in the personality prints project. There are variations to be sure—the stylistically early pieces have less connective clarity and flow than the later ones; bottom panels that offer pictorial Indian material do not show such clear development. As a general rule, though, this top-to-bottom reading strategy reflects the perceptual experience of the works, even as it offers an excellent guide for interpreting their meanings. In artistic terms, the sequence frequently reflects a continuum that runs from representation to symbolization to abstraction.

But here's the thing: If one reads the images as *starting* with modernist art and the contemporary moment, then this sequence suggests that the personality prints were statements focused on the future rather than the past—and that the future was the most important location for the "Indian." The triptychs begin in the contemporary moment, Mary Sully's *now,* and look *forward*, beyond modern abstraction to something else, something new that emerges from the Indigenous cosmopolitanism of the bottom panels.

We can call that new thing an *American Indian abstract.* It should properly be seen as a radically innovative, culturally overdetermined, futurist vision that claimed both the right to represent as a Native woman *and* a full claim on the ability to shape modern art itself. This American Indian abstract had a rich genealogy—both personal and cultural—and it laid an important claim on political meaning. For now, we can summarize Mary Sully's project as a move toward the claims made by this Indian abstract, and we can note its narrative power. Modernist primitivism captured so many people, white patrons and Indian artists alike. The Indian abstract sought to reverse the narrative of social evolution that produced such primitivism. It laid claim instead to Indian futurity, and it did so formally, through the three-panel structure that invited both holistic readings *and* a visual experience of sequence and development. It is an egg that might make us look again at its chicken. Or that we might crack in order to cook up something new. It is a powerful Indigenous way of thinking about time and narrative—and in that sense about Indian history (and *Indian History*), modernism, the modern, and what might lie ahead.

CHAPTER FOUR

CONTEXTUALIZATION

The Impossible Subject

IN 1914 THE AMERICAN PAINTER MARSDEN HARTLEY, LIVING IN BER-
lin, crafted four paintings—the *Amerika* series—that figured an experience
of transatlantic modernism. The works crystalized around his engagement
with the same kinds of primitivisms Mary Sully sought to question: Ger-
man folk arts and traditions on the one hand, and on the other, Hartley's
enthralled viewing of American Indian objects in Berlin's ethnographical
Museum für Völkerkunde.[1] Philosophically, he hoped to face forward, toward
a modernist aesthetic future—but when it came to content and feeling, Hart-
ley looked back over his American shoulder, into an Indigenous past. The
Amerika images edge between symbol, representation, and abstraction, and
they blur Germanic themes with Native American iconography. Indeed, as
Gail Levin has argued, one of Hartley's most famous early works, *Portrait of a
German Officer* (1914)—an image featuring similar iconic assemblages—was
likely an interruption of the *Amerika* paintings, spurred by the death of his
close friend Karl von Freyburg. Hartley returned, in two subsequent works, to
his expatriate experiments on Indian themes.[2] Cryptic, dreamlike composi-
tions, the *Amerika* paintings evoke oceanic distance as well as cultural cargo
transported between the modernity of Europe and the supposed archaism

4.1. Marsden Hartley, *Indian Fantasy* (1914). Oil on canvas, 46¹¹⁄₁₆ × 39⁵⁄₁₆ inches. North Carolina State Museum. Purchased with funds from the State of North Carolina. Object number 75.1.4

of the New World. With their symmetries, iconographies, and modernist spatial geometry play, they invite a disorienting and evocative comparison to the work of Mary Sully.

Consider Hartley's *Indian Fantasy*. A red tipi lodge decorated with white and blue occupies the bottom center of the image. It opens to a four-layered world, which is centered in turn by star and corn symbolism. The red lodge is encircled by a green ring that offers a spatially simultaneous view of its interior. On each side sits a stylized figure in blanket and headdress, with pottery or baskets nearby. Cresting the top of this green ring is a low-angle perspective on a campsite circle, with ten painted lodges. This imagery is in turn subsumed within an even larger tipi, yellow with red and green "star" patterns. And outside this lodge, on a shoreline, sit two symmetrically placed campfires, a bow and arrow, a pipe, a bowl, and other implements. Four canoes, each containing two stylized headdress Indians, float on the water beneath a rainbow, astronomical figures, and the image's focal point: the face-on figure of an enormous bird. The canoe-water-fish motif makes a printlike pattern reproduction, and the layered tipi structures create a strong vertical line that establishes a bilateral symmetry.

Hartley's image was painted almost a decade and a half before Sully began the personality prints project. One is struck, however, by the uncanny affinities in their visual and formal strategies. Both images explore bilateral symmetry; both use a three-part structure in which the middle section comprises a repetitive design pattern. Hartley plays with a perspectival view (foreground Indian tipi, middle ground oceanic print, background rainbow), but he questions and qualifies it with a cubist sensibility, dislocating spatial coherence through the visually challenging multilayered tipi and the oncoming bird. The bird demands our attention; it is located in painting's background, but it can also—in an optically illusive play—simultaneously *precede* the tipi images of the foreground, like a figure jumping out at an audience from a contemporary 3-D screen. Sully, too, experimented with such perceptual movement. Compare Hartley's *Indian Fantasy* to the top panel of Sully's *The Indian Church* (fig. 1.9): the doors of both artists' tipis open into multiple spatial worlds, and the two paintings vibrate at a similar frequency. Both artists imagined circular rows of lodges (compare *Indian Fantasy* to the camp circle in *Bishop Hare*, fig. 2.4), a ring structure that questions

time-space relationships (compare it to *The Architect*, fig. 3.45), face-on bird images (compare it to *Sir Malcolm Campbell*, fig. 3.50); modified rainbow backgrounds (compare it to *The Indian Church* again, or to *Billie Burke*, fig. 3.24), and a frequent evocation of Indian material culture, scattered almost randomly on the ground in Hartley's case, suggested constantly in Sully's.

Mary Sully probably did not take direct inspiration from Hartley's images. She would not have seen exhibitions in the 1910s and early 1920s. A well-timed Chicago show in early 1928 seems not to have included the Indian paintings. By the time Sully arrived in New York in 1931, Hartley was painting New England and then Mexico.[3] But of course Sully did not have to see a Hartley image in a gallery or museum. She gathered much of her intelligence from newspapers, magazines, film, and radio. Though there is indeed an eerie air to the juxtaposition, we can also imagine a web of cultural ideas situating Sully and Hartley in a shared aesthetic space that produced near-magical correspondences.

Mary Sully was not part of the modernist circuit that took Hartley from Maine to New York to Paris and Berlin to New Mexico and beyond, but one did not need a passport to breathe the air and drink the water of modernism. Thousands of now-invisible artists, critics, and teachers engaged its aesthetic and philosophical challenges, to say nothing of the much larger audiences that considered both the art and the commentary, and the additional circles that entered the conversation through literature, music, theater, photography, architecture, and design. Nor is Hartley the only artist of that moment whose work tempts evocative comparisons with Mary Sully's. Reading Sully through Hartley points to a particular time and place among an array of multiple modernisms. If you view her work through (or alongside) the work of Charles Demuth, John Sloan, Gertrude Stein, Eugene O'Neill, or others, different comparative insights open up.

The previous chapter focused interpretive energy on Sully's images—form, characteristics, visual vocabularies, and meanings. This one seeks to peel back another layer, looking at Sully and her work through the lens of contextual comparisons. Exactly what *kinds* of modernisms help make sense of the personality prints and their maker? To consider that question, we need necessarily return to the chicken-and-egg dynamics that circumscribe that thing we call "modernism."

Modernism is the slippery kind of object that one makes sense of by surrounding it from all sides (as opposed to an effort to identify and understand its core). You might define it by parsing its various linguistic forms. Or by bounding it with a before-and-after chronology, or tracing its genealogy. Or by breaking it down by disciplinary knowledge and practice. Or by isolating and listing what seem to be its characteristic moves. Or all of the above. In the end, you are attempting to capture a tone, a feeling, a cultural moment that existed in relation to the material lives of peoples and societies. In that sense, Mary Sully's art is both modernist in execution and reflective on modernism itself. How could it be anything but modernist?[4]

As we've seen, the word *modernism* tells the story of a series of aesthetic movements that played out over the course of the later nineteenth and the first part of the twentieth century. They drew their energy—both affirmative and critical—from the conditions of *modernity*, commonly (and usefully) framed around powerful transformations that became painfully visible in the mid- to late nineteenth century. Chief among these was the consolidation of capitalist economic relations in the form of industrialization, technological innovation, vertical organization, monopoly, labor struggle, rationalized assembly lines, and Fordist principles that linked effective production with strategies for ensuring consumption. Speed and transportation created a new globalism, with spasms of structural violence exploding across the mid-nineteenth century and into the twentieth. One consequence of industrialization, technological advance, and increased mobility was a massive increase in the populations of cities, as fewer people, using machines, managed larger and larger parcels of agricultural land. The twentieth-century great migrations of African Americans from rural South to urban North and West transformed city life and American culture, as did the flight of rural western and midwestern residents into the cities. The demography of urbanization was defined as well by the arrival of massive numbers of European immigrants, which set off intense debates concerning cultural assimilation and ethnic and racial difference, given shape in harsh border and immigration restrictions often aimed at Asian and Latin American populations. American Indian people, of course, offered Americans an early social laboratory for considering such issues, and they continued to suffer from and resist assimilation and colonial land-grabbing.

The social costs of these transformations drove a disparate set of reformers, commonly grouped together under the label "progressivism." Progressive reformers moved to constitute and then mobilize the power of the modern state through legislation and the creation of new administrative capacities. The American military—fresh from the hyperviolent final suppression of American Indian populations—looked for redemption and expansion in overseas imperial ventures in the Caribbean and Pacific. Urbanization, migration, industrialization, technological innovation, economic struggle and consolidation, reform, globalization, state formation and empire—these are the main descriptive categories for making sense of the material world of modernity. Modernism was both its result and, sometimes, its critical conscience.

In describing these things, writers used the root word *modern*, which functions not to name an epoch in historical time but simply to denote the present moment in relation to the past. "Present moment," of course, is a potentially expansive category, and *modern* twists itself into tight knots in relation to modernity (conditions) and modernism (cultural aesthetics).[5] This definitional approach points as well toward *antimodernism*, which offered alternative and oppositional cultural possibilities in response to the anxieties of modernity. Indeed, modernism, in artistic terms, was often *anti*modernist, employing and resisting the shocks of modernity. Here too American Indians occupied disproportionate space, for they rapidly came to carry a range of antimodernist meanings: they were precapitalists who lived by barter and subsistence; they were spiritually pure, in touch with the earth and a living world of mystic possibility; they had maintained effective social institutions and communities—they were, in short, primitives uncontaminated by the conditions of modernity.[6]

In the early twentieth century, the formation of this American primitivist (anti)modernism emerged from a transatlantic circuit that linked Paris, Berlin, and New York with New Mexico and other parts of the West. Marsden Hartley, for example, would go to New Mexico in 1918, at the invitation of modernist booster Mabel Dodge Luhan. Taos and Santa Fe played host to artists like Joseph Sharp, who came to Taos in 1893, and Bert Phillips and Ernest Blumenschein, who framed their own arrival as a kind of art world origin story. By 1915 a group of artists (including E. Irving Couse, W. Herbert

Dunton, and Oscar Berninghaus) was identifying itself as the "Taos Six" and had founded the Taos Society of Artists. Like salvage ethnographers, the enraptured artists focused energy on painting archaic Indians before they disappeared. Taos and Santa Fe would play host, over the years, to cosmopolitan painters such as Robert Henri, John Sloan, John Marin, and Andrew Dasburg, and New Mexico would of course become the home of Georgia O'Keeffe, who made New Mexico modern a category all her own.[7]

White painters like Marsden Hartley, the Taos Six, and the Luhan circle drew from Indian subjects and the New Mexico landscape to imagine a particular form of American abstraction, drawing modernism and Indian primitivism into a close alignment. The flow between New York and its aesthetic hinterlands enabled John Sloan, Oliver La Farge, Mabel Dodge, and so many others to argue both for the linked importance of *Indian* representation (as in the Exposition of American Indian Arts, for example) and Indian *representation* (in the works of primitivist-inflected white modernists). These dynamics would, as Sascha Scott has shown, lead some New Mexico artists to a preservationist politics that supported Indian people—though largely out of the artists' own desires to maintain the "authentic timelessness" of their subjects or to make metaphoric connections to their own claims to insightful marginality.[8]

What of the chronology and character of modernism? American modernism might be loosely bounded in time and period, on one side by the neoclassical academic painting of the Gilded Age and the art nouveau and arts and crafts movements of the early twentieth century, on the other by the series of post–World War II movements—often figured in terms of abstract expressionism—that would later be bundled under the uncertain rubric *postmodern*.[9] In between these markers, a number of modernist artistic movements flourished: synchromism, symbolism, cubism, functionalism, futurism, surrealism, precisionism, art deco, moderne, and primitivism, among others. As Erika Doss has argued, these "embodied neither a unified vision nor a uniform aesthetic practice." One applies, with caution, only a few broad-brush characteristics. For Doss, these include "stylistic emphasis on dynamism, flux, paradox, ambivalence, montage, overlapping, and simultaneity; and its social aims of tearing down class, race, and gender barriers, among others."[10] Aesthetic modernism, then, lived in a paradox in which

integration of dialogical difference—of art and life, modern and primitive, fine art and mass culture, individual and society, Taos and New York—was both a goal and a structural impossibility.[11] When Taos was no longer distinct, what was the point?

Within this thematic structure, one might locate a series of markers that anchor American modernism in time: the 1908 independent exhibition of The Eight, a group of artists that rejected the academicism of the National Academy and celebrated the painting of "real life"; the 1913 Armory Show, which brought European modernists to New York and surfaced American ones; the formation of the circle of American modernists around Alfred Stieglitz's 291 Gallery, Stieglitz's publication *Camera Work*, and his subsequent galleries during the 1920s; the founding of the Museum of Modern Art in 1929 and the Whitney Museum of American Art in 1931. Each of these— and one could choose other exhibitions, circles, and institutions—reflected the range of possibilities that filled the air and water of the modern. MoMA, for example, focused on European avant-gardes while the Whitney preferred contemporary American painters, advocated for the "real life" approaches, and ran a series of biennial exhibitions of new work. The Stieglitz circle, as Wanda Corn has argued, featured a productive tension between transatlanticists and "stay at homes."[12]

Historian Dorothy Ross has argued that the modernist decades witnessed a complex of engagements that were not simply aesthetic or economic but were equally driven by the development of social sciences that tried to come to terms with the failures of the enlightenment project. She outlines a dense network of thinkers and writers—philosophers, psychologists, sociologists, political economists, anthropologists, and cultural critics—among whom one might identify a category of *cognitive modernism*: an effort that recognized the contingency of supposedly solid scientific knowledge and the possibilities for a science of the human, exemplified by figures such as William James, Sigmund Freud, and Max Weber. This crisis of knowledge in natural and social science, with a lineage to the philosophical critiques of Friedrich Nietzsche, helped produce a second category, one of *aesthetic modernism* that sought to escape the alienations of modernity in all the ways we have been considering: through primitivism, radical experiments with form, and a rethinking of the process of creation itself.

Or, as Ross suggests, maybe it was the other way around. One might begin instead by tracing an equally long genealogy in literature, art, and music that produced aesthetic modernism. The arts functioned as both diagnosis and symptom of modernity, and perhaps it was the aesthetic that drove inquiries in philosophy and the social sciences. This frame should sound familiar. The chickens and eggs of modernism take on new/old forms, for the distinctions between "cognitive" and "aesthetic" are obviously heuristic ones, meant to capture the dynamics of thought and action that made modernism as much a dialogue or network—a culture, perhaps—as it was a movement or an epoch.[13]

NEW YORK MODERN

Ross's metapicture of science and art captures an intimate dynamic between the sisters Mary Sully and Ella Deloria, the latter making the leap into the early interdisciplinary social sciences, the former seeking to engage the world of aesthetic modernism. They accompanied one another on their journeys, creating their own intricate weaving of aesthetic and cognitive modernisms. The sisters' lifelong conversation focused on the challenges of Indian history and futurity, on questions of perception, race, environment, and intelligence, and on their shared interest in the psychology of individuals and cultures. New York proved an excellent place for their explorations. They lived in the city or in nearby New Jersey (Fort Lee and Cliffside Park were favorite addresses) from February 1931 to June 1932, November 1932 to June 1933, November 1933 to June 1934, November 1934 to June 1935, May 1936 to May (?) 1937, February to July 1940, and January to July 1941, and then on and off for much of the early to mid-1940s.[14]

During the 1930s Mary Sully had access to shows at the Museum of Modern Art, the Whitney, the Metropolitan Museum of Art, and a host of galleries and smaller venues, all adding up to a rich visual tutorial in modernist art.[15] For all her timidity in close social settings, Sully navigated the crowds of New York. Perhaps the anonymous worlds of the city and the mass media offered her more opportunities to become "Mary Sully, artist" than did the intimidatingly intimate contexts of Santa Fe patronage or Oklahoma education.

Nor was she wholly devoid of social contact. The sisters were present in the spring of 1931, when their brother Vine was ordained at the St. Luke's Chapel in Greenwich Village, and a year later, when he was married in Sloatsburg, New York. Indeed, Ella Deloria had known her sister-in-law's family for years and often rode the train to Sloatsburg to supervise the (anti)modernist, faux-Indian activities of the local Camp Fire Girls group.[16] These visits brought Mary Sully into contact with local personalities that would later appear in the series, notably Daniel Carter Beard, one of the cofounders of the Boy Scouts, and Albert Payson Terhune, a writer of animal stories and sketches. Both were near-neighbors of her Sloatsburg in-laws, minor celebrities in the firmament of the personality prints, and personal acquaintances of the family.

Interesting in this regard is Mary Sully's curious choice to draw Annie Stein. Amid a portrait gallery rich with musicians, athletes, and actors, Stein—hardly a household name—is the only visual artist. Born in 1879, Stein was married to lawyer and real estate investor Charles Stein. A member of the Art Students League, she received honorable mention in an amateur contest in 1933.[17] In 1936 Stein presented watercolors at the Morton Gallery on 57th Street, a prominent venue in the heart of the studio and gallery district. Two years later, she showed Hudson River scenes in watercolor at the Studio Guild.[18] A second show at the 115th Street branch of the New York Public Library—only a few blocks from Ella Deloria's office at Columbia—won praise for "spontaneous brushwork, space-filling in manner, and clear bright colors." "Soundly constructed and brushed with vigor," observed a reviewer who seemed to know her work, "these papers are earnest of the artist's more recent progress."[19] Her slight public profile suggests that—like with Dan Beard and Albert Payson Terhune—Sully may have had at least a passing acquaintance with Stein.

Annie Stein does not appear on the circa 1938 list of personalities, likely confirming its relatively late date of creation. And stylistically, the image follows strategies used in Sully's later work—the cubist triangles of color in each corner of the top panel, for example. The blue curves and horizontal wave structures located in the middle and bottom panels may gesture to the Hudson River, which seems to have been an important subject for Stein. The flower theme takes on increasing importance, culminating in

4.2. Mary Sully, *Annie Stein*

six decorative medallions in the bottom panel, which shift the eight-point flower slightly on its axis to transform it into a "star-quilt" pattern. In the early 1940s, the occasional mentions of Stein's work in the *New York Times* gallery announcements came to an end. Stein died in 1947.

The existence of the personality print *Annie Stein* (fig. 4.2) suggests that Sully had established some connection to a minor New York City artist—one with resources at her disposal and the ability to get her work into galleries. Stein was a member of both national and local arts organizations, and one might speculate that Sully knew her not only as a local artist but as a potential patron for the personality prints.[20] You might read the image, then, as a pragmatic effort to woo a patron—Sully and her sister made other attempts to reach out to the subjects of the art, in hopes of financial support. But it might also be read as evidence of some small social connection outside Sully's sister, and as an expression of aesthetic kinship, of solidarity among aspirational artists.

4.3. Marias de Zayas, *Theodore Roosevelt, Camera Work* no. 46 (1914)

In that sense, Sully would have found herself in the company of well-known modernists who not only established self-conscious circles of like-minded peers (The Eight, The Six, the Ashcan School) but self-consciously chose to paint portraits of their friends and colleagues. Stieglitz and O'Keeffe pictured one another. Ernest Blumenschein painted a collective portrait of the Taos arts colony.[21] In 1913 Marius De Zayas showed at Stieglitz's 291 gallery a series of "absolute caricatures" that introduced abstraction and symbolism into the concept of the portrait. De Zayas caricatured his friends—Stieglitz, for example, appears as equations, a photographic gaze, and other symbolic gestures (mustache, glasses, lenses)—but he also expanded his vision to include personalities such as Theodore Roosevelt (fig. 4.3). These innovations echoed in Francis Picabia's "machine

4.4. Francis Picabia, *Portrait d'une jeune fille américaine dans l'état de nudité*. *291* no. 5/6 (1915), 3

4.5. Charles Demuth, *I Saw the Figure Five in Gold* (1928). Oil, graphite, ink, and gold leaf on paperboard. Metropolitan Museum of Art. 49.59.1

portraits," published in *291* in 1915, in which a sparkplug might represent a young American girl (fig. 4.4, likely Agnes Ernest Meyer) and Stieglitz himself could be figured as a mechanical hybrid camera-automobile.[22] De Zayas served as both talent scout and "art whisperer" for Stieglitz in the next years, proving central in the transatlantic dialogue that introduced Picasso and African primitivisms to the United States. As important, De Zayas helped consolidate a coherent modernist form: the capturing of the essential personalities of individuals through the strategy of abstraction.[23]

The most famous of these efforts was that of Charles Demuth, who in the 1920s created a series of nine "poster portraits" of his fellows.[24] That project culminated in 1928 with his visual reading of poet William Carlos Williams's personality, *I Saw the Figure 5 in Gold* (fig. 4.5). In the painting, Demuth frames Williams through the writer's poem "The Great Figure," which describes the rush of a fire engine on a rainy New York night:

Among the rain
and lights
I saw the figure 5
in gold
on a red
firetruck
moving
tense
unheeded
to gong clangs
siren howls
and wheels rumbling
through the dark city.[25]

The painting uses word signifiers ("Bill," "Carlo," and "WCW") to iden-
tify Williams as the subject. His poetic personality is captured through
the multiple, fragmented planes and the repeated figure 5, simultaneously
visible across four temporal moments. At the center of the image, "No. 5"
identifies the firetruck, while surrounding iterations of the numeral (larger
and smaller) suggest the movement of the truck as it draws near. In the
upper right corner, a single gold curve—the only evidence of an enormous
5—cues the viewer that the truck is an instant from occupying the same
space and time. Circles of light (and, one might argue, clanging sound) bring
the viewer more deeply into the poem—and, as importantly, into its liter-
ary effects. Like the broken-sentence realism found in a Williams poem, the
seeming simplicity of the rushing figure 5 demands that the viewer engage
the apparently mundane as the content of a complex modernist aesthetic.[26]

Demuth's poster images mirrored the central concept behind Sully's per-
sonality portraits, and despite sometimes bewildered critical reception, he
found it among his more generative ideas. As the poster portraits accumu-
lated, they began to suggest that a collection of individuals might add up to
something more than constituent parts—in this case, a circle of artists that
helped define American modernism. Demuth's collection grew to include not
only Williams but also John Marin, Marsden Hartley, Wallace Stevens, Georgia
O'Keeffe, Arthur Dove, Charles Duncan, Gertrude Stein, and Eugene O'Neill.[27]

What exactly did Demuth or Mary Sully mean when they painted or drew the relationship between person and personality? Cultural historian Warren Susman once argued that the 1920s saw a shift in American society from a culture of *character*—a deeply rooted, well-developed sense of the self that focused on widely shared virtues—to what he called a culture of *personality*. Personality, for Susman, was media driven, surface oriented, and impermanent, taking its most visible and influential forms in the creation of celebrities, people central to the consolidation of the culture industries of radio, film, publishing, and advertising. They were actors, singers, sports heroes, public speakers, and politicians, and their movements and utterances were tracked by columnists and commentators.[28]

Neither concept—character or personality—denied the possibility of essential qualities that could be the subject of representation. Indeed, one key factor in the rise of "personality" was a Freudian psychological dynamic that framed individuals in terms of depths and surfaces. Part of the project for both Demuth and Sully seems to have been the mediation between depth that was personal, private, and essentialist—a vestige, perhaps, of a notion of

4.6. Charles Demuth, *Love, Love, Love. Homage to Gertrude Stein* (1928). Oil on panel, 51 × 53 cm. Museo Nacional Thyssen-Bornemisza, Madrid. Inv. no. 521 (1973.56)

4.7. Charles Demuth (1883–1935), *Longhi on Broadway* (1928). Oil on board, 86 × 68.6 cm. Boston Museum of Fine Arts, 1990.397

character—and the public personalities around which more superficial clusters of meanings might form.

Both artists found themselves struck by at least two of the same people: Gertrude Stein (fig. 4.6) and Eugene O'Neill. In 1926 Demuth sketched a possible portrait of the playwright, while querying his wife at the time, Agnes Boulton O'Neill, as to whether O'Neill would be receptive to being included in the poster portraits series.[29] The rough pencil sketch frames a window view of the sea, with a mast or sail structure, the crossbrace of which is formed from O'Neill's name. A flask and a desiccated flower in a pot sit on a sill in the foreground. Robin Jaffee Frank has suggested that the flask reflects the Dionysian impulses of the Provincetown Players circuit, of which both Demuth and O'Neill were part, and that the image likely serves as a "poster" for O'Neill's play *The Moon of the Caribbees*. Frank sees the flower as symbolic of the native women of the Caribbean, who board the ship bearing rum and sexuality and are hailed by one of the crewmembers: "This way,

Rose, or Pansy, or Jessamine, or black Tulip, or Violet, or whatever the hell flower your name is. No one'll see us back here."[30]

Robin Frank and Wanda Corn also read the later Demuth image *Longhi on Broadway* (1928; fig. 4.7), which incorporates intricate gestures toward theater and letters, as a portrait of O'Neill. Both scholars note the importance of masks to O'Neill's aesthetic in the 1920s—reflecting his interest in representing the shifts between public and private, conscious and unconscious—as well as the symbolic references visible in the bottle (Dionysian alcohol), the ivy placed within it, and the distinct and identifiable set of gestures that make up the cubist-planed collection of books and magazines.[31]

Sully's *Eugene O'Neill* (fig. 4.8) also seeks to capture O'Neill's realist sensibility, and it too turns to the flower as a site of meaning. Flowers function differently here, however, gesturing to twoness, doubling, and the anxieties that flow from a notion of surface and depth. Three public-facing flowers in bloom are complicated by more frightening images that appear behind a gridded screen—a rose is paired with thorny cactus; a tulip with failing leaves and a threatening scissor; a blooming poppy with a headless poppy run amuck, black hands reaching from the stalk. One might also read Sully's image through O'Neill's plays: perhaps *The Moon of the Caribbees* or—considering the potential race signifiers in the poppy segment—*The Emperor Jones*.

As evocative, however, is his play *Strange Interlude*, which won the Pulitzer Prize in 1928 and was made into a 1932 film starring Clark Gable and Norma Shearer.[32] In both, the characters alternate between speaking directly to one another and then articulating, for the audience alone, an interior monologue that reveals their inner thoughts. Such unspoken thoughts—behind the screen, as it were—unveil to the audience a Freudian depth, and indeed, the themes of the play involve the familiar deep questions surrounding sexuality, madness, and infidelity. Spoken words, as one character suggests, are "the mask" for the complicated anguishes that lie beneath.[33] Sully's three flowers may reflect the three male characters—Sam, Ned, and Charles Marsden (a composite reference to O'Neill's painterly friends Charles Demuth and Marsden Hartley)—who triangulate the love of the lead female character.

Sully seeks to capture Gertrude Stein (fig. 4.9) through her famous phrase "a rose is a rose is a rose is a rose," a modernist literary ontology that made its way into her writing on more than one occasion. For Stein—as for Sully

4.8. Mary Sully, *Eugene O'Neill*

4.9. Mary Sully, *Gertrude Stein*

herself—the word *rose* referred both to its referent (a physical rose or, ana-logically, the depth of a person such as Stein) and to the cluster of meanings that were carried by the word (or, to continue the analogy, made visible by the person's public personality). As the rose develops over the course of Mary Sully's three panels, it maintains its "roseness" even as it is broken apart and abstracted into a hieroglyphic motif in the bottom panel. The rose, in Sul-ly's image, is simultaneously pictorial, symbolic, and semiotic—an image, a metaphor, and a sign. What comes into question—as is the case at the end of Stein's repetition—is its referential depth.

Later postmodernists would cheerfully cut the *signifier* ("rose") free from any of its *signified* meanings ("love," for example), focusing instead on an infinite deferral of meaning. Modernists, on the other hand, organized one of their key explorations around the uncertain but productive relation between referents, signified meanings, and the signifying words or images that con-veyed both. When Demuth figured Stein as a mask, the numbers "123," and the fragmented word "love," he was building meaning out of signs only par-tially sundered from their referents, inviting his audience to consider object, signifier, and meaning. Robin Jaffee Frank's reading of the image illustrates the issue well, for it emphasizes both the unstable association of the image with Stein herself, and a wider world of significations (Broadway, a restau-rant, Demuth's art dealer). "Cut off by the frame," Frank writes, "the third LOVE implies infinite restatement. . . . Demuth's reiteration of LOVE, like Stein's 'a rose is a rose is a rose,' questions the significance of a word made meaningless by conventional usage."[34] Demuth's viewers are asked to oscil-late between depth and surface, referent and signifier, materiality and idea. In *I Saw the Figure 5 in Gold*, he translated the dynamic into a shifty cubist multiplicity, building motion into the stasis of a single-plane painting. One can allow the image to sit still, or one can let the eye put the rushing "5" in motion, guided by the diagonal grays emanating from the image's center. Oscillation, movement, and perceptional play proved critical concepts for both literary and visual modernism.

Such oscillations—rose to love, referent to sign, motion to stasis, thought to speech, person to personality (and back again)—also defined Mary Sully's work, visible in her interest in visual illusions that invited the same shifting twoness of surface and depth. As we have seen, cut-outs and the play between

positive and negative space have a long history in Dakota women's arts. But Sully's visual illusions also drew from broader contexts, for human perception, across cultural difference, is governed by brain functions that fill in gaps in actual perception, make guesses, construct meaningful wholes, and perhaps anticipate futures. These functions are exposed in familiar optical illusions involving double images (rabbits and ducks, for example, or young and old women) or figure/ground relations (the chalice that is simultaneously two faces). Such visual play is found wherever humans make marks.

As an effort to conjure three-dimensional space out of two-dimensional surface, Western art has long played with shifting perceptions, most prominently via perspective, a form of visual illusion so dominant that it has become naturalized to Western eyes, and so powerful—especially when paired with colonial and imperial force—that it can serve as an agent of domination.[35] Many of Sully's images play with pictorial perspective (recall, for example, *The Indian Church*), sometimes juxtaposing it with the kind of flat-plane picture space that so often connected modernism with primitivism.

The top panel of *Eugene O'Neill* at first suggests three-dimension perspective in the form of simple line-drawn cubes. As the eye moves down the image, however, that suggestion is undone, for the potted plants are figured in flat two-dimensional terms, inviting an oscillation between cube and not-cube, two dimensions and three. Flat-plane drawing was one of the reasons Indian artists like Stephen Mopope and Awa Tsireh seemed to speak to the modern. But long before modernism, Indigenous artists also grappled with the representation of space and time.

A narrative surrounding men's ledger book art suggests that it lived in two dimensions only, and that Native artists learned perspective from white mentors. Those same artists, however, established conventions for other illusions, including what we might think of as a fourth dimension: time—the one that so excitingly challenged cubists and other modernists. Ledger and war book art can seem confusing in its doubled imagery; the proliferation of hoof prints that illustrate who went where, when; and the simultaneity of smoke, bullets, arrows, wounds, action, and death. Thomas Stone Man's illustration of the death of Sitting Bull, for example (fig. 4.10), shows the chief's movements from his cabin, his pinioning by three members of the Indian police, and his body, fallen from where it stood only an instant before:

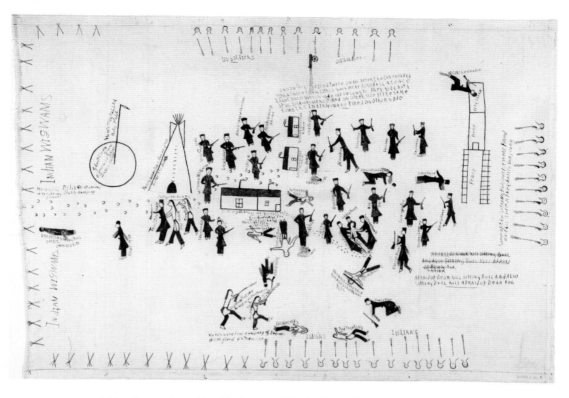

4.10. Thomas Stone Man, *The Arrest and Death of Sitting Bull* (ca. 1920). Ink on muslin, 30½ × 43 in. (77.5 × 109.2 cm). Anderson O'Brien Fine Art, Omaha (Courtesy of Jo Anderson)

three discrete moments in time, connected within the same image. These artistic strategies, common in the ledger book tradition, were all efforts to capture time—and to do so in ways that might make one think of Marcel Duchamp's iconic 1912 painting *Nude Descending a Staircase* or Charles Demuth's golden 5 racing toward, and then into, and then (hopefully) past the viewer.

Mary Sully engaged all these forms of perceptual play, building time/motion and figure/ground illusions into many of her images. *Admiral Byrd*, for example (fig. 4.11), presents a figure/ground illusion—jagged peaks pointing skyward alternate with icicles jutting down. And we have already seen the tipi/robe oscillation of *The Indian Church*, the cutout illusions in *Henry Joy*

4.11. Mary Sully, *Admiral Byrd*

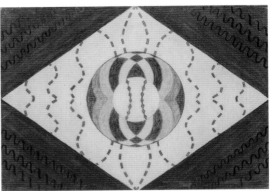

4.12. Mary Sully, *Dizzy Dean*

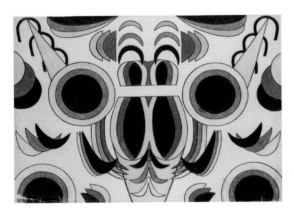

4.13. Mary Sully, *Fred Astaire*

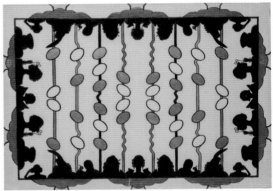

4.14. Mary Sully, *Bing Crosby*

and *Babe Ruth*, the dual figure/ground features in *Pavlova*, and the double-perspective use of a circle in *The Architect*. In *Dizzy Dean* (fig. 4.12) the circle effect is focused directly on an experience of time and motion. Brown borders in each corner create a white baseball diamond. On both the brown and the white backgrounds are zigzagging lines, clearly referencing the "dizziness" of Dean, an All-Star pitcher with the St. Louis Cardinals during the 1930s. The focal point of the image is a baseball, perfectly centered on

the paper and surrounded by a curiously segmented colored disk. Sully has aligned the stitching on the baseball (look carefully at the diamond pattern of the stitches) with the "dizzy lines" (note their rectangular shapes) of the background. Letting one's eye play between the background, the disk, and the ball will cause it to move, as if jumping from the paper directly toward the viewer, simulating the experience of a thrown pitch. Likewise, *Fred Astaire* (fig. 4.13) seeks to offer an image of time/motion akin to *Dizzy Dean*, as Astaire's feet tap in rapid movement across space.

Sully also explored illusions focused on seeing and being seen. In *Easter (in a large city)*, for example (see sidebar in this chapter), she frames the bottom of the first panel with a silhouetted audience, transforming the image of a city street into a theater. *Billie Burke* (top panel), *Ziegfeld* (fig. 3.47), and *Channing Pollock* suggest the same kind of structure, in which the viewer watches an audience observing action on a stage.[36] Similar watching or listening figures appear in *Lawrence Tibbett* and *Harry Emerson Fosdick*. In the eerie image *Bing Crosby* the audience seems captured by Crosby's mouth and his moving vocal chords, which oscillate with sound waves and are strung with musical notes. The point of view might be from the back of a venue, looking over the audience's shoulders and directly into Crosby's wide-open mouth. Or it may be from some imagined point inside the singer's body, looking past his vocal cords out to a distant audience. Both perspectives are unnerving and uncanny.

MODERN CITY

One of Mary Sully's "idea" images, *Easter (in a large city)* focuses as much on "city" as it does on "Easter," illustrating a large crowd, adorned in Easter hats, making their way into church (recall how *Good Friday* put its focus on shoes). During the sisters' New York years, that church might have been the Cathedral of St. John the Divine, located near Columbia University. The massive cathedral—one of the largest churches in the world—was under construction for much of the early twentieth century, opening in its full glory only in 1941. Or perhaps the church was St. Thomas, in Manhattan, home of the choir school where the sisters once

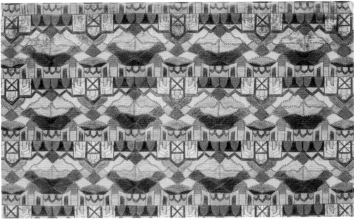

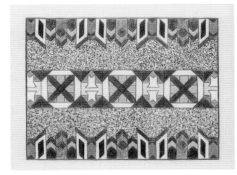

Mary Sully, *Easter (in a large city)*

proposed relocating their nephew. In the image, the church itself is barely visible in the form of twin doors located at the very top of the first panel, almost lost in the crowd.

Easter illustrates some of Sully's strategies for human figuration: back views that focus on clothing, color, texture, and complexity of form; profiles (like the back views) drawn from Plains Indian pictographic traditions; and black silhouettes. In this case, the framing silhouettes suggest a film audience viewing the crowd that pushes into a church, giving the work a recursive quality: it is a visual representation of a film representation of a ritual representation.

The top image follows the same structure as *The Indian Church*, with a line of bodies forming a center and mirror images establishing symmetry to either side. With such a riot of diverse color and form, it is not easy to establish a focal point. The best candidate, perhaps, is the silhouetted figure at the base of the central line of the symmetry, who is framed not by the dark brown jacket of the man lined up before him but through a peculiar tan halo.

The halo offers an opportunity for the eye to shift between the multicolored crowd and the black silhouettes, from a framing foreground to the activity above. The brown of the man's jacket, however, matches the

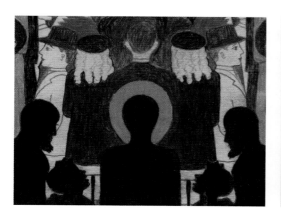

Top panel detail: Figure with halo, centering a focal-point triangle with other points located in the doubled figures of the young boy and old man.

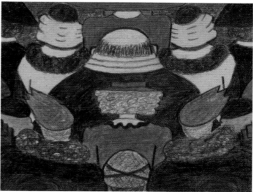

Top panel detail: Cartoonish caricature of a monklike figure, offering viewers a second focal point.

brown of the crosses on the church doors at the top of the page, and the halo gives this central figure an angelic or Christlike connotation. The gazes and directionality of the figures located below then present interesting possibilities. The young boy and old man silhouetted near the Christ figure give him their full attention. With the brown-jacketed man, they form a triangle structure that anchors the base of the image. The massive crowd either walks past him or actively turns its back on him in order to focus on the church.

Near the top of the image, an unnaturally large man with a bald head that looks like a monk's tonsure offers a second focal center, again linking the figures of church, halo, and crowd. The color explosion and the focus on fashion and stylized faces suggest the influence of comic strips. Indeed, the monk looks more like a cartoon character than an actual monk—and it is not hard to read in hair and hats the presence of Little Orphan Annie, Dick Tracy, and other comics of the period. One gets the feeling that Sully had acquired a new, larger box of pencils and sought to take full advantage of an enlarged color palette.

Likewise, *Easter* demonstrates Sully's attentiveness to fashion and clothing design. Almost all women and most men wear hats; the variety is dazzling to the point of comic-book over-the-top. In the crowd one finds bonnets, fedoras, pillboxes, top hats, broad-brims, porkpies, berets, florals, hair wraps, a kind of upright tiara, and even hats that look like a dunce cap, a floppy liberty cap or jester's hat, and a tricorn or academic mortarboard. In the center, Sully places what may be an African American woman—unhatted—with hair gathered and tied. The image offers clothing in all colors and cuts, but given the proliferation of figures, Sully wisely limited most clothing to pure colors so as to let the image itself create a multicolored design.

A first viewing of the top panel of *Easter* might lead one to focus the eye on detail—the individual fashions and figures that make up

Top panel detail: Proliferating hats include blue dunce cap, floppy red cap, red beret with feather, orange pert hat, and over-the-top brown hat.

Top panel detail: African American woman (?) with tied-up hair

Design icon from middle panel: Sully has patched together a quilt of many colors, distilled from the clothing colors found in the top panel.

the social crowd. But the image just as easily asks the viewer to blur the church-goers into an undifferentiated mass of color, reflecting the swirl of life that made up the city. Squint your eye and you may see something approaching the color blend found in the middle panel, which offers a complex translation of the crowd, visible in a repeating design icon.

Sully suggests that the individual fashions of the crowd are something to be stitched together—literally—in the form of a quilt in the middle panel, with shapes and colors drawn roughly from the the top panel. The middle panel offers two alternating patterns, each with a strong bilateral symmetry. One pattern is based

Top panel detail: Color combinations from the top panel—orange, brown, fuchsia, blue, green, black, and pink—are captured and transformed in the middle panel's symmetrical patterns.

in a line that runs from the sharp point of a wooden latticework structure down through the points of a fuschia diamond to a second latticework point below. The other follows a strong line of vertical black stitching on a brown background that traces upward to the point of a maroon diamond

and the line formed between four fuschia "shields." Downward, the line follows through a black and dark blue "hourglass" figure to the brown latticework point below. Focus on one pattern's central line and the other pattern becomes a symmetrical figure on either side. Shift your gaze to the other pattern, and the relationship reverses itself. The panel insists on keeping the eye moving, in something akin to the playfulness of a figure/ground illusion.

The colors in these quilt patterns can perhaps be matched up to groupings of people from the top panel, creating a kind of puzzle for the viewer to solve. From which person does Sully draw that fuschia color? Is the yellow taken from the two blonde figures? Does the black and dark blue in the middle panel follow from the dark-suited men in the top? Has she toned that bright orange down into a kind of burnt sienna?

Sully also seems to turn her icons upside down. The fuschia tablets so prominent at the top of the design icon—which carry a semiotic touch of the Bishop's hat—are surely drawn from the curious fuschia hats located near the bottom of the crowd image. Likewise, the brown structures of the open door of the church have been relocated as well, from top to bottom. Finally, the design icon centers a curious figure that seems to include the wooden frame, the cross, and possibly the form of the church—all turned upside down.

The church's doors and columns are more developed in the second panel than in the first. They continue to grow in importance as the image develops across the three panels. In the bottom panel, the church now structures the horizontal line, while a few highly abstracted clothing colors form a pattern of open books or doors. But the most striking feature of the image is the way in which the mass of people at church shifts across the three panels. In the first, they appear as a comic book riot of colors; in the second, they are transformed into a crazy quilt; in the third, it is as if Sully had flown to the top of a skyscraper to look down on the crowd, holding in the back of her mind the pointillism of Georges Seurat.

In her range of technical interests—dimensional experimentation, perspectival play, and optical challenge—Mary Sully aligned herself with artists

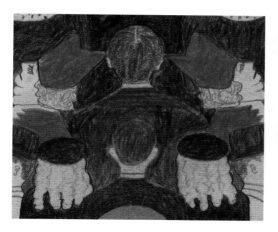

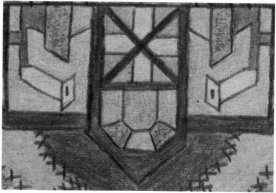

Top panel detail: Fuchsia bishop's hat, quoted in the top section of the pattern design of the middle panel

Middle panel detail: "Church" pattern, which establishes a visual structure for church references in the bottom panel

of the early twentieth century. Her concerns with figure/ground questions concerning signs and substances, people and personalities, and watching and being watched placed her within the broad conversations of American modernism. These covered the globe and reached from New York to New Mexico—and in her case, even to the less romantic hinterlands of South Dakota.

To peel back yet another layer of context, we might do well to oscillate our own contextualization along the same lines as the modernists of the early twentieth century. The New Mexico circuit mattered to Sully, even though she did not traverse its pathways, for it centered an emergent American Indian arts tradition, exemplified by painters such as Stephen Mopope and Awa Tsireh. How might we read her work in the light of this particular *Indian modernism*, this other art history?

INDIAN MODERN

In December 1931, at the Grand Central Station Art Galleries in New York City, the Exposition of American Indian Arts opened its enormous exhibition of Native art. It featured over six hundred objects and would tour fifteen American cities during 1932. If mounted today, according to art historians Janet Catherine Berlo and Ruth Phillips, the show would fall into the "blockbuster" category.[37] It is not unreasonable to speculate that Sully and her sister

might have visited the exposition. In the late fall of 1931 and winter of 1932, they lived in New York while Ella worked on linguistics and ethnography at Columbia University. By then Sully would have been working at least three (and possibly four) years on the personality prints, and she may well have had a sense of herself as an Indian modernist.[38] The exposition offered her the opportunity to think of her work differently, in the context of a developing American Indian market aesthetic.

The largest touring exhibition of Indian work prior to the 1970s, the exposition reframed already collected ethnographic objects as art even as it introduced over forty new watercolors from the Indian artists of the Oklahoma and New Mexico schools. The show set the terms for Indian arts, and it sought to make them speak to modernist art criticism. Its intellectual claims and material presence in the Grand Central galleries would shape subsequent exhibition practice over the next decades.[39] That practice would include the American Pavilion at the 1932 Venice Biennale, the 1939 Golden Gate International Exposition, and the landmark event of early-twentieth-century Native arts, the 1941 three-floor Museum of Modern Art exhibition *Indian Art of the United States*.[40] In 1931 the exposition formalized three arguments about an Indian aesthetic: it made a coherent claim for the critical place of Indian arts in the United States, offered a series of introductions to specific forms and media that characterized Native art, and made an explicit connection between older traditions and new artistic works—all claims that would have made sense to Mary Sully.

In the catalog essay that framed the exposition, painter John Sloan and anthropologist and writer Oliver La Farge laid out assertive claims for American Indian expression in the museum and art world. First, as we have seen, they named and rejected the ethnographic approach taken by most museums, in which "the choice vase and the homely cooking pot" were considered under the same rubric.[41] In that common approach, objects offered evidence of the essential unity of any particular Indian culture—Pueblo, Kiowa, Dakota. Cultures were holistic units with clear boundary lines. At the same time, the generalization "Indian culture" was itself a holistic category defining a "premodern" practice distinct from white modernity. The ethnographic approach offered a sophisticated social science reading of culture, they conceded. Missing was a consideration of objects as *art*. Ethnographic

presentation denied to Indian people long histories of artistic development that could—and should—be connected to the contemporary world.

More aggressively, they rejected the "curio concept" of American Indian art. Visitors to Indian Country, they said, saw Indian people as curios to be consumed. "Indian-made" souvenir objects served as evidence of that consumption and as cheap commodities in their own right. The low-end souvenir prices demanded by tourists established an economic structure in which Indian artists could not charge the costs of time, labor, and materials necessary for fine arts production, relegating them to "little sweet-grass baskets, absurd bows and arrows, teapots, candlesticks and any number of wretched souvenirs."[42]

Sloan and La Farge suggested instead that Indian artists ought to be included in both the aesthetic and economic landscape of American arts, embraced for a distinctive Indian modernism. It arose from an exotic, endangered past that was rich with intentional art and legible to white viewers in the terms of modernist primitivism. The Indian, they began, was a particular type of *realist*: "he does not confine his art to mere photographic impression, nor does he resort to meaningless geometric design."[43] Sloan and La Farge made ready sense of this brand of meaningful design, for they observed that the Indian was also a "natural symbolist." These claims—to both representational realism and symbolic geometry—helped make the art legible as modernist.

Indian modernism was distinct, however. Unlike American modernism, characterized by a "search for release from exhaustion," the Indian modern took shape as "an expression of a continuing vigour seeking new outlets." The art was "old, yet alive and dynamic." Indeed, the Indian artist, for Sloan and La Farge, synthesized, bridged, and hybridized difference in powerful ways. The work had "primitive directness and strength, yet at the same time . . . sophistication and subtlety. Indian painting is at once classic and modern."[44] These are oscillating figure-ground statements. In them, Sloan and La Farge struggled to make sense of the relation between tradition and the present, between representation and abstraction. Those dynamics defined an Indian modernism—or perhaps just modernism itself.

The classicism to which they referred included a gesture both to the strategies of a Western classical aesthetic *and* to a long, "classic" history of

Indian art. The Pueblo watercolorists exhibiting in New York applied "the discipline of line and color developed through centuries of decorating every imaginable object of daily or sacred use with designs innately suited to the objects decorated and charged with traditional cultural concepts."[45] Turning from new art production back to older traditions of pottery, weaving, and basketry, one could perceive in the old all the elements used and refigured in the new.

Like many of the young Native artists being cultivated in the schools of New Mexico and Oklahoma, Mary Sully never put her aesthetic intentions in print.[46] She had imagined for herself a career as a Native artist or designer, however, and here were Sloan—who had shown at and helped organize the 1913 Armory Show, taught at the Art Students League, and painted the Indian Southwest—and La Farge—who won the Pulitzer Prize in 1929 for his Indian novel *Laughing Boy*—making arguments about art that must have sounded something like her own: a base in traditional artistic expression, an engagement with modernity on the artist's terms, and meaningful intellectual and symbolic forms of geometrical abstraction and design. The only thing about their framing that must have given her pause was the hungry desire of the modern primitivist for an archaic authenticity. Her art would engage—and then reject—that particular concept. The bottom line, though, was that Indian art was first and foremost *art*; it deserved respect and an appropriately calibrated market. If drawn from the past, it also pointed to the aesthetic problems of the present and possibilities of the future.

STATE MODERN

Marsden Hartley, John Sloan, and the other circuit riders of the modernist West reflected five interlocking modes of engagement with Indians and Indianness. In them we can see the ways that cultural discourses linked—or did not link—to another important context for situating Mary Sully, that involving government policies and the arts. First, in the museums of Paris and Berlin and the landscapes of New Mexico, Hartley, Sloan, and others encountered ethnographic objects and American Indian people and practices, which produced *direct* cultural encounters. Second, these material encounters collided with a developing set of ideological contexts to produce

a particular *kind* of primitivism, one that offered an experience of authenticity and the possibility of self-identification and transformation. While in Germany, for example, Hartley confessed, "I find myself wanting to be an Indian . . . to go to the West and face the sun forever—that would seem the true expression of human dignity."[47] Sloan caricatured other observers of Indian life as superficial and touristic, underscoring a claim to the superiority of his own experience.

Third, this meaningful primitivist cultural imaginary was tightly wedded to an engagement with American cultural nationalism. Though Hartley was thoroughly enamored with Germany—often in ways that troubled his contemporaries—his view of Indians was that not of a German but of an American. He saw Indians as the most powerful signifier of American Indigeneity and thus of a form of resonant American nationalism.[48] Fourth, Hartley, Sloan, and many other artists experienced these dynamic engagements with Indianness through spatial oscillations with the Southwest, entering and leaving the region in ways that defined the circuits of modernism. "I am an American discovering America," Hartley wrote in 1918, while visiting Taos; "I like the position and I like the results."[49] Finally, modernist artists—and certainly their discourses—helped enable American Indian artists to produce work, situate themselves as artists, and, critically, to imagine *markets* for their art. In that context, the Venn diagram circle that contains the aesthetic overlapped with the circle containing the rapidly developing administrative capacities of the American *state*.

One of the main motives behind the Exposition of American Indian Arts was frustration with the Federal Office of Indian Affairs and its inability to support the economic possibilities for Native arts and crafts producers.[50] Indian policy reformers of the 1920s and 1930s saw Indian arts through the lens of modernist primitivism, but—like Sloan and La Farge—they also pushed it as a development asset for struggling reservation economies, which were under the tight oversight of the federal government. As Robert Schrader, Molly Mullin, Erika Bsumek, Elizabeth Hutchinson, and others have detailed, the Indian arts and crafts economies that emerged in the late nineteenth century had largely come to a standstill by the early 1930s.[51] Handcrafted Indian-made goods were inadequately distributed, priced, and marketed. Non-Indian-made mass-produced trinkets were labeled and sold

to tourists as "Indian," thus undercutting the already fragile market. The Indian Office proved to be of little help.

Appointed in 1933, New Deal reformist Indian commissioner John Collier sought to change the dynamics. He embraced efforts to build and support arts and crafts, culminating in the 1935 Indian Arts and Crafts Act, which created an Arts and Crafts Board to promote, protect, and develop Indian aesthetic economies. That board, chaired effectively by René d'Harnoncourt, would pursue falsely labeled commodities, create exhibition opportunities, and seek to market Indian arts and crafts.[52]

At the same time, Indian arts advocates sought to take advantage of New Deal efforts to support artists during the Great Depression. The first of these, the Public Works of Art Project, ran from December 1933 through March 1934. It advertised for artists, took applications, and established regional committees charged with selecting artists, some of whom were American Indians. Not surprisingly, Oklahoma and New Mexico—and particularly Santa Fe—emerged as small centers for public arts employment for Native artists, who created, among other products, murals at colleges, schools, and later post offices.[53]

As the PWAP ended, Nina Pereira Collier—John Collier's daughter in law—mounted an unsuccessful campaign for an extended project aimed specifically at Native artists. In 1936, seven months after the creation of the Federal Art Project (FAP)—the arts arm of the Works Progress Administration—Nina Collier met with its director, Holger Cahill about an Indian program, akin to the Indian branch of the Civilian Conservation Corps. Her proposal included everything from education and apprenticeship to easel painting to silver and leatherwork, to illustration and design to the mural painting so dear to the New Deal. Funding difficulties blocked the proposal, however, leaving Indian artists—and Nina Collier had identified some three hundred of them—to pursue support through the FAP. Not surprisingly, they saw only mixed success.[54]

In the 1930s the federal government became the most important patron of American arts. In addition to the Federal Art Project of the WPA and the Farm Services Administration's documentary photography projects, a number of federal agencies—including the Bureau of Indian Affairs—found opportunities for arts employment. Erika Doss notes that from 1933 to 1945, the various federal arts programs produced 3,350 public murals, 18,000 sculptures, 108,000 easel paintings, 250,000 prints, 2 million posters, and 500,000

photographs. The government spent $35 million and funded more than twelve thousand artists.[55] Throughout the 1930s, FAP works were exhibited in New York, at the Federal Art Gallery on Thirty-Eighth Street, modeling for Mary Sully and others the possibilities for federal arts support.[56]

Ella Deloria tried in these years to plug Sully into the New Deal efforts. Her strategy, however, focused on massaging high-ranking connections—Indian commissioner John Collier, for example—rather than addressing the paperwork grind that characterized the programs. While this approach had proven successful with the Episcopal Church—where she made direct personal appeals to the bishop of South Dakota—it failed in a more bureaucratic environment.

It is hard to know how many letters the sisters sent out on Sully's behalf. The few that survive suggest their strategies. An undated letter from the Mount Rushmore sculptor Gutzon Borglum suggests that Ella began by asking for "advice," a code word for assistance or patronage. In a 1937 letter to actress ZaSu Pitts, Mary Sully seems to have asked for permission to use Pitts's name under an image, a superfluous request that suggests the hope for patronage or purchase. In both cases, "the artist" remains mysterious: Ella did not name Sully or describe her as a sister, and Sully reverted to her Deloria name and pretended not to be the artist in question! Their efforts generated neither public nor private patronage. Indeed, the only governmental support offered in these years came to Ella, for a project among the Lumbee Indians of North Carolina. Sully designed costumes for a pageant organized by her sister. If the two entered the decade with hopes for Sully's art, they must have ended it knowing that she had missed a critical moment of opportunity. With federal support programs for artists, rising interests in folk art, and a renewed embrace of American artists speaking the languages of cultural nationalism, Sully was a logical candidate for government assistance and a public audience. But she received neither.

MODERN MARGINS

New Deal support accompanied and prodded stylistic and thematic shifts in American arts. In the 1910s and 1920s, modernisms ranged from the capturing of everyday lives of real people that enthralled the Ashcan School to

the conceptual experimentations of various avant-gardes, inspired by Europe but seeking to carry innovation forward in the United States. Now, cultural nationalism, a central aesthetic assertion of American modernism, became a "rescue ideal" in relation to the Great Depression. New styles—particularly regionalism and social realism—sought to capture American essentials, turning audiences, patrons, and artists away from abstraction and toward representational art (figs. 4.15 and 4.16).[57] While a number of future abstract expressionists—Jackson Pollock and Willem de Kooning in particular—were on the roster of the FAP, they produced work in the 1930s that more often than not fit the project's desire for figurative images.

As styles shifted and the ethnographic was challenged by the sociological, Mary Sully found herself increasingly out of alignment with the arts culture that surrounded

4.15. Thomas Hart Benton, *America Today (Building the City)* (1931). Egg tempera with oil glazing over Permalba on a gesso ground on linen mounted to wood panels, 92 × 117 inches. The Metropolitan Museum of Art, Gift of AXA Equitable. 2012.478a-j. Benton was known for his expressive realism and regionalist focus. His interest in the working lives of everyday people reflected aesthetics central to the arts programs of the New Deal.

her. Her project had bound its aesthetic challenges around an inflexible form, taking up art and design questions raised in earlier decades.[58] It makes some sense, then, to see the ways in which Sully's later style became more representational—if still cryptically symbolic—and gestured to more explicit Indian content, referencing both the developments in American Indian painting and a rising interest in alternative arts.

Sully's work emerged not only out of Great Plains Indian arts, experimental modernism, and post-1925 design but also from a cultural context that looked specifically for arts emanating from the margins. Within the mainstream art world, such work self-consciously proclaimed itself as avant-garde. But the real margins were global, temporal, social, and cultural: they included Mexico and the Caribbean, Asia, Africa, and the Pacific, "traditional" and "primitivist" art defined for its sense of being out of time or place. The 1931 Exposition of American Indian Arts sought to bring one such

4.16. Charles Sheeler, *Americana* (1931). Oil on canvas, 48 × 36 inches. Metropolitan Museum of Art, Edith and Milton Lowenthal Collection, Bequest of Edith Abrahamson Lowenthal. 1991.24.8. A painter and photographer of the geometries and forms of industrial America, Sheeler celebrated another key element of New Deal aesthetics, that of the transformation of modern life through technology and its rationalist efficiencies.

margin to the center. So did the black arts movement of the 1920s, the increasing institutional interest in "folk" art, and even the emergence of arts linked to margins such as the asylum and the prison.

Holger Cahill, who would later direct the New Deal's Federal Art Project, spent much of the 1920s building both exhibitions and a discourse surrounding folk art as an important native form.[59] By 1931 Cahill and Edith Halpert had opened the American Folk Art Gallery in New York, and in 1932 Cahill curated a large show at the Museum of Modern Art, *American Folk Art: The Art of the Common Man in America, 1750–1900.* Cahill's periodization made it clear, however, that contemporary artists were not part of his vision, nor were nonwhite artists who were not part of a European national heritage. At the same time, Cahill's sense of what folk art was—work absent professional training, with design qualities that made it useful to modern art, sincere and powerful in its crudeness, created by marginal artists that might include women and the working class—opened the door to the possibilities of contemporary folk arts. Indeed, during the 1930s the definition of "folk" arts shifted to include contemporary self-taught artists, validated by a 1938 MoMA show, *Masters of Popular Painting*, which featured works by housepainters John Kane and Lawrence Lebduska as well as African American artist Horace Pippin.[60]

The discourses surrounding "folk"—primitivism, self-taught, authenticity, cultural nationalism—might well have echoed in Sully's ears. Some clearly overlapped with discourses surrounding American Indian painting as framed by Sloan and La Farge. And Sully's artistic derivations from

traditional Plains Indian women's art are undeniable, though that context was more likely to be visible to Indianist primitivists than to theorists of folk art. Nor did "folk"—at least in Cahill's influential definition—extend its social intent much beyond beautiful but utilitarian craft production and intimate, authentic locality.

Unquestionably, the most important dialogue between margins and centers—a dialogue ripened and vibrant in the late 1920s—centered on the New Negro Arts Movement. As Emily Lutenski has demonstrated, the aesthetic connections between Harlem and the Southwest were deep, cross-racial, and productive of new possibilities.[61] And Mary Sully's life and art practice looked familiar in its context: Like many African American modernists, she was mobile and peripatetic, with no secure or steady source of income. Like them, her trajectory cut across conventional boundaries such as urban and rural, commercial and vernacular, European and non-European. If Langston Hughes, for example, was able to recount his beginnings in more international terms than Sully, the dynamics of constant movement, uncertain employment, nonpaying art, and cultural richness belonged to both of them.[62]

Moving spatially through New York and the Columbia neighborhood, Sully must have had some degree of encounter with a vibrant African American arts scene. In *Easter*, she places a black figure in the crowd. Her frequent use of silhouettes echoes not simply old silhouette traditions but also the work of Aaron Douglas, and later Jacob Lawrence. Her late 1930s list of personalities includes singer Marian Anderson, which might reflect either Sully's abiding interest in operatic and concert singers or the hypervisible race politics of the 1939 refusal by the Daughters of the American Revolution to let Anderson sing in Constitution Hall in Washington, DC, followed by her enormous Easter Concert at the Lincoln Memorial. Whether through Anderson's musical personality or the Easter event, Sully's inclusion of Anderson places the artist in at least a fragmentary dialogue with African American arts and cultures.[63]

And yet Mary Sully arrived in New York in 1931 with her project well under way, initially formed in Kansas and South Dakota, far from the Harlem Renaissance. While it seems likely that Sully engaged with black arts culture—it, too, was part of the indirect archive she assembled—the politics that drove African American arts, of uplift, integration, and race conscious-

ness, did not map easily to Sully's own slowly developing political consciousness, which would come to focus on a critique of conquest and colonization. Her only other visible engagement with African American culture in the personality prints project was highly mediated and problematic: a treatment of the character of "De Lawd" from Marc Connelly's 1930 play *The Green Pastures* (film version in 1936), which retold biblical stories in a black vernacular. Though one of one six Hollywood films of the period to have an entirely African American cast, the film was a spectacle of stereotypes constructed to present a sentimental, secularized experience of religion rather than race. Sully's image follows suit, suggesting that while she may have recognized historical ironies and stylistic opportunities in the relation between Indian and African America, she too easily folded herself into a white hegemonic position when it came to the material politics of race.

The margins and edges are places not only of critical opportunity but also of social, political, and economic danger. Groups of artists occupying such locations claim a kind of entitlement by proclaiming themselves (or having critics proclaim on their behalf) to be part of an avant-garde, a vanguard or advance guard. The metaphor is military and it lives both in space (the vanguard moves ahead) and progressive time (the vanguard attacks first while the remainder of the culture/army follows behind). Those on the edges take comfort in having edgy company.

A single artist like Mary Sully does not fit the metaphor. We might think of her more as an *éclaireuse,* a scout positioned in a liminal space that let her explore the terrain of the complicated present and the multiple possibilities of the future.[64] Without an institutional network or a *garde,* Sully invites consideration in light of categories that gesture to both the creative possibilities and the dangers of the *solo* artist on the edges: naive, vernacular, self-taught, outsider. Art historians have populated these categories with a remarkable number of "quiet artists"—those working for themselves, in local contexts, or in prisons or mental health facilities—and their work sometimes shares contextual elements with the personality prints project.

Edgy forms of intuitive art emerged out of religious visions or fantasy, for example, often in a context of hardship, incarceration, or institutionalization. Sully's work had little to do with such images of the fantastic, though there are insights to be drawn from their stylistic and formal elements.

Prison arts and other vernacular contexts suggest the compensatory power of bilateral and rotational symmetry, expansive color, and formal rhythm among artists with little training or few skills in drawing.[65] Sully's early work avoids the drafting of human faces and forms; even in later work (such as *The Indian Church*), her figures are quintessentially naive, often silhouettes or cartoon sketches. Geometrical abstraction, it turns out, offers a particularly vibrant set of opportunities for artists who might otherwise struggle with the representation of people.

Though psychological issues are central to her story, it is not clear that Mary Sully belongs in one beguiling category, that of "outsider art," for it continues to resonate (despite the expansion of the category in contemporary art) too closely with the midcentury French artist and collector Jean Dubuffet's notion of *art brut*. These were works made for the artist only, without any awareness of or engagement with an "art world" that inevitably absorbed and assimilated innovation. Outsider artists, in this sense, were untouchable by mainstream culture and its social and political contexts because they themselves were immune to it—thus the common linkage of *art brut* to artists defined by psychological disabilities that often led to institutionalization.[66] Sully confronted mental health challenges, to be sure, but she and her doctor rejected institutionalization, evidence that she was in fact "touchable" by mainstream culture. She envisioned an audience for her art, and the possibility of patronage and a market. She may have been marginal to many cultural valences, but she was not truly outside any of them. Indeed, through her wide engagement, one might argue instead that she created a new kind of cultural center around herself as an *éclaireuse*, marked by a "one-way" aesthetic engagement with the world. It spoke to her and she spoke to it, even if that world had few opportunities to listen.

THE IMPOSSIBLE SUBJECT

Mary Sully crafted her project out of joint in relation to her time and space. She was not well positioned to learn from the Harlem Renaissance. She gazed at the Indian arts market from a distance, and at the modernists through newspapers, magazines, and museum galleries. Sully was not folk enough for Holger Cahill's folk revivals and yet not professional enough—no showings,

no training—to be considered artist enough for the government programs.[67] New Deal funding possibilities, so painfully close, remained out of reach. Her selection of individuals and modes of expression drew from 1930s culture—she made most of her drawings during that decade. But the conceptual frameworks for the personality prints had been created by late 1927 and developed and rehearsed in 1928 and 1929, prior to the stock market crash, the unfolding of the Great Depression, and the coming of the New Deal. With the form set, the innovations of 1930s art produced for Mary Sully superficial stylistic resonances rather than deep formal ones. She mostly avoided the 1930s move to realism and its political urgency, remaining among a shrinking set of artists who continued to play with abstraction. When she took up politics in her later works, she focused not on the sociological world of New Deal arts but on the crushing weight of colonialism—an Indigenous critique with little popular traction.

Opportunity knocked during the 1930s for some artists, but not for Mary Sully. Her absence from the New Deal roster is particularly poignant because, in many ways, her project *was* timely. It was almost perfectly aligned with the FAP's interest in fostering national cultural unity through the arts, for what were the personality prints if not a collective portrait of America? Likewise, she might have fit herself into the Bureau of Indian Affairs' newfound interest in building Indian arts economies. Though her work speaks to and from many of the contexts of modernism and American Indian arts, she remains an impossible subject, difficult to locate in any program, school, category, or temporality—even that of "outsider" art.

Matters did not improve. The pictorial shifts in Sully's style in the late 1930s seem like minor adjustments when placed next to the radical transformations of the mid-1940s and the postwar period. Abstract expressionism challenged social realism, regionalism, the black arts movement, the muralists, the folk artists, and others. Even as abstract expressionists gestured to the pictograph and hieroglyph—yet another generation of artists to find primitivist inspiration in the Indian-inflected—they sucked the oxygen out of the room for an artist like Mary Sully, whose work must have seemed wildly out of date by the late 1940s.[68]

If Sloan and La Farge had offered in 1931 a kind of secondhand brief for her art, consider the critique implicit in the aesthetic offered by Willem

de Kooning: "I'm not interested in 'abstracting' or taking things out or reducing painting to design, form, line, and color. I paint this way because I can keep putting more things in it—drama, anger, pain, love, a figure, a horse, my ideas about space. Through your eyes it again becomes an emotion or idea."[69] The act that de Kooning rejected—of "abstracting" from the symbolic and representational world and offering well-plotted design, form, line, and color—had emerged as the heart and soul of Mary Sully's artistic practice. De Kooning's images of ferocious women destroyed the dialectics of figure and ground that had offered both formal and epistemological focus for Sully. She was in no way ready for abstract expressionism.

Nor were Indian arts standing still. As Jackson Rushing has argued, artists such as Joe Herrera simultaneously offered the most advanced expression of Studio Style painting and a direct challenge to it (see fig. 4.17). And Bill Anthes has definitively traced a new Native modern emergent between the 1940s and 1960s.[70] Herrera incorporated Studio Style training, ethnographic copy work, personal investigations of rock art, and kiva murals with painting in the now-classic modernist traditions of the early twentieth century, producing stunning new forms of Indian modernism in the 1950s.[71] Yanktonai artist Oscar Howe, after mural painting during the New Deal, abandoned the Santa Fe Studio Style in the 1940s for a quasi-cubist abstraction inspired by "spiderweb" planes and structures adapted from traditional Plains arts (see fig. 4.18).

4.17. Joe H. Herrera (Cochiti Pueblo, 1923–2001), *Untitled* (1951). Oil on board, 16 × 20 inches. University of New Mexico Art Museum, Jonson Gallery Collection. 82.221.1363. Courtesy of Joe H. Herrera Jr.

These were only a few of the Native artists exploring new possibilities. By the 1960s Native forms of abstraction, symbolism, cubism, and expressionism would be state of the art in Indian Country. Innovative Native arts found a new home in the Institute of American Indian Arts, built on the old Santa Fe Indian School legacy but focused on the development of new styles, media, and markets. In the context of both American art and Native American arts,

Mary Sully suffered not only from her own reticence but from an uncannily bad sense of timing. She arrived in the 1930s too late, carrying a sense of abstraction developed in the 1920s. By the time abstraction entered a new phase in the 1940s, she was doubly out of aesthetic time, in effect two decades out of sync—though, arguably, a prescient voice speaking not only to the past but to the future.

My mother once recalled that she had experienced Susie Deloria as something of an eavesdropper. If a conversation was taking place in the living room, Susie would sit at the top of the stairs or in the kitchen and listen in, never able or willing to take part. The metaphor aptly describes Mary Sully's relationship with modernism. It was a one-way conversation to which she listened attentively but was never able or willing to join. One might describe her engagement with American Indian arts in a similar way: she observed and learned, and sometimes gestured in its direction, but kept her distance. And she eavesdropped as well—though perhaps not as seriously—on the other artistic currents of the 1930s, which did not inspire her to abandon either the form or the conceptual thrust of *personality* that structured the project. Perhaps the position of *éclaireuse* rests on the skill of eavesdropping. Advance forces press ahead, egging one another along. A spy in the house of modernism watches and listens, observes and draws. Mary Sully watched and listened from a discreet distance to the sounds of American culture, positioning herself at its edges, the location from which artists see more clearly the social whole that they seek to capture through images.

4.18. Oscar Howe (Yanktonai Dakota, 1915–83), *Victory Dance* (ca. 1954). Watercolor on paper, 19 × 12 inches. Philbrook Museum of Art, Tulsa, Oklahoma, 1954.6

REALIZING MARY SULLY

PSYCHOLOGY AND CULTURE

The Nature of the Margin

I N A CHURCH ORGANIST (FIG. 5.1), GRAY VAULTED COLUMNS AND ARCHES frame a musical encounter, as notes emanate from the pipes of an organ and waft upward, changing shape and position as they move. At the bottom of the image, near the pipes, the notes are precisely arranged. As they reach a stained-glass window and ricochet off the ceiling, they scatter, bringing the eye and the ear into alignment around the rich pulses of a multitonal echo. The entire structure rings with the visuality of sound, and while it surely offers another example of Mary Sully's expressive imagination, *A Church Organist* also points to the very nature of her perception and her thinking.

In this book's second chapter, I traced Sully's personal history, pursuing questions about her upbringing and her psychological health. Chapter 3 explored the visual vocabularies open to her. The two parsed the personality prints by asking *who* she was and *what* she might have seen. In this chapter, I hope to peel back more layers, questioning *how* she saw—an issue of perception—and how she *made sense* of her marginality—a question that connects history, experience, and her own intellectual work. G. Wilse Robinson situated her as an individual subject shaped by personal history. We might now try to consider her as a *cultural* subject shaped by the traumas of

5.1. Mary Sully, *A Church Organist*

colonialism, the cutting-edge conversations of the moment, and the psychological challenges that shaped the moderns.

In the late 1920s, Susan Deloria remade herself, with a new vocation that explained her eccentricities as it focused her life around a coherent purpose. The four hundred–plus drawings that comprise the personality prints required significant time, energy, and commitment, undertaken during years of severe economic challenge and frequent travel. Many of Sully's contemporaries spent free hours with puzzles and games (to the chagrin of Dorothea Brande). She devised her own overambitious puzzles—how to capture and transform the essence of the voice on the radio, the profile in the magazine, the actor on the screen?—and then solved them through visual creations. Her works reflected a unique vision of American life, one that originated in her complex cultural positioning and her cosmopolitan travel circuit, which, if it missed Santa Fe and Oklahoma, cycled repeatedly through New York City, the northern Great Plains, and points in between.

Other Indian people—and other Indian artists—could boast similar forms of cosmopolitan experience and multicultural vision. Their works hewed more closely to "tradition," inspired and engaged with forms of antimodernism, however, while Sully's directly addressed the questions of modernism itself.[1] As we have seen, those questions often plumbed the relationship between individuals and their worlds. Was it more useful to think of people in terms of character or personality? Surface or depth? What someone said or what they seemed to be thinking? How they did or did not conform to the dictates of their society? And what should one make of nonconformism that blurred gently into seeming dysfunction, of (for example) the excessive shyness of someone like Mary Sully herself? How, in other words, did Sully think about the psychology of personality? And how did that thinking make its way to her paper and pencils?

The personality prints were portraits, to be sure, but they also meditated on Sully's own psychological issues. She "woke up" and reinvented herself as an artist, but that new self was never fully confident or complete. Recall the ambivalence of the sisters' 1946 response to Virginia Dorsey Lightfoot, in which Sully refused to speak for herself, letting Ella ventriloquize: she "does not want anything said about her or her work." Sully wanted the identity, but in a qualified way that evaded the possibility of criticism or

judgment: "She paints in oils, too, but not seriously." She refused to answer Dorsey's questions but "[felt] bad to be unable to help."[2] This ambivalence likely had something to do with her inability to pursue, in any but the most halfhearted way, patronage, sponsorship, or support during the years of the New Deal.

To understand that ambivalence more fully—and the ways that it may have shaped the art itself—one might consider more deeply Sully's relationship with her sister. In the late 1920s Ella Deloria realized that her life would include a dependent sister who camped out alone in her bedroom with paper and colored pencils. But it is equally clear that Sully brought value to what was actually a partnership: a listening ear, her own keen perceptual intelligence, and a shared awareness of the complications of cross-cultural knowledge production. As Ella watched over Sully's fragile personality, she also provided grist for Sully's mill, introducing ideas that the two discussed and that shaped Sully's interests. In this sense, the artist could not have been more fortunate, for in 1927, as Sully was commencing the personality prints and seizing a new identity, Ella Deloria made a similarly radical life change, which took her from the YWCA and the Haskell Indian School back to Columbia University and the leading edges of American anthropology.

Franz Boas hired Ella Deloria for a language translation project during the summer of 1927. She felt an immediate affinity for the work and developed a plan for her own re-creation of self—not as an artist but as a scholar. Ella's reinvention would take place in the context of linguistic anthropology and would return her to New York City. First, she overachieved Boas's translation assignments, moving quickly through a first round and then a second. She traveled to South Dakota to collect additional material, signaling to Boas that she was capable and eager. He gave her another assignment, corrections to an account of the Dakota Sun Dance, for which she received her first publication credit, in 1929, in the *Journal of American Folklore*.[3]

Ella's correspondence with Boas during the fall of 1927 is bold. She proposed that she leave Haskell and return to New York to work for him on translation and ethnographic training and then take up field investigation during the summers. In January 1928 Boas met her terms—two hundred dollars per month for linguistic work in New York and fieldwork in the Dakotas—as well as an offer to live at his home during the transition.[4] Her

sister stayed behind in Kansas City that winter, working as a domestic and very likely on the personality prints project.

In the summer of 1928, the sisters reunited in South Dakota for Ella Deloria's first season of field collection of Sioux linguistics and folklore. Their travels centered at Lake Andes, South Dakota, and the Yankton reservation home to which their father had retired. The sisters' brother, Vine, had been there almost a full year, watching over their failing father and resisting entreaties that he commit himself to the church and attend seminary. As a college graduate, athlete, and New York cosmopolitan in his own right, Vine found the routines of home to be a spinning of his wheels. When the sisters arrived in August for a quick visit on their way back to New York, he made his move—a hasty letter to the bishop declaring his love for Jesus and a desire to attend General Theological Seminary in New York City. Before Ella and Susie quite knew what was happening, the roles had been reversed: Vine was on a train to New York, and they were in Lake Andes caring for their father. And there they would stay—with occasional forays to Sioux Falls and Sioux City—until the spring of 1931, when they returned to New York.[5]

For Ella the years were marked by frustration: her life in anthropology had started well, but kinship obligations to her father did not permit her to leave him (or her sister) behind. The excellent salary that she had negotiated with Boas disappeared, and his correspondence grew testy, wondering when she would be back at Columbia. Ella offered to do translations, proposed ethnographic collecting—anything that would hold his interest, keep her in the field, and generate some income. Boas had seen in her a unique opportunity to secure a fieldworker who could serve as something more than a guide or translator.[6] As Margaret Mead would later observe, Ella was able to bridge two worlds. The observation is today a tired one—people like Ella and Mary Sully occupied a much more complex terrain than that captured by the "two worlds" metaphor. And indeed, Mead went on to frame Ella's "unique triple capacity": she was "one who knew much, who was extraordinarily favorably placed to further investigation, and who became steadily more sophisticated in the methods and standards of anthropological work."[7] As literary scholar Susan Gardner has pointed out, Boas recognized that Ella was unique: no one else was positioned to move so well in and out of so many different cultures—Dakota, academic, anthropological, American.[8] That movement

was witnessed firsthand by Mary Sully, and supported by her in material and intellectual ways.

Boas's interest in working with Ella Deloria likely led him to assign her to a study that had enough funding attached to satisfy her salary requirements. It did not concern linguistic translation or ethnographic collection, however, but instead focused on "the psychological tests by which it has been claimed racial differences can be established."[9] On February 6, 1928, Boas wrote two letters. The first was to Ella and it included money for her travel expenses to New York City; the second was to Otto Klineberg, a psychologist who Boas hoped would join the study, which was to be a cross-disciplinary collaboration between anthropology and psychology. Aware of the cultural bias involved in any form of intelligence testing, Boas thought that the development of a test might itself offer a mechanism for understanding a culture. He proposed to create intelligence tests based not in dominant white American cultural understandings but in minority cultures in the United States. His target groups included Dakota and Pueblo tribes, African Americans, and the "mountaineers of Tennessee." In a clever reversal, the tests could then be applied to white students in New York City to measure influences of race and environment. The anthropologist would begin by coming to an understanding of children's upbringing, after which the psychologist would devise and administer the test.[10] The issue was hardly foreign to Ella, who had been encouraged during her summer semester at the University of Kansas to consider intelligence testing of mixed-blood and full-blood Indian children and had rejected the idea, knowing that "there has never been an intelligence test given to fullblood children which has been fair because so much of it is foreign to their background."[11]

Klineberg would later become a heroic figure in social psychology, offering expert testimony on race, intelligence, and environment in the Delaware case that would be bundled as part of *Brown v. Board of Education*. That body of intellectual work began on this project, which was slated to include another Boas student, Zora Neale Hurston, on the African American side. During the sisters' two-and-a-half-year exile in South Dakota, the intelligence-testing project became the tenuous tie that held Ella Deloria and Franz Boas together, and it looped Mary Sully into a conversation at the leading edge of American social research. Boas offered Ella only loose

guidance, suggesting that she look for intelligence measures in physical patterns (sign language, for example) and form perception, and that she pay particular attention to social conditions that created either repression or unusual freedom of expression. His vision of Indian personality and culture had an evocative intersection with Indigenous aesthetics: beadwork, he thought, might offer opportunities to discover form perception and work persistence.[12] Klineberg came to the Standing Rock reservation in the spring and early summer of 1930 to convert Ella's anthropological observations into an intelligence test based on Dakota skills.

Imagine the sisters' cloistered years in South Dakota. Though Ella had been born at Yankton, the family had lived at Standing Rock for decades, and it—not Yankton—was the home of their closest friends. For Ella, that meant potential cultural informants as well, and they made a short-lived and unsuccessful attempt to return as a family to the northern reservation. Their father's failing health and the presence of many of his wife's relatives taxed Ella's meager finances and depleted her political capital with the church. The 1930 census found the sisters seeking respite in Sioux Falls but listed their professions not as "artist" and "ethnographer" but as "nurses." Her father's bank had failed in December 1928; Ella's failed two years later.[13]

Mary Sully, on the other hand, had her stock of paper, her colored pencils, her magazines, and perhaps a list of likely personalities for the project. To her, isolation at home offered few obstacles and the benefits of time and space. She almost certainly crafted a number of triptychs during the long months, even as Ella was trying to manage budget, health, church, kinship relations, and of course her own suddenly threatened career. The sisters must have conversed about the Klineberg project, as Ella struggled to produce the anthropological work that might define a Dakota-based intelligence test. In the end, the Sioux intelligence tests came to focus on skills Boas had noted and Mary Sully knew well from her own work: the ability to perceive, understand, remember, and reproduce beadwork patterns (fig. 5.2).[14]

5.2. Ella Deloria, *Beadwork Testing Pattern* (Otto Klineberg to Franz Boas, May 24, 1930). Author's collection

5.3. Mary Sully, *Eugene O'Neill* (reverse side)

As weavers, beaders, and quillworkers know well, the development and application of patterns poses significant intellectual challenge, requiring mathematical perception, spatial intelligence, memory work, and strategic and tactical planning. Such challenges are visible, for example, in some of Mary Sully's false starts. In *Eugene O'Neill* (fig. 5.3) one can see in the lightly drawn grid, frequent erasures, and sometimes wobbly pencil the difficulties of establishing, remembering, and executing complex pattern. As an intelligence test, beadwork patterns reflected a highly gendered view of Dakota culture, but the emphasis on general perceptual intelligence echoed a note found in many descriptions of Indian racial inheritance. John Sloan and Oliver La Farge, for example, began their manifesto with these words: "The American Indian race possesses an innate talent in the fine and applied arts. The Indian is a born artist; possessing a capacity for discipline and careful work, and a fine sense of line and rhythm, which seem to be inherent in the Mongoloid peoples."[15] Bishop Burleson, observing Indian students' skill in

handwriting, maps, and drawings, theorized an environmental origin: "their inherent training in observation from the old days, when upon the reading of the trail signs a man's very life depended, had produced an adaptation in this particular that was rather marked."[16] New Mexico patron Alice Corbin Henderson, writing about Awa Tsireh, echoed similar sentiments: "These young artists of the Pueblos had simply, with fine consistency, carried their distinctly Indian vision into a new field of expression. This new development, in fact, represented no 'break,' but was merely an extension of the centuries-old art tradition of the Pueblos."[17] Mary Austin, Dorothy Dunn, Oscar Jacobson, and others all articulated such essentialisms.

Like the aesthetic problems concerning perception, time, space, individuals, and cultures, a critical social issue floated through the air of modernity: How was one to make sense of racial difference in relation to cultural environment and historical development? And how were these categories impressed—or not—on individuals? Older understandings of innate racial qualities persisted, even as they collided with new ideas emphasizing relativism and environment, visible in the culturalist arguments found in anthropology, sociologists' reflections on immigration and assimilation, the drive for culture-based power erupting out of the Harlem Renaissance, and the various forms of white desire attached to Harlem, the Southwest, and other locations of "authentic," supposedly nonmodern culture. White "crossers" and "slummers" could insist on the absolute racial difference of other cultures while asserting equally strongly that they *themselves* could change in relation to Indian or black environments—and that racially defined others could be brought, through cultural change, into American society.[18] The Indian arts—quill, bead, basket, pottery, weaving, and more—seemed to have something to say to both the theoretical questions and the aesthetic ones. Klineberg, Deloria, and Boas sought to engage those issues through the medium of the racial intelligence test. Sully's personality prints sought to do so through the production of images. The projects were joined at the hip.

The sisters returned to New York in the spring of 1931, spent that summer in the Dakotas conducting fieldwork, and then circled back to the city in the fall—just in time to visit the Exposition of American Indian Arts, which opened in December of that year. For the next three years, this work rhythm played out well. Despite the economic crisis of the Depression, a small but

reliable stream of funding flowed; the sisters survived and found a measure of stability. These must have been good years for the personality prints project, and it is likely no coincidence that the year 1934 attaches to significant events in the lives of so many of Sully's subjects. Boas was entering a spiral of declining health, however, and delegated the management of Deloria's work to Ruth Fulton Benedict, who would become a significant intellectual figure in the lives of both sisters.

SULLY AND PSYCHOLOGY REVISITED

Mary Sully's thinking surely drew from the larger culture of personality advanced by the mass media of the 1920s. It gestured to the experiments in the modernist portraiture undertaken by De Zayas, Picabia, Demuth, and others. It quite likely drew from her sister's engagements, first in 1926 and then in 1930, with questions of racial intelligence. And it almost certainly enlisted her own experience in 1925, when she went through something like "the talking cure" with G. Wilse Robinson. That experience—and her sister's speculations about "bumps on her neck" and other theories—confronted Sully in a personal way with psychological ideas and practices. Though we cannot offer a diagnosis for her ills, it may be useful to speculate at the edge of her psychology, for the personality prints—for all their artistic ambitions— also functioned as a kind of personal therapy or coping strategy.

Susan Deloria may have had episodes of reactive depression; that is, rather than an organization of brain neurotransmission that produces deep lingering depression (treatable today through antidepressants), her personality, interacting with the events and environments that surrounded her, was subject to a numerous discrete periods of depression.[19] A number of events might have generated such episodes: the death of her mother in 1916, the failed 1924 attempt to open a store, an equally futile 1926 effort to create a business making and selling dolls. Indeed, as Ella would point out in a 1925 letter, these were not her only failures: "Susie has made in all roughly speaking, a dozen or more attempts to train for something and has never carried a thing through. She is, therefore, not qualified to hold the humblest position and is today working for her room and board in a modest home in Lawrence, Kansas."[20]

Susie Deloria confronted environmental factors that magnified her individual challenges. As Ella observed, Susie had grown up being whipsawed culturally between the worlds of reservation home and church boarding school. Her self-presentation was under constant surveillance from both church teachers and administrators and the Indian community, both of which could be highly—and sometimes capriciously—judgmental. She trailed behind an older sister who demonstrated conspicuous achievement, and she was apt to be upstaged by a younger brother who was athletically gifted and socially gregarious. She magnified class anxieties, particularly at All Saints School, complaining later, "I went to school on money that was not mine . . . and I used to be very sensitive about it and I just couldn't live up to the best that was in me."[21] The death of her mother let her take refuge at home following high school—not the best choice for her—but her father's remarriage in 1917 brought a challenging stepmother into her family. Susie fled South Dakota to tag along with Ella in Kansas, a new but equally difficult environment where she knew no one and had no additional support or sympathy.

In every context, Susie Deloria confronted expectations and barriers having to do with race: How to be Indian in a white world? To be stereotyped by an American vision of noble Indian princesshood? To listen as bishops and anthropologists debated ideas of racial intelligence, knowing that you might stand as an example for one of their claims? What did it mean to be a mixed-blood in an Indian world? To be light-skinned in a reservation school? To be the daughter of a Native missionary, and thus of an institution that—for all of its potential for resistance and cultural persistence—was also a mainstay of colonial domination?

Susie's place as a woman was no less vexed. She may have aspired to be an artist, but when she bent her education toward a career path the road narrowed: primary school art *teacher*. How would she reconcile the conservative gender conventions required of Dakota women, the Victorian prescriptions that the church offered its women, and the challenging cultures of liberation that spilled from movies and magazines in the 1920s?[22] The combination of race issues, gender prescriptions, and persistent poverty arrayed themselves in shifting constellations during the course of her life, changing over time but generating structural conditions in which it was difficult to express anger or offer open resistance.

And one might wonder about the cumulative, intergenerational effects of what we might describe as historical trauma. Her father had confronted the full effect of the transition to reservation colonial supervision, sent off to a missionary school with his hair cut. In adulthood, he constantly sought to hold his family together as he watched three wives sicken and die. In 1890 he had been asked to ride out to Sitting Bull's camp to persuade him to come in to the agency, only weeks before the leader was killed, with the soul-piercing trauma of the Wounded Knee massacre following shortly after. Sully accompanied her sister as she gathered up the testimony and the language of the old people, a constant reminder of both the supposed pastness of Indian history and the repressions that sought to erase its memory. And if she wanted the name "Sully" to evoke the portraitist Thomas, it could not help but gesture also to the harsh military history of the general, Alfred. These were only some of the legacies she carried.

Under such conditions, depression and agoraphobia might be considered rational responses, and they were capable of doubling and tripling their weight and effect.[23] Ella praised Susie for her intelligence, artistic gifts, and sensitivity and noted that she *would* have done well in her courses but for her frequent "health" issues. Since Ella was equally positive about Susie's good physical health, it seems probable that attending class put her under stress, which inhibited her performance . . . which then added additional stress, which led to missed classes . . . which added additional stress, creating a spiral that ended with poor grades and withdrawals.

But if Susie became increasingly withdrawn, she also manifested early symptoms that went beyond depression, usefully seen in terms of anxiety disorder and panic attacks. On more than one occasion, Ella described abrupt "fainting spells" when Susie had to meet people. "Poor child," Ella wrote, "she never could go to communion at any big service without nearly falling down and suffering all the way."[24] In 1925, trying to argue that her sister was doing better and might take up college again, Ella boasted that Susie had been able to take Easter communion at the 11:00 (large) service, reporting to Ella, "I was as calm as if I were alone in that Church."[25]

As we have seen, Susie navigated the anonymity of the city. Her anxieties may have been less about crowds of strangers than about her performance in small groups or in situations that required face-to-face social engagement.

In those circumstances—meeting people, attending church, offering small talk—one finds again and again the key words that attached to her life: shyness, bashfulness, nervousness, oversensitivity. Every time Susie had to meet people, she confronted an "inward conflict . . . till it ended by her not going out, but staying at home crying because she couldn't be like the other girls."[26] During her time at G. Wilse Robinson's clinic, Susie offered descriptions of her improvement that described her actual symptoms: "Isn't it strange," she recounted to Ella, "that I haven't the hesitancy about meeting people now? I think why I used to avoid everyone was that I couldn't explain what was the trouble and I was always afraid they might think I was just no account and lazy."[27] Robinson's therapy regime did not, despite her cheery assurances, help with these problems over the long (or even short) term. Indeed, Susie's narrative of a nearly instant cure suggests the ways that she knew the psychological script well enough to be self-delusional or manipulative or both.

In her correspondence, Ella hinted at other symptoms that might have gone beyond anxiety attacks and that might also have led to self-seclusion—intense and debilitating periods of an altered state of mind, perhaps more characteristic of bipolar disorders.[28] In March 1925, Susie "had a melancholy spell . . . and was much exhausted."[29] "When she is herself," said Ella, "she is so very sane that it seems a crime to accuse her. And then when she is beyond controlling herself, she is most unreasonable, and makes such scenes as I would die to have anyone see."[30] Both my father and my aunt recall periods when she could be frightening. My aunt has long harbored suspicions about Susie's aggressive actions in disciplining her. And my father resisted mightily when Ella and Susie proposed to enroll him in a New York school, where they would "look after him."[31]

Susie's issues—depression, anxiety, perhaps some form of bipolar disorder—produced a prolonged fallow. In the fall of 1925, following Susie's treatment with Robinson, Ella noted that she was happy to see her sister "persisting in trying to find something definite to do to earn her living, where, for years she seemed utterly indifferent to earning her way."[32] Yet Ella also noted that it was "pathetic that she cannot, with all her brains, artistic sense, and refinement, find herself qualified to do any but the merest housework at twenty-five dollars a month."[33] Indeed, Ella tried hard to wean Susie, realizing that she had become not only financially but also emotionally

dependent. Ella made it clear to Bishop Burleson that she had supported Susie financially from the first moments she made money herself, and that Susie had long assumed such support was her due. She begged Burleson, who was then pursuing Susie's enrollment at Tabor College, to list Susie's age as twenty-one: "I believe there is a psychological effect on her (or anyone in her predicament) to fear that everyone knows she has reached 28 without making something of herself. Truly, I feel that she is not a great deal beyond twenty in actual development because these last several years have been lived in a coma, and she has not had the life that girls of her age enjoy."[34] What *was* clear to Ella was that Susie had "heaps of talent," if she could just find a way to put it to use and make something of herself. The correspondence course in poster design, the semester at the University of Kansas, the Chicago effort: all aimed to help Susie wake up and live. In January 1927 Ella told the bishop that while "living is cheaper in Kansas, it offers nothing for her art! And it has been deadly to keep her here near me and dependent."[35]

This moment, in late 1927 and early 1928, marked turns in both lives. Ella returned to New York and remade herself as a linguistic anthropologist and Native ethnographer. Susie remade herself as Mary Sully, artist and designer, though she never felt fully comfortable with her new name and the identity it signified. In her response to Virginia Lightfoot Dorsey, for example, Ella uses both "Susie Mary" and "Mary." At times, Sully went by Mary Deloria or Mary Susie Deloria or (on one occasion) "Mary Sue Deloria," suggesting an ongoing experiment in naming a fluid kind of personality.

PERCEPTION AND PERSONALITY

These shifting modes of self-presentation—and the art itself—lend themselves to at least one other way of thinking about her mental health issues: synesthesia, a neurodevelopmental condition in which stimulation to one of the five senses—sound, for example—generates a consistent and automatic response in a different sense—color perception, for instance. Writers, artists, and musicians have long sought to create synesthetic experiences for themselves and their audiences—it is an old and powerfully metaphoric way of thinking and perceiving.[36] The two varieties, it is worth noting, are distinct: physiological synesthesia, in which perceptual wires get crossed, is not the

same as aesthetic synesthesia, in which an artist attempts to overlap or double sensory perceptions in the viewer.

Sully's images frequently cross color with movement (recall the colored disk that organizes the optical illusion in *Dizzy Dean* or the racetrack ovals in *Sir Malcolm Campbell*) or music (recall the sonic color erupting from the organ pipes in *Jesse Crawford* or the strings of *Mildred Dilling*'s harp). Such images can easily be read as having aesthetically focused synesthetic qualities. Indeed, music and the language used to describe it frequently rely on the notion of "color" or "shade." Minor keys are "darker," major keys "lighter." Chordal variations produce tonal "color." The organ itself is designed to offer a performer a huge range of musical colors, so the image-color relationship in *A Church Organist* or *Jesse Crawford* makes sense on its own terms.

In *A Church Organist*, a central bank of pipes produces notated sounds, each closely positioned in relation to a specific pipe and distinguished by distinct colors (fig. 5.4a). A set of three red notes, each subtly different in shade, suggests three distinct chromatic notes played in a lower register. A purple-blue-yellow combination near the top of the pipes suggests newly sounded melodic notes. Slightly above the pipes, a black-gray-white set of notes—a previously played phrase—resounds in the air and is still visibly linked to specific pipes. Rising higher still, toward the stained-glass window, are more notes: white, black, green, and turquoise. Their diamond shapes suggest that they are earlier phrases, now echoing through the church (fig. 5.4b). Near the ceiling, notes of many colors scatter, intelligible no longer as musical melodies but as the reverberating feel and affect of the organ's sound, vibrations made visible in the zigzagging waveform imagery introduced into the window frame itself.

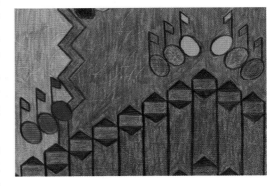

5.4a. Mary Sully, *A Church Organist* (detail): Notes placed near the organ pipes suggest an effort to represent specific melody and harmony.

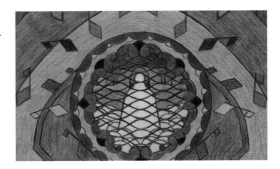

5.4b. Mary Sully, *A Church Organist* (detail): As the notes rise higher into the vault of the church, their transformation from oval to diamond shapes reveals the attenuation of specific pitch and instead emphasizes reverberation, echo, and a transition to generalized "sound."

The image is not simply a representation; it is evidence of a finely honed perception that has intricately linked together color, sound, and spatiality. Indeed, one might reverse engineer the image, linking each pictured note to the sound of a specific organ pipe, giving a sense of the music—if not of a specific melody, then of relative pitches, high and low. You might place them in a time sequence using the criterion of distance from the pipes. Perhaps the two sets of notes closest to the pipes—shades of red and purple-blue-yellow—reflect notes sounded together, not melody but harmony. Here is an aesthetic that quickly and brilliantly short-circuits perceptual gaps between sound, color, and spatiality.

Beyond its role as an evocative representational practice, however, synesthesia is also a physiological condition. It is, in that sense, the *involuntary* joining of one sense to another at the moment of perception. Not a choice, in other words, but an inevitability. The second sensory experience, the one that is being connected, is not simply imagined; it is *perceived*, as neurotransmitters cross from one sense perception pathway to another. People with synesthesia literally taste shapes, hear colors, smell sounds. And for some, those pathways carry back-and-forth traffic: in other words, a sound may generate the perception of a color—but a color might also carry the perceptual feel of a sound.[37]

Synesthesia can reflect a number of positive cognitive alterations—excellent memory, higher aesthetic or creative sensitivity, strong performance on tests of perception, or perfect pitch. At the same time, however, synesthesia can also be accompanied by challenges, including difficulties with math, sense of direction, and the abstract thinking used in poetry or philosophy. Many synesthetes are unaware that they experience the world differently from the majority of the population, and growing to maturity with unusual sensory perceptions can lead to social struggles as they work to fit themselves into the developmental structures that produce social and cultural common sense.

Psychologist Richard Cytowic offers a detailed "composite" portrait of a synesthete. With only a few exceptions (left vs. right handed, for example), it hews remarkably close what we might take to be a description of Mary Sully:

> A left-handed female who feels alienated, has a cosmic and comprehensive worldview (weltanschauung), and a feeling of self-importance, or

sense that something quite special will happen to her at any moment. She is shy, sensitive, and runs the emotional gamut from the highest highs to the lowest lows on a constant basis. She is also artistic and creative and has a propensity to engage in the visual arts, often later in life. She is highly intelligent and intuitive, but conveys an abstruseness that causes others to perceive her as "dense" and difficult to understand. She is embarrassed and confused by her condition and will not reveal it to many people. However, to lose her synesthesia would be catastrophic, denying her a most rich and enjoyable way of seeing the world.[38]

Synesthetes have described the importance of the relationship between color and symmetry, and the condition has long been associated with visual arts and music. One psychologist, for example, surveyed a sample of 358 fine art students and reported that 23 percent (n=84) experienced some form of synesthesia, a much higher rate than in the population at large.[39] Others have linked synesthesia to hypersensitivity and intense somatic responses to stresses, including meeting new people, hearing loud sounds, receiving criticism, and experiencing moments of embarrassment. These, of course, are among the very factors that show up in Ella's accounts of Mary Sully's failures to thrive in social situations.

The case for Sully as a synesthete is impossible to prove, and there are reasons to proceed with caution. Some synesthetic artists, for example, describe their work as "visionary," meaning that they simply record the complete and holistic image that appears in their mind. They do not construct an image so much as capture a visualization. Such visualizations, it seems, are not pictorial but elementary and completely abstract in nature. With only a very few exceptions, Mary Sully's work engages enough of the representational and symbolic to suggest that it is not simply the direct recording of a synesthetic visualization.

Most synesthetic artists, however, find ways to harness their vision, producing work that is informed by, but not directly representational of, synesthetic experience. Others find that synesthesia plays a more-or-less unconscious role in their work. Carol Steen, for example, was initially unaware of her synesthesia. Awareness of her condition led Steen to transform her arts practice in order to take full advantage of it.[40] Many of the artists in Sharyn

Udall's 2010 collection *Sensory Crossovers* offer such "harnessed works," which incorporate both synesthetic imagery and different forms of representation and abstraction.[41] It is possible that Mary Sully, too, found inspiration in shapes, colors, and symmetry while rarely attempting to replicate her unique perceptions in a literal sense. Or she may have sought to blend her remarkable perceptual skills together with multiple visions, representing something of a synesthetic experience but blurring it with Sioux visions of color, symmetry, and form and her own sense of modernist abstraction.

Given the struggles and constraints on her life, it is tempting to consider whether some part of Mary Sully's social and psychological difficulties originated in a perception of the world that was physiological more than it was cultural. Richard Cytowic and David Eagleman point out that synesthetes often experience ridicule in school settings where their parallel senses produce insights that make no sense to peers and teachers. While many synesthetes are able to identify their differences, others grow to adulthood with little idea that they are experiencing the world differently—which intensifies the opportunities for alienation and misunderstanding. For someone like Mary Sully, who carried not simply physiological and psychological burdens but also social and cultural ones, withdrawal into a private world—or at least one that was small, close, and intimate—might well have been a logical option.

MARY SULLY AND MUSIC

Sully loved film stars, and many of her images seem to spring straight out of Hollywood. But close behind was music—and in particular the brand of crossover artist who jumped from the opera hall to the radio studio and back again, or the famous bandmaster who brought patriotic music to universities and small-town circuits. John Philip Sousa toured his band for four decades, from its founding in 1892 until his death in 1932—which came shortly after leading a band in rehearsal of his most familiar piece, *The Stars and Stripes Forever*. Sousa's father was a member of the Marine Band, and Sousa began studying several instruments when he was six years old. After his own stint in the Marine Band, Sousa commenced a career performing and conducting. In 1880 he became the leader of the

Marine Band, serving five presidents before leaving the post to create the John Philip Sousa Band. Over the course of his career, Sousa composed 136 marches—many still prominent in band repertoires—15 operettas, and 70 songs, among other pieces. He was also involved in the invention of the sousaphone, the forward-facing tuba that has anchored marching bands for the last century—though Sousa conceived of it as a concert instrument, and his band did not march. Sousa was a friend of the University of Illinois's first director of bands, Albert Austin Harding, and thought the Illinois group the "world's greatest concert band." In 1929 he wrote the *University of Illinois March*, and the following year he served as guest conductor, splitting a concert with Harding.

Sully's use of color here is symbolic more than it is synesthetic, with the orange and blue that dominate the second and third panels reflecting the colors of the University of Illinois. In the top panel, the sousaphone is framed in red, white, and blue, and the notes that it emits have the same patriotic color palette. They are arranged on a circular field of green, in marching band formation, with horizontal orange bars suggesting the seats of a stadium and the bells of the sousaphones marking the edges of a football field. At the same time, however, the circular field of green also functions as the front view of a sousaphone itself. In the second panel, a nod to the University of Illinois emerges in the orange-and-blue background, with cubed orange triangles representing the distinctive bell of the instrument and overlapped green circles suggesting what Sousa intended for the horn: frontal projection of sound. Here, the sound grows louder as each circle expands, in a way that might recall Arthur Dove's synesthetic painting *Foghorns*. In the bottom panel, the green arrows suggest something similar—the directionality of green sound, and a robust red, white, and blue patriotism. Six red, white, and blue (and green) images form a mild optical illusion: Are these diamond-shaped notes with stems and flags? Or are they blue boxes, open at top and bottom and drawn with perspective, so as to appear alternately from above and then from below?

Born in 1896 in Bakersfield, California, Lawrence Tibbett was a major glamour figure in American opera during the 1930s and 1940s. He studied voice in New York City and in 1923 signed his first contract with the New York Metropolitan Opera. Tibbett's story is classic and familiar. After

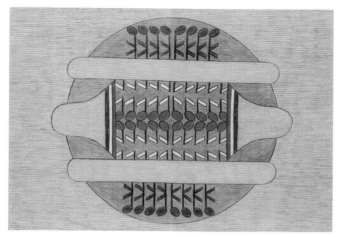

Mary Sully, *John Philip Sousa*

Mary Sully, *Lawrence Tibbett*

appearing in lesser roles and as an understudy, he was hastily recruited, in 1925, as a last-minute replacement. Tibbett seized the moment, offering a dramatic interpretation that brought down the house, inspiring a sixteen-minute ovation. It marked the first time that an American-born singer, without any European training, had created such a furor. Tibbett had a powerful bass-baritone voice and a dramatic stage presence (one biographer calls him a "singing actor"), and he built a successful career. In 1940 Tibbett's voice was afflicted by an undisclosed illness, and his singing declined. He turned eventually to a leadership role with the American Guild of Musical Artists, which he cofounded in 1936 and led as president from 1940 to 1952.

Mary Sully's image for Tibbett offers one of her finest and most complex optical illusions, one so seemingly open and so rich with color that its blobs and shapes skirt synesthetic abstraction—though it also contains clear representations in the form of hills and musical notes. The notes explode with a wide-ranging color palette that runs up the central axis of the picture. On either side are loosely bounded forms filled with bars and patterns of color. Outlines and radical color shifts seem to limn a humanoid figure, with two pink notes serving as eyes, a yellow triangle as a nose, and two outstretched arms, emphasized in yellow. A closer look, however, reveals that this figure is the abstract side of an illusion, one formed by the eye's natural tendency to follow color and a strong vertical axis. Refocus your attention on the brown background, and you'll see a modernist representation of a canyon, with side canyons nearby and open holes in the terrain. The bands of color are the representations of sedimentary rocks—purple and black, orange and blue, red, black, and white. And the colored notes are music erupting out of a canyon, most likely Temescal Canyon, near Santa Monica, where Lawrence Tibbett had a small cabin and where, in a rustic amphitheater, he occasionally performed. In the middle panel, as if through a pinhole in a camera obscura, the scene is further abstracted—and turned upside down. The mountains and sky occupy the bottom of the pattern, while the pinhole view becomes a note shape, with an accompanying flag dropping below. In the bottom panel, the colors of both the land and the music are converted to a center-symmetry kaleidoscopic pattern perfectly suited to the explosions of color Sully associated with Tibbett's voice and music.

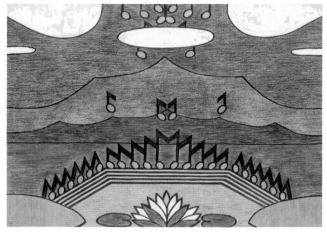

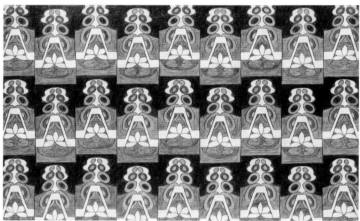

Mary Sully, *Lily (Pons)*

Though the title for this image is handwritten on the back as simply "Lily," it almost certainly refers to Lily Pons, a French-American opera singer, actress, and cultural icon active from the 1930s until her retirement in 1973. A talented pianist and singer, Pons did not begin serious vocal training until 1925, when she was twenty-seven years old. She sang in French provincial opera houses until her discovery and signing by the Metropolitan Opera in 1930, where she served as a principal coloratura soprano for thirty years. Pons starred in three films in the mid-1930s, *I Dream Too Much* (1935), *That Girl from Paris* (1936), and *Hitting a New High* (1937). Pons was also a familiar pitchperson for various companies, and she marketed herself and her personality in women's magazines. In 1932 opera fan George Leicester Thomas, whose family ran a fish and aquatic plants company in Frederick County, Maryland, successfully lobbied for a post office, which was installed in the back room of the business with the locator name "Lilypons, MD." Pons herself, with much fanfare, attended the post office's dedication in 1936, floating in a canoe across the lily ponds and gathering flowers to return to her home in Connecticut. She returned in 1938, and she made it her practice to send her Christmas cards to Maryland to be postmarked "Lilypons."[42]

The representational clarity of the image—a lily, flanked by two ponds—echoes the strategy employed by Pons herself and by her admirer George Thomas, who played off the homonymic associations (lilly to Lily, ponds to Pons) in order to fix her personality as meaningful and memorable. Musical notes emanate from a musical staff–like bridge and float upward to heaven. In an effort to reinforce the whiteness of the lily—the central color linked to the image and the sound—Sully has stepped outside of the medium of colored pencil, applying paint to the oval forms of the clouds. In the second panel, the linkage between white flower, musical bridge, and white cloud is heightened, as white stands out against blue and green backgrounds. As the notes ascend, however, they take on other musical colors, in particular the color red, which is not visible in the top panel. Red comes to structure the bottom panel, however, as thirty red diamonds refigure the music, even as abstracted white and green figures capture the vertical axis of flower, bridge, and cloud.

Isolated as she was, Mary Sully always had a strong lifeline to the world: her sister was a powerful personality in her own right and navigated difficult intellectual and institutional terrain of her own. Ella's daytime conversations came home at night; her challenges—not Sully's—may well have centered the relationship. Indeed, my aunt Barbara Sanchez recalls not only Ella's oversight of her sister but also the ways that Mary Sully nurtured and prodded Ella, who struggled for years to finish her ethnography, *The Dakota Way of Life*.[43] The intellectual dynamics between the sisters became particularly evocative when they returned in 1931 to New York City, where Ella continued her anthropological training in seminars taught by Franz Boas and Ruth Benedict, thinkers worth considering as intellectual influences on Sully's project. Benedict, in particular, drew insights from social margins as she pursued two themes at the heart of Sully's art: cultural "patterning," and the relationship between individuals and cultures. In 1931 she began Social Science Research Council "Project 35," a study of the "culture and personality of North American Indians," which emphasized long-term fieldwork among twenty tribes.[44]

Ruth Benedict's scholarship was deeply informed by her own positionality. She had a close relationship with her former student, intellectual colleague, and sometime lover Margaret Mead. In the summer of 1928, while Ella was learning the ethnographic ropes in South Dakota, Benedict and the newly divorced and not-yet-remarried Mead had stayed together in Mead's New York apartment. Scholars of these two inspired women have suggested that during that summer, Benedict realized that while she and Mead had no romantic future together—Mead was truly bisexual and refused to be placed in a compromising social position as a lesbian—Benedict herself was willing to take a different path. As Benedict biographer Margaret Caffrey puts it, the relationship with Mead "affected her so deeply that from that time forward, she became a woman-loving woman, willing to try a relation socially as well as spiritually with another woman."[45] In 1930 Benedict formally separated from her husband, and in 1931, as Ella (and her sister) were reentering the Boasian world, Benedict established a relationship with a woman named Natalie Raymond.[46]

Benedict then turned, in at least some of her scholarship, to the question of homosexuality and the cultural definitions of "abnormality." Boasian anthropology—with its emphasis on close ethnographic study, comparative interpretation, and cultural relativism—proved a perfect vehicle for Benedict, who could easily move across time and space to demonstrate that other cultures viewed homosexuality quite differently. Anthropology helped destabilize "the normal," and intellectuals like Benedict, Boas, and Klineberg carried that news into the discipline of psychology, which—having helped establish parameters for "normal" and "abnormal"—was well placed to question and undo those categories.

In 1932 Benedict began writing two pieces that not only laid out the argument but also modeled an interdisciplinary approach to the relationship between "personality and culture." She published the first, "Anthropology and the Abnormal," in the *Journal of General Psychology* in 1934. The second was a full-length book, *Patterns of Culture* (also published in 1934), which proved to be one of the most important pieces of anthropological writing of the twentieth century.[47] Benedict argued against biological determinisms and pushed readers to look always for complex cultural explanations—and thus for the possibility of directed social and cultural change. Humans had made their worlds, and they could unmake and remake them.

Benedict wanted her readers to think about the place of the individual within culture. The question of "personality"—what social mechanisms formed it, whether it was conformist or unique, and how one would know—had left its fingerprints all over the 1920s, and Benedict was about to bring it to full fruition in the 1930s. Many of the questions had been taken up by medical thinkers, primarily psychologists, who focused on individual cases and the environments that had produced them.

Benedict suggested something different—that one could also think heuristically about culture as "personality writ large." When she said this, she aimed not to reduce any one culture to a characteristic personality, but to emphasize context and historical change. Cultures selected features from an "arc of possible human behavior." Too broad a range of selections produced unintelligibility; therefore, cultures depended on "the selection of some segments of this arc. Every human society everywhere has made such selection in its cultural institutions. Each from the point of view of another ignores

fundamentals and exploits irrelevancies."[48] Certain traits, she suggested, might over time take on disproportionate weight in a particular culture, giving not an absolute character but a historically developed set of priorities and interests. For an observer looking at the abrupt shifts in social and cultural forms over the preceding decades, and those that characterized the Great Depression and New Deal, the United States looked like a perfect laboratory to consider "personality writ large" in relation to historical change.[49]

Benedict's fusion of psychology's "individual" with anthropology's "culture" allowed her to discuss cultures holistically even while emphasizing variation across time and space—or in the real-time distinctions between professed ideals and actual practices. *Patterns of Culture* also encouraged readers to consider the ways cultures produced and valued individuals, and the relationship between a person and their culture. Most individuals, she suggested, had "congenial responses"—personalities—that aligned well with their cultures, though some did not. Those people mattered. She made the case for the study of those "whose congenial responses fall in that arc of behavior which is not capitalized by their culture. These abnormals are those who are not supported by the institutions of their civilization. They are the exceptions who have not easily taken the traditional forms of their culture."[50]

Such individuals were not psychopathic; rather, they could be found in the categories at the social margins: the hobo, the trance-seer, the homosexual, the shaman—and the artist. Benedict suggested two possibilities for such people: the culturally uncongenial individual might cultivate "a greater objective interest in his own preferences," engaging in a meta-reflection on self and society that would allow one to manage one's difference rather than to be forced into conformity. In tandem, however, societies could—and should—increase their tolerance. "Tradition," she argued, "is as neurotic as any patient."[51]

Both possibilities offered a brief for Mary Sully. The first described her own position as an "uncongenial"; the second held out the possibility of social change, and thus the potential for a politics. By the mid-1930s Ruth Benedict had become the central intellectual figure in the world Ella and her sister occupied. In that context, it is worth noting Sully's willingness to draw portraits not simply of popular celebrities but of those edging into cultural uncongeniality. We might return, for example, to Sully's decision to draw

5.5. Mary Sully, *Lunt and Fontanne*

Patsy Kelly, a performative, nonconforming lesbian in Hollywood who paid the price for celebrating the social margins. Kelly, in turn, might lead us to reconsider the parfleche boxes representing Lunt and Fontanne, which are drawn not in traditional colors of red, yellow, blue, and green but rather in light purple, clearly a gesture to their "lavender marriage," which is ornately celebrated in the triptych's first panel (fig. 5.5).

Studying Sully's personalities with an eye on sexuality, one might linger on her choices of Edna St. Vincent Millay, Katharine Cornell, Greta Garbo, Noel Coward, and Alexander Woollcott, among others—all individuals willing to step to the far edges of heteronormativity and beyond—as subjects of her prints. My own analytical interests in triangulating Sully in relation to Charles Demuth and Marsden Hartley (recall O'Neill's conflation of the two men)

might lead directly back to *Gertrude Stein* (fig. 5.6)—made into a "personality" portrait not only by Demuth and Sully but by Hartley as well. Here, Sully herself is surrounded by three critical figures of queer modernism. And this kind of reorientation—courtesy of figures such as Benedict and Stein—suggests a number of others from equally interesting social margins: the dwarfed electrical engineer Charles Steinmetz, leprous saint Father Damien, deaf and blind Helen Keller, and robust nonconforming women such as Amelia Earhart, Beryl Markham, and Annie Peck-Smith, among others.

Ruth Benedict synthesized a new intellectual structure for thinking about culture and personality, and she was developing, articulating, arguing, discussing, gathering data, and writing during the years of the early 1930s, when Ella Deloria and Mary Sully were at last returned to New York City. Ella sat in on Benedict's classes, discussed new theories with other students, and formed herself as a linguistic ethnographer.[52] Benedict's thinking was passed to Sully on a daily basis through her sister, perhaps through public sessions at Columbia and, after 1934, through *Patterns of Culture.* There, Sully found both a brief for her own fringe positions and an argument for paying attention to individuals occupying various kinds of margins. With Ella, Sully also nurtured a growing sense of the importance of Dakota culture and the critical role of women as culture carriers across generations. And Benedict modeled exactly the kind of discerning self-reflective eye for culture and personality that Sully had sought to engage in her art since the late 1920s. Invented earlier, and independently, Sully's work was itself a species of culture and personality anthropology. Her top panels reflect personality, situated within culture; middle panels capture culture, expressed through personality.

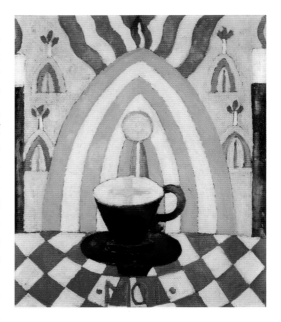

5.6. Marsden Hartley, *One Portrait of One Woman (Gertrude Stein)* (1916). Oil on composition board, 30 × 25 inches. Collection of the Frederick R. Weisman Art Museum at the University of Minnesota, Minneapolis. Bequest of Hudson D. Walker from the Ione and Hudson D. Walker Collection. 1978.21.64

COLLECTIVE PORTRAIT

Benedict, Boas, and Kleinberg were not the only ones with culture, personality, and measurement on their minds. The meeting of Freudian psychology and industrial management produced a host of personality inventories, tests, and practices aimed at dealing with nonconforming or maladjusted personality in terms of work. Developed during World War I, the Woodworth Psychoneurotic Inventory used over one hundred yes/no questions to determine the nature of a personality. Commonly considered the first personality test, it gave rise to a number of elaborations and variations over the next fifteen years.[53] These included the X-O Emotions Tests (1919), the Colgate Tests of Emotional Outlets (1925), the Mental Hygiene Inventory (1927), the Personality Schedule (1930), the Bernreuter Personality Inventory (1931), and, in 1935,

5.7. Hermann Rorschach, *Rorschach Card 10.* Author's collection. Compare, for example, *Lawrence Tibbett* (sidebar, this chapter).

the Thematic Apperception Test (TAT), which asks subjects to create a series of stories that speak to ambiguous pictures, drawn from a set of thirty-two images. The stories were thought to offer access to unconscious psychological traits and emotions.[54] Sully's moment also saw the increasing acceptance of the Rorschach inkblot tests (fig. 5.7), first published in 1921 but slow to take hold in the United States. Ten inkblot cards—structured by a familiar bilateral symmetry—generate responses reflecting personality characteristics, emotional function, and mental disabilities such as schizophrenia. By 1939 the Rorschach was being used as a general personality test, and while there is no direct linkage, the evocative overlaps tempt one to read Sully's images as if they were something like a Rorschach card.[55]

Cultural fascination with the psychology of personality extended beyond the diagnostic and into the therapeutic. Émile Coué's *Self Mastery through Conscious Autosuggestion*, translated from French and published in the

United States in 1922, argued that the repetition of words or images—positive or negative—would cause them to move into the unconscious, where they could have real effects on life and body. Positive messages—he was famous for the phrase "Every day, in every way, I'm getting better and better"—could thus shape not only physical but psychological healing, a theme taken up by Norman Vincent Peale and other popularizers focused on the active molding of personality.[56] As we have seen, Dorothea Brande's 1936 self-help book *Wake Up and Live* sold two million copies and serves as a metaphor (if not a potential inspiration) for Sully's own efforts.

"Personality improvement therapy" rested fundamentally on the idea of the unconscious. The unconscious, one of the key concepts permeating modernism, underpinned most psychological theories of personality, which migrated in the early twentieth century from medical contexts into the popular imagination. The idea of the unconscious is commonly located first in Pierre Janet's interests in the relation between personal traumas and present-day disorders, but then as an idea that expanded to form both a field of inquiry and a cultural logic. Sigmund Freud's work on the dissociation of personality, Alfred Adler's notion of an inferiority complex, William James's fascination with trance states, multiple consciousness, and the possibilities manifested in spiritualism, and Carl Jung's sense of the mind as a seat of multiple complexes, visible in archetypal forms: all these (among others) created possibilities for modernist artists interested in linking surfaces and depths, spoken words and hidden thoughts, persons and personalities.[57]

Psychological thinkers such as Freud, James, and Jung did not hesitate to link their work on individual personality issues with historical or sociological questions concerning the relationship between individual personality and social and cultural processes. In *Civilization and Its Discontents*, Freud sought to explain relationship between individual desires and social law by imagining and narrating archaic histories. Jung frequently crossed into anthropological and folkloric terrain in linking various mythic structures and stories to universal archetypes found in the unconscious.[58] James mused as early as 1880 on the place of individuals in generational social change. In his lecture "Great Men and Their Environment," he analogically linked the figure of the individual in history to the role of mutation in evolutionary genetics: "Societies' mutations from generation to generation are deter-

mined (directly or indirectly) mainly by the acts or examples of individuals whose genius was so adapted to the receptivities of the moment or whose accidental position of authority was so critical that they became ferments, initiators of movements, setters of precedent or fashion, centers of corruption, or destroyers of other persons, whose gifts, had they had free play, would have led society in another direction."[59]

And we might go on, for the theorization of the individual personality—functional and dysfunctional—in relation to culture and society proved a preoccupation among the authors of modernity. Mary Sully's conception of the personality prints project took place in relation to these questions, which connected directly to her own psychological and cross-cultural experiences. She and her sister continued to contemplate the question of the individual and society, and both lived realities that deepened the questions: the challenges of being Indian in a white world, of being women in a male world, and of being poor in a world of consumption.

As Sully developed her project during the two and a half years in South Dakota, Ella was close at hand, working with Otto Klineberg to create racial intelligence tests that sought to measure the kinds of perceptual intelligence that Mary Sully, a failure in the terms of Western education, was honing through her art. And as Ella engaged the formative moments of culture and personality anthropology—one of the first interdisciplinary movements and one of the most important schools of midcentury social science thought—so too was Mary Sully engaged in refining what we might now identify as a vernacular artistic vision of that field of inquiry. For surely the sisters made their own relationship a mode of intellectual exchange. A beginner social scientist—thrown into the highest academic reaches of anthropology—traded critical ideas with a self-taught artist who was herself thinking through the nature of her own expression and watching her project evolve. By 1934 *Patterns of Culture* would have been visible on a table or bookshelf in their apartment; before that, its ideas were everywhere in their intellectual world.

The personalities found in Mary Sully's work sat in a similar relation to the culture of the late 1920s and 1930s as the case studies of individuals and exemplary cultures found in Benedict's book. Both Sully and Benedict thought that single instances could illuminate "culture writ large."

For the anthropologist, abstraction appeared in the form of a generalizable argument—an inductive expansion of cases into "rules," principles that might be portable in time and space. Though we imagine its meanings to be very different, in truth *abstraction* did not have such a different meaning for the artist. It reflected her efforts to locate and represent hidden, essential, surprising qualities in both subject and form. For Sully, abstraction was to be found both in the individual images *and* in their additive dimension: they formed an archive of people that constituted a representational universe. That archive captured not simply a small group—the Stieglitz circle, for instance—but the larger form of the culture itself. Her middle-panel patterns were, quite literally, "patterns of culture" in and of themselves (figs. 5.8–5.10). And her move toward an Indian abstract in her bottom panels was not simply aesthetic; it was also theoretical and summative.

Every triptych was thus supersaturated with overdetermined meaning. Each personality print captured an essence of the individual in question, aligned or misaligned with the arc of American culture in the 1930s. Each image suggested an argument about the forward-looking narrative of Indian futurity. Each revealed something of the complicated cultural and psychological world of Mary Sully herself. And each conjured a piece of a social whole. As Charles Demuth's "poster portraits" project would suggest, one way to represent a social group—a small circle of artists or a larger culture itself—is to build a collection of representative figures, personalities capable of standing for ideas beyond themselves. Federal art projects took this mission seriously, producing thematic portraits of the nation in the 1930s. But Sully was not interested in reflecting the social experiences of America's displaced workers or its desiccated farmlands. Rather, she reveled in the people that powered its emergent popular culture: its radio performers, movie actors, athletes and daredevils, popular social commentators, writers, and celebrities, people on the social edges. She took as her greatest subject the popular culture that cultural historian Lawrence Levine once referred to as "the folklore of industrial society," and she did so from a marginal position that both challenged her and gifted her with a penetrating and revelatory vision.[60]

She self-reflectively created work representing herself, not simply as a marginal case but as a joyful consumer of mass culture. In this, of course,

5.8. Mary Sully, *Gossip*

5.9. Mary Sully, *The Architect*

5.10. Mary Sully, *Timothy Cole*

Sully was not alone. Regionalist Thomas Hart Benton's *America Today* series capitalized on and critiqued film and radio culture; Reginald Marsh, Stuart Davis, and many others engaged cinema and popular culture. Holger Cahill and others prompted viewers to consider visual folk culture.[61] As we have seen, however, Sully's own vision emerged from a unique positioning—cultural, psychological, perceptual—characteristic of no other artist working at that time.

When one adds up the individuals and the meanings that emerge in the personality prints project—the flamboyant talents, the hard work and trajectories to fame and infamy, the crazy world of celebrity and the celebrity world of crazy, the new media of radio and film, and more—what emerges is a collective portrait of the American 1930s, a culture-and-personality study that captures the contradictions and celebrations not only of individuals but of a society itself, and does so from the point of view of an anthropologically informed American Indian critic. In 1943 Margaret Mead published *And Keep Your Powder Dry: An Anthropologist Looks at America*, a culture-and-personality study of the United States. At roughly the same moment, Mary Sully was edging toward the abandonment of her own project, which had, in many ways, beaten Mead to the punch and taken a page from the "outsider" authority wielded by anthropologists. Melding aesthetic impulses from earlier in the century with psychological insights, culture-and-personality questions, and the booming popular culture industry, Sully's project had offered an artistic vision of a complex nation and the intellectual and cultural worlds that it contained.

CHAPTER *SIX*

POLITICS AND THE EDGES

Reading *Three Stages of Indian History*

THIS BOOK BEGAN WITH BEGINNINGS: A GRAY BOX OF DRAWINGS, A gesture to the Indian arts of New Mexico and Oklahoma, and a presentment of the curious image *Three Stages of Indian History*, rich with a busy too-muchness that challenged viewers' ability to make sense. Between then and now, between there and here, I've tried to peel back multiple layers of context, situating the artist Mary Sully, her history and psychology, and her cultural milieu so that we might return once again to *Indian History*, prepared to read it well. Text and context, in this instance, are dialectical: a close reading of the image offers a kind of master key that allows us to look back across the full sweep of the personality prints project and see the politics undergirding Sully's art. Those politics were personal, to be sure. They played out in poverty, mobility, and uncertainty, a scramble for survival by two Indian women navigating a difficult world. They were also cultural, for Ella Deloria and Mary Sully engaged the primitivism at the heart of global modernism even as they crafted tools aimed at Dakota linguistic and aesthetic survival. Such personal and cultural politics unfolded against a backdrop of structural political change in Indian Country that we might see in terms of an emergent future based on a historical past of autochthony, autonomy, and *sovereignty*.

6.1. Mary Sully, *Pair of Painted Parfleche Boxes* and *Silhouette of Boy and Horse*. From Ella Deloria, *Rites and Ceremonials of the Teton*. Ella Deloria Archive AISRI

The invitation to read Sully's art through politics is not necessarily an obvious one. Unlike much of the art of the 1930s, the personality prints seem disconnected from the explicitly political. There are no muscled workers, Dust Bowl refugees, hollow-eyed sharecroppers, African American migrants, or nationalist murals narrating history, memory, and progress. Sully chose only a few actual politicians for her project, and they were celebrities in their own right—Franklin D. Roosevelt and New York mayor Fiorello LaGuardia. The images she created for anti-Semites Henry Ford and Charles Lindbergh and of American fascist Dorothea Brande—perhaps sites of political critique—were decidedly apolitical: Ford and his automobiles, Lindbergh for his flight and the kidnapping of his son, and Brande's book (and film) *Wake Up and Live*. Still, the act of making art is often a political act, and as we have seen, Sully was engaged with the structural issues surrounding race, culture, gender, class, sexuality, and the socially marginal—all sites of uneven power that demand a politic. In what follows, I explore the politics of protosovereignty, the cultural, and the personal in an effort to make visible the political stakes of Sully's efforts with paper and pencil.

Ella Deloria's anthropological career had nearly come undone between fall 1928 and spring 1931, when the sisters committed to caring for their father in South Dakota and Ella was unable to work with Franz Boas in New York City. Between 1932 and 1934, however, Ella generally thrived under a relatively stable funding situation, as Boas handed management of some of his projects over to Ruth Benedict. Under the auspices of Benedict's "Project 35: Acculturation," Ella moved from the linguistic work and intelligence testing she had conducted with Boas to a full-blown ethnography of the Sioux, one of a number of case studies the project sought to complete. The manuscript would prove a burden to her over time, but in the early years of the Great Depression, the assignment offered a sense of security at a precarious moment.

At some point during the later 1930s or early 1940s, Ella Deloria enlisted her sister as her illustrator, a request that helped refine and reframe Sully's image making and interests. It is no coincidence that most of the ten triptychs with illustrative bottom panels came in these later years. Work as an illustrator also pulled Sully into the politics of salvage ethnography and the premise that Indian people and culture were disappearing and thus required

6.2. Mary Sully, *Girl Wearing Decorative Braid Ties*. From Ella Deloria, *Rites and Ceremonials of the Teton*. Ella Deloria Archive AISRI

ethnographers to collect and document what remained. Salvage work demanded a theory of change over time: it necessarily ran from authentic past to degraded present to uncertain future—which is the exact trajectory Sully uses to caption *Indian History*.

Thirty-two ethnographic illustrations accompany Ella Deloria's papers and manuscripts, and in them, we can see connections to Sully's late move to pictorialism (figs. 6.1–6.4). The overlap between the parfleche boxes in *Lunt and Fontanne* (fig. 3.28) and figure 6.1 are readily apparent, for instance. So too the link between the illustration *Girl Wearing Decorative Braid Ties* (fig. 6.2) and the captioned bottom panel in *Jane Withers* (fig. 3.44). Sully's ethnographic images range from truly documentary depictions of material culture to illustrations of cultural practice (*Three Girls Playing with Dolls and Miniature Tipis*, fig. 6.3) to silhouetted figures that echo the representations found in many of the personality prints.[1] Indeed, it seems clear that Sully forcefully inserted her own aesthetic into the supposedly neutral practice of scientific illustration, particularly in terms of the silhouette and the cultural illustration.

6.3. Mary Sully, *Three Girls Playing with Dolls and Miniature Tipis.* From Ella Deloria, *Rites and Ceremonials of the Teton.* Ella Deloria Archive AISRI

The bleed between the personality prints and the illustrations was substantial. Clearly, she used paper from her art supply for the ethnographic work: the pieces are on paper sized for her middle panels. Both the ethnographic images and her bottom panels use a hand-drawn black border. Her image *Floral Beaded Cape* (fig. 6.4) is obviously duplicated in the bottom panel for *Shirley Temple* (fig. 6.5). And in *Three Girls Playing with Dolls and Miniature Tipis*, Sully incorporates into a scene both her set of parfleche boxes and a girl with hair ties, suggesting that many of these images—both triptychs and illustrations—were drawn at roughly the same time. Indeed, one might argue that the drawing's emphasis on green grass, rich material culture, and idyllic life offers a pathway leading directly to the bottom band—*Pre-Columbian Freedom*—in the top panel of *Three Stages of Indian History* (fig. I.1a).

During these good years—perhaps their best—the sisters' interests proved deeply and productively entangled, both intellectually and aesthetically.

6.4. Mary Sully, *Floral Beaded Cape.* From Ella Deloria, *Rites and Ceremonials of the Teton.* Ella Deloria Archive AISRI

6.5. Mary Sully, *Shirley Temple*

231

The remainder of the 1930s, however, saw the slow dissolution of their economic security and a painful confrontation with the intimate politics of race, money, and social capital. Ella was moved from regular salary to contract work and finally back to the kind of piecework labor that she had started with Boas in 1927, when she was paid for individual translations. She cobbled together grant projects (a study that took her to the Navajo reservation in winter 1939), government work (the Lumbee investigation that took her to North Carolina in fall of 1940 and the late fall of 1941), and church work and public speaking (which took her, for example, to Silver Creek, New York, in early 1940). Often, Ella attempted to carve out a paying role for her sister: costume design for the Lumbee pageant, illustration work for the ethnographies, assistant status in other cases. The sisters patched together housing in those years, relying on church rectories, rooms at Indian schools, short-term rentals, and frequent visits and house-sitting stays with their brother. At one point, Ella informed Boas that the sisters were basically living out of their car. The claim was melodramatic but not far from the truth.

Ella, applying for fellowships and grants, keenly recognized her lack of graduate credentials in an academic setting that increasingly prized such things.[2] She had started down the road to a graduate education in Kansas in 1926. But it was clear to both Ella and Susie that Indian people like themselves had been structurally impeded by their prolonged educational paths, their inability to draw on accumulated wealth, and the small pool of potential marital partners available to educated mixed-blood women. Most important was the requirement that Ella be available to her colleagues as an "informant," with insider expertise that compromised her claim to scholarship. As Mead had recognized but not fully understood, Ella was an exceptional figure, savvy and lucky enough to have garnered significant training from Franz Boas. That training, however, was uncredentialed and thus compromised in the money-world of foundations and grants.

In that sense, Ella Deloria was to anthropology as Mary Sully was to art: an informally trained, uncertified person with a cogent view from the margins and an ongoing struggle to reach or stay at the center. Sully's contemplation of Indian history, then, necessarily emerged out of her experience of the personal hard times that characterized the last years of the project, and the ways in which those challenges were directly connected to the unequal structures

6.6. Mary Sully promotional photograph. Author's collection **6.7.** Ella Deloria promotional photograph. Author's collection

defining past, present, and future, which kept Indian people as outsiders. In these contexts—as well as the ethnographic, the pictorial, and the salvage—*Indian History*'s navigation of joyful nostalgia, dispiritedness, and anxiety comes more clearly into focus.

FORM AS NARRATIVE

American Indian history and *Indian History* materialize together in a pair of studio photographs of Mary Sully (fig. 6.6) and Ella Deloria (fig. 6.7). Sully drapes a softly folded blanket over her shoulders; a beaded headband holds her braided hair. Classic signifiers of Indianness, the blanket, bead, and braid cross-pollinate with the dewy-eyed conventions of the Hollywood promotional photograph, demonstrating Sully's willingness to play a primitivist

game of cultural politics. Ella's photo is more complex, blending and blurring primitivist conventions with high-end Native goods production. Her fringed dress is beautiful, collared with a full yoke of precise beadwork. Her headband is perfectly quilled, her moccasins and leggings equally superb, topped off with a long hair-pipe necklace (not dissimilar to the necklace shown in Sully's illustration) and an immaculately finished belt. Her hand grasps a hide, one portion of which drapes on the floor, parallel to her moccasined foot. The tanned skin of the dress flows seamlessly into the soft hair of the hide: nature and culture connect through the medium of her hand. In the background, a faintly visible painted backdrop of river, trees, and mountains suggest the kind of faux landscape imagined by Alfred Sully in *Indian Maidens* (fig. 1.3). In these photos, Pehandutawin's granddaughters look directly and fearlessly into the camera, daring the viewer to return the gaze of the historically repressed, not-fully-colonized Indigenous subject.

If the personality prints figured Mary Sully as a self-reflective consumer of popular culture, the two photos positioned the sisters as both the creators and the subjects of that culture. They invited the gaze of a mass audience, reflected that audience's cultural expectations, and asserted the importance of an Indigenous past, present, and future. The images, in that sense, tracked on the same temporalities found in *Three Stages of Indian History*, and they invite the viewer to understand Sully in the explicitly political context of resistance, survival, and engagement that Anishinaabe scholar Gerald Vizenor has famously framed as *survivance*.[3]

The sisters' Indian princess photographs also return our gaze to the relation between the tropes of modernist primitivism and Sully's engagement/ rejection of them. I argued earlier that even as it played with primitivist iconographies, her art took shape in the development across three panels of a future-oriented Indian abstract. I emphasized the qualities of *transformation*, such that top, middle, and bottom could be figured as first, second, and third, and that this viewing logic carried the force of an antiprimitivist Indian modernism. But one might pursue the theme further. First, second, and third themselves suggest the possibilities of *narrative* and yet another relabeling of the panels, beginning, middle, and end, such that they create a narrative arc. What were the stories Sully sought to tell? What were the stories she contended against?

Here's one: social evolution and the possibility of Indian transformation. Here's another: racial difference and the impossibility of change. And a third: settler colonialism, which insisted on the vanishing of Indians and their replacement by American settlers. To these stories she responded with formal visual narratives emphasizing survival, resistance, challenge, and the future. The key to understanding these narratives may be found in *Indian History*, where one can see Sully making a critique of the devastations of the colonial past even as she offered an aesthetic case for an Indian politics of possibility, life, and futurity.

It has been impossible to imagine Indians in the United States without recourse to various ideas of social evolution. Nineteenth-century culturalist thinkers such as Lewis Henry Morgan placed Indians on a three-part developmental scale—savage, barbarian, and civilized. Policy makers understood that the theory carried a corollary: Indians would either die out or advance—perhaps against their will—into a "more developed" stage of society. With the advent of post-Darwinian social evolutionary thinking in the later nineteenth and early twentieth centuries, the scale grew more complex, but Indians' place on it remained near the bottom. Federal policy and Christian missionization, often intermixed in both structure and personnel, aimed to move Indian people rapidly through the stages of social evolution, lifting them from the "primitive" past into the "modern" present. Education, agricultural economies, reservation confinement, wage work—these and other strategies aimed to "civilize" Indians and thus solve the riddle of Indian difference by evolving them by force into the "modern."[4] The very words *modern* and *modernity* cannot be anything but laced through with political content for Indigenous peoples.

Other theorists argued for more rigid racial categories. Some earlier racial thinkers, for example, emphasized a notion of polygenesis: multiple creations had produced distinct races with clearly visible boundaries that made assimilation impossible. After the failure of decades of efforts aimed at assimilating Indians, twentieth-century Americans turned with increasing frequency to race as a marker of absolute kinds of differences that could not be bridged.[5] Hard-wired racial difference seemed to explain why Indians were so resistant to change even in the face of culture-smashing devices like boarding schools, religious proscription, and forced language loss. And even while Boas, Klineberg, and Benedict sought to shift the intellectual

template from the biologies of race to the fluidities of culture, other Americans embraced notions of eugenics and racial essentialism.[6]

Assimilationists assumed that Indians would disappear as they were incorporated into American society; racialists projected a more brutal vanishing. Waves of settlers had taken Indian land through a relentless series of strategies: military conquest, violence that we can truly name as genocidal, treaties and land contracts, forced removal, allotment, and the detribalizing work of churches, schools, and the agents of an American state consolidating its power. Settler colonialism is an ideology of complete vanishment and replacement: Indians "disappear" (rather than being killed or actively dispossessed) and they leave behind the land itself to settlers who replace them (and who then consider themselves to be indigenous). Every statue of a dejected "end of the trail" Indian, every Indian death scene, every consignment of Indian people to the past does the ideological work of settler colonialism. To assert life and presence in this context is to resist, and even attack, settler colonial violence and ideology, which was never a completed project. Indeed, the new and nastier formations of race reveal the ways that settler colonial ideological narratives failed to account for the continued existence of supposedly vanished Indians.

Paradoxically, as racial and cultural boundary setting became harder-edged in the early twentieth century, white American moderns began to covet the "primitive" virtues that they saw on the far edge of the lines defining whiteness and modernity. They sought to cross those lines, gather up vestiges of the "authentic" life Indian people were thought to "still" possess, and return to the modern world with life-giving bounty. These were the contradictions that structured everyday life for the Native peoples of Mary Sully's generation. White Americans valued Indians for an authenticity located outside of modernity while demanding that they evolve socially and culturally such that they could be assimilated into it. Indian authenticity rested on the ground of unchangeable racial difference. But assimilation assumed the priority of culture and environment and the possibility of transformation.[7] Indian people were faced with the contradictory demand to both eliminate and preserve their difference.

By the 1920s a national conversation erupted around the clear failures of nineteenth-century conquest, assimilation, and replacement policies. Those

policies had been intensified in the first decades of the twentieth century as Americans found ways to accelerate land loss at the level of the land parcel. Across the continent, Americans tried to break down the communal social structures and landholding of Indian peoples, believing that individually allotted lands held the key to Indian participation in modern agricultural and industrial society. The 1887 Dawes (or General) Allotment Act established the mechanisms for this transformation, providing for reservations to be surveyed, subdivided, and allotted to Indian individuals, with the "surplus" land sold to white settlers who would presumably model modern civilization. Allotment meant checkerboarded reservation spaces, which required the pacification—the final military domination—of Indian people, signified in the bloodiest possible terms by the merciless 1890 massacre of starving Sioux refugees at Wounded Knee, South Dakota. Allotment was a colonial policy, in other words, of land disaggregation and social desegregation, with the eventual goal of economic and political integration of Indian land, if not necessarily of Indian people.

An Indian on 160 acres would be forced to farm or ranch in order to provide sustenance. An Indian who "lost" his or her land—that is, had it taken—would be forced into the wage-labor economy, while the land itself became cheaply acquired capital for the speculator. In either case, these changes would transform Indian people's economic position from one of subsistence and sharing to one of low-end labor. Social and cultural change would follow, aided by a suite of colonial impositions: boarding schools, Christian missions, and restrictions on traditional cultural practices.[8] Individualized Indian land passed rapidly into the hands of white speculators. Janet McDonnell has estimated between the 1887 Dawes Allotment Act and its elimination in 1934, Indian landholding declined from 138 million acres to 52 million acres.[9] Among those acres were Ella's allotment, one of Vine's allotments, and the allotment their mother had bequeathed jointly to the sisters.

Even in the midst of this assault, Indian people made their way. Wage labor created new migration patterns, and many Indian people joined emerging industries that, like so much of modernism, drew on white Americans' nostalgia and primitivist desires. Native people never saw modernity as a bright line, though. The modern was no epoch; it simply *was*, the condition created by the structures of domination that had been forced on them.

Indian people were, in that sense, "native" to modernity itself. It was simultaneously a meaningless category, a state of being, and an occasion to play cultural politics with white anxieties. Much of this new labor took shape in performances of "Indianness" for white audiences in Wild West shows, medicine shows, vaudeville, music, the film industry, professional and college sports, and the Chautauqua and other educational lecture circuits. Along with performance, Indians engaged in the production of material culture that took the primitivist meanings found in performances and made them into tangible, marketable objects—the "tourist" art so decried by John Sloan and Oliver La Farge.

Among the Indians making their way were Ella Deloria and Mary Sully, both willing to promote themselves as Indian princesses for white audiences enraptured by primitivist desire. Ella supplemented her income by working as a lecturer on Indian matters, often using the educational circuits of the Episcopal Church. She purchased mass-produced Indian trinkets at wholesale from a company in New England and marked them up for sale at her lectures. She established a long-term relationship with a family deeply invested in the Camp Fire Girls organization and became a regular consultant. She posed for a melodramatic Indian painting. Even as she made plans in 1928 to move to New York to live and work with Franz Boas, Ella was asking Bishop Burleson to front her money to organize her travel around a series of lectures. Her 1944 book, *Speaking of Indians*, represented a meeting of her educational mission and her scholarship, carefully crafted for an audience that mingled primitivist desire with Christian charity.[10]

It is no accident that Mary Sully's best picture captures her in a blanket and beaded headband, and it is hard to miss the connection between its geometrical forms and those found in the personality prints. The same play appeared in another moment when she left her bedroom retreat in an effort to win for herself a public. In May 1939 Sully signed a handwritten release to appear in a newsreel series called *Unusual Occupations*, a collection of short films about employment and hobby curiosities. The film was shot while the sisters were in Gallup, New Mexico, as part of the Navajo study on which Ella had found work, and it opens with wide-angle shots of mesas and Pueblos, evocative "Indianist" music, and a sonorous, deep-voiced and authoritative narration:

On the high mesa lands of New Mexico, near Gallup, is the oldest Indian village in the United States, carrying on the traditions of a prehistoric past. Corn is prepared as it was before the white man, with culture in one hand and the rifle in the other, began to civilize the Sioux. The home of Mary Sully, a full-blooded Sioux, who caught the culture and now produces beauty based on an art that was old when Spain was new."[11]

Sully appears in an intricate headband that gathers in the long dark hair of a wig (at this point, she seems to have been keeping her hair short). She wears a fine beaded leather dress. As in the promotional photos, these physical markers made her visually sensate to an audience for which she was framed as old, prehistoric, traditional, and largely uncivilized. The narration captures the dynamics of assimilation ("culture in one hand") and violent conquest ("rifle in the other") even as it evokes La Farge and Sloan's modernist primitivism. The phrase "now produces beauty based on an art that was old" places Sully in the present ("now"), highlights her aesthetic aims ("produces beauty"), and allows for transformation ("based on an art") that links present with past ("that was old"). If it mingled its primitivism with an unwitting statement about Sully's political aesthetic, the film did not succeed in expanding her audience. The sisters often performed a brand of tightly constrained "Indianness" for white audiences, even as they stood as evidence that Indian people were themselves native to modernism and modernity. They were also its makers and shapers, and their work had not simply cultural but also social and political possibility. For every picture of Ella in buckskin, there is another to be found of her in the sophisticated clothing of her New York City life (figs. 6.8 and 6.9).

The form of the personality prints, as I've suggested, offers the possibility of a primitivist social evolutionary narrative that leads to assimilation when read bottom to top. The bottom panels, with their "Indian" sensibilities, frame a beginning point back in archaic time: the story told by any triptych might start in a "savage," nonmodern past, confirmed in spatial terms by the relatively smaller size of the bottom "Indian" panel and its "pictographic" forms (fig. 6.10). It would then "progress"—literally—through a social evolutionary change to something like Morgan's "barbarism," Sully's grids and

6.8. Ella Deloria, ca. 1916. Author's collection **6.9.** Mary Sully, ca. 1945. Author's collection

patterns offering a glyphic picture of social structuring (fig. 6.11). The story would then end with the top panel, figured as the modern present, a time of alphabets, the semiotic sophistication of the metaphor and the visual pun, and other hallmarks of a supposedly advanced civilization (fig. 6.12).

I've suggested instead that a productive coherence emerges when we read the three panels from top to bottom as a developmental narrative of Indian survivance and futurity. That narrative begins with a top panel focused on the aesthetics of the modern, locating the beginning of the story in the present moment. The pieces then develop visual themes through middle panels that are also middles of linear narrative. They move toward an end, a dramatic culmination located in the culturally overdetermined images that appear in the bottom panel. These reflect a development, over time, toward an Indian abstract, an aesthetic that staked a claim on Indian people living *forward*

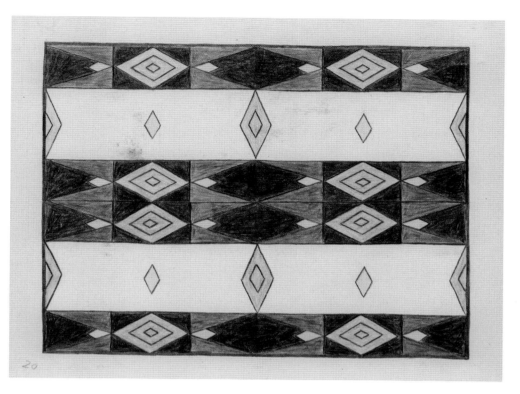

6.10. Mary Sully, *Alison Skipworth*, top panel

through history to present and future. Those bottom panels—like the sisters' promotional photographs—capture the possibilities of a productive dialectic between Indian past and present, tradition and innovation, tribal life and cosmopolitan experience, art and design. They almost always reference some recognizable attitude of Native representation. Their strategies ranged from the inclusion of Indian content in complex images, the direct evocation of Indian designs, pictorial representations of Indian life, and the ethnographic image-texts found in panels for *Billie Burke, Jane Withers,* and *Alice.* And they take on a particularly salient message in *Indian History.*

In her later work (figs. 6.13–6.16), Sully took a different kind of "Indian turn," visible in the only three personality prints that focus exclusively on American Indian themes. Two of these—*Bishop Hare* (fig. 2.4) and *The Indian Church* (fig. 1.9)—emerged directly from her engagement with her

6.11. Mary Sully, *Alison Skipworth*, middle panel

6.12. Mary Sully, *Alison Skipworth*, bottom panel

6.13. Mary Sully, *Claudette Colbert*. Like so many of Sully's designs, Indian-inflected geometric complexity reflects long-standing quillwork and beadwork traditions.

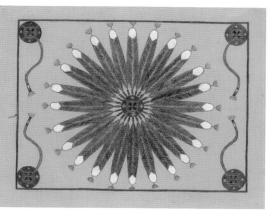

6.14. Mary Sully, *Anton Lang*. The image reflects the prominence of feather arts in many Indigenous traditions, specific evocations of Navajo sand paintings, and broad American cultural expectations linking American Indian peoples with feathers.

6.15. Mary Sully, *Timothy Cole*. As Indian women's bead arts engaged with pictorial representation in the early twentieth century, so too did some of Sully's images, particularly as she began her own practice of ethnographic illustration.

6.16. Mary Sully, *Leap Year*. Here, as in many Sully images, the modified parfleche design features the familiar yellow, blue, red, negative space color scheme, framed by diamonds, squares, and right angles.

own family and tribal past, which was heavily structured by William Hobart Hare and the institution of the Episcopalian Church. The last of her Indian prints, *Three Stages of Indian History*, engages a different question, emerging from her personal struggles, the vanishing narratives of ethnography and settler colonialism, and the politics of Indian Country in the 1930s: how to think about the trauma of Native pasts and presents, and the possibilities and constraints of a challenging future. *Indian History* invited its viewers to contemplate not simply the cultural politics of modernist primitivism but the sweat-and-blood questions of Indian survival.

THE OLD AND NEW OF EMERGENT SOVEREIGNTY POLITICS

In 1911 American Indian leaders gathered (on Columbus Day) in Columbus, Ohio to found the Society of American Indians (SAI), the first pan-Indian political and intellectual think tank. Modeled in part on the National Association for the Advancement of Colored People, the SAI established many of the debates and positions that would characterize subsequent Progressive-Era reform in Indian policy affairs. The society was the most prominent and the most national of a series of Indian organizations that formed across the country over the next decades. Its *Quarterly Journal* and conference proceedings remain critical sources in early-twentieth-century Native American history today.[12]

One of the papers given at the 1911 meeting was by Angel De Cora, a Ho-Chunk artist who taught art at the Carlisle Indian Industrial School. De Cora, arguably the most important and underappreciated American Indian artist of the early twentieth century, prefigured Sully's efforts. Unlike Sully, De Cora had received substantial studio training, visible in her skilled representational drawing. Like Sully, she mixed figurative art, Native design, and an ambition for a broad audience. Indeed, De Cora clearly saw herself as a modern Indian artist and went some way toward articulating the meaning of that claim. At the SAI meeting, DeCora observed that she had trained generations of young Indian designers who had

> shown resourceful minds in application of their Native designs to modern furnishings. Indian designs could be used very effectively in

brick and slate works, in parquet and mosaic floors, oilcloths, carved wood furniture, tiles, stencil designs for friezes and draperies, designs for rugs, embroidery, applique, metal work, enameled jewelry, and page decorations. Manufacturers are now employing Indian designs in deteriorated fashion. If this system was better understood by the designers, how much more popular their products would be in a general market.[13]

As we have seen, the question of "deteriorated fashion" quickly emerged as critical for Indian artists and their supporters and would become a key part of the political reform efforts of the 1930s. As important, though, De Cora outlined a role for Indian arts in the context of the arts and crafts movement, the long hangover of which would structure Sully's thinking in the 1920s and 1930s.

Much of the political push in Indian Country took place at the tribal level as individual groups lobbied the federal government for treaty claims, settlements, policy changes, and better reservation management. Given the prominence of the Southwest in the modernist imagination and the constant circulation of artists and writers through the area, it is unsurprising that some of the first intrusions of the local into national politics would come out of New Mexico. A key figure in this eruption was the social reformer (and future Indian commissioner) John Collier, who had an epiphany concerning culture and personality questions during a visit to Taos Pueblo in 1920. As he recalled in a later memoir:

The discovery that came to me there, in that tiny group of a few hundred Indians, was of personality-forming institutions, even now unweakened, which had survived repeated and immense historical shocks, and where were going right on in the production of states of mind, attitudes of mind, earth-loyalties and human loyalties, amid a context of beauty which suffused all the life of the group. What I observed and experienced was a power of art—of the life-making art— greater in kind than anything I had known in my own world before. Not tiny, but huge, this little group and its personalities seemed. . . . Only the Indians, among the peoples of this hemisphere at least, were

still the possessors and users of the fundamental secret of human life—the secret of building great personality through the instrumentality of social institutions.[14]

Like Sloan and La Farge, John Collier wanted Americans to value Native cultures both on their own terms and for their contributions to an American whole that was both *essential* (that is, Indians were aboriginal to the continent and thus the nation) and *dialectical* (that is, Indians were part of the mix of peoples in whose relationships was to be found America).[15] The preservation of Indians' "life-making," "personality-forming" social institutions became the focus of his entire life and career.

In 1922 Collier took charge of a diffuse effort to support New Mexico Pueblo Indian land claims, creating in the following year the American Indian Defense Association. Collier spent much of the decade attacking the policies of the Bureau of Indian Affairs, and he echoed the push for political reform first enunciated by the Society of American Indians. In 1923 Secretary of the Interior Hubert Work appointed a "Committee of One Hundred" to discuss and offer advice on the conflicts emerging around Indian policy. Its response included the delivery to President Calvin Coolidge of a copy of G. E. E. Lindquist's 1923 report, *The Red Man in the United States*, which supported the Bureau of Indian Affairs and the assimilation program even as it revealed the widespread poverty and employment and housing problems on reservations.[16] The following year, the Indian Citizenship Act made all Indian people citizens of the United States without requiring the renunciation of tribal ties. Though Indians maintained dual political affiliation, the act had the effect of forcing a new political status—incorporated American citizen—onto them. In 1926, with Indians and Indian policy both still under assault, Work appointed Lewis Meriam to lead a comprehensive survey of Indian conditions. The resulting report, *The Problem of Indian Administration* (1928), captured in excruciating detail the failures of the allotment policy and the challenges faced by Indian communities.[17]

Thus was the table set for the implementation of a new order in American Indian policy on the part of the federal government, which began with the 1933 appointment of John Collier as the Commissioner of Indian Affairs and the passage in 1934 of the Indian Reorganization Act (IRA).[18] Along with two

other pieces of legislation (the Johnson-O'Malley Act and the Indian Arts and Crafts Act), the IRA centered the so-called Indian New Deal. The IRA was a vexed piece of legislation, compromised and contested, and structured around Collier's own sense of the importance of Indian communities—shaped mostly in his encounters with the Pueblos—as model social structures that required salvage, preservation, and nurture. It ended the allotment policy and offered Indian groups the opportunity to form their own tribal governments, councils based on the model of American representative democracy and subject to approval of the Secretary of the Interior.

In many ways, the IRA was simply another form of domination. It established an American structure for quasi-indirect colonial rule, as councils became the visible and approved venue for negotiations with the federal government and private corporations, often to Indian disadvantage. In other ways, however, the IRA offered positive aspects to be grasped for the future. It reversed the flow of Indian land into white hands and offered tribes opportunities to acquire, consolidate, and hold land collectively. It laid the groundwork for what, in the postwar years, would be the development of a treaty-based argument for American Indian political sovereignty (though, as many scholars have pointed out, this sovereignty was always already a colonized form of political status, and Indian leaders had consistently raised the issues of their treaties in diplomatic negotiations). It established the groundwork for new forms of Indian economic development and political leadership, though both have been fraught in their own ways.

One thing is clear: the IRA jolted into being a new political context and conversation. Collier submitted his bill in February 1934 and immediately convened a series of Indian Congresses in March and April, ostensibly to gather tribal input but mostly to explain and recruit tribes to participate in the IRA, which required their active election. On the nine South Dakota reservations, the IRA was debated and voted on in the summer and fall of 1934 (except Sisseton, which voted "no" in April 1935). The drafting and approval of IRA constitutions, the election of the first tribal councils, and the first meetings took place in most communities over the next two years.[19]

The sisters came to know the world of the IRA well. In 1934 Ella Deloria and Mary Sully were primarily in New York, but ethnographic work took them to the Flandreau Santee Sioux reservation, its school a frequent retreat

for Ella. In 1935 they oscillated between New York, Montana, and their brother's home in Martin, South Dakota, near both the Pine Ridge and Rosebud reservations. The following year they wintered in Martin before returning to New York. In the following years, the sisters spent time at Pine Ridge; at Yankton; at Flandreau; at Window Rock, Arizona, in Navajo country; at Oneida, in Wisconsin; and with Lumbee people in Robeson County, North Carolina. During the years in which the IRA was debated and implemented, then, they covered a significant amount of American Indian territory.

No one in Indian Country could avoid the debates surrounding the IRA and the adoption or refusal of IRA constitutions. It was one of the most political moments in twentieth-century Indian history, forcing Native communities to debate past, present, and future in the context of settler colonial domination. This debate and discussion offered the large-scale context in which Mary Sully created *Three Stages of Indian History: Pre-Columbian Freedom, Reservation Fetters, the Bewildering Present*. Its political pulse was overdetermined, beating its ways through her own travels, through Ella's travails at Columbia and in the field, through her brother's work in the church and as an occasional translator for government officials, and through the primitivisms that motivated individuals like John Collier and that offered Sully and her sister a constrained set of problematic opportunities to reflect and represent a contradictory and dangerous Indianness.

INDIAN HISTORY

Likely one of her last works—and thus a potential culmination of the project—*Three Stages of Indian History: Pre-Columbian Freedom, Reservation Fetters, the Bewildering Present* (fig. 6.17) repays sustained and careful attention. The top panel offers a chronological narrative that runs from the bottom of the image (*Pre-Columbian Freedom*) to the top in a series of four horizontal sections. It is curious that there are four sections to the top panel, as the caption for the image as a whole recounts a history in three parts (only two of which actually reference history): an idyllic past of domestic harmony and freedom, the recent constraints of the desperate reservation period, and the uncertainties of the present and the yet-to-be-determined modern future. The bottom band is marked by color: green grass with red accents, and a

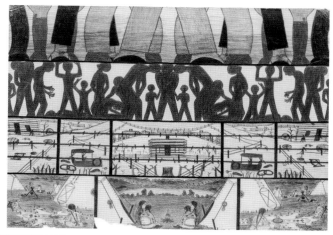

6.17. Mary Sully, *Three Stages of Indian History: Pre-Columbian Freedom, Reservation Fetters, the Bewildering Present*

collection of material culture that offers bits of blue, yellow, white, and black. Moving from bottom to top, one next finds a rural reservation landscape, rendered in black ink and graphite pencil, featuring squared-off lines, log cabins, fences, failing crops, and the broken-down promise of modern technology (fig. 6.18). The communal camp circle found in *Bishop Hare* (fig. 2.4) has been broken up into individual property lines, marked by a landscape of fences. A thick barbed-wire fence frames the entire scene, even as it breaks the landscape down into five discrete sections, symmetrically arranged: a b c b a. Next (again moving toward the top), in a powerful section that reflects the present, brown silhouetted Indian figures squirm, die, mourn, and seek escape upward. There, at the boundary that distinguishes the top section, they encounter a sinister collection of dark legs and feet, among which one finds blue jeans, military boots, and a firmly rooted pair of legs in a pin-striped suit, with spats.

The top two horizontal sections run across the entire image; the bottom two sections are subdivided, into three (the idyllic past) and five (the grim reservation) subsections. The shared colors and icons can make these subsections seem like a continuous image that is divided in one case by a see-through fence and in the other by the near-continuity of the tipi and the green flow of the landscape. Close inspection, however, reveals that while Sully teases the viewer with the possibility of continuity across the strip of fence, each of these subsections is distinct, posing a subtle visual challenge to the eye.

6.18. Mary Sully, *Three Stages of Indian History* (detail): These "reservation" sections appear to be part of the same scene but are in fact discrete, similar to the segmentation technique used by Diego Rivera and other muralists.

6.19. Diego Rivera (1886–1957), *Detroit Industry, North Wall* (1932–33). Detroit Institute of Arts. Gift of Edsel B. Ford

The strategy in this top panel is explicitly representational and narrative, and it is not difficult to see the possibilities of other artistic influences. One might read the divided form as referencing the mural traditions of Diego Rivera, Aaron Douglas, and others, who modeled the possibilities for multi-part framing structures, narrative painting, and the impulse to link history and politics.[20] Look closely, for example, at Rivera's *Detroit Industry* (fig. 6.19). On the left and right sides of the main panel, conveyor belts seem to establish continuity across panels, working in ways quite similar to Sully's thick black fence, echoed in the factory beams that subdivide Rivera's mural. Here, too, the effect is powerful: the belt unifies the image even as it invites the viewer to observe subtle distinctions in content, perspective, and light.

Likewise, there is a similar case to be made—in terms of structure, theme, and aesthetic strategies—that Sully may have been informed by Aaron Douglas's *Aspects of Negro Life* and thus an engagement with the politics of black

history as it took shape in the modernism of African American New York. If Sully had once hoped for New Deal funding, Douglas actually received it, a 1934 commission from the Public Works of Art Project to paint four murals for the 135th Street Branch of the New York Public Library.

Douglas presents a four-part history, moving from a tribal moment, through scenes of trauma, into an uncertain present and future. The section in Sully that we can think of as representing *Pre-Columbian Freedom* res-

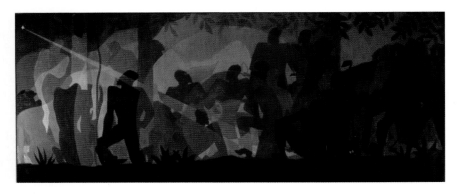

6.20. Aaron Douglas, *Idyll of the Deep South* from *Aspects of Negro Life* (1934). Schomberg Center for Research in Black Culture, Art and Artifacts Division, The New York Public Library Digital Collections

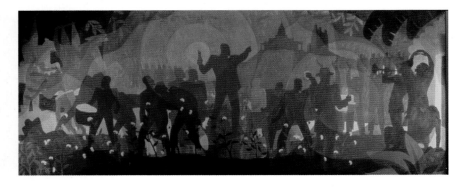

6.21. Aaron Douglas, *From Slavery to Reconstruction* from *Aspects of Negro Life* (1934). Schomberg Center for Research in Black Culture, Art and Artifacts Division, The New York Public Library Digital Collections

6.22. Mary Sully, *Three Stages of Indian History* (detail): Figures of modernist anxiety offer a clear stylistic evocation of the work of Aaron Douglas.

6.23. Aaron Douglas, *Song of the Towers* from *Aspects of Negro Life* (1934). Schomberg Center for Research in Black Culture, Art and Artifacts Division, The New York Public Library Digital Collections

onates powerfully with Douglas's first mural, *The Negro in an African Setting* (not pictured), which plays with near-symmetries, segments the picture plane (subtly, with circles and light gradients), and uses motion and movement to evoke freedom. Indeed, Sully's subtitles cast Indian history in a black idiom, framing the past in terms of freedom and the fetters of bondage. *An Idyll of the Deep South* (fig. 6.20) and *From Slavery through Reconstruction* (fig. 6.21) both suggest lenses for reading Sully's wrecked cars and brown silhouettes. Cotton plants permeate the latter, echoing the failed corn of the stark reservation scene. Chains and hooded nightriders sit in relation to the fences and bare cabins that imprison Indians in reservation fetters. Sully's "brown" section (fig. 6.22) seems a direct evocation of Douglas's fundamental style; in both, one sees bent silhouetted bodies and arms reaching hopefully, painfully upward. Indeed, the visual resonance between Sully's upraised arms and the raised arms and upward striving gestures in *From Slavery through Reconstruction* are powerful.

Those upraised arms appear again in Douglas's *Song of the Towers* (fig. 6.23). But the image also offers another evocative visual trope: green spectral hands grasp at black figures seeking modern freedom in the cities, and a sickly greenish ribbon of gas extends across the entire image. In *Indian History*, a similar fog or gas winds through the legs and feet of the top section. Douglas establishes a clear focal point: the circle that contains both the Statue of Liberty, with its promise of freedom, and the saxophone, the modern expression of black culture, autonomy, and futurity. But his protagonists stand and sprint on a moving industrial cog that

promises an endless chase after an elusive freedom. Sully's legs and feet are similarly ambiguous signs: they surely reflect the military-industrial-corporate-government-settler order that has seized the continent. But perhaps there is also the possibility that those unhappy feet belong to Indian people, assimilated into the noxious fog of American domination.

Sully's work is clearly her own—it's hardly derivative of Douglas. But there is every possibility that she saw *Aspects of Negro Life*, which would have been located not many blocks from Ella's headquarters at Columbia University. Perhaps it served as a jumping-off point, joining Sully to later artists such as Jacob Lawrence and Kara Walker, who have taken inspiration from Douglas's silhouettes, historical conscious-ness, and political will.[21]

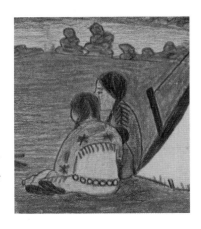

6.24. Mary Sully, *Three Stages of Indian History* (detail): From the top panel's "Precolumbian Freedom" section, the blue yoke dress and small child in red offer colors that are captured and transformed in the middle and bottom panels.

Sully's conception of pre-Columbian freedom recalls the woman-centered imagery that boldly centers *The Indian Church*. In the central subsection, four (really, two symmet-rically doubled women) sit outside their lodges in front of a fire, while across a lake and in the distance ordered camps rest (fig. 6.24). Barely visible, tucked between the women as if for safekeeping, is a small child dressed in red—an

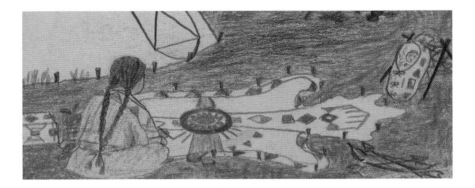

6.25. Mary Sully, *Three Stages of Indian History* (detail): Women's camp scenes from the top panel's "Precolumbian Freedom" section. A baby rests in a cradleboard—a sign of futurity and possibility. A woman artist works on a rawhide design, introducing the "arrow" icon that is a central theme in the middle panel. To the artist's left sits a completed parfleche box, while a close look reveals her hair ties, both frequent themes across Sully's images and illustrations.

important reference that will be drawn through all three panels. The near woman wears a decorated dress with a blue yoke. Symmetrical subsections bracketing this centerpiece represent a woman's world, with a kettle on the fire, a baby in its rest, and a woman with her paints hard at work decorating a stretched piece of rawhide (fig. 6.25). A painted parfleche box sits close at hand. In the far distance, a standing figure in a headdress and a few silhouetted figures are barely visible. These women are, in a sense, the grown versions of the three girls at play in her ethnographic illustration.

Like a 1930s dust storm, a looming cloud of darkness intrudes at the center of the idyllic image (fig. 6.26). A foreshadowing of the history that is to come, the cloud is linked, in its graphite dullness, to a large, dead stump in the section above. One might argue that the image of the tree and the log cabin reference Sioux visions and prophecies from the past, found, for example, in the classic *Black Elk Speaks* and quite possibly heard by Ella during her collecting work. Black Elk recalled a prophecy that hard times would come to the people, the circle would be broken, and they would live in ugly, gray, square houses. Likewise, he emphasized that the people's circle depended on the life of the holy tree, which centered the Sun Dance and the metaphoric conception of the camp circle. When the tree flowered, the people would be well; when it died, they would struggle.[22]

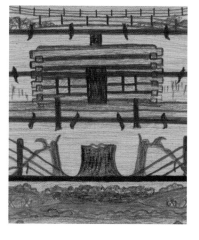

6.26. Mary Sully, *Three Stages of Indian History* (detail): A vertical alignment of trauma: from bottom, the dust storm of colonial history looming on the horizon, the dead stump remnant of the tree of life, and a square cabin that replaces the round tipi, thus fulfilling an ominous prophecy of property lines and boundaries that challenged the communalism of Dakota culture.

Women disappear in the top three sections, as modernist silhouetted figures tell a painful story. A body lies motionless on the ground. A mourner curls over, while another figure reaches out to offer comfort. Children tug at a parent for reassurance. A figure points upward: could this be a way out? No, for the figures that struggle to escape upwards, testing the ceiling and gazing up, are being ground underfoot, literally stomped on by the poisonous urban industrial military world of the American future. Three of those Indian silhouettes are painfully compressed, their heads bent back upon their shoulders. It is a grim vision, offset only by the opportunity to let one's gaze wander down the panel, back to the verdant green of the Indian past.

6.27. Mary Sully, *Three Stages of Indian History* (detail): Design icon from the middle panel, which incorporates and transforms icons and colors from the top panel, including the yellow hide painting, red arrows, negative-space white lodges, and green grass.

In the middle panel (fig. 6.27), Sully abandons any pretense of commercial design, with a riot of color, icon, repetition, and variation. The panel offers an explicit aesthetic development of the themes; it is not interested in becoming a wallpaper or silk scarf. Time is skewed here. The representation of history in the top panel runs from bottom (past) to top (present). The three panels—at least in my reading—move from modern present (top) to Indian future (bottom). The result is a confusion of space and narrative, creating a temporal uncertainty captured by the visual complexity of the middle panel. The four sections of the top panel remain, clarified into simpler patterns, and they take on a kind of wavelike rhythm. The barbed wire emerges as a powerful statement of constraint, of fences and boundaries and restriction. The brown figures of modern anxiety retain their basic form, though the bent-over figures slump further in defeat. The shoes, curiously, have been elaborated, as the pinstripes and spats are combined into a single figure, more gangsterlike than their original iteration, while the brown boots are given spurs and thus figured as cowboy boots (naturally evocative in terms of Indians) and the blue jeans offer a small splash of color over a curious pair of sharpened, hobnailed boots.

The "Indian" colors of parfleche—green, blue, red, yellow—are captured from the woman's hide painting in the side subsections and reframed as a rounded yellow rectangle with blue-red-green interior. But these colors are elaborated through the addition of a highly abstracted figure—arrows and

diamonds in purple, red, and pink. This icon captures the arrowlike figures of the hide paintings on each edge, the conical forms of the *tipi*, and the bow and arrow on the ground, as well as tiny patches of green grass. The purple and pink seem to have no antecedents in the top panel. But the purple color frames the conical *tipi* forms and calls to mind the *tipi*/robe found in *The Indian Church*, suggesting the possibility of an intertextual reading of these late images. And pink (*ṡa-mná*), as Ella would note in one of her ethnographies, combined "red" (*ṡa*) and "odor" (*mná*) to give the sense that pink emanated from red, was a "vibrating" form of red.[23] Combined with significant areas of negative space, the band that elaborates pre-Columbian freedom emerges as an almost garish statement that bids to dominate the design pattern; its garishness (let's call it instead "color power") has consistency and logic in the Sioux world from which it arises.

In the bottom panel (fig. 6.28), the horizontal bands have been turned 90 degrees, becoming vertical lines based on diamond patterns and the basis for a new form of symmetry. Three of the four bands are doubled: at the right and left edges of the image, one finds two symmetrical articulations of the band of shoes, marked by the blue jeans and black boots (defined by a tiny pink diamond, a color borrowed from the second panel). Moving toward the center of the paper are bands that rewrite the brown of modernist anxiety and the black of barbed wire. At the center, and overwriting the barbed wire, is a single band of color. Yellow, blue, red, and green—parfleche colors—are arranged in a single geometrical pattern of diamonds. Gently backgrounding the Indian design is the purple color introduced in the middle design pattern, evocative of *The Indian Church*.[24]

6.28. Mary Sully, *Three Stages of Indian History* (detail): Central symmetry in the bottom panel. Indian futurity becomes visible as Indian color (yellow, blue, red, green, purple) overwrites the barbed wire of history.

There is a powerful politics to this image, with its self-conscious evocation of colonial domination. And while the first panel focuses on the hurts of history, confusion of the present, and perils of the future, this third panel suggests that Indianness—Indian color

power, figured in traditional terms—will overcome the barbed wire of past and present. The band of Indian color draws from the yellow, blue, and red of the painted robe, to be sure. But it is worth considering other sources of color that might also have been carried across these panels. A close look at *Pre-Columbian Freedom*, for example, reveals other sources of blue—the blue of the lake, for instance, or the blue yoke of the woman's dress. Even more, one might locate a scattering of red—fringe on the lodges, a red medallion (common in *tipi* decoration), and perhaps most telling, the tiny swath of red that covers the child in the central subsection.[25]

Indeed, if one were to associate red with the child—a powerful signifier of Indian futurity—then it is worth noting the appearance of children not only in happy memory, but in modernist trauma. They seek help and point to the future even in the midst of disarray. And in the bottom panel, those children continue to be represented: they exist as small red diamonds in the middle of the "modern anxiety" column (fig. 6.29). Indian futurity, in the form of future generations, is thus built into the modern, even in its worst manifestations. This insistence on fertility and regeneration refuses the settler colonial ideological imperative to imagine and call into being Indian disappearance. Sully rejects it entirely.

6.29. Mary Sully, *Three Stages of Indian History* (detail): Red diamonds signify the sacredness and futurity carried by Indian children, even in the midst of the challenges of the present and future.

And the same generational futurity proves central to the ongoing memory and practice of the past, of culture and tradition. Indian women—the blue yoke and the yellow hide painting, the purple of the church and the *tipi*—are critical to this linkage of past and present. The red diamonds thus sit, in the bottom panel's "Indian" band, in a central location, at the very heart of each yellow diamond, emergent on a narrow band of blue. Women, it is clear, create the next generations and thus the future.

This was, in fact, a conclusion that Ella Deloria had already reached through her ethnographic work, and as she and Mary Sully considered their own partnership. Childless in no small part due to the dynamics of race, gender, kinship obligations, New York modernity, the informant dynamics of anthropology, and their own education and cosmopolitanism, the ques-

tion had to have taken on an unimaginable poignancy. At one point, Ella contemplated for Boas the relation between cultural continuity and gender roles: "Children of white men and *Indian* mothers are steeped in folklore and language, but children of *white* mothers and Indian fathers are often completely cut off from the tribal folk-ways. If every Dakota woman disappeared today, and all the men took white wives, then the language and customs would die."[26]

Indian History, in this sense, offers not simply a critique of past and present forms of colonial dominations, or a formal push into the future, but also a specific admonition about how exactly the future could and should unfold—even if it had not unfolded in that way for the sisters.

In this sense—in its combination of grief, critique, diagnosis, and admonition—*Indian History* functions as Mary Sully's most explicitly political work in both concept and execution. It does in fact offer a master key, a kind of metamap through which one can (re)read each of the individual personality prints as a developmental narrative of Indian futures. Sully's consistent emphasis on women's roles, found in both *Indian History* and *The Indian Church*, maps to ideas visible in Ella's culture and personality study and to Sully's own frequent invocation of powerful and interesting women in the project. Indeed, one should read Sully's work through a lens of gynocentrism that we might take as evidence of an early articulation of Indigenous feminist consciousness.[27] The bottom panels are saturated with meanings that are "Indian" and "more-than-Indian." When placed in a developmental sequence or the narrative of a story, they offer a consistent conclusion that resounds across the full reach of the personality prints: Indian possibility, survivance, and futurity are possible through Indigenous striving but often figured in terms of women, not simply in their reproductive capacity but as the carriers of self-determining culture, and thus the keys to political futures.

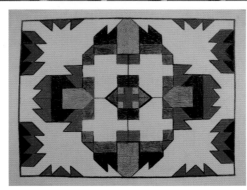

CONCLUSION

Luta and the Double Woman

THE RED CROSS (FIG. C.1) SERVES AS A REMINDER OF THE RELATION-
ship between color and Dakota cosmology, and the ways in which red
has long served as a marker of a good and successful life. The Dakota world
takes shape as a sacred hoop, divided into quarters by two "roads," with each
quarter represented by a meaningful color: for the north, white; for the east,
yellow; for the west, black; and for the south, red. One strove to walk on "the
good red road" and to help one's people do the same. It is no coincidence
that Sully used red in so many of her images, often (as in *Indian History*)
linking the color to Indian life and futurity.

Here, Sully gestures not only to the founder of the Red Cross, Clara Bar-
ton, but to crossed roads—and indeed to the proliferating semiotic possibili-
ties encapsulated in the color red: blood, love, passion, racialized Indianness,
a Gertrude Stein rose. Red explodes across the triptych's top panel, serves as
a background color for a figure/ground movement in the middle panel, and
centers a rotational symmetry in the bottom panel. In what follows, I take
the color itself as a road or a path—a way for us to begin to pull together
the entangled complexity of the life and work of Mary Sully, and the ways it
might speak to us simultaneously of modernism, Indian futurity, and Dakota
epistemology.

C.1. Mary Sully, *The Red Cross (Clara Barton)*

261

In the late 1930s the two sisters faced significant challenges in their efforts to walk the good red road. In 1937 Franz Boas asked Ella Deloria to check on the ethnographic work of James Walker, a physician at Pine Ridge. She was unable to confirm any of his findings, and Boas insisted that she was wrong or not trying hard enough.[1] The Walker assignment created a small fissure in their relationship, and as Boas's health declined, their once strong connection grew somewhat tenuous. Boas died in 1942, but the Walker project represented the last major piece of work that he offered Ella, leaving the sisters scrambling for money and for secure housing.[2] In 1938 they moved at least five times, taking up residence at their brother's home in Martin, summering at the Flandreau Indian School dormitories, returning to Yankton in the fall, and then heading to the Southwest and the Navajo study that would keep them in Arizona and New Mexico through the spring of 1939.[3]

Perhaps it was in those years that Sully and her sister read *Wake Up and Live* and decided to act—despite the monumental weight of both personal and collective history—as if there were no possibility of failure. If ever there were a time for Mary Sully's art to generate income, the late 1930s was that moment, and the sisters mounted a sincere but amateurish and ultimately unsuccessful marketing effort. They aimed as much for potential patrons as they did for potential audiences—though of course the two went hand in hand. Indeed, Ella would soon redirect her writing to a consumer audience through her popularizing book *Speaking of Indians* (1944) and a novel, *Waterlily*, written in the 1940s but not published until 1988.

The sisters wrote their query letters to ZaSu Pitts, Gutzon Borglum, and perhaps some of the project's other personalities, posing as agents for an undiscovered artist. They set up the first exhibits of the work. In June 1938 Ella Deloria wrote Franz Boas that she had been in Wisconsin: "I had a chance to lecture at Green Bay to the Woman's Club in connection with some designs made by a Sioux girl, which the Art Federation was exhibiting. I made $15.00 but cleared only ten, as my share for gasoline was five dollars."[4] The unnamed "Sioux girl" was her sister, of whom Boas was well aware. Later that summer or fall, the sisters mounted short exhibitions at the Flandreau Vocational High School in South Dakota and at the Pipestone Indian School nearby in Minnesota. They developed a format: the individual personality prints were taped together (fig. C.2) and hung as a collec-

C.2. Snapshot of *Fred Astaire*, taped and ready for display

tion. Ella would then lecture, explicating details of the images and talking of Sioux life.

Following these shows, they sought out formal testimonials. From Pipestone, acting principal Mabel Berry noted that the show had been up two afternoons and evenings, being extended an extra day for local public high school teachers, who walked 125 students two miles to the Indian School to see the exhibit. The art was amenable to both adults and children, Berry said, and anyone doubting their own interest in creative art would be pleased by the lecturer's explanations. Berry concluded with the bottom line: "It was

said by those most capable of judging that the display was worth the price of a ticket many times over." Ella prompted a tardy Eda Borsett of Pipestone for her formal endorsement, which did not arrive until February 1939.[5] Byron Brophy, superintendent at Flandreau, responded with a brief statement, "The exhibit of 'Luta Personality Prints' was a huge success. . . . Any organization interested in Art would do well to consider its presentation in the annual program."[6] While the sisters may have been able to mount shows beyond these three, Ella's letters do not feature other communications that would suggest that they were significant in either number or impact.

The letters continued to frame the forty-three-year old Mary Sully as a kind of secret double, a "young Sioux girl" or an "Indian artist" whom one or the other had happened to chance upon and take under wing. In March 1939, for example, J. B. Reuter of Casper, Wyoming, wrote to Franz Boas with his own testimonial in support of a proposal from Ella for a new line of research: "[Ella] has the assurance of assistance by Miss Mary Sully (Luta), sympathetic artist of the Dakota tribe, whose thorough knowledge of Dakota ways and things would be essential in giving an accurate picture of the material properties of these rites—accurate both racially and tribally." Here, Sully is on the edge of being framed not only as an ethnographic artist but possibly as an informant for Ella! Reuter went on to quote from Ella's draft project proposal, giving us a picture of how the sisters presented Mary Sully as someone other than Ella's sister: "[She] is the young Indian artist who made the 'Personality Prints'—her own mental pictures of noted individuals, from which she worked out textile and Indian designs. The exhibition of her work is planned for this fall in Chicago and is being written up as a feature article for the *American Weekly*."[7]

The claims for a Chicago showing and national publicity seem like wishful thinking. At the same time, the marketing made Mary Sully less the emotional property of Susie Deloria and more a fungible public figure, eternally young, expert in Indian ways, a designer of whom you had surely heard. Mary Sully? She was simply the latest thing. It was likely during this period that the sisters prepared the typescript list of personality prints, probably as part of a marketing package that may have included the testimonials and photographs. Some of these they included in their appeal to Borglum, who responded in a polite but noncommittal manner.[8]

Over the next years, Sully completed something on the order of twenty-five additional images before she stopped. It is impossible to say how or exactly when the project came to its conclusion. A slowdown, perhaps, as Sully turned to other projects? Perhaps simply exhaustion and frustration, combined with some of the injuries Sully began to suffer (she broke an arm slipping on ice and burned herself badly on a car radiator)? Or was there a forthright decision to abandon the project, which one might have imagined to have run its course? Ella noted in 1938, for example, that Sully and a group of women were making six-foot play tipis for children, which retailed for fifty dollars and which the sisters had installed in Omaha and Denver and hoped to sell.[9] Like Sully's other plans, this one seems to have gone nowhere. Sully continued to work on her art, buying general instruction books for painting in oils and continuing to draw.

The evidentiary trail Sully left behind, always dim, almost completely disappears at this point—at least in terms of the art. The sisters continued their pattern of mobility, spending time in New York, Tampa, South Dakota, and Arizona. They made Oberlin, Ohio, their base for a few years, regularly spent summers at Flandreau, and, between 1955 and 1958, returned to their roots, running the St. Elizabeth's School at Standing Rock, where they had once been students. They spent time in Rapid City, South Dakota, in Sioux City, Iowa, and in Lincoln, Nebraska. Their movements could be paradoxical from a fiscal perspective, driven alternatively by expensive short-term advantage or by affordable housing available through friends, relatives, or institutions. They were willing to invest time and resources driving to Denver or Omaha in order to set up Sully's model tipis, or to Green Bay, or to any number of other places. At some points, the sisters seem to have separated for a season or two before reuniting in another place. On occasion, Ella reported that her sister was "working full time," but whether for wages or on her art was never quite clear.

Sully began to suffer the effects of ill health and began a slow march out of this world. My father observed that even if the Deloria family had "made a successful adjustment to the white man's world and become prominent people in the new way of life, they had never learned to trust the white medicine." His primary example was his aunt Susan Deloria, "who refused treatment when she had cancer until it was too late to do anything for her."[10] She died in Omaha on August 29, 1963.

In addition to the personality prints, Sully left behind at least three other bodies of material. The largest collection was the ethnographic illustrations—thirty-three of them—meant to accompany Ella's as-yet-unfinished ethnographic project.[11] A small second collection of work, mixed among the collection of personality prints, is composed of a few curious images that seem to hybridize animals and objects. And finally, as Ella prepared a collection of Dakota legends for publication, Sully created twelve drawings meant to illustrate specific points in the narratives.[12] These later works demonstrate Sully's mature drawing skills, framed by elaborately drawn borders that use the kind of geometrical designs often found in the personality prints.

The personality prints themselves traveled in the large box of thick gray cardboard with reinforced corners. When Mary Sully died in 1963, the collection stayed with Ella Deloria until her death in 1971, when the box passed to my grandfather, Vine Deloria Sr. For Ella the 1960s had at last been marked by relative successes, as she finally received some modest grant funding and made progress on the serious linguistic work of her grammar and dictionary. In 1974 the University of South Dakota not only welcomed the donation of her collected papers but also created the Ella C. Deloria Research Professorship; among its goals was the "development and publication of the Ella C. Deloria research materials in the archives of the University."[13] In relation to Ella's late-career standing, the gray box of odd drawings must have seemed incidental and unimportant. Mary Sully's ethnographic illustrations and the Dakota legends drawings—if not already with Ella's materials—were separated out and sent to the archive. The personality prints themselves remained behind.[14]

Shortly afterward, my grandfather handed them off to my mother, who he thought might catalog and preserve them. She served as a quiet but tenacious advocate for Mary Sully's art, particularly in relation to my father, who saw in it little of value. My mother kept watch over the personality prints for three decades, through moves into and out of four different houses and through a devastating 1994 house fire, which they miraculously survived. In 2006 we pulled them out and looked through them with a laptop by our side, with internet searches enabling us to quickly identify and learn something about forgotten celebrities like Alice Fazende or Alison Skipworth. Unlike our previous viewing, in the mid-1970s, we found we could now open up a bit of a window into the mind of Mary Sully.

In Byron Brophy's testimonial one finds one small addition to the discourse surrounding the art: he recalls for the collection a formal name, the "Luta Personality Prints." J. B. Reuter's recommendation letter suggests something only slightly different, that "Luta" was the artist's Dakota name, and he places it in parentheses following the mention of Mary Sully. What did *lúta* mean in relation to the project? Lakota dictionaries define the word as "scarlet" or "red," listing the Dakota dialect version *dúta* as well. It is a word that has appeared in this story before, as a name. Mary Sully's grandmother was Susan Pehandutawin: Crane (*pehan*) Red (*duta*) Woman (*win*). And Clara Barton's Red Cross was, like the project as a whole, a study in *lúta*—in more ways than one.

The artist had at her disposal two of her grandmother's names (Susan and *Lúta*), her mother's name (Mary Sully), and her own name (Susan Deloria), and she built identities out of all of them in various combinations. The diminutive "Susie" fit her on some occasions, but she grew to prefer the more formidable "Mary" or "Mary S."—though sometimes "Mary Susie" or even, while in North Carolina, "Mary Sue." Sometimes she chose Deloria, sometimes Sully, depending on whether she was framing herself as the artist or as the artist's representative. Of course, the name "Mary Sully" allowed her to evoke the portrait tradition of her great-grandfather Thomas Sully and the world of cross-cultural traffic and uneven power that had given birth to her mother. But by naming herself and her work *Lúta*, she vehemently returned the project to Lakota/Dakota roots, even as she used *Lúta* to express her admiration for Clara Barton and the many other figures for whom she created personality prints.

There is another "red" in the Dakota language, *šá*, and the distinction between the two is worth contemplating. The word *šá* might be thought of in a couple of ways: as a somewhat darker shade of red, and as perhaps a more "everyday" understanding of the color. *Lúta*, on the other hand, might be more often found in names, and it suggests a brighter shade of red, the scarlet often associated with leaves turning color or porcupine quillwork. In Ella Deloria's Lakota-English dictionary, *lúta* is defined like this: "it is red; crimson; ceremonial red. 'holy red.'" *Lulyá*, a modifying form, suggests

transformation, of coloring or painting or making something red.[15] Indeed, the online *New Lakota Dictionary* makes these kinds of linkages explicit: "to be red, scarlet (used for describing objects with spiritual or ceremonial significance); also used in personal names, signifies a more shiny red than *šá*."[16]

In addition to the cross-generational naming connections to Sully's grandmother, the use of *Lúta* in personal names carries a deeper connotation: that of the honoring of individuals, an act often linked to the production of red quillwork—according to Ella Deloria, the oldest and truest form of Dakota decorative tradition and the highest of women's arts. In this sense, the personality prints were more than simply Mary Sully's "mental pictures" of individuals or her complex engagement with modernism or with the politics of settler colonial history and Indian futurity. They were also meant to recognize and describe the achievements of individuals (see, for example, fig. C.3), to honor their talent, generosity, courage, or virtue in a traditional sense, as with the gift of red-quilled moccasins (the same kind of object her ancestor Pehandutawin may have given Alfred Sully, who ungratefully shipped them back to Philadelphia with a flippant note to give them away).

DOUBLE WOMAN

We might well think of this honoring practice as a Dakota-centric vision of the same kinds of intellectual questions that drove culture-and-personality anthropology. But it is not the only way to think about these questions. The curiously split and interwoven identities of Susan Deloria, troubled recluse, and Mary Sully, productive and ingenious artist, reflected the doubled identity with which she lived her life, visible in her play with names. In a very real sense, the parallels and contrasts between the two sisters themselves represented an equally deep splitting and doubling: one shy and private, the other public and outgoing; one a visibly high achiever, the other an underachiever who bid for invisibility. These differences actually tied them more tightly together, as the sisters functioned as paired opposites of one another. At the same time, their distinct personalities also reveal the ways in which their practices of art and anthropology intertwined and ran closely in tandem. Both operated from the margins, seeking entrance into high-end Western

C.3. Mary Sully, *George Ade*. Sully's label highlights her reasons for honoring Ade, notably his demonstration of the Dakota quality of generosity. Here, she recognizes him in the form of both the color *Lúta* and the quilled moccasins.

intellectual and aesthetic worlds. Both sought audiences but failed to win them during their lifetimes. Both engaged similar questions, focused on culture and knowledge, and did so from complicated positions. Both built a Dakota archive for the future. And to the extent that their projects overlapped, they did much of that building in dialogue with one another.

In 1993 art historian Janet Catherine Berlo used the Lakota figure of the Double Woman to frame an argument about the ways in which cultural materials—"myths and folklore," as she framed it—could be used to understand epistemological meanings of American Indian women's arts that went beyond technique or classification. Her article "Dreaming of Double Woman," though a quick overview, has served as a critical touchstone ever since, useful for its evocative assessment of the ambivalences that seem to emerge from so many Native stories.[17] In Berlo's reading, the visible and consistent power embodied in women's arts is always crossed by its dangers: social displacement, uncontained sexual power, uncontrollable spiritual hazard, female solidarities (even cross-species), and other forms of excess that reveal and render the hazards that underlie the creative impulse to make art.

Ella Deloria collected only a few accounts of Double Woman dreams or the ceremony connected to her. One woman offered her few details but a rich explanation:

> I was skilled in porcupine work. That is the only real art among the Dakotas. It is the first-born of the methods of ornamentation. The most difficult. It comes already learned, taught by the Two-Women, who appear in a vision and give a choice to the dreamer as to whether she will choose a life of industry and respectability or whether she will prefer to be unskilled, and to spend her time roaming about, indulging her passions. I chose the good life, so they gave it to me, with the skill to weave quills into all sorts of fantastic figures. The trick comes ready learned; no human can teach it or learn it.[18]

Another Double Woman dreamer told of a fantastic vision in which she was led underwater—often the location of bad powers—and followed a red fish, "perfectly embroidered with quills, in the precise pattern of the scales," which led her to a tipi beautifully decorated with quillwork. She wanted to cross the tipi to the honor seat at the other side. On the right side of the lodge, two beautiful women ignored her as they worked their quills. On the left side, two equally beautiful women smiled, made room, and signaled in a friendly manner for her to join them. A choice was being presented.[19] She made her way to the right side and focused her attention on the quillwork.

The sounds of the cordial women became faint, and when she looked found that they had vanished.[20] This woman would be not lewd but a skilled artist.

The ceremony itself featured women "whose lives were controlled by the Two-women, and they were either some of the lewdest and worst women in the tribe, or some of the very finest, most womanly women, but they enacted their ceremony all together." Dressed as they had seen the Double Woman in their individual dreams, they walked the camp circle in pairs, good and bad joined together as each held the end of a thong rope from which was suspended a doll. Swinging the rope with each step, they sang songs that had no endings but were interrupted by laughter, thought to be that of the Double Woman herself. They were bewitched, victims of the dream, and they acted out their enchantment, walking individually now across the camp center and hitting each other hard with their carrying bags when they encountered one another.[21] The ceremony was counted odd among Dakota people themselves, its strangeness reflecting a "sinister, an evil suggestion. [The songs] don't say anything definite, but they create a mood that is devastating."[22] Ella's manuscript is filled with additional notes, often linking Double Women dreamers to the *heyoka* dreamers, those who had visions of the thunders and were thus required to act as "contraries," doing things backwards—a challenging life.

Ella noted that "in general, those touched by the Two-Women are to be pitied. Even if they somehow chose correctly and became very model women and were the secret possessors of porcupine work skill, nevertheless they were under a spell. It was something they could not shake off."[23] The Double Woman was the manifestation not only of good and bad choices but of the complexity of the individual personality in relation to her social world. Even the gifted woman confronted the very real danger that while her arts might bring her respect, her exceptionality threatened to unbalance her life, setting up a social distance from her peers and leaving her as a talented but odd outsider, one to approach with trepidation. For that reason, as Ella recounted, when a woman is very skilled, "people always say, 'Have you dreamed something?' . . . They [the women] smile cryptically and deny it."[24] Ella closed her account with a personal note that bears exactly on the multigenerational affiliations Mary Sully saw in her own art: "My mother's mother [Susan Pehandutawin] was very skillful, and people used to say she was a Two-woman, but I never heard her speak of it."[25]

Susan Gardner, perhaps the most diligent literary scholar of Ella Deloria, used the Double Woman to frame Ella in her introduction to the 2009 edition of *Waterlily*, writing of the choice between artistic skills and the sexually transgressive life that meant one had "run away from the *tipi*" under the control of a bad nature. While these choices did not describe Ella Deloria exactly, Gardner, like Berlo, suggests that they offer a kind of epistemological ground for considering her life.[26] For Gardner, Ella's skills were *doubled* by her different cross-cultural identifications, but she was of necessity also a transgressive figure: "her enormous body of writings was her 'porcupine quill embroidery.' Like the good woman, she chose a life of 'industry' rather than 'lewdness,' but to pursue her ethnological work at all, she had, indeed, to 'run away from the tipi.' She more than 'lightly transgressed the rules' of traditional Dakota female decorum in a public domain, and 'restlessness' certainly did 'mark her life.'"[27]

The Double Woman offers affective and evocative ways to contemplate the career of Ella Deloria: how she had been outside her community, taken transgressive roles more often associated with men, and produced a body of creative work. But if both sisters had, at least metaphorically, chosen a life of "quillwork," Mary Sully was the more touched by the possibilities and dangers of the Double Woman. She literally doubled her name and her identity, engaged in a modern version of quillwork and creative skill, and lived at the social margins. For a Double Woman dream always set a woman apart. Those who had the artistic gift might become so absorbed in their art that they lost the balance in their life. Or maybe it is useful to say it inside out: those who lost control over their lives might devote all their attention to an art that offered them a kind of stabilization. And it is clearly the case that the unreliable Mary Sully of the mid-1920s found, through focused work with pencil, paper, and drawing board, a kind of stability. If she was a marginal figure in relation to her family and to American society, Mary Sully also claimed a marginal but validated location in Dakota Sioux culture, a place she occupied with a claim to artistic excellence.[28]

We might say, then, that *lúta* and the Double Woman offer epistemological frameworks through which one might locate Mary Sully as a particularly *Dakota* artist. Though she fit no other school of Native painting, her continual engagement with the quillwork tradition and its affiliated

arts—beadwork, hide painting, and quilting—reveals rooted commitments to Great Plains women's arts, situating her efforts in a context that emphasized the honoring of individuals. To build a universe of honored others was a chance for Mary Sully to constitute *herself*, to claim the ability to judge, perceive, and represent key elements in American culture. Positioned on the margins of American society, she was able to imagine herself as a kind of Dakota ethnographer, viewing the United States with what later anthropologists would call an *etic* vision, a distanced approach that resonated with modernist aesthetics. In this, she formed a curious mirror with her sister, whose insider ethnography was later described by Lakota anthropologist Beatrice Medicine using the explicit opposite: an *"emic* voice."[29]

In the realm of modernist aesthetics—a place she also claimed—Mary Sully engaged a general imperative to abstraction, to reworking form and content, engaging the unconscious, queering the vision, and playing with symbolism and representation in ways that made art "new." Artists took many positions on modernist imperatives. They turned to landscape, to the intentional warping of realism, to hyperrealism, to ethnic and economic underclasses, and to the sensation of experience. From Gaugin to Picasso to Sloan to Hartley and beyond, many made fetishes out of "the primitive," finding in the arts of other people the glyphs, symbols, and abstractions of form that allowed them to create. The most modern things, in this sense, were among the most deeply engaged with the primordial and archaic. Sully was both of and not of this world. She embraced the complexities of the symbol-image-abstraction nexus, blurring the range from flat-out pictorialism to near-complete abstraction. She devoted much of her energy to establishing relationships between, and playing with, abstractions figured simultaneously in the terms of both art and design. She read glyphs and symbols not out of the primitive but out of the modern itself. She created visual languages of illusion that reflected the doublings of meaning so characteristic of modernity: speech and thought, art and life, surface and depth, person and personality.

Other Native artists, no matter how easy it can be to think of them as "traditional," clearly engaged various forms of modernist practice. But Sully, though completely unknown, arguably offered the stiffest aesthetic resistance to modernist primitivism, creating instead a powerful form of

antiprimitivist Indian modernism. The Indian futurity encoded within her three-part structures both evoked and rejected primitivism, a rejection evident in her choice of subjects, her play with abstraction, and her insistence on narratives that ended with complication, not primitive simplicity. Her few visual evocations of primitive simplicity—in *Bishop Hare*, *The Indian Church*, and *Indian History*—are all put to use around a critique of the violence of American settler colonial history.

In that sense, those three particular late images—led by *Indian History*—function as the keys that unlock political commitments less transparent in many of the other images. Mary Sully was keenly aware of history—after all, she offered her sister support with sets and costumes on a number of historical pageants, all of which aimed to trace the relationship between past and present for Indian people. In Robeson County, that meant tracing pasts that took Lumbees back to the Lost Roanoke Colony. At Haskell, it meant contemplating the transition into boarding schools and Western knowledge taught to children being detribalized in her own backyard, a mirror of her own upbringing. In the Episcopal Church, that meant the juxtaposition of pre- and postmissionary worlds. She watched as her sister endeavored to recover and preserve a Lakota/Dakota cultural world that had been battered from every side.[30] In small towns, cities, and plundered reservations, she and her family contemplated the small gestures of the Indian Reorganization Act. How could her consciousness not be political? Her aesthetic claim, a resistance to primitivism grounded in Indian futurity, was in fact a political claim as well. The third panels in every one of her personality prints mapped, in one way or another, onto the resurgent Indian colors that overwrite the barbed wire of the colonial past in *Indian History* and that take form as a folded quill pattern in *The Indian Church* and the four-directions cross in *Bishop Hare*.

Modernist artists sucked the forms and contents from the things they labeled "primitive." Rarely did they commit to the politics of Indian pasts and presents—and when they did, their commitments served their own interests first. They ran in packs. Indeed, the very meaning of *avant-garde*—"advance guard"—suggests not only newness and innovation but a guard, a group. Edgy artists gravitated together not simply for mutual support and generative competition but (perhaps even more) to be *visible* to the art

establishment and the world at large. Naming and being named as "The Eight" or "The Ashcan School" or "The Provincetown Players" allowed aesthetic innovation to enter both consciousness and market. It is no coincidence that subaltern artists constitute their practice and enter mainstream cultures in similar ways, as "The Black Arts Movement" or "The Kiowa Six" or "The Santa Fe Studio School." Even as such groups forcefully create their own rich and diverse artistic communities, their patrons, sympathizers, and institutional supporters smooth the path that leads to taste-setting elites, wider audiences and markets, and possible inclusion in future canons. Who was the American Indian artist able to jump into modernism as an individual? Few people can name the Kiowa Six as a group; fewer still can name the members.

And what of the *avant*? The words are military at heart, suggesting a vanguard that attacks an enemy early in a battle while the slower-moving army assembles for a longer and larger confrontation. The very idea of advance, in the aesthetic context, implies movement forward, a claim to the radical for what will later be seen, perhaps, as merely progressive but that will nonetheless push societies from the staleness of the past into a future that is not simply different but also assumed to be superior. The avant-garde functions at an edge, but its field is time and history and its goal is the future. Other people, not so historically fortunate, aim not only toward the temporal future; they also aim synchronically, from the suffering margins toward the centers of social, cultural, political, and economic power. Their claim is on the future, to be sure, but it is also on a past of pain and loss and the possibility of justice in the present. Mary Sully developed such a consciousness. What she lacked was a group—a Yankton Five or Northern Plains School—that could lift her work as part of a collective, issue a manifesto, or even, at worst, serve as a critical art object for a John Sloan or Edgar Hewitt. She was a solo artist in every sense of the word, seeking to push forward an advance and to spy on the centers from the margins. You could not call her an *avant-garde*, but you might call her an *éclaireuse*, a scout. Mary Sully's group was comprised of two—herself and her sister—and despite all their doublings and mirrorings of one another, two people cannot comprise a critical mass.

If Mary Sully lacked a circle of action, she had at least had one of influences. Images such as *Indian History* or *Greed* or *Easter* allowed Sully to

figure the concept of "culture" in her own intellectual engagement with the circle of intellectuals—her sister, Otto Klineberg, Ruth Benedict, and Franz Boas, among others—who fused anthropology and psychology together into the powerful interdisciplinary formation known as "culture and personality." The day-to-day mechanics of this flow of ideas are hardly clear. Did Sully tag along with her sister to Benedict's and Boas's classes? Or were Ella and her books the main conduits for their thinking? Sully's project was well formed and partially executed by the time the sisters returned to New York City in 1931, so one might as readily ask the extent to which she had conceptualized the possibilities for a revealing cultural archive of individual personalities in *avant* and in parallel with those anthropologists, perhaps most simply out of the combination of her unique vision and three imperfectly attended courses on art history, design, and contemporary America at the University of Kansas.

Perhaps the more compelling question is how these intellectual worlds interacted. It is easier to imagine Mary Sully being shaped by the weight of the anthropological than the other way around. And yet Otto Klineberg and Ella Deloria used the abstraction of geometric pattern—drawn from Sully's world and her talents—as the basis for their racial intelligence test, drawing a genealogical line that places her as a distant relation to those who advanced *Brown v. Board of Education*, even as she watched and learned from Aaron Douglas. The stylistic changes and the growing weight, range, and ambition of the personality prints collection surely owes something to Sully's mediated encounter with the world of Columbia University anthropology. But Mary Sully's art was close at hand, a model worth considering as Ella grappled with Benedict's ideas. The personality prints offered a concrete illustration, vernacular and aesthetic, of how the big theory might work in artistic practice.

The figure of the Double Woman might tempt us to locate Mary Sully in a single cultural location, as an American Indian artist looking at a (mostly) white world. Yet Sully's own upbringing was rigorously bicultural, and this doubling mattered too. There was the Dakota world of the weekly ration camps, the summers spent with grandparents at Yankton, the parents speaking D-dialect Dakota at home, and the memorization of church liturgy in two languages. There was also an equally clearly defined white culture–based

world of St. Elizabeth's School, with Mary Sharpe Francis insisting on proper English and offering instruction in Latin. It was the world of the railroad, the agency, and the range-riding bishop, the world of All Saints Boarding School, and the fetishization of the emergent racial formation called "mixed blood."[31] In the Dakota world, good women were chaste and conservative in one way; in the Victorian moral world of the church, they were the same, but out of a very different kind of cultural logic. In the Dakota world, kinship relations defined nearly everything. Their social utility was made possible by their extraordinary rigor, with certain disapproval waiting for those who failed in their obligations. In the white world, social categories—race, class, gender, region, education—proved equally restraining. To consider Mary Sully in *bicultural* terms, we must visualize a doubled set of social constraints, a tremendous cluster of limiting factors ranging from structural oppression to neighborhood gossip.

Mary Sully lived within such boundaries and constraints, which overlapped in ways that could be immobilizing. But her life also suggests the productive side of biculturalism—a multiplicity of cultural influences that also created *possibility*. All those names: she could be Indian, white, American, modern, southern, ancestral. She was beautiful, proud, sometimes funny, and pathetic. She could be a student, a nurse, or an artist—the latter a visible role that explained away her eccentricity and reclusiveness. She was consumer, producer, and dependent, the object of popular culture and its critic. She was urban and rural, western and cosmopolitan, a driver of automobiles. These were not simply identities or subjectivities but cultural complexes with histories and meanings.

Cultural shape came to her as if it were music from all directions. Some of this culture-music was loud or was repeated, offering forms and structures. Other music was soft but insistent. Some sounded just once but with powerful effect. Some came early; some came later. Mary Sully was the listening subject at the center of these fields, formed by them over time, forming herself in relation to them. Her inner world was complex, unknowable but visibly interesting physiologically, psychologically, socially, and culturally. On the outside edge of the outside of multiple cultures, she was also her own center, a perverse kind of artist/culture hero, able to bring into the world the "new" so craved by modernists.

And yet she found no audience, no patron. It is hard—even for me, a sympathetic ally—to sustain such heroic language when almost no one has ever seen the work, which has had no purchase in the worlds of American art or American Indian art.

There is a famous moment in Roland Barthes's *Camera Lucida* in which he muses on the temporal displacement created by a contemporary viewing of an Alexander Gardner photograph of the hanging of the Lincoln conspirators in 1865: "He is going to die. I read at the same time: this will be and this has been." We know that the conspirators are 150 years dead, and yet as they appear to us, death lies in their future. There is another moment, in Bruno Latour's *We Have Never Been Modern*, less famous because it unfolds in less pithy prose. There were once premodern people, he suggests, who did not divide nature and society. And we have been living, of late, in a moment in which science, discourse, and politics mix to such an extent that here, too, what were once divisions between nature and society have collapsed. The moment when we believed in such divisions—it lasted a long time—we called "modernity," and the world functioned in terms of the duality. But in fact, Latour argues, the distinction between nature and society *never* existed—which means that we need not simply rethink our history but retroactively imagine ourselves without recourse to the category "modern."

These are close analogues to the kind of historical time shift that the personality prints create for me, as both viewer and critic. Something that was utterly invisible in its moment seems to displace and transform the experience of the art that followed. Abstract expressionism, pop art, Indian modernism—these have shifted the tiniest bit on their axes. How can this be? No one saw Sully's art, so it cannot serve as the material precedent for anything that came after. No one saw Sully's art, so it was not in dialogue with the arts of its moment. And yet it seems to deepen the aesthetics of the moment and enable those that followed. It tells a different story about American Indian arts than has been told before, forcing a revision of its conceptual basis and its keywords: patronage, tradition, market, Southwest, Oklahoma, tourist art, instruction. And if it can indeed force such a revision on American Indian arts, then should it not also demand something of American art as a whole?

Mary Sully's art might create, in a lightning flash, a visible cohort of American Indian women making art: Angel De Cora, Nellie Two Bear Gates, Edmonia Lewis, Wa Wa Cha, Maria Martinez, Gerónima Cruz Montoya, Tonita Pena, Lois Smoky, and other less visible women of the moment, weaving baskets, crafting ceramics, bending birch bark, drawing on paper, and painting on canvas, all crafting art within the same contexts of modernity and Indigenous cultural continuity and futurity.

Sully's art might even serve to rehabilitate our understanding of white modernist primitivism. It is easy to read John Sloan, Marsden Hartley, Mabel Dodge Luhan, and other patrons, collectors, and tastemakers in terms of an indulgent and appropriative agenda of self-discovery through an engagement with otherness, one that preserved every bit of structural privilege built on race and class. The critique is accurate, but perhaps it is incomplete. These were also thoughtful, engaged, intelligent people, and we tend to forget that when they looked at Indian arts, they saw something important and transformative. What was it? An imaginary stolen from a falsified Indigenous past, to be sure, but also the vibrancy and power of human expression. What they saw, one realizes, was what is also visible in Mary Sully's drawings: perception, creativity, art. In Indian arts they saw something *like* Mary Sully, even as she moved imperceptibly past them.

Ella Deloria and Mary Sully were radically different people—and yet not so different.[32] One's art functioned something like the other's ethnography: anonymous and largely invisible until after their deaths. Today, *Waterlily*, published almost fifty years after it was written, is Ella Deloria's most visible text, considered a landmark both in terms of its postcolonial subjectivity and its turn from ethnography to fictional narrative. Her ethnographic monograph, in textual form as early as 1933, has been offered, in a lightly edited version, through a small regional press only.[33] And Ella produced all the elements necessary for language reclamation work: a grammar, a dictionary, and a collection of texts. The works of both women, in other words, have become reclamation projects from the past. Together, they carry the possibility of rewriting that past and thus reshaping not only the present but our picture of the 1930s, 1940s, and 1950s. Together, Ella Deloria and Mary Sully created texts able to jump the queue of time—which makes one wonder whether they imagined obscurity and failure or rediscovery and legacy,

whether they conceived of their work as archives left behind for the future or as experiments lost and futile.

The personality prints represent a body of work that one might well argue belongs in our collective *archive*—that is, the collection of our surviving possibilities, imagined in its broadest sense. Likewise, there is a strong argument that the body of work may well belong in our *canon*—that is, the definitive texts that capture culture and meaning with such richness and economy that they become touchstones so evocative we are required to dwell on them. The personality prints may even belong in our *historiography*—that is, the roll call of intellectual actors who have established methodological and epistemological pathways that lead to the questions and interpretations central to the *now*. For all their aesthetic simplicity and sophistication, for all their cultural complexity, the personality prints offer the occasion not simply for theorizing the period between the late 1920s and the early 1940s but for *experiencing* it in new ways. Because that affect, of course, is what art offers, and these images, for all else that they represent, surely give us that.

NOTES

INTRODUCTION: NATIVE TO MODERNISM

1 Since this project considers a large number of images produced by Mary Sully, subsequent captions will assume the continuity of the basic information and will offer only the artist and title. The artist: Mary Sully (Dakota, 1896–1963); the medium and size: colored pencil on paper, 34.5 × 19 inches. The location: author's collection. The photographer: except where otherwise noted, all images were photographed by Scott Soderberg.

2 Janet Catherine Berlo and Ruth B. Phillips, *Native North American Art*, 2nd ed. (New York: Oxford University Press, 2015), 256–58; and Robert G. Donnelley, "Transforming Images of Resistance: The Art of Silver Horn and Later Kiowa Artists," in Robert G. Donnelley, with contributions by Janet Catherine Berlo and Candace S. Greene, *Transforming Images: The Art of Silver Horn and His Successors* (Chicago: David and Alfred Smart Museum, 2000), 88–91.

3 Berlo and Phillips, *Native North American Art*, 258; and Sascha T. Scott, *A Strange Mixture: The Art and Politics of Painting Pueblo Indians* (Norman: University of Oklahoma Press, 2015): 153–79. As Sascha Scott points out, "traditional"—always a fraught concept—is even more so in this case, since hunting figures have almost no visual precedent in Pueblo visual culture and may reflect a visual language adopted in the transcultural art being produced by Plains artists such as the Kiowa Five or the earlier ledger arts traditions (personal correspondence, July 13, 2016).

4 Robin Finn, "Helen Wills Moody, Dominant Champion Who Won 8 Wimbledon Titles, Dies at 92," *New York Times*, January 3, 1998; and Helen Wills, *Tennis* (New York: C. Scribner's Sons, 1928).

5 Wills would win her sixth US Open in September 1929.

6 The original group of Kiowa students included Lois Smokey, Spencer Asah, Jack Hokeah, Stephen Mopope, and Monroe Tsatoke. Smokey left the university after

a short time, and her place was taken by James Auchiah. Scholars have generally used the term "Kiowa Five" to describe this group. In the context of this project, it seems inappropriate to exclude Lois Smokey from this history, thus my use of "Kiowa Six." Some thirty-one Kiowa students would pass through Jacobson's program. See J. J. Brody, *Indian Painters and White Patrons* (Albuquerque: University of New Mexico Press, 1971), 119–26; Lydia Wyckoff, *Visions and Voices: Native American Painting from the Philbrook Museum of Art* (Tulsa: Philbrook Museum of Art, 1996); and Donnelly, "Transforming Images of Resistance," 88–91. For additional context on American Indian art history, see the essays in Janet Catherine Berlo, ed., *The Early Years of Native American Art History: The Politics of Scholarship and Collecting* (Collingdale, PA: Diane Publishing, 1992).

7 Oscar Jacobson, *Kiowa Indian Art: Watercolor Paintings in Color by the Indians of Oklahoma* (Nice, France: C. Szwedzicki, 1929). On Jacobson, see Anne Albright, Janet Catherine Berlo, and Mark Andrew White, *A World Unconquered: The Art of Oscar Brousse Jacobson* (Norman: Fred Jones Jr. Museum of Art, 2015).

8 W. Jackson Rushing, "Modern by Tradition: The 'Studio Style' of Native American Painting," in *Modern by Tradition: American Indian Painting in the Studio Style*, ed. Bruce Bernstein and W. Jackson Rushing (Albuquerque: Museum of New Mexico Press, 1995), 26.

9 On the Henderson collection, see the 2015 Smithsonian exhibition *The Modern Pueblo Painting of Awa Tsireh*, http://americanart.si.edu/exhibitions/archive/2015/tsireh. Also see J. J. Brody, *Pueblo Indian Painting: Tradition and Modernism in New Mexico, 1900–1930* (Santa Fe, NM: School of American Research Press, 1997). For a Pueblo portfolio, see Hartley Burr Alexander, *Pueblo Indian Painting: 50 Reproductions of Watercolor Paintings* (Nice, France: C. Szwedzicki, 1932).

10 Robert Perry, *Uprising! Woody Crumbo's Indian Art* (Ada, OK: Chickasaw Press, 2009); Dorothy Dunn, *American Indian Painting of the Southwest and Plains Areas* (Albuquerque: University of New Mexico, 1968); Nancy Marie Mithlo, *For a Love of His People: The Photography of Horace Poolaw* (New Haven: Yale University Press, 2014); Laura E. Smith and Linda Poolaw, *Horace Poolaw, Photographer of American Indian Modernity* (Lincoln: University of Nebraska Press, 2016).

11 For a concise summary of these movements, see Berlo and Phillips, *Native North American Art*, 244–61.

12 Exposition of Indian Tribal Arts, Inc., *Introduction to American Indian Art: To Accompany the First Exhibition of American Indian Art Selected Entirely with Consideration of Esthetic Value* (New York: Exposition of Tribal Arts, 1931; reprint, Glorieta, NM: Rio Grande Press, 1970).

13 See Winona Garmhausen, *History of Indian Arts Education in Santa Fe* (Santa

Fe: Sunstone Press, 1988); and Joy L. Gritton, *The Institute of American Indian Arts: Modernism and U.S. Indian Policy* (Albuquerque: University of New Mexico Press, 2000). The best assessment of Native modernist artists of these generations, with a wider field of vision than simply Santa Fe, is Bill Anthes, *Native Moderns: American Indian Painting, 1940–1960* (Durham, NC: Duke University Press, 2006).

14 Donnelly, "Transforming Images," 88–91.

15 As Janet Catherine Berlo observes, their flat decorative style "owed as much to international trends in *art moderne* in the decades between the two world wars as it did to local indigenous traditions." Berlo, "Artists, Ethnographers, Historians," in Donnelley, *Transforming Images*, 42. Only a few decades later, Fritz Scholder (for example) famously insisted that he would not "paint the Indian" and then found himself doing exactly that. See Lowery Stokes Sims, with Truman T. Lowe and Paul Chaat Smith, eds., *Fritz Scholder: Indian Not Indian* (Washington, DC: National Museum of the American Indian, 2008).

16 I want to acknowledge and express my gratitude to Courtney Cottrell and Katherine Carlton, who investigated conservation issues surrounding paper and paint with Cathleen Baker, a conservation expert, as part of a 2013 museum studies capstone project at the University of Michigan.

17 I would like to acknowledge and express gratitude to Jordan Weinberg, who conducted thorough, creative research on the various personalities and advanced this project in significant ways.

18 Ella Deloria to Virginia Dorsey Lightfoot, February 3, 1946. The question is contained within a multipage document responding to several questions posed by Lightfoot. This correspondence is located in the Ella Deloria Archive of the Dakota Indian Foundation, Chamberlain, South Dakota (hereafter, Ella Deloria Archive, DIF), and includes letters to and from Ella Deloria collected by Dr. Agnes Picotte from a variety of archives. See www.dakotaindianfoundation.org/homeo .aspx. A significant number of primary sources—correspondence, manuscripts, and miscellany—have been published online through the American Indian Studies Research Institute of Indiana University at http://zia.aisri.indiana.edu/deloria _archive/index.php (hereafter, Ella Deloria Archive, AISRI).

19 Ella Deloria to Virginia Dorsey Lightfoot, February 3, 1946.

20 John Sloan and Oliver La Farge, "Introduction to American Indian Art," in Exposition of Indian Tribal Arts, Inc., *Introduction to American Indian Art*, 13–14.

21 Gritton, *Institute of American Indian Arts*, 151–56. Bill Anthes frames Native American modernism as "an expression of a transformed consciousness, which constitutes a particular (not universal) modernity that is unique to Native

American artists in the twentieth century" (*Native Moderns*, xxi). He joins others arguing for multiple modernisms in seeking to position Native artists outside both Greenbergian formalism *and* revisionist views emphasizing the urban (and, in particular, New York City), capitalist industry, and intertwined cultures of production and consumption.

22 Anthes, *Native Moderns*, xvii–xxvii. Anthes's treatment of Yeffe Kimball, who appropriated an Osage identity in the 1940s and '50s, suggests the important position that might have been occupied by a figure like Sully, an American Indian woman seeking to cross into the modernist mainstream. As Anthes notes, "Had Kimball actually been a Native American artist, she would have been a truly groundbreaking figure" (118).

23 See, for example, Geeta Kapur, *When Was Modernism: Essays on Contemporary Cultural Practice in India* (New Delhi: Tulika, 2000); Chika Okeke-Agulu, *Postcolonial Modernism* (Durham, NC: Duke University Press, 2014); and Lauren Kroiz, *Creative Composites: Modernism, Race, and the Stieglitz Circle* (Berkeley: University of California Press, 2012).

24 Though my meaning is somewhat different, the phrase is drawn from Mae Ngai, *Impossible Subjects: Illegal Aliens and the Making of Modern America* (Princeton: Princeton University Press, 2004), and emerges out of conversations with Jay Cook, who has been among my most prized interlocutors during the course of this project.

25 Mark Rifkin, *Beyond Settler Time: Temporal Sovereignty and Indigenous Self-Determination* (Durham, NC: Duke University Press, 2017).

1. GENEALOGIES: SOUND FROM EVERYWHERE

1 Letter from Fort Pierre, Dakota Territory, April 19, 1857, box 1, folder 15 (Correspondence 1856–1857), Alfred Sully Papers, Yale Collection of Western Americana, Beinecke Rare Book and Manuscript Library, Yale University (hereafter Sully Papers). Red Crane Woman's name is easily translated: Pehán, "Crane"; Lúta (also Duta), "Red"; Wiŋ, "Woman": thus Pehánlútawiŋ or Pehándútawiŋ. The other girl's name: Kimímela, "Butterfly." See also Vine Deloria Jr., *Singing for a Spirit: A Portrait of the Dakota Sioux* (Santa Fe: Clearlight, 1999): 59, and Stephen Hyslop, "Courtship and Conquest: Alfred Sully's Intimate Intrusion at Monterey," *California History* 90: 1 (2012): 4–17. The most comprehensive, though problematic, biography of Alfred Sully is Langdon Sully, *No Tears for the General: The Life of Alfred Sully, 1821–1879* (Palo Alto: American West Publishing, 1974). The author was Alfred Sully's grandson. The book is dedicated to the "Two Mary Sullys" (his mother and wife), which conceals the fact that (counting his two) there were

four Mary Sullys. I note, with appreciation, my correspondence with Lilah Pengra, biographer of Isiah Dorman, who reminded me—citing an interview with Norbert and Agnes Picotte—that beaded moccasins were made "just for intimate others; not to sell or trade." Correspondence with the author, February 2, 2015.

2 WA MSS S-1311, box 5, folder 78, Sully Papers.

3 Hyslop, "Courtship and Conquest," 7. See also Langdon Sully, "General Sully Reports," *American Heritage* 16:1 (December 1964), for Alfred Sully's own written account of his first marriage and its end.

4 April 19, 1857, box 1, folder 15, Sully Papers, also as quoted in Sully, *No Tears*, 122.

5 Ella Deloria, "Sioux Indian Museum" annotated list, 47–48.

6 On secret gift giving, see Ella Deloria, *The Dakota Way of Life*, ed. Joyzelle Godfrey (Sioux Falls, SD: Mariah Press, 2007): 45

7 In a footnote, Langdon Sully observes that Alfred Sully's wife, Sophia, "refused to let her husband hang the picture of the Indian girls in her house." Sully, *No Tears*, 243n13.

8 Dakota language is considered to have three mutually intelligible dialects: "D," "L," and "N": for example, Dakota, Lakota, and Nakota. The word "red" might have been heard and spoken, at Fort Randall, as *duta* or *luta*, thus, Pehánlútawiŋ or Pehándútawiŋ.

9 On Thomas Sully, see Thomas Sully and William Keyse Rudolph, *Thomas Sully: Painted Performance* (Milwaukee, WI: Milwaukee Art Museum, 2013); Carrie Rebora Barratt, *Queen Victoria and Thomas Sully* (Princeton, NJ: Princeton University Press in association with the Metropolitan Museum of Art, 2000); Edward Biddle and Mantle Fielding, *The Life and Works of Thomas Sully* (New York: Kennedy Graphics, 1970).

10 Deloria, *Singing for a Spirit*, 59.

11 The *Oxford English Dictionary* records usage of the term as early as 1600, but the modern sense of the word seems to have taken hold in the mid-nineteenth century.

12 Angela Cavender Wilson and Eli Taylor, *Remember This! Dakota Decolonization and the Eli Taylor Narratives* (Lincoln: University of Nebraska Press, 2005); Michael Clodfelter, *The Dakota War: The United States Army Versus the Sioux, 1862–1865* (Jefferson, NC: McFarland, 1998).

13 Paul N. Beck, *Columns of Vengeance: Soldiers, Sioux, and the Punitive Expeditions 1863–1864* (Norman: University of Oklahoma Press, 2013). I am in debt to Stefan Aune for framing the Sully campaigns as part of a new strategy of anti-insurgency that came to fruition during and following the Civil War. For the links between the West and the Civil War, see Virginia Scharff, ed., *Empire and Liberty:*

The Civil War and the West (Berkeley: University of California Press, 2015); and Adam Arenson and Andrew Graybill, eds., *Civil War Wests: Testing the Limits of the United States* (Berkeley: University of California Press, 2015).

14 Vine Deloria Jr., *Singing for a Spirit*, 9–19, 31–33; Vine Deloria Sr., "The Establishment of Christianity among the Sioux," in *Sioux Indian Religion: Tradition and Innovation*, ed. Raymond J. DeMallie and Douglas Parks (Norman: University of Oklahoma Press, 1987): 95–102.

15 Vine Deloria Sr., "Coming of Christianity," 106.

16 Vine Deloria Jr., *Singing for a Spirit*, 54–67.

17 Black Elk, as told through John G. Neihardt, *Black Elk Speaks: Being the Life Story of a Sioux Holy Man* (Lincoln: University of Nebraska Press, 2014); Black Elk, and John G. Neihardt, ed. Raymond J. DeMallie, *The Sixth Grandfather: Black Elk's Teachings Given to John G. Neihardt* (Lincoln: University of Nebraska Press, 1984); Lee Irwin, *The Dream Seekers: Native American Visionary Traditions of the Great Plains* (Norman: University of Oklahoma Press, 1994).

18 Vine Deloria Jr., *Singing for a Spirit*, 9–19; Vine Deloria Sr., "The Establishment of Christianity," 95.

19 For an introduction to the Niobrara Cross, see the Diocese website, www.dioces-esd.org/diocese/niobrara-cross/, accessed October 6, 2015. The nineteenth-century Niobrara Missionary District encompassed South Dakota and northern Nebraska. See Virginia Driving Hawk Sneve, *That They May Have Life: The Episcopal Church in South Dakota, 1859–1976* (New York: Seabury Press, 1977). For Bishop Hare, see M. A. DeWolfe Howe, *The Life and Labors of Bishop Hare: Apostle to the Sioux* (New York: Sturgis and Walton, 1911).

20 Sneve, *That They May Have Life*, 54.

21 Deloria, *Singing for a Spirit*, 42–45; Sneve, *That They May Have Life*, 13–15. Ella Deloria's version, "Indian Chief Helped to Build Kingdom," can be found at Ella Deloria Archive, AISRI, http://zia.aisri.indiana.edu/deloria_archive/browse.php.

22 Deloria, *Singing for a Spirit*, 48–49; Sneve, *That They May Have Life*, 13–16.

23 Deloria, *Singing for a Spirit*, 49–54.

24 For a brief account, see Sneve, *That They May Have Life*, 51–55.

25 See, for example, Vine Deloria Sr.'s rousing account of early church meetings: "I've been in faded Indian chapels where they sang simple hymns and said simple prayers and read the Bible beautifully. Some of those catechists were real orators; they knew what they read, and boy, they moved you. And the singing just rattled the windows. When you would say, 'The Lord Be With You!' the whole room rocked, "And With Thy Spirit!'" Deloria, "Coming of Christianity," 111.

1 Dorothea Brande, *Becoming a Writer* (New York: Harcourt, Brace and Company, 1934); Seward Collins, "The Monarch as Alternative," *American Review* (April 1933): 22–27. On Collins, see Michael Tucker, *And Then They Loved Him: Seward Collins and the Chimera of an American Fascism* (New York: Peter Lang, 2006); and Joanna Scutts, "Fascist Sympathies: On Dorothea Brande," *Nation*, August 13, 2013, www.thenation.com/article/fascist-sympathies-dorothea-brande/.

2 Scutts, "Fascist Sympathies."

3 Dorothea Brande, *Wake Up and Live* (New York: Simon and Schuster, 1936), 30–32.

4 Sully did personality prints for both Walter Winchell and Patsy Kelly, one of the other leads in the film, increasing the odds that the film may have been meaningful to her.

5 To carry forward the metaphor of purple vestments of *The Indian Church*, the relationship here is not unlike that between the anticipation of a redeemed future that characterizes Advent and the discipline, willpower, and sacrifice of Lent.

6 Brande, *Wake Up and Live*, 93–94.

7 See also Joanna Scutts, *The Extra Woman* (New York: Liveright, 2017).

8 Brande, *Wake Up and Live*, 35.

9 On Ella Deloria, see Janette K. Murray, "Ella Deloria: A Biographical Sketch and Literary Analysis" (PhD dissertation, University of North Dakota, 1974); María Eugenia Cotera, *Native Speakers: Ella Deloria, Zora Neale Hurston, Jovita González, and the Poetics of Culture* (Austin: University of Texas Press, 2008); Ella Cara Deloria, *Waterlily* (Lincoln: University of Nebraska Press, 2009), particularly three pieces of accompanying context and analysis by Susan Gardner, "Introduction," Agnes Picotte, "Biographical Sketch of the Author," and Raymond J. DeMallie, "Afterword"; Ella Deloria, *Speaking of Indians*, with an introduction by Vine Deloria Jr. (Lincoln: University of Nebraska Press, 1998); Beatrice Medicine, "Ella Deloria: The Emic Voice," in *Learning to Be an Anthropologist and Remaining "Native": Selected Writings*, ed. Beatrice Medicine with Sue-Ellen Jacobs (Urbana: University of Illinois Press, 2001); Ruth J. Heflin, *I Remain Alive: The Sioux Literary Renaissance* (Syracuse, NY: Syracuse University Press, 2000); and Penelope Kelsey, *Tribal Theory in Native American Literature: Dakota and Haudenosaunee Writing and Indigenous Worldviews* (Lincoln: University of Nebraska Press, 2008).

10 Beatrice Medicine, "Ella Deloria," 285.

11 Ella Deloria, "Miss Mary S. Francis," 3. This manuscript is located in a collection of Mary Francis's Papers in the possession of her great-niece Susan Gunderson,

to whom I am grateful for both conversation and permission to quote from the material.

12 Ella Deloria, "Miss Mary S. Francis," 6.

13 Virginia Driving Hawk Sneve, *That They May Have Life: The Episcopal Church in South Dakota, 1859–1976* (New York: Seabury Press, 1977), 7.

14 Sneve, *That They May Have Life*, 116.

15 M. A. DeWolfe Howe, *Life and Labors of Bishop Hare*, 63; Sneve, *That They May Have Life*, 115–34.

16 Thanks to Rani-Henrik Ericsson for assisting me in thinking about the many Sioux color semiotics that come into play in these images. On the sacred hoop, see John G. Neihardt, *Black Elk Speaks: The Complete Edition* (Lincoln: University of Nebraska Press, 2014), 26.

17 Ella Deloria to Hugh Latimer Burleson, January 9, 1927, Correspondence File 1 (February 19, 1924–December 22, 1927), Ella Deloria Archive, DIF.

18 Susan Deloria to Hugh Latimer Burleson, August 16, 1924, Correspondence File 1 (February 19, 1924–December 22, 1927), Ella Deloria Archive, DIF.

19 Yankton File no. 312, Indian Office Files 30180, 1916, National Archives and Records Administration (NARA) Record Group 75. These are materials associated with the probate of Mary S. Deloria and include her will, findings and recommendations, appraisals, and the transfer of deed from Susan M. Deloria to Ella Deloria, consolidating with Ella the ownership of their jointly inherited land. The time between the transfer (June 1, 1918), its notarization (October 19, 1918), and its approval (October 29, 1919) suggests both the pace of the Indian Office bureaucracy and Ella's lack of leverage with the Yankton agent.

20 The 1920 census shows Ella living as a trainee and resident at the YWCA in New York City. Susie was not counted in Ella's household (as she would be later) or as part of her father's household in South Dakota, which lists his new wife, Julia, her nephew, and every Indian student resident at St. Elizabeth's, along with the various teachers and workers. It is also worth noting that the probate file contains correspondence from Susie suggesting that the land is to be sold to support her education, a constant theme in the sisters' correspondence during 1924–27.

21 Thanks to Kathy Lafferty of the Spencer Library at the University of Kansas for information on Susie and Ella's enrollment, and on the bureaucratic and registration procedures of the university in the 1920s.

22 The letter was not addressed simply to the Indian Office bureaucracy but specifically to the Commissioner of Indian Affairs, Charles Burke, the father of Josephine Burke, one of Ella's former students and closest friends at the All Saints School. Ella Deloria to Charles Burke, January 18, 1926.

23 Vine Deloria Sr. to Charles Burke, March 2, 1926, Correspondence File 1.

24 Ella Deloria to Henry Peairs, April 18, 1926, Ella Deloria Archive, DIF.

25 Indeed, in one letter (in 1925) Ella notes that the Haskell administration was worried about whether Ella would fail, as other Indian teachers had done in the past, and whether Susie would be a burden to her.

26 Ella Deloria to Hugh Latimer Burleson, February 27, 1925, Correspondence File 1 (February 19, 1924–December 22, 1927), Ella Deloria Archive, DIF.

27 Ella Deloria, "A Very Confidential Report."

28 Susan Deloria to Hugh Latimer Burleson, August 16, 1924, Correspondence File 1 (February 19, 1924–December 22, 1927), Ella Deloria Archive, DIF.

29 Ella Deloria to Hugh Latimer Burleson, February 27, 1925; Susan Deloria to Hugh Latimer Burleson, August 16, 1924; both in Correspondence File 1 (February 19, 1924–December 22, 1927), Ella Deloria Archive, DIF.

30 Hugh Latimer Burleson to Ella Deloria, June 11, 1926, Correspondence File 1 (February 19, 1924–December 22, 1927), Ella Deloria Archive, DIF.

31 Vine Deloria Sr. to Charles Burke, March 2, 1926.

32 Ella Deloria to Henry Peairs, April 18, 1926.

33 Ella Deloria to Hugh Latimer Burleson, February 27, 1925.

34 Vine Deloria Jr., "Introduction," in Ella Deloria, *Speaking of Indians* (Lincoln: University of Nebraska Press, 1998), xiii.

35 Hugh Latimer Burleson to Ella Deloria, March 5, 1925.

36 Clifford Beers, *A Mind That Found Itself: An Autobiography* (New York: Longmans, Green, 1908).

37 Clifford Beers, *The Mental Hygiene Movement* (New York: Longmans Green & Co, 1921).

38 Harry James Boswell, "Biographical Sketch of G. Wilse Robinson," 1912, Missouri Valley Special Collections Room, Kansas City Public Library.

39 John Punton, "A Clinical Analysis of 976 Cases of Nervous and Mental Diseases," *Kansas City Medical Index-Lancet*, ed. John Punton, 27, no. 3 (March 1906): 67–80. Here, Punton breaks five years of casework into discrete categories, commenting on each.

40 Kyle Crichton, "Haphazard Patsy," *Collier's*, April 18, 1936, 32, 88. See also Boze Hadleigh, *Hollywood Lesbians* (Fort Lee: Barricade Books, 1994); and William J. Mann, *Behind the Screen: How Gays and Lesbians Shaped Hollywood, 1910–1969* (New York: Viking, 2001).

41 On Cook, see Tom Longden, "Nilla Cram Cook: Linguist and Writer, 1910–1982, Davenport," http://data.desmoinesregister.com/famous-iowans/nilla-cram-cook.

42 "Children of Divorce," *Ladies' Home Journal*, March 1934, 16.

43 Ella Deloria to Hugh Latimer Burleson, March 25, 1925. In this detailed letter, Ella laid out a full page of details on Susie's treatment. Also see G. Wilse Robinson to Hugh Latimer Burleson, March 31, 1925, Correspondence File 1 (February 19, 1924–December 22, 1927), Ella Deloria Archive, DIF. For an overview of therapeutic culture, see T. J. Jackson Lears, *No Place of Grace: Antimodernism and the Transformation of American Culture, 1880–1920* (New York: Pantheon, 1981), 47–58.

44 Ella Deloria to Hugh Latimer Burleson, April 22, 1925, Correspondence File 1 (February 19, 1924–December 22, 1927), Ella Deloria Archive, DIF.

45 Judith Aron Rubin, *Art Therapy: An Introduction* (Philadelphia, PA: Brunner/Mazel, 1999), 85–106.

46 The Rorschach cards actually emerged out of an artistic concept: klecksography, the art of inkblot picture making. See John E. Exner and Irving B Weiner, *The Rorschach: A Comprehensive System*, 2nd ed. (New York: Wiley, 1995); James Geary, *I Is an Other: The Secret Life of Metaphor and How It Shapes the Way We See the World* (New York: HarperCollins, 2010).

47 This turned out to be wise not only in terms of her own mental health management but because Tabor (not to confused with the Mennonite college in Kansas) would close in 1927. These letters include Hugh Latimer Burleson to F. W. Clayton, October 28, 1925; F. W. Clayton to Burleson, October 29, 1925; Burleson to Ella Deloria, November 4, 1925; Ella Deloria to Burleson, November 7, 1925; Burleson to Ella Deloria November 9, 1925; and Ella Deloria to Burleson, December 22, 1925; all in Correspondence File 1 (February 19, 1924–December 22, 1927), Ella Deloria Archive, DIF.

48 Ella Deloria to Hugh Latimer Burleson, January 31, 1926, Correspondence File 1 (February 19, 1924–December 22, 1927), Ella Deloria Archive, DIF.

49 For housing, Ella Deloria to Hugh Latimer Burleson, January 31, 1926. For glasses, Ella Deloria to Burleson, March 16, 1926. For grades and summer school expenses, Ella Deloria to Burleson, June 9, 1926. For last expenses, Burleson to Deloria, June 11, 1926. All in correspondence File 1 (February 19, 1924–December 22, 1927), Ella Deloria Archive, DIF.

50 Ella Deloria to Hugh Latimer Burleson, January 9, 1927: "It occurred to me that I might be able to get further help for Susie whom I am keeping in school in Chicago. In some ways this (Lawrence, KS) is the cheapest place to live, but the town offers no advantages and with her art and all, I felt she must go. It is deadly to keep her here near me all the time. It sort of inhibits her so that she can not be natural. I must have help with the tuition part or she will be interrupted again, and that would be fatal."

51 Ella Deloria to Hugh Latimer Burleson, February 27, 1925: "Now she is working on a correspondence course in poster making. Personally, I have no faith in it, but what can I do but let her, since I am clear off here (New York City) and she is in Kansas?"

52 Ella Deloria to Hugh Latimer Burleson, January 13, 1928, Correspondence File 1 (February 19, 1924–December 22, 1927), Ella Deloria Archive, DIF.

3. INTERPRETATION: TOWARD AN AMERICAN INDIAN ABSTRACT

1 See, for example, Greg Grandin, *Fordlandia: The Rise and Fall of Henry Ford's Forgotten Jungle City* (New York: Picador, 2010).

2 See, for example, "Sweetheart Killed in Civil War; Never Wed; Now She's 100," *Chicago Daily Tribune*, August 31, 1936; "Spinster, 102, Dies, Still a War Fiancee," *Washington Post*, January 18, 1939, P 14.

3 Wanda Corn, *The Great American Thing: Modern Art and National Identity, 1915–1935* (Berkeley: University of California Press, 1999).

4 My potted history might be accompanied by a parallel history of midcentury and subsequent criticism, a few highlights of which might include writings by Harold Rosenberg (elevating the act of artistic creation and the authenticity of the subjective and personal over the formal), Clement Greenberg (a teleological sense of modernist aesthetic development and the importance of an American avant-garde, paired with a commitment to formalist reading and the autonomy of the work), Rosalind Krauss (a theoretically informed series of explorations of poststructuralist thinking—Michel Foucault and Roland Barthes, for example—and neo-Freudianism via Lacan, willing to read early twentieth-century modernism through high-gloss postmodern aesthetic theory), Hal Foster (rejecting the autonomous work of modernist art in favor of a renewed focus on contingency . . .), and T. J. Clark (. . . and in particular, socioeconomic contexts made visible through a Marxist critical tradition). See Harold Rosenberg, *The Tradition of the New* (Chicago: University of Chicago Press, 1982); Clement Greenberg, *Art and Culture: Critical Essays* (Boston: Beacon Press, 1965); Rosalind Krauss, *The Originality of the Avant-Garde and Other Modernist Myths* (Cambridge: MIT Press, 1985); Hal Foster, *Art Since 1900: Modernism, Antimodernism, Postmodernism*, 2nd ed. (New York: Thames and Hudson, 2011); T. J. Clark, *Farewell to an Idea: Episodes from a History of Modernism* (New Haven, CT: Yale University Press, 1999).

5 Arthur Wesley Dow, *Composition: A Series of Exercises in Art Structure for the Use of Students and Teachers* (New York: Doubleday, Page, and Co., 1914).

6 On art nouveau, see Jean Lahor, *Art of the Century: Art Nouveau* (New York:

Parkstone, 2012); and Alastair Duncan, *Art Nouveau* (London: Thames and Hudson, 1994). On the American context of antiquarianism, folk art, and critics seeking a usable past, see Corn, *Great American Thing*, 297–302. On arts and crafts philosophy, see T. J. Jackson Lears, *No Place of Grace: Antimodernism and the Transformation of American Culture, 1880–1920* (New York: Pantheon, 1981), esp. 60–96; Joseph Cunningham, "Irene Sargent and the Craftsman Ideology," in *Gustav Stickley and the American Arts and Crafts Movement*, ed. Kevin W. Tucker (New Haven, CT: Yale University Press and Dallas Museum of Art, 2010): 55–65; and Julie Kaplan, ed., *The Arts and Crafts Movement in Europe and America: Design for the Modern World* (London: Thames and Hudson, 2004).

7 On art deco, see Alastair Duncan, *Art Deco Complete: The Definitive Guide to the Decorative Arts of the 1920s and 1930s* (New York: Harry Abrams, 2009); Christina Cogdell, *Eugenic Design: Streamlining America in the 1930s* (Philadelphia: University of Pennsylvania Press, 2004); and Carla Breeze, *American Art Deco: Modernistic Architecture and Regionalism* (New York: Norton, 2003). On Egyptian revival, see Sara Ickow, "Heilbrunn Timeline of Art History: Egyptian Revival," Metropolitan Museum of Art, July 2012, www.metmuseum.org/toah/hd/erev/hd_erev.htm.

8 Johnson, *American Modern*, 9–15; and for more examples, 72–83.

9 Remington, *American Modernism*, 30–31.

10 Johnson, *American Modern*, 30–37. See, for example, Jennifer Marshall, *Machine Art, 1934* (Chicago: University of Chicago Press, 2013).

11 Vine Deloria Jr.'s unpublished autobiography, in author's possession, offers an account of my father's visit to the fair with his two aunts.

12 Lesley Jackson, *Twentieth Century Pattern Design*, 2nd ed. (Princeton: Princeton Architectural Press, 2011), 62.

13 Denman Ross, *A Theory of Pure Design* (New York: Peter Smith, 1933); Jay Hambidge, *The Elements of Dynamic Symmetry* (New York: Dover, 1967); and Clarence Hornung, *Handbook of Designs and Devices: 1836 Geometric Elements Drawn by the Author* (New York: Harper Brothers, 1932).

14 In this, Sully might make one think about the craft-meets-art-meets-industrial-graphics of the Bauhaus movement, which embraced simple form, color, and experimentation. Though the book could not have been on Sully's reading list, there are evocative passages to be read against the personality prints in Wassily Kandinsky, *Point to Line to Plane: Contribution to the Analysis of the Pictorial Elements* (1926), trans. Howard Dearstyne and Hila Rebay (New York: Solomon R. Guggenheim Foundation, 1947), particularly in terms of time, sound, repetition,

geometry, force, and the linkages between primary colors and primary forms, all of which suggest commonalities in the perceptual and aesthetic challenges associated with shared—if distinct—forms of modernisms.

15 Fulton Oursler and Will Oursler, *Father Flanagan of Boys Town* (New York: Doubleday, 1949); Hugh Reilly, *Father Flanagan of Boys Town: A Man of Vision* (Boys Town: Boys Town Press, 2008); *Boys Town*, directed by Norman Taurog (1938); and *Men of Boys Town* directed by Norman Taurog (1941).

16 The footprints in this image are eerily resonant with Rorschach card number 1.

17 Cornelia Otis Skinner, *Family Circle* (Boston: Houghton Mifflin, 1948).

18 Corn, *Great American Thing*, xv.

19 Gaylord Torrence, *The American Indian Parfleche: A Tradition of Abstract Painting* (Seattle: University of Washington Press, in association with Des Moines Art Center, 1994), 19; and Colette A. Hyman, *Dakota Women's Work: Creativity, Culture, and Exile* (Minneapolis: Minnesota Historical Society Press, 2012).

20 On the gendered dimensions of Plains art, see Janet Catherine Berlo and Ruth Phillips, *Native North American Art*, 2nd ed. (New York: Oxford University Press, 2015), 130–42; Janet Catherine Berlo, *Spirit Beings and Sun Dancers: Black Hawk's Vision of the Lakota World* (New York: Braziller, with New York State Historical Association, 2000), 3–7; and Castle McLaughlin, *A Lakota War Book from the Little Big Horn: The Pictographic "Autobiography of Half Moon"* (Cambridge: Peabody Museum Press, 2013), 39–48.

21 On quillwork, see Berlo and Phillips, *Native North American Art*, 134–36; Janet Catherine Berlo, "Dreaming of Double Woman: The Ambivalent Role of the Female Artist in North American Indian Myth," *American Indian Quarterly* 17, no. 1 (1993): 31–43; and David Penney, *Art of the American Indian Frontier* (Seattle: University of Washington Press and Detroit Institute of Arts, 1992).

22 Ella Deloria, "Sioux Indian Museum Inventory and Concordance," 53–54.

23 In the New Lakota Dictionary Online, *wizíphaŋ*; the NLD uses *wókphaŋ* to refer to parfleche.

24 Torrence, *American Indian Parfleche*; Berlo and Phillips, *Native North American Art*, 132. The 1852 Riggs Dictionary entry for *wizipan* offers a useful summary: "the rawhide sack or satchel made by western Sioux. The hide is fleshed and pinned to the ground to dry in the sun. Such painting as desired is done at once on the upper side, while the hide is green. When dry the hair is scraped off, and the cases are made, folding and lacing the ends together." See Stephen Return Riggs, *A Dakota-English Dictionary: Contributions to North American Ethnology*, volume 7 (Washington, DC: Government Printing Office, 1892), 583–84; and Dakota Wind, "Parfleche: Art History on the Northern Plains: An Examination of the Origin of an

Art Form," "The First Scout" (blog), July 8, 2011, http://thefirstscout.blogspot.com/2011/07/parfleche-art-history-on-northern.html.

25 Ella Deloria, "Man's Moccasins, Painted," in "Sioux Indian Museum Inventory," 49.

26 Torrence, *American Indian Parfleche*, 92.

27 Torrence, "Parfleche Envelope," *The Plains Indians: Artists of Earth and Sky* (Paris: Musée du quai Branly, 2014), 180.

28 I'm thinking explicitly here in terms of nondualistic dialogue and the possibilities of communication, at unconscious levels, between artist and viewer. See, for example, M. M. Bakhtin, *The Dialogic Imagination: Four Essays* (Austin: University of Texas Press, 1981); Michael Holquist, *Dialogism: Bakhtin and His World* (London: Routledge, 1990); and Janet Wolff, *The Social Production of Art* (New York: St. Martin's Press, 1981).

29 Ella Deloria, "Sioux Indian Museum," 46: "The principal type of container made of painted rawhide, parfleche, was wokpa, which came in matched designs and belonged in pairs."

30 Ella Deloria, "Decorative Items," in "Sioux Indian Museum Inventory," 35. In Mary Sully's only public relations photo (fig. 6.6), she wears a geometric beaded headband.

31 Berlo and Phillips, *Native North American Art*, 136.

32 Torrence, *Plains Indians*, 122.

33 Ella Deloria, "Turtle, Beaded Charm," in "Sioux Indian Museum," 106.

34 See John Ewers, "A Century of Plains Indian Art Studies," in *Plains Indian Art: The Pioneering Work of John C. Ewers*, ed. Jane Ewers Robinson (Norman: University of Oklahoma Press, 2011); Berlo and Phillips, *Native North American Art*, 142–51; Torrence, *Plains Indians*, 218–68; Robert G. Donnelley, with Janet Catherine Berlo and Candace S. Greene, *Transforming Images: The Art of Silver Horn and His Successors* (Chicago: David and Alfred Smart Museum of Art, 2000); and J. J. Brody, *Indian Painters and White Patrons* (Albuquerque: University of New Mexico Press, 1971). Thanks to Jill Ahlberg Yohe, who reminded me of the shift in women's beadwork toward representational imagery in the early twentieth century.

35 Berlo and Phillips, *North American Indian Art*, 318; Marsha MacDowell and C. Kurt Dewhurst, eds., *To Honor and Comfort: Native Quilting Traditions* (Santa Fe, NM: Museum of New Mexico Press in association with Michigan State University Museum, 1997). See in particular articles by Laurie Anderson (93–102) and Beatrice Medicine (111–18), which deal with Sioux quilting traditions and histories. Anderson notes that in 1933, a WPA project endeavored to establish a quilting

industry among women at Pine Ridge. Both writers offer accounts of young girls training in quilting technique, often in the context of women's societies.

36 Eric Renshaw, "Looking Back: All Saints School," *Sioux Falls Argus Leader*, Feb. 14, 2015. www.argusleader.com/story/life/2015/02/15/looking-back-saints-school /23397663/. See also the December 1972 National Register of Historic Places Nomination Form for All Saints School—Main Building, https://npgallery.nps.gov/pdf host/docs/NRHP/Text/73001748.pdf.

37 On Fazende, see "Sweetheart Killed in Civil War" and "Spinster, 102, Dies, Still a War Fiancee." On children of divorce, see "Children of Divorce," *Ladies' Home Journal*, 51 (March 1934): 16, 72. The themes of *Children of Divorce* suggest that Sully was responding to the article, which is focused on divided homes, rather than on the 1927 novel (by Owen Johnson) and silent film *Children of Divorce*, which follows a love triangle in which all three characters are children of divorce.

38 "American Women and Royal Marriages: There Is a Long List of Such Unions and Strange Are the Romances Developed from Them," *New York Times*, December 6, 1908, SM 4. See also Elisabeth Kehoe, *The Titled Americans: Three American Sisters and the British Aristocratic World into Which They Married* (New York: Atlantic Monthly Press, 2004).

39 On temporal/spatial epistemologies, see Vine Deloria Jr., *God Is Red: A Native View of Religion* (New York: McMillan, 1972).

40 On White Buffalo Calf Woman, see Black Elk, recorded and edited by Joseph Epes Brown, *The Sacred Pipe: Black Elk's Account of the Seven Rites of the Oglala Sioux* (Norman: University of Oklahoma Press, 1953); on Deer Woman, see stories in Ella Deloria, *Dakota Texts* (Lincoln: University of Nebraska Press, 2006). Originally published in 1932, *Dakota Texts* includes sixty-four stories, many of which feature transforming figures: Deer Woman (30, 31), Doubleface (9, 10, 11, 48), Iktomi (1–8), White Plume Boy (19), and Elk Man (29), among others. See also Julian Rice, *Deer Women and Elk Men: The Lakota Narratives of Ella Deloria* (Albuquerque: University of New Mexico Press, 1992).

41 Considering the presence of a title card, we might add a "fourth" panel to that list.

42 If one were to follow this interpretive path, it would be worth noting the first articulations of the "big bang" theory of the universe happened in 1927 (Georges Lemaître) and 1929 (Edwin Hubble), with much debate and discussion in the early 1930s—including some in the popular press. If these scientific currents were part of the discursive world available to Mary Sully, probably more pressing and visible was the October 1931 death of Thomas Edison, which generated a massive outpouring of public tribute and recollection.

1 On Hartley, see Barbara Haskell, *Marsden Hartley* (New York: Whitney Museum of American Art, 1980); and Dieter Scholz, ed. *Marsden Hartley: The German Paintings, 1913–1915* (Berlin: Distributed Art Publishers, 2014).

2 Gail Levin, "Marsden Hartley's 'Amerika': Between Native American and German Folk Art," Traditional Fine Arts Organization, 1993, www.tfaoi.com/aa/7aa/7aa24.htm.

3 Hartley had a number of gallery shows throughout the 1910s and 1920s; *Portrait of a German Officer* appears in several listings. See Haskell, *Marsden Hartley*, 194–208, for a list of exhibitions and linked bibliography.

4 See, for example, Sascha T. Scott, *A Strange Mixture: The Art and Politics of Painting Pueblo Indians* (Norman: University of Oklahoma Press, in cooperation with the William P. Clements Center for Southwest Studies, Southern Methodist University, 2015), 9–10, for an argument concerning multiple modernities—in conversation with, yet distinct from, white American models.

5 Erika Doss, *Twentieth-Century American Art*, Oxford History of Art series (New York: Oxford University Press, 2002), 37.

6 T. J. Jackson Lears, *No Place of Grace: Antimodernism and the Transformation of American Culture, 1880–1920* (New York: Pantheon Books, 1981); Philip Deloria, *Playing Indian* (New Haven, CT: Yale University Press, 1998): 95–127; Leah Dilworth, *Imagining Indians in the Southwest: Persistent Visions of a Primitive Past* (Washington, DC: Smithsonian Institution Press, 1996); and Marianna Torgovnick, *Gone Primitive: Savage Intellects, Modern Lives* (Chicago: University of Chicago Press, 1990).

7 Charles Eldridge, Julie Schimmel, and William Truettner, eds., *Art in New Mexico, 1900–1945: Paths to Taos and Santa Fe* (New York: Abbeville Press, 1986); Dean A. Porter, Teresa Hayes Ebie, and Suzan Campbell, eds., *Taos Artists and Their Patrons, 1898–1950* (Notre Dame: Snite Museum of Art, 1999); and Corn, *Great American Thing*, 272–80.

8 Scott, *A Strange Mixture*, 3–13, 53–54, and 70–73.

9 I have no wish to get involved in arguments about the "great divide" between the modern and postmodern and where abstract expressionism does or does not fit. My own provisional understanding is indebted to Fredric Jameson's formulation: Modernity is to Postmodernity as Modern is to Postmodern as Modernism is to Postmodernism. The changed material conditions of postwar American hegemony represent an epochal change from the Fordist early twentieth century (modernity) and thus a change in cultural production as well, visible and able to

be reasonably categorized, if in retrospect, as that thing we once called "post-modernism." Fredric Jameson, *Postmodernism, or the Cultural Logic of Late Capitalism* (Durham: Duke University Press, 1991).

10 Doss, *Twentieth-Century American Art*, 12.

11 Doss, *Twentieth-Century American Art*, 11–13.

12 Doss, *Twentieth-Century American Art*, 77–79; Corn, *Great American Thing*, xix; and Christine Stansell, *American Moderns: Bohemian New York and the Creation of a New Century* (New York: Metropolitan Books, 2000).

13 Dorothy Ross, "Introduction: Modernism Reconsidered," in *Modernist Impulses in the Human Sciences, 1870–1930*, ed. Dorothy Ross (Baltimore: Johns Hopkins University Press, 1994), 6–8 and passim. See also other essays in the collection, particularly David Hollinger, "The Knower and the Artificer, with Postscript 1993" (26–53), and Dorothy Ross, "Modernist Social Science in the Land of the New/Old" (171–89); Dorothy Ross, *The Origins of American Social Science* (Cambridge: Cambridge University Press, 1991); Mark C. Smith, *Social Science in the Crucible: The American Debate over Objectivity and Purpose, 1918–1941* (Durham, NC: Duke University Press, 1994).

14 I've arrived at these dates through a study of Ella Deloria's correspondence; in author's possession.

15 See, for example, "MoMA Exhibition History," www.moma.org/calendar/exhibitions/history. In her first years in New York, at MoMA alone, Sully would have been able to see Rivera, Demuth, Picasso, African mask primitivism, murals, and a tremendous collection of European and American modernists.

16 Deloria, *Playing Indian*, 111–24.

17 "Iron Worker Wins Art Scholarship," *New York Times*, September 18, 1933.

18 "Exhibition Notes," *New York Times*, November 18, 1936; Edward Alden Jewell, "Museum Arranges Walter Gay Show," *New York Times*, April 9, 1938; "Activities in New York and Elsewhere in Museums and Galleries," *New York Times*, November 16, 1941.

19 Howard Devree, "A Reviewer's Notebook," *New York Times*, May 15, 1938. The review continues: "Ten water-colors of the Hudson River waterfront, by Annie Stein, are being shown at a branch of the New York Public Library, 203 West 115th Street. Miss Stein had a one-man show last year at the Morton Gallery." See also "Events Here and There," *New York Times*, November 16, 1941.

20 Stein died in 1947; it is likely that Sully had either abandoned or slowed significantly on the project by that point, so it is probably not the case that the image is a memorial to Stein. See "Mrs. Charles Stein," *New York Times*, July 20, 1947.

21 Scott, *Strange Mixture*, 111.

22 William Innes Homer, "Picabia's *Jeune fille américaine dans l'état de nudité* and Her Friends," *Art Bulletin* 57:1 (March 1975): 110–15.

23 Marius de Zayas and Francis M. Naumann, *How, When, and Why Modern Art Came to New York* (Cambridge: MIT Press, 1996); and Corn, *Great American Thing*, 223.

24 Demuth's effort is the major focus of Wanda Corn's brilliant reading in chapter 4 of *The Great American Thing*, 193–237, and her earlier *In the American Grain: The Billboard Poetics of Charles Demuth* (Poughkeepsie: Vassar College, 1991).

25 By William Carlos Williams, from *The Collected Poems*, volume 1: *1909–1939*, copyright ©1938 by New Directions Publishing Corp. Reprinted by permission of New Directions Publishing Corp.

26 For Corn's more detailed reading, see *Great American Thing*, 201–9.

27 Robin Jaffee Frank and Charles Demuth, *Charles Demuth: Poster Portraits, 1923–1929* (New Haven, CT: Yale University Art Gallery, 1994).

28 Warren Susman, *Culture as History: The Transformation of American Society in the Twentieth Century* (New York: Pantheon, 1984), 271–85.

29 Charles Demuth and Bruce Kellner, *Letters of Charles Demuth, American Artist, 1883–1935* (Philadelphia: Temple University Press, 2000), 80–81.

30 Eugene O'Neill, *The Moon of the Caribbees*, in *The Great God Brown, The Fountain, The Moon of the Caribbees, and Other Plays* (New York: Boni and Liveright, 1926), 213, as quoted in Frank and Demuth, *Charles Demuth*, 88. Kellner, in a footnote in *Letters*, questions whether *Longhi on Broadway* was actually a portrait of O'Neill. It is also worth noting the similarity between the O'Neill sketch and one for Marsden Hartley. See Yale Art Gallery 1991.41.1.

31 Frank and Demuth, *Charles Demuth*, 90–100.

32 Corn, *Great American Thing*, 197. Corn notes also the play *The Great God Brown*, which asks actors to wear masks and then to remove them when revealing the character's "true" nature.

33 Thanks to Steven Bloom for considering this image in relation to his encyclopedic knowledge of O'Neill, and for suggesting *Strange Interlude* as a possible reference.

34 Frank and Demuth, *Charles Demuth*, 105

35 See Céline Delavaux, *The Museum of Illusions: Optical Tricks in Art* (Munich: Prestel, 2013); Jonathan Crary, *Techniques of the Observer: On Vision and Modernity in the Nineteenth Century* (Cambridge, MA: MIT Press, 1990), and *Suspensions of Perception: Attention, Spectacle, and Modern Culture* (Cambridge, MA: MIT Press, 2000).

36 The three personalities form a triad, as all were connected through Ziegfeld

(Pollock worked as a publicist and sketch writer for him; Ziegfeld was married to Billie Burke).

37 Berlo and Phillips, *Native North American Art*, 261–62.

38 If one dates the earliest prints to her fall 1927 time in Chicago, then it would have been four years. Ella's note of January 1928 that Sully had "created beautiful designs" but not sold any yet offers a potential piece of evidence for 1927. It is not clear, however, that the "beautiful designs" comment referred to the personality prints or to other efforts, since lost. There is another logic, that Sully began the project in the fall of 1928, when she found herself relocated to Lake Andes on the Yankton reservation.

39 Berlo and Phillips, *Native North American Art*, 261–62.

40 W. Jackson Rushing, "Marketing the Affinity of the Primitive and the Modern: René d'Harnoncourt and the 'Indian Art of the United States,'" in Janet Catherine Berlo, ed., *The Early Years of Native American Art History* (Seattle: University of Washington Press, 1992), 191–236. For the broader context, see W. Jackson Rushing, *Native American Art and the New York Avant-Garde* (Austin: University of Texas Press, 1995).

41 John Sloan and Oliver La Farge, "Introduction to American Indian Art," in Exposition of Indian Tribal Arts, Inc., *Introduction to American Indian Art*, 13.

42 Sloan and La Farge, "Introduction to American Indian Art," 13–15.

43 Sloan and La Farge, "Introduction to American Indian Art," 15.

44 Sloan and La Farge, "Introduction to American Indian Art," 15. On the question of differential modernities, see their note ix.

45 Sloan and La Farge, "Introduction to American Indian Art," 15.

46 Indeed, many of these artists were content *not* to be artists; they were met with suspicion from their home communities. Money from art could be redirected as capital investments for agriculture, which carried for male artists much more positive associations when it came to gender and respect.

47 As cited in Lauren Bergman, "Navigating Marsden Hartley's Symbols," *Unframed*, September 10, 2014, https://unframed.lacma.org/node/1433. See also Scholz, *Marsden Hartley*, 61–64, for an account of Hartley's play, in Berlin, with a faux-Indian identity, "Firebird, the Sioux."

48 See Scott, *Strange Mixture*; and Corn, *Great American Thing*. Wanda Corn's most in-depth essay about the series is "Marsden Hartley's Native Amerika," in *Marsden Hartley*, ed. Elizabeth Mankin Kornhauser (New Haven, CT: Yale University Press, 2002).

49 Quoted in Doss, *Twentieth-Century American Art*, 87. As Wanda Corn points out, Germany—permeated with Karl May fantasies—was a perfect European location

from which to engage American Indian primitivisms, as George Grosz did. See Corn, *Great American Thing*, 111–12.

50 Robert Fay Schrader, *The Indian Arts and Crafts Board: An Aspect of New Deal Indian Policy* (Albuquerque: University of New Mexico Press, 1983), 49–50.

51 Schrader, *Indian Arts and Crafts Board*; Molly H. Mullin, *Culture in the Marketplace: Gender, Art, and Value in the American Southwest* (Durham: Duke University Press, 2001); Erika Marie Bsumek, *Indian-Made: Navajo Culture in the Marketplace, 1868–1940* (Lawrence: University Press of Kansas, 2008); and Elizabeth Hutchinson, *The Indian Craze: Primitivism, Modernism, and Transculturation in American Art, 1890–1915* (Durham, NC: Duke University Press, 2009).

52 See Jennifer McLerran, *A New Deal for Indian Art: Indian Arts and Federal Policy, 1933–1943* (Tucson: University of Arizona Press, 2009), 7–56, for a useful summary of the complementary but distinct positions of Collier (economic development) and d'Harnoncourt (taste and an upper-class collectors' market).

53 Schrader, *Indian Arts and Crafts Board*, 79–80; McLerran, *A New Deal for Native Art*, 166–67; Smithsonian National Postal Museum, "Indians at the Post Office: Native Themes in New Deal–Era Murals," http://postalmuseum.si.edu/indiansat thepostoffice/index.html (accessed October 15, 2015).

54 Schrader, *Indian Arts and Crafts Board*, 79–82. Small pockets of opportunity existed for Indian artists: the Treasury Section of Fine Arts, the Department of Interior Building Section of the Fine Arts Mural Project, arts and crafts work within the Indian Division of the Civilian Conservation Corps (for example, the Alaska Totem Pole Project), and the various arts and crafts cooperatives, marketing efforts, and exhibits fostered by the Indian Arts and Crafts Board itself. See McLerran, *A New Deal for Indian Art*, 103–223.

55 Doss, *Twentieth-Century American Art*, 99.

56 See, for example, Victoria Grieve, *The Federal Art Project and the Creation of Middlebrow Culture* (Urbana: University of Illinois Press, 2009), which outlines the role of the FAP in advancing a progressive, culturally democratic vision of art as an everyday practice rather than a highbrow, aestheticized domain for the romantic artist and wealthy collector.

57 William Carlos Williams, *In the American Grain* (New York: A. & C. Boni, 1925); and Corn, *Great American Thing*.

58 It is worth considering Sully's "out-of-placeness" in relation to Ruth Benedict's theorization of the individual without a "congenial" alignment with his or her culture, as discussed in chapter 5.

59 Grieve, *Federal Art Project*, 44–56

60 Grieve, *Federal Art Project*, 51–57.

61 Emily Lutenski, *West of Harlem: African American Writers and the Borderlands* (Lawrence: University Press of Kansas, 2015).

62 Thanks to Jay Cook for reminding me of the Langston Hughes autobiography: Langston Hughes, *I Wonder As I Wander: An Autobiographical Journey* (New York: Rinehart, 1956).

63 Unfortunately, that image is one of nine images on that list that are no longer with the collection; it is possible that it is one of the five untitled and (as yet) unidentifiable images. On the 1920s, see Ann Douglas, *Terrible Honesty: Mongrel Manhattan in the 1920s* (New York: Farrar, Strauss, Giroux, 1995); and Charles Shindo, *1927 and the Rise of Modern America* (Lawrence: University Press of Kansas, 2010).

64 The word *éclaireur/éclaireuse* carries not only the solo or singular aspect of "scouting" in advance but also connotations of lightening, brightening, or clarifying. Thanks to my colleague Peggy McCracken for contemplating with me alternatives to *avant-garde*, and to Sascha Scott for suggesting its potential utility for considering artists such as Albert Pinkham Ryder and Joseph Cornell.

65 Compare, for example, the vision-inspired work of Minnie Evans or the prison art of Henry Ray Clark.

66 Lucienne Peiry, trans. James Frank, *Art Brut: The Origins of Outsider Art* (New ed., Paris: Flammarion, 2006); and David Maclagan, *Outsider Art: From the Margins to the Marketplace* (London: Reaktion, 2009).

67 Holger Cahill, in his 1932 exhibition *American Folk Art: The Art of the Common Man in America* for the Museum of Modern Art, looked to the preindustrial past for "the simple and unaffected childlike expression of men and women who had little or no school training in art, and who did not even know that they were producing art."

68 Interestingly, Ella Deloria commented in the mid-1940s that her own practice of North American linguistic ethnography was increasingly out of date in relation to the field.

69 As quoted in label for de Kooning's *Woman and Bicycle*, Whitney Museum Online Collection, http://collection.whitney.org/object/1081 (accessed February 10, 2016).

70 Bill Anthes, *Native Moderns: American Indian Painting, 1940–1960* (Durham, NC: Duke University Press, 2006).

71 W. Jackson Rushing, "Modern by Tradition," in Bruce Bernstein and W. Jackson Rushing, *Modern by Tradition: American Indian Painting in the Studio Style* (Santa Fe: Museum of New Mexico Press, 1995): 61–69.

5. PSYCHOLOGY AND CULTURE: THE NATURE OF THE MARGIN

1 Both were "modernist" in this sense, since antimodernism was itself a key dimension of modernism.

2　Ella Deloria to Virginia Dorsey Lightfoot, February 3, 1946, Ella Deloria Papers, DIF.

3　Ella Deloria, "The Sun Dance of the Oglala Sioux," *Journal of American Folklore* 42, no. 166 (1929): 354–413. For the transition, see Murray, "Ella Deloria," 91–103; and Cotera, *Native Speakers*, 46–48.

4　Franz Boas to Ella Deloria, January 11, 1928; January 18, 1928; January 26, 1928, Correspondence File 2, January 11, 1928–November 24, 1930, Ella Deloria Papers, DIF.

5　For a concise summary of these years, see Murray, "Ella Deloria," 103–12.

6　The extent to which Boas relied on Native informants, not simply for objective information but for authorship and coauthorship, has recently been explored by Isaiah Wilner. See "Raven Cried for Me: Narratives of Transformation on the Northwest Coast of America" (PhD dissertation, Yale University, 2017).

7　Margaret Mead, "Unpublished Introduction to Camp Circle Society," 2–3.

8　Susan Gardner, "Introduction," in Ella Deloria, *Waterlily*, 2nd ed. (Lincoln: University of Nebraska Press, 2009), v–xxvi.

9　Franz Boas to Ella Deloria, January 26, 1928.

10　Franz Boas to Ella Deloria, February 6, 1928; Franz Boas to Otto Klineberg, February 6, 1928. Correspondence Folder 2, Ella Deloria Papers, DIF.

11　Ella Deloria to Hugh Latimer Burleson, June 20, 1926. This was the conclusion Klineberg reached as well. For the Dakota tests, see Otto Klineberg, *Race Differences* (New York: Harper and Brothers, 1935), 162.

12　Franz Boas to Ella Deloria, October 21, 1929. See also Roseanne Hoefel, "'Different by Degree': Ella Cara Deloria, Zora Neale Hurston, and Franz Boas Contend with Race and Ethnicity," *American Indian Quarterly* 25, no. 2 (Spring 2001): 181–202.

13　On Philip Deloria's bank failure, see Ella Deloria to Hugh Latimer Burleson, February 23, 1929. Ella kept the bank failure a secret from her father. On Ella's bank, see Ella Deloria to Franz Boas, January 1, 1931. Ella Deloria Papers, DIF

14　Otto Klineberg to Franz Boas, April 16, 1930. Klineberg's assessment of Dakota children is worth quoting at length: "Tests in which the activity or technique of the work formed the basis would probably not show anything, but tests in which the designs are used as the basis for problems to be solved seem rather more promising. I have made copies of some of the more typical designs which I have so far seen, and I shall try out several methods of using these designs in tests. In connection with design, I have already noticed in the schools that the Dakota children are especially good at drawing (and also writing). Their work is very neat, and seems to me, and also to the teachers, definitely superior to that of average white children." For a detailed account of the tests, see Klineberg to Boas, May, 24, 1930. See also Klineberg, *Race Differences*, 161–62.

15 Sloan and La Farge, "Introduction to American Indian Art," 13.

16 Burleson to Ella Deloria, July 15, 1926.

17 Alice Corbin Henderson, "A Boy Painter among the Pueblo Indians and Unspoiled Native Work," *New York Times* (1925), as quoted in Scott, *Strange Mixture*, 155.

18 I have made these arguments previously, in Deloria, *Playing Indian* (New Haven, CT: Yale University Press, 1998). See also Ann Douglas, *Terrible Honesty: Mongrel Manhattan in the 1920s* (New York: Farrar, Strauss, Giroux, 1995); Robert M. Dowling, *Slumming in New York: From the Waterfront to Mythic Harlem* (Urbana: University of Illinois Press, 2007), esp. 139–71; and Houston A. Baker, *Modernism and the Harlem Renaissance* (Chicago: University of Chicago Press, 1987).

19 Contemporary psychological theory frames depression as "unitary"—that is, a singular form that ranges across a broad spectrum—but clinicians and social workers continue to find useful distinctions between "reactive" or "exogenous" depression and nonsituational "melancholic" or "endogamous" forms of depression. For a useful definition, see John Harris and Vicky White, *A Dictionary of Social Work and Social Care* (Oxford: Oxford University Press, 2013). For a quick background, see Jin Mizushima et al., "Melancholic and Reactive Depression: A Reappraisal of Old Categories," *BMC Psychiatry* 13, no. 311 (2013). I am indebted to my colleagues Abby Stewart and Gus Buchtel for considering some of Susan Deloria's symptoms and guiding me—cautiously—through some speculative possibilities.

20 Ella Deloria to Hugh Latimer Burleson (from NYC), February 27, 1925, Correspondence File 1, Ella Deloria Project, DIF.

21 Susan Deloria to Hugh Latimer Burleson (from Lawrence, KS), August 16, 1924, Correspondence File 1, Ella Deloria Project, DIF.

22 As Maria Cotera has argued, Ella did so by assuming the culturally resonant role of the "perpetual virgin." See Cotera, *Native Speakers*, 51–53.

23 This insight comes directly from my colleague Abby Stewart.

24 Ella Deloria to Hugh Latimer Burleson (from Eufaula, OK), April 22, 1925, Correspondence File 1, Ella Deloria Project, DIF.

25 Ella Deloria to Hugh Latimer Burleson (from Eufaula, OK), April 22, 1925.

26 Ella Deloria to Hugh Latimer Burleson (from Eufaula, OK), April 22, 1925.

27 Ella Deloria to Hugh Latimer Burleson (from Eufaula, OK), April 22, 1925.

28 For a useful description, see Iria Grande, Michael Berk, Boris Birmaher, and Eduard Vieta, "Bipolar Disorder," *The Lancet*, September 18, 2015, http://dx.doi.org/10.1016/S0140-6736(15)00241-X.

29 Ella Deloria to Hugh Latimer Burleson (from Eufaula, OK), March 25, 1925, Correspondence File 1, Ella Deloria Project, DIF.

30 Ella Deloria to Hugh Latimer Burleson (from NYC), February 27, 1925.

31 Vine Deloria Jr., "Autobiography," February 16, 1996, 10–12.

32 Ella Deloria to Hugh Latimer Burleson (from Haskell), October 16, 1925, Correspondence File 1, Ella Deloria Project, DIF.

33 Ella Deloria to Hugh Latimer Burleson (from Haskell), October 16, 1925.

34 Ella Deloria to Hugh Latimer Burleson (from Haskell), November 4, 1925, Correspondence File 1, Ella Deloria Project, DIF.

35 Ella Deloria to Hugh Latimer Burleson (from Haskell), January 9, 1927, Correspondence File 1, Ella Deloria Project, DIF.

36 See, for example, Wassily Kandinsky, *Concerning the Spiritual in Art*, trans. M. T. H. Sadler (1914; reprint, New York: Dover, 1977). Kandinsky was likely a synesthete (a claim that is not uncontested), and he theorized the linkages between sound and vision, particularly in terms of color, while also making an argument for abstraction based on a comparison between visual art and musical composition. Artists in the Stieglitz circle, including Arthur Dove and Georgia O'Keeffe, read Kandinsky and explored the possibilities of visual art that evoked synesthetic perceptual crossings and overlaps.

37 For a comprehensive brief overview, see Jamie Ward, "Synesthesia," *Annual Review of Psychology* 64 (January 2013): 49–75.

38 Richard Cytowic, *Synesthesia: A Union of the Senses*, Springer Series in Neuropsychology (New York: Springer, 1989), 49–52.

39 V. S. Ramachandran and E. M. Hubbard, "Synesthesia, Cross-Activation, and the Foundations of Neuroepistemology," in *The Handbook of Multisensory Processes*, ed. Gemma A. Calvert, Charles Spence, and Barry E. Stein (Cambridge, MA: MIT Press, 2004), 876.

40 Carol Steen, "Visions Shared: A Firsthand Look into Synesthesia and Art," *Leonardo* 34, no. 1 (2003): 203–8.

41 Sharyn R. Udall, with Nancy Weekly, *Sensory Crossovers: Synesthesia in American Art* (Albuquerque: Albuquerque Museum, 2010).

42 Fred Rasmussen, "Post Office Named for a Star of Opera Lilypons: Tiny Office Operated from 1932 to 1963 at Waterlily Company," *Baltimore Sun*, October 5, 1997, http://articles.baltimoresun.com/1997-10-05/features/1997278029_1_lily-pons -lilypons-frederick-county.

43 Interview with Barbara Sanchez, December 25, 2015.

44 On Ruth Benedict, see Margaret Caffrey, *Ruth Benedict: Stranger in this Land* (Austin: University of Texas Press, 1989); Judith Schachter Modell, *Ruth Benedict: Patterns of a Life* (Philadelphia: University of Pennsylvania Press, 1983); Virginia Heyer Young, *Ruth Benedict: Beyond Relativity, Beyond Pattern* (Lincoln:

University of Nebraska Press, 2005); Margaret Mead, *Ruth Benedict* (New York: Columbia University Press, 1974); Margaret Mead, *Anthropologist at Work: Writings of Ruth Benedict* (Boston: Houghton Mifflin, 1959); Hilary Lapsley, *Margaret Mead and Ruth Benedict: The Kinship of Women* (Amherst: University of Massachusetts, 1999); and Lois Banner, *Intertwined Lives: Margaret Mead and Ruth Benedict and Their Circle* (New York: Knopf, 2003).

45 Caffrey, *Ruth Benedict*, 202.

46 Young, *Ruth Benedict*, 62–66.

47 Ruth Benedict, *Patterns of Culture* (Boston: Houghton Mifflin, 1934); Ruth Benedict, "Anthropology and the Abnormal," *Journal of General Psychology* 11 (January 1934): 59–82.

48 Benedict, *Patterns of Culture*, 254, 24.

49 For an intriguing experiment in historical writing that takes a related approach, see Hans Ulrich Gumbrecht, *In 1926: Living at the Edge of Time* (Cambridge: Harvard University Press, 1997).

50 Benedict, *Patterns of Culture*, 258.

51 Benedict, *Patterns of Culture*, 272–73.

52 Virginia Young notes that Benedict, despite a reputation for social awkwardness, built a social circle around herself that ranged from colleagues ("an evening's round of drinks after a seminar") and what might be called "fictive kin"—Boas, Mead's family, and others who fit within a circle of "extended family." See Young, *Ruth Benedict*, 65–66.

53 Robert E. Gibby and Michael J. Zickar, "A History of the Early Days of Personality Testing in American Industry: An Obsession with Adjustment," *History of Psychology* 11, no. 3 (2008): 164–84.

54 See Gibby and Zickar, "A History," for a broad survey of these and other tests. Otto Klineberg's *Race Differences*, which draws on scores of studies, can sometimes read like an interminable list of various tests and measures.

55 John E. Exner, *The Rorschach: Basic Foundations and Principles of Interpretation*, vol. 1 (Hoboken: John Wiley and Sons, 2002). It is worth noting that Rorschach's blots were part of a longer tradition of inkblot art, bundled under the label *klecksography*, which was early taken up by psychologists such as Alfred Binet and Victor Henri as ways into the "involuntary imagination."

56 Emile Coué, *Self Mastery through Conscious Autosuggestion* (New York: American Library Service, 1922); and Donald B. Meyer, *The Positive Thinkers: Popular Religious Psychology from Mary Baker Eddy to Norman Vincent Peale and Ronald Reagan*, rev. ed., with a new introduction (Middletown: Wesleyan University Press, 1988). Peale's most famous book, *The Power of Positive Thinking*, was not

published until 1952, but he began a public career in radio and publishing in the mid-1930s.

57 Henri F. Ellenberger, *The Discovery of the Unconscious: The History and Evolution of Dynamic Psychiatry* (New York: Basic Books, 1970); Gerald Sykes, *The Hidden Remnant* (New York: Harper, 1962); Simon Boag, *Freudian Repression, the Unconscious, and the Dynamics of Inhibition* (London: Karnac Books, 2012); and Peter Gay, *Freud for Historians* (New York: Oxford University Press, 1985).

58 Sigmund Freud, *Civilization and Its Discontents*, trans. James Strachey (New York: W. W. Norton, 1989); Carl G. Jung, *Modern Man in Search of a Soul*, trans W. S. Dell and Cary F. Baynes (New York: Harcourt Brace, 1933); and Jolande Jacobi, *The Psychology of C. G. Jung: An Introduction with Illustrations* (New Haven: Yale University Press, 1973).

59 William James, "Great Men and Their Environment," *Atlantic Monthly* 46 (October, 1880): 441–49.

60 See Lawrence Levine, "The Folklore of Industrial Society: Popular Culture and Its Audiences," *American Historical Review* 97, no. 5 (December 1992): 1369–99; and responses by Robin D. G. Kelley, "Notes on Deconstructing 'The Folk'"; Natalie Zemon Davis, "Toward Mixtures and Margins"; T. J. Jackson Lears, "Making Fun of Popular Culture"; and Levine's response.

61 See, for example, Leo Mazow, *Thomas Hart Benton and the American Sound* (Philadelphia: Penn State University Press, 2012).

6. POLITICS AND THE EDGES: READING *THREE STAGES OF INDIAN HISTORY*

1 See AISRI, Ella Deloria Archive, Dakota Ethnography, Box 2, Drawings by Mary Susan Deloria (Mary Sully), http://zia.aisri.indiana.edu/deloria_archive/browse.php ?action=viewcontainer&id=24.

2 Cotera, *Native Speakers*, 48.

3 Gerald Vizenor, *Manifest Manners: Narratives on Post-Indian Survivance* (Lincoln: University of Nebraska Press, 1999). Vizenor's deliberate imprecision—the word is defined multiple times, each through a confusing but evocative statement—focuses attention on what he argues is essential: an active presence, the opposite of passivity or victimry (another term coined by Vizenor), not just survival and not just resistance but the active, forward-facing claim to Indigenous autochthony and autonomy.

4 See Lewis Henry Morgan, *Ancient Society* (Tucson: University of Arizona Press, 1985). On ideology and federal Indian policy, see Robert F. Berkhofer Jr., *The White Man's Indian: Images of the American Indian from Columbus to the Present* (New York: Vintage, 1979); Brian Dippie, *The Vanishing Indian: White*

Attitudes and U.S. Indian Policy (Middletown, CT: Wesleyan University Press, 1982); Francis Paul Prucha, *The Great Father: The United States Government and the American Indians* (Lincoln: University of Nebraska Press, 1995); and David Wallace Adams, *Education for Extinction: American Indians and the Boarding School Experience, 1875–1928* (Lawrence: University Press of Kansas, 1995).

5 See Frederick Hoxie, *A Final Promise: The Campaign to Assimilate the Indians, 1880–1920* (Lincoln: University of Nebraska Press, 1984).

6 Alexandra Minna Stern, *Eugenic Nation: Faults and Frontiers of Better Breeding in Modern America* (Berkeley: University of California Press, 2005); Wendy Kline, *Building a Better Race: Gender, Sexuality, and Eugenics from the Turn of the Century to the Baby Boom* (Berkeley: University of California Press, 2001); Christina Cogdell, *Eugenic Design: Streamlining America in the 1930s* (Philadelphia: University of Pennsylvania Press, 2004); and Susan Currell and Christina Cogdell, *Popular Eugenics: National Efficiency and American Mass Culture in the 1930s* (Athens: Ohio University Press, 2006);

7 These are brief summaries of arguments made in Deloria, *Playing Indian*, and Deloria, *Indians in Unexpected Places* (Lawrence: University Press of Kansas, 2004).

8 Wilcomb E. Washburn, *The Assault on Indian Tribalism: The General Allotment Law (Dawes Act) of 1887* (Philadelphia: Lippincott, 1975); Emily Greenwald, *Reconfiguring the Reservation: The Nez Perces, Jicarilla Apaches, and the Dawes Act* (Albuquerque: University of New Mexico Press, 2002); Adams, *Education for Extinction*; Tsianina Lomawaima, *They Called It Prairie Light: The Story of Chilocco Indian School* (Lincoln: University of Nebraska Press, 1994); Brenda J. Child, *Boarding School Seasons: American Indian Families, 1900–1940* (Lincoln: University of Nebraska Press, 1999); Matthew Sakiestewa Gilbert, *Education beyond the Mesas: Hopi Students at Sherman Institute, 1902–1929* (Lincoln: University of Nebraska Press, 2010); Tisa Wenger, *We Have a Religion: The 1920s Pueblo Indian Dance Controversy and American Religious Freedom* (Chapel Hill: Published in association with the William P. Clements Center for Southwest Studies, Southern Methodist University, by the University of North Carolina Press, 2009); William Bauer, *We Were All Like Migrant Workers Here: Work, Community, and Memory on California's Round Valley Reservation, 1850–1941* (Chapel Hill: University of North Carolina Press, 2009); Jeffrey Ostler, *The Plains Sioux and U.S. Colonialism from Lewis and Clark to Wounded Knee* (Cambridge, UK: Cambridge University Press, 2004); Philip Deloria, "From Nation to Neighborhood: Land, Policy, Culture, Colonialism, and Empire in U.S.-Indian Relations," in *The Cultural Turn in U.S. History: Past, Present and Future,* ed. James Cook,

Lawrence Glickman, and Michael O'Malley (Chicago: University of Chicago Press, 2008): 343–82.

9 Janet A. McDonnell, *The Dispossession of the American Indian, 1887–1934* (Bloomington: Indiana University Press, 1991), vii.

10 On Ella's practice of lecturing, see Ella Deloria to Hugh Latimer Burleson, January 13, 1928 ("I am going to speak at various places on my way [to New York City], and those places are practically arranged for. I should make over three hundred dollars a month. But for advertising and a few things like that, I need to have some immediate money."); Ella Deloria to Franz Boas, December 19, 1927 ("Whenever I am in New York, I should like to take whatever opportunity comes to speak about Indians, always in the evening, and so it did not interfere with my daily work. That should give me a little extra from time to time. Even as a student there, I used to get such a chance two or three times a month, and if such chances came again, I should feel free to take them"). For retail activities, see "Invoice from The Mohonk Lodge," June 8, 1933, http://zia.aisri.indiana.edu/deloria_archive/browse .php, and "Letter from the Mohonk Lodge, June 9, 1933, http://zia.aisri.indiana .edu/deloria_archive/browse.php.

11 Jerry Fairbanks, producer, *Unusual Occupations*, 1944, episode 2. See www.shield-spictures.com/Resources/Unusual%20Occupations%20Episode%20Guide.pdf

12 See "Special Issue: Perspectives on the Society of American Indians," ed. Chadwick Allen and Beth Piatote, *American Indian Quarterly* 37, no. 3 (Summer 2013), and *Studies in American Indian Literatures* 25, no. 2 (Summer 2013); Hazel W. Hertzberg, *The Search for an American Indian Identity: Modern Pan-Indian Movements* (Syracuse: Syracuse University Press, 1971); Lucy Maddox, *Citizen Indians: Native American Intellectuals, Race, and Reform* (Ithaca, NY: Cornell University Press, 2005); Lawrence C. Kelly, *The Assault on Assimilation: John Collier and the Origins of Indian Policy Reform* (Albuquerque: University of New Mexico Press, 1983); and Kenneth R. Philp, *John Collier's Crusade for Indian Reform, 1920–1954* (Tucson: University of Arizona Press, 1977).

13 Society of American Indians, *Report of the Executive Council on the Proceedings of the Annual Meeting of the Society of American Indians* (Washington, DC, 1912), 87.

14 John Collier, *From Every Zenith: A Memoir; and Some Essays on Life and Thought* (Denver: Sage Books, 1963), 126. See also Philp, *John Collier's Crusade*, 1–4.

15 Sascha Scott, *Strange Mixture*, demonstrates how artists, politically, became anti-assimilationists dedicated to the preservation of essential Indian qualities—but that they did so in order to maintain their own access to "primitive" virtues, part of an *intercultural* dynamic.

16 G. E. E. Lindquist, *The Red Man in the United States: An Intimate Study of the Social, Economic, and Religious Life of the American Indian* (New York: George H. Doran Company, 1923); and Philp, *John Collier's Crusade*, 51. For Lindquist, who emerged as a central opponent of Collier's BIA, see David W. Daily, *Battle for the BIA: G. E. E. Lindquist and the Missionary Crusade against John Collier* (Tucson: University of Arizona Press, 2004).

17 Lewis Meriam et al., *The Problem of Indian Administration* (Baltimore: Johns Hopkins University Press, 1928).

18 Vine Deloria Jr. and Clifford Lytle, *The Nations Within: The Past and Future of American Indian Sovereignty* (New York: Pantheon, 1984); Graham D. Taylor, *The New Deal and American Indian Tribalism: The Administration of the Indian Reorganization Act, 1934–45* (Lincoln: University of Nebraska Press, 1980); Kenneth Philp, *Indian Self-Rule: Fifty Years Under the Indian Reorganization Act* (Sun Valley, Idaho: The Institute of the American West, 1983); and Elmer Rusco, *A Fateful Time: The Background and Legislative History of the Indian Reorganization Act* (Reno: University of Nevada Press, 2000).

19 Vine Deloria Jr., *The Indian Reorganization Act: Congresses and Bills* (Norman: University of Oklahoma Press, 2002); and Thomas Biolsi, *Organizing the Lakota: The Political Economy of the New Deal on the Pine Ridge and Rosebud Reservations* (Tucson: University of Arizona Press, 1992).

20 One of these potentials might be Gerald Nailor's 1942/43 Navajo history murals at Window Rock. See Jennifer McLerran, *A New Deal for Native Art: Indian Arts and Federal Policy, 1933–1943* (Tucson: University of Arizona Press, 2009), 5–15.

21 Susan Earle, ed., *Aaron Douglas: African American Modernist* (New Haven, CT: Yale University Press in association with Spencer Museum of Art, 2007). I am indebted to Sascha Scott for pushing me to consider this comparison more thoroughly, and for suggesting its outlines.

22 John G. Neihardt, *Black Elk Speaks*, complete edition (Lincoln: University of Nebraska Press, 2014); John G. Neihardt, *When the Tree Flowered: An Authentic Tale of the Old Sioux World* (New York: Macmillan, 1951); and Black Elk and Joseph Epes Brown, *The Sacred Pipe: Black Elk's Account of the Seven Rites of the Oglala Sioux* (Norman: University of Oklahoma Press, 1953).

23 Ella Deloria, "Sioux Indian Museum" annotated list, 24.

24 Ella Deloria, "Sioux Indian Museum" annotated list, 25.

25 For red medallions and an image—likely drawn by Mary Sully—see AISRI ethnographic notes, http://zia.aisri.indiana.edu/deloria_archive/browse.php?action=viewpage&id=1698.

26 Ella Deloria to Boas, August 7, 1940.

27 If Indigenous feminism concerns the intersectional work necessary to imagine Native sovereignty and de/anticolonial work alongside issues having roots in sex and gender analysis and oppression, then perhaps one might imagine Sully—who clearly considered gender, class, and Indigeneity in the same constellation—to have occupied an early space of Indigenous feminism. One might trace a genealogy that directly connects the sisters to Standing Rock anthropologist Beatrice Medicine, whose coedited book (with Patricia Albers), *The Hidden Half: Studies of Plains Indian Women* (New York: University Press of America, 1983), marks an important early moment in the academic development of gender and feminist analysis. See, for example, Cheryl Suzack, Shari Huhndorf, Jeanne Perreault, and Jean Barman, eds., *Indigenous Women and Feminism: Politics, Activism, Culture* (Vancouver: University of British Columbia Press, 2010); and Joanne Barker, *Critically Sovereign: Indigenous Gender, Sexuality, and Feminist Studies* (Durham, NC: Duke University Press, 2017). While the conversations surrounding the relation between feminism and Indigeneity are relatively recent, most writers find space for the reclamation of past moments that speak to contemporary understandings. Sully's work may offer one such moment.

CONCLUSION: LUTA AND THE DOUBLE WOMAN

1 Ella Deloria to Franz Boas, June 28, 1938; Cotera, *Native Speakers*, 53–59; James R. Walker, ed. Elaine Jahner, *Lakota Myth* (Lincoln: University of Nebraska Press, 1983); James R. Walker, ed. Raymond J. DeMallie, *Lakota Society* (Lincoln: University of Nebraska Press, 1982); and James R. Walker, ed. Raymond J. DeMallie, *Lakota Belief and Ritual* (Lincoln: University of Nebraska Press, 1980).

2 Ella Deloria to Franz Boas, dated "late 1938" ("I am very sad today because all the things I have planned have fallen thru so far and I am without work. . . . Times are simply impossible out here, and I actually don't know what I am going to do next.")

3 I have tried to trace the sisters' peripatetic movements through the locations from which Ella wrote letters. Some of this travel was clearly out of necessity— they had no stable residence—but other travel was clearly related to work. One also gets the sense that travel had become a way of life, perhaps with some pleasure attached to the necessity. As early as 1930, Brent Woodward (who replaced her father as the missionary at St. Elizabeth's) offered a critique of her habit of "moving about the country from place to place in connection with your work." Brent Woodward to Ella Deloria, February 24, 1930. Ella Deloria Project, Correspondence File 2.

4 Ella Deloria to Franz Boas, June 30, 1938.

5 Eda Borseth to Ella Deloria February 25, 1939, http://zia.aisri.indiana.edu/deloria
_archive/data/ED_PPP/MaterialFrom_VD/Material%20Recieved%20from%20
Vine%20Deloria36-0001.jpg.

6 For Mabel Berry and Byron Brophy, see "Correspondence regarding 'personality
prints' by Mary Sully," in Ella Deloria Archive AISRI, http://zia.aisri.indiana.edu
/deloria_archive/browse.php?action=viewpage&id=226.

7 Ella Deloria, "Proposed Line of Research," March 8, 1939, with letter from Reu-
ter of the same date. Ella Deloria Papers, DIF, Correspondence Box 3. *American
Weekly* was a weekly news magazine inserted into Hearst newspapers over the
course of much of the early twentieth century. While many covers survive, there
are few surviving issues.

8 In the AISRI archive, the list is bundled with letters from Brophy, Pitts, and Berry.

9 Ella Deloria to Rosebud [Yellow Robe], May 27, 1938, Ella Deloria Papers, DIF,
Correspondence File 3.

10 Vine Deloria Jr., "Autobiography," February 24, 1996, 11–12.

11 For the entire collection of thirty-three images, see Ella Deloria Archive, Dakota
Ethnography, Box 2, Drawings by Mary Susan Deloria (Mary Sully) AISRI, http://
zia.aisri.indiana.edu/deloria_archive/browse.php?action=viewcontainer&id=24.

12 For a collection of eleven images, see Ella Deloria Archive, Dakota Ethnography,
Box 2, Dakota Legends (eleven of the nineteen stories are prefaced by an illustra-
tion), AISRI http://zia.aisri.indiana.edu/deloria_archive/browse.php?action=view
container&id=13.

13 Position announcement, University of South Dakota, [1974], http://zia.aisri.indiana
.edu/deloria_archive/browse.php?action=viewpage&id=244.

14 Letter from Lloyd R. Moses to Vine Deloria Sr., May 21, 1974, http://zia.aisri.indiana
.edu/deloria_archive/browse.php?action=viewpage&id=243.

15 Ella Deloria dictionary breaks the word down thusly: "lul, from Luta, red; +ya—cause."
Typescript of Lakota-English dictionary manuscript, AISRI Archive: http://zia.aisri
.indiana.edu/deloria_archive/browse.php?action=viewpage&id=713. See also Buec-
hel dictionary, 326; Riggs Dictionary, 303, 440.

16 *New Lakota Dictionary Online*, www.lakotadictionary.org/nldo.php.

17 Janet Catherine Berlo, "Dreaming of Double Woman: The Ambivalent Role of the
Female Artist in North American Indian Myth," *American Indian Quarterly* 17,
no. 1 (Winter 1993): 31–43. See also, for example, Susan Gardner, "Introduction"
to *Waterlily* (Lincoln: University of Nebraska Press, 2009),: xxi–xxii. Gardner's
thorough though as yet unpublished manuscript on Ella Deloria is titled "Dream-
ing of Double Woman." The "doubling" move goes back to Ruth Benedict, who,
in *Patterns of Culture*, evoked the Double Woman to gesture to cross-gender

affiliation and performance (82) in anticipation of her later argument concerning gender and sexual disorientation (263–65). In the exhibition catalog *Plains Indians: Artists of Earth and Sky* (2014), object descriptions concerning beadwork invoke the figure of the Double Woman. See, for example, Emil Her Many Horses, "Man's Moccasins," 237; and Castle McLaughlin, "Woman's Side-Fold Dress," 106. Gaylord Torrence, in *The American Indian Parfleche*, figures the Double Woman as the source of dream-originated designs and describes the figure as the "feminine culture hero" (248). David Penney's acclaimed catalog *Art of the American Indian Frontier* uses the Double Woman (referring back to Clark Wissler's 1912 invocation of the figure) to frame a discussion of both the social aspects of women's quilling societies and the epistemological choices around sexuality and gender (29–30). The illustration of the Double Woman ceremony in Penney's *Art of the American Indian Frontier*, from an 1890 autograph book from the Rosebud reservation, carries the complicating caption: "Witches playing with their baby." Clearly, the Double Woman is a complex entity. Whatever culturally resonant metaphorical meanings it carried in the past, the figure has also become a prompt to think cross-culturally, to work within an engaged, if angular, relation to legacy Sioux epistemology while also framing complex questions about the nature of culture and individual, overlap and duality, interstices and doubling.

18 Ella Deloria, "Rites and Ceremonials," 93.

19 It was presented to Saswe in very much the same form. See Deloria Jr., *Singing for a Spirit*, 17–18.

20 Ella Deloria, "Rites and Ceremonials," 93–95.

21 Ella Deloria, "Rites and Ceremonies of the Teton," 88–92. This manuscript is available at http://zia.aisri.indiana.edu/deloria_archive/browse.php?action=view document&id=255. Since introductory material is included in the online page count, see 90–94 for her account of the Double Woman. Subsequent page numbers refer to the original manuscript (that is, her page numbering).

22 Ella Deloria, "Rites and Ceremonials," 92.

23 Ella Deloria, "Rites and Ceremonials," 92.

24 Ella Deloria, "Rites and Ceremonials," 95.

25 Ella Deloria, "Rites and Ceremonials," 98.

26 Gardner, "Introduction," xxi–xxii.

27 Gardner, "Introduction," xxii.

28 As one observer of this art commented, "The figure of the Double Woman gave shape to a Dakota philosophy that refused to throw away the 'damaged,' but tried instead to find ways to allow them into the society."

29 Beatrice Medicine, "Ella C. Deloria: The Emic Voice," in *Learning to Be an Anthro-*

pologist and Remaining "Native": Selected Writings, Beatrice Medicine, ed. with Sue Ellen Jacobs (Urbana: University of Illinois Press, 2001).

30 On Ella Deloria's associated career as a creator and producer of pageants, I have been informed by the work of Susan Gardner, whom I thank for her scholarship and her willingness to share with me her manuscript "A Vision of Double Woman: Ella Cara Deloria and the Profession of Kinship."

31 Medicine, "Ella Deloria," 283–85.

32 Beatrice Medicine, one of the few to consider the sisters together, observed, "Ella and Mary Susan exemplify two early Siouan female professionals—one an anthropologist and the other an artist—who provided emotional support to one another during their sojourns in New York City. Although they did not express this culture conflict, the two sisters may be viewed as two professional Native women who faced the dilemma of choosing between careers in both white and Native worlds." See "Ella Deloria," 277.

33 Ella Cara Deloria, The Dakota Way of Life (Sioux Falls: Mariah Press, 2007).

INDEX

Note: *Three Stages of Indian History* appears as *Indian History* within the entries. Illustrations are indicated by *fig.* following page numbers.

Big Bang theory, 137, 295n42

Black Elk Speaks (Black Elk and Neihardt), 49, 50*fig.*, 255

black lodge, 44, 49–50, 54

blanket designs, 53–54

Blue Eagle, Acee, 10

Blumenschein, Ernest, 149, 155

Boas, Franz: anthropological fieldwork, 194, 302n6, 305n52; culture and personality, 235–36, 276; Ella Deloria's training with, 214, 215, 232; failing health, 199, 262; intelligence testing project, 195–96, 198; Lakota language translation work, 87, 193; Reuter correspondence with, 264; Walker assignment, 262

Boasian anthropology, 20, 215

Bordeaux, John, 36, 45

Borglum, Gutzon, 179, 262, 264

Borsett, Eda, 264

Boys Town, 106, 107

Brande, Dorothea, 60, 228; *Wake Up and Live* (1936, also film), 60–62, 77–78, 220, 228

Brill, A. A., 76

Brophy, Byron, 264, 267

Brotherhood of Christian Unity (BCU), 52, 65

Brunot, Annie, 45

Bsumek, Erika, 177

Bureau of Indian Affairs, 178, 185, 246

Burke, Billie, 110–11, 125, 298–99n36

Burke, Charles, 288n22

Burleson, Hugh Latimer, 69, 71, 74, 75, 86, 197–98, 202

Busby Berkeley dancers, 126, 126*fig.*

Bushotter, George, 87

C

Caffrey, Margaret, 214

Cahill, Holger, 178, 181, 224, 301n67

Campbell, Malcolm, 142

camp circles, 66, 68*fig.*, 146, 250, 255

Camp Fire Girls, 153, 238

candy store enterprise, 72–73

Cannon, T. C., 23

capitalism, 30, 34, 148. *See also* curio concept of American Indian art

Cathedral of St. John the Divine (New York), 167

celebrity, culture of, 37–38, 42, 56, 128–29, 132, 224

"celebrity," as term, 37, 285n11

Chicago, relocation to, 86, 89, 128, 203, 290n50

children as signifier of Indian futurity, 258–59

"Children of Divorce" (*Ladies Home Journal*), 82–84

churches and cathedrals, 167, 169, 172. See also *Indian Church, The* (Mary Sully)

Civilization and Its Discontents (Freud), 220

Claymore, Edith, 121

Colgate Tests of Emotional Outlets (1925), 219

Collier, John, 178, 245–47

Collier, Nina Pereira, 178

Collins, Seward, 60

colonial domination: the church's role in, 200; in *Indian History*, 253–54, 255*fig.*, 257; land allotment, 237; Mary Francis's modification of, 65; reflected in Sully family, 45–46; and Sully's art, 185; and tropes of romantic tragedy, 29–30

color, use of: for abnormality, 217; in collection as a whole, 274; continuities in panels, 134–35; imagined, 59; for intangibles, 142; by Mopope, 6; and motion, 170–72, 204; in parfleche designs, 117–18, 243*fig.*, 256; red in *Indian History*, 254–55; and sound, 204; symbolic use, 208; Tiffany windows. See also *lúta*; red, significance of; *šá*

Columbia University anthropology, 193–94, 276. *See also* Benedict, Ruth Fulton; Boas, Franz

comic pages and comic books, 126, 170

commercial design, 42, 96, 104–5

Composition: A Series of Exercises in Art Structure for the Use of Students and Teachers (Dow, 1899), 99, 102–3

Connelly, Marc, *The Green Pastures* (1930), 183

Cook, George Cram "Jig," 78

Cook, Joseph, 51

Cook, Nilla (Nila) Cram, 78, 80, 82

Coolidge, Calvin, 246

Corn, Wanda, 95, 112–13, 151, 159

Cornell, Katharine, 217

Cotera, Maria, 303n22

Coué', Émile, *Self Mastery through Conscious Autosuggestion* (1922 in US), 219–20

Couse, E. Irving, 149–50

Coward, Noel, 217

Crawford, Morris de Camp, 102

cross, theme of, 66, 68*fig.*

cross-cultural sacred-secular structures, 52–53, 56

Crumbo, Woody, 10, 23

cubism and pointillism, 128

cultural assimilation: anti-assimilationists, 308n15; Christianity's role in, 53; Indian

resistance to, 148, 235–36; Indians making their way, 236–37, 239; migration and immigration. *See also* colonial domination; federal allotment policy; racial differences; social evolution and transformation

cultural politics: of promotional photographs, 233–34; racial differences, 235–36; social evolution and transformation, 234–35, 239–40; in Sully's art, 227; survivance and futurity. *See also* politics undergirding Mary Sully's art

culture and personality, 157–58, 215–16, 218, 275–76

Cunningham, Glen, 109–10

curio concept of American Indian art, 175

cutout tradition, 119, 163. *See also* positive and negative space; time and space, representation of

Cytowic, Richard, 205–6, 207

D

Dafoe, Allan Roy (Dr.), 132

Dafoe Hospital and Play House of Dionne Quintuplets, Callander, Ontario, Canada, 133*fig.*

Dafoe Nursery, 132–33

Dakota arts traditions: beadwork, 12n17, 30, 118–21, 196–97, 243*fig.*, 285n1, 294n30; feather arts, 243*fig.*; hide painting, 116, 117; ledger-book arts tradition, 6, 11, 114, 164, 281n3; *óskapi*, 116; parfleches, 116–18, 117*fig.*, 217, 229, 243*fig.*, 293n24, 294n29; quillwork, 114, 116, 267, 268, 270, 272, 312n17; quilting, 121–22, 294–95n35; *Spotted Tail Shirt* (1845–1855), 116*fig.*

Dakota epistemology, 136, 261, 272–73. *See also* Double Woman

Dakota themes: camp circles, 66, 68*fig.*, 146, 250, 255; sacred hoop, 66, 261

Dakota War of 1862, 42–43

Dasburg, Andrew, 150

Davis, Stuart, 224

Dawes Allotment Act (1887), 237

Dean, Dizzy, 165

debts, correspondence concerning: with Bishop Burleson, 73–74, 86, 202, 290–91nn50–51; with Henry Peairs, 71–72, 74–75; with Office of Indian Affairs, 70–71

De Cora, Angel (Ho-Chunk), 244–45, 279

Deer Woman, 136

Deloria, Barbara (librarian and author's mother), 5, 47*fig.*, 266

Deloria, Barbara (niece), 45, 47*fig.*

Deloria, Ella (sister)

——biographical details, 47*fig.*; childhood and education, 63, 64, 66, 68; death of, 266; as Double Woman, 272; photographs, 233–34, 233*fig.*, 239, 240*fig.*; role as woman, 303n22; struggle to earn a living, 194, 196, 228, 232, 238, 262, 310n2 (*See also* debts, correspondence concerning)

——career of: anthropological colleagues, 45; on children in Indian futurity, 258–59; on the color pink, 257; *The Dakota Way of Life*, 214; ethnographic work, 228, 247–48, 279, 301n68; on Great Plains art forms, 117–18, 120–21; intelligence testing, 195–96, 196*fig.*, 198, 221, 276; *Speaking of Indians* (1944), 66, 68*fig.*, 262; as teacher, 69, 238, 262–63, 289n25, 308n10; training and expertise, 194, 214, 215, 232; translation project, 87–88; Walker assignment, 262; *Waterlily* (novel, 1998), 262, 272, 279; at the YWCA, 70, 288n20

——correspondence: with Bishop Burleson, 86, 202, 290–91nn50–51; with Franz Boas, 193, 194, 195; with Henry Peairs, 71–72; with Office of Indian Affairs, 70–71; with Virginia Lightfoot, 19, 192–93, 283n18

——partnership with Mary Sully: art classes, 86; dynamic of, 87, 152, 193, 196, 214, 313n32; efforts to exhibit Sully's work, 179; on Great Plains art forms, 114, 116, 117; life in New York, 152; on Mary Sully as artist, 19; personality comparison, 72

Deloria, Philip (Sam) (nephew), 45, 47*fig.*

Deloria, Philip J. (née Tipi Sapa, or Black Lodge) (father), 47*fig.*; failing health of, 194, 196; marriages, 70; Native leadership, 52; as ordained minister, 44, 45, 51, 63, 64–65; Wounded Knee massacre, 201

Deloria, Susan Mabel. *See* Sully, Mary (née Susan Mabel Deloria)

Deloria, Vine, Jr. (nephew), 45, 47*fig.*

Deloria, Vine, Sr. (brother): about, 45, 47*fig.*; care of father, 194; childhood and education, 69; correspondence with Charles Burke, 74; education debts, 71, 73–75; ordination and marriage, 153; possession of personality prints, 4, 266

Demuth, Charles: Gertrude Stein, 217–18; *I Saw the Figure 5 in Gold*, 156–57, 163; *Longhi on Broadway* (1928), 159–60, 159*fig.*, 298n30;

G

Gabe, Anna, 63
Gandhi, Mohandas K., 78, 80, 82
Garbo, Greta, 217
Gardner, Alexander, photograph, 278
Gardner, Susan, 194, 272, 311n17
Gates, Nellie Two Bear, 121, 121fig., 279
genealogy of Mary Sully's family, 47fig., 284–85n1
geometric abstract, 105, 113, 133, 175–76, 276
geometrical abstraction (bottom panel), 114–23;
 from beadwork, 118–21; from hide painting,
 116–18; from quillwork, 114–16; from quilting,
 121–23
geometrical abstraction and human
 representation, 184
Golden Gate International Exposition (San
 Francisco, 1939), 10, 174
Grand Central Station Art Galleries (New York),
 173, 174
gray box with personality prints, 4–5, 266
Great Plains arts: gender roles in, 114; geometry,
 symbolism, representation, and abstraction,
 119; Sully as Dakota artist. See also geometrical
 abstraction (bottom panel)
Green, Kneeland "Ruzzie," 102
Guerra, Manuela de la, 29
G. Wilse Robinson Sanitarium for Nervous and
 Mental Diseases, 76, 84

H

Hall, G. Stanley, 76
Halpert, Edith, 181
Hambidge, Jay, 103
Harding, Albert Austin, 208
Hare, William Hobart, 51, 65, 244
Hartley, Marsden: *Amerika* series, 145–46;
 critique of, 279; in Demuth's collection, 157;
 gallery shows of, 296n3; *Indian Fantasy* (1914),
 144fig., 146–47; in modernist circuit, 78, 149,
 150; *One Portrait of One Woman (Gertrude
 Stein)* (1916), 218fig.; primitivism and self-
 identification, 177; triangulating Sully with, 217
Haskell Indian School (Lawrence, Kansas), 70,
 274, 289n25
Helen Wills (Sully, ca. 1929): bottom panel, 13fig.;
 forms and patterns in, 13–14; indigenous and
 modern in nature, 22; meaning in, 7–9; middle
 panel, 12fig.; *Time* cover, 88; top panel, 8fig.;
 use of space, 18
Henderson, Alice Corbin, 9, 198

Henri, Robert, 150
Herrera, Joe H. (Cochiti Pueblo, 1923–2001), 186,
 186fig.
Hornung, Clarence, *Handbook of Designs and
 Devices* (1932), 103–4
Howe, Oscar (Yanktonai Dakota, 1915–83), 23, 186;
 Victory Dance (ca. 1954), 187fig.
Hubbard, Elbert, 99
Hurston, Zora Neale, 195
Hutchinson, Elizabeth, 177
Hutton, Barbara, marriages of, 129
Hyslop, Stephen, 29

I

identity and transformation: cultural genealogy
 of name, 36, 37, 62–63, 267; in Deloria sisters,
 193; *possibility* in biculturalism, 277–78;
 re-creation of self. See also Double Woman
Idyll of the Deep South (Douglas), 253
Indian Arts and Crafts Act (1935), 178
Indian Church, The (Mary Sully), 48fig.; allusions
 to in *Indian History*, 257; bottom panel, 54;
 compared to Hartley's *Indian Fantasy*, 146,
 147; critique of settler colonial history, 241,
 244, 274; elements of commercial design, 105;
 middle panel, 51, 53–54, 53fig., 55fig., 57fig.;
 oscillation in, 165; top panel, 46, 49–51, 49fig.,
 54; woman-centered imagery, 254
Indian Citizenship Act (1924), 246
Indian futurity, 22, 254fig., 257–58fig., 258–59,
 261, 274
Indianness, signifiers of, 146, 233–34
Indian policy affairs, reform in, 244
Indian princess figure, 28, 200
Indian Reorganization Act (IRA), 246–48, 274
Indian women, primacy of, 54
Inge, William Ralph, 18
inheritance, mother's, 69–70, 288n19. See also
 land, ownership of
Institute of American Indian Arts (IAIA), 10, 21, 186
intelligence testing, 195–97, 196fig., 198, 221, 276

J

Jackson, Andrew, 36
Jackson, Lesley, 102
Jacobson, Oscar, 9, 11, 198, 282n6
James, William, 76, 151, 220–21
Janet, Pierre, 220
Jefferson, Thomas, 37
Jung, Carl, 76, 220

K

kaleidoscopes, 126
Kandinsky, Wassily, 304n36
Kane, Helen, 112
Kane, John, 181
Keller, Helen, 218
Kellner, Bruce, 298n30
Kelly, Patsy, 77–78, 217, 287n4
Kimball, Yeffe, 284n22
Kimímela (Ke-ma-me-lar), 28, 30, 284n1
kinship relations in Dakota world, 277
Kiowa Agency (Anadarko, OK), 9
Kiowa Art (ed. Jacobson), 9
Kiowa Six, 9, 12, 23, 275, 281–82n6
Klineberg, Otto: culture and personality, 235–36,
 276; Dakota strengths, 302n14; expertise, 195;
 intelligence testing, 196, 198, 221; normality
 and abnormality, 215; tests and measures,
 305n54
Kooning, Willem de, 180, 185–86

L

La Farge, Oliver, 20, 150, 174–75, 176, 197
Lafayette, Marquis de, 37
LaGrande, Peter, 36
LaGuardia, Fiorello, 228
Lakota arts traditions. *See* Dakota arts traditions
Lamont, Jennie, 45
land, ownership of, 69–70, 71, 288n19
land policies, 237
Lane, Mrs. Willie Baze, 11
Latour, Bruno, *We Have Never Been Modern*, 278
Lawrence, Jacob, 182, 254
Lebduska, Lawrence, 181
ledger-book arts tradition, 6, 11, 114, 164, 281n3
Levin, Gail, 145
Levine, Lawrence, 222
Lewis, Edmonia, 279
Lightfoot, Virginia Dorsey, 19, 192–93, 283n18
Lilypons (Maryland), 212
Lindbergh, Charles, 228
Lindquist, G. E. E., *The Red Man in the United
 States* (1923), 246
Luhan, Mabel Dodge, 78, 149, 150, 279
Lunt, Alfred, 118, 217
lúta (var. *dúta*, scarlet or red), 267–68, 269*fig.*,
 272–73
Lutenski, Emily, 182

M

"machine age" exhibitions, 102
machine portraits, 155–56
Man's Moccasins (ca. 1880), 119*fig.*
marginality: of art communities, 179–84;
 Benedict's work on culture and personality,
 214–18; in Dakota Double Woman, 272; Ella
 Deloria's frustrated career, 193–95; racial
 differences, 195–99; reflected in personality
 prints, 221–24; Sully's psychological issues,
 192–93, 199–203; synesthesia, 203–7
Marin, John, 150, 157
markets for Indian art, 177–78, 262–64
Markham, Beryl, 218
Marsh, Reginald, 224
Martinez, Crescencio, 10
Martinez, Maria, 9, 279
McDonnell, Janet, 237
Mdivani, Alexis, 129
Mead, Margaret, 194, 214, 224, 305n52
Medicine, Beatrice, 273, 310n27, 313n32
mental health: and artists, 184; Mary Sully's,
 74–77, 84–85, 199; normality and abnormality,
 215–16; theories concerning, 76–77, 199
Mental Hygiene Inventory (1927), 219
Meriam, Lewis, *The Problem of Indian
 Administration* (1928), 246
Metropolitan Museum of Art, 102
Metropolitan Opera, 208, 212
military domination, 43–44, 45–46, 56
Millay, Edna St. Vincent, 78, 217
moccasins: in Alfred Sully's paintings, 28–29, 30;
 beaded and quilled tradition, 30, 34, 35, 116,
 119*fig.*, 234, 268, 285n1; gifted to Alfred Sully,
 27, 34, 268; on Mary Sully, 64*fig.*; in personality
 prints, 54, 119, 269*fig.*
modernism: American Indian modernism, 5–10,
 173–76; antimodernism, 149–50, 192, 301n1;
 cognitive and aesthetic, 151–52; concept of,
 147–48, 163; contexts and framing, 94–95,
 291n4; cultural nationalism, 180; dynamics
 of, 147–52; Indian artists as native to, 19–23;
 and postmodernism, 150, 296–97n9; queer
 modernism, 218; Sully's engagement with. *See
 also* Native modernism
modernist artists and their art: abstraction in
 portraits, 155–63; engagement with Indian
 culture, 176–77; modernist ideas in *Easter*,
 167–73; Sully's alignment with, 139, 153, 155;
 visual illusion for time and space, 163–67

prints, 18; "List of Personality Prints" (ca. 1938). *See also* Sully, Mary, personality prints

Personality Schedule (1930), 219

perspective (in art), 126, 164

Peters, Susan, 9

Philadelphia Museum of Art, 102

Phillips, Bert, 149

Phillips, Ruth, 119, 173

Picabia, Francis, 155–56, 156*fig.*

pictorial representations: ethnographic illustrations, 123–25; gender roles, 114; realism in Indian art, 175; women's beadwork, 121

picture and symbol (top panel), 106–13; modern art and popular culture, 133; pictorial representation, 8, 106–9; semiotic abstraction, 111–13

Pipestone Indian School (Minnesota), 262, 263

Pippin, Horace, 181

Pitts, ZaSu, 262

Planting Society. *See* Brotherhood of Christian Unity (BCU)

pointillism, 128

politics undergirding Mary Sully's art: cultural politics, 233–44; personal politics, 227–33; sovereignty politics. See also *Three Stages of Indian History*

Polk, James, 37

Pollock, Channing, 298–99n36

Pollock, Jackson, 180

Pons, Lily, 212

Poolaw, Horace, 10

popular culture, 126–28, 222, 234

positive and negative space, 136, 163, 243*fig.*, 256*fig.*, 257

Possible Bag (ca. 1885), 119*fig.*

primitivism: global context of, 180; performing. *See also* modernist primitivism

prison arts, 184

progressivism, 99, 149

Project 35: Acculturation, 214, 228

Provincetown Players, 78, 159, 275

psychoanalysis and art, 85

psychology of personality, 218–21. *See also* culture and personality

Public Works of Art Project, 178

Pueblo land claims, 246

Pueblo visual culture, 281n3

Punton, John, 76

Punton Sanitarium, 76

purple, Episcopal symbolism of, 49

Q

quillwork: and Double Woman, 270, 312n17; in *The Indian Church*, 54; as metaphor for creative work, 272; Plains women's skill in, 114, 116; red quillwork, 267, 268

quilting, 121–22, 294–95n35; patterns in *Easter*, 171–72

R

racial differences, 198, 235–36

racial intelligence, 200, 221

rainbow, theme of, 49, 50*fig.*, 54

Raymond, Natalie, 214

recontextualization of Indian art, 10, 20–23, 278–80

red, significance of, 261

Red Cross, 261

red in *Indian History*, 254–55

red road, good, 261, 262

Reed, John, 78

Reuter, J. B., 264, 267

Rifkin, Mark, 22

Rites and Ceremonials of the Teton (Deloria), illustrations in, 226*fig.*, 229, 229*fig.*, 230, 230*fig.*, 231*fig.*

Rivera, Diego, 7–8, 251, 251*fig.*

Robinson, G. Wilse, 76, 77, 84–85, 191, 202

Roosevelt, Franklin D., 228

Rorschach, Hermann, 85; *Rorschach Card 10*, 219*fig.*; Rorschach inkblot tests, 219, 290n46, 293n16, 305n55

rose, meaning of, 160, 163

Ross, Denman, *A Theory of Pure Design* (1907), 103

Ross, Dorothy, 151, 152

Rubin, Judith, 85

Rushing, W. Jackson, 10, 186

Ruth, Babe, 42

S

šá (red), 267

sacred hoop, 66, 261

salvage ethnography, 228–29

San Ildefonso Pueblo (New Mexico), 9, 10, 11, 12

Santa Fe Studio School (Santa Fe, NM), 10, 12, 186, 275

Santee (Eastern Sioux) floral style, 118, 124

Saswe (François Des Lauriers) (grandfather), 44, 47*fig.*, 49–50, 52

scale, development of, 136–37

Scholder, Fritz, 23, 283n15